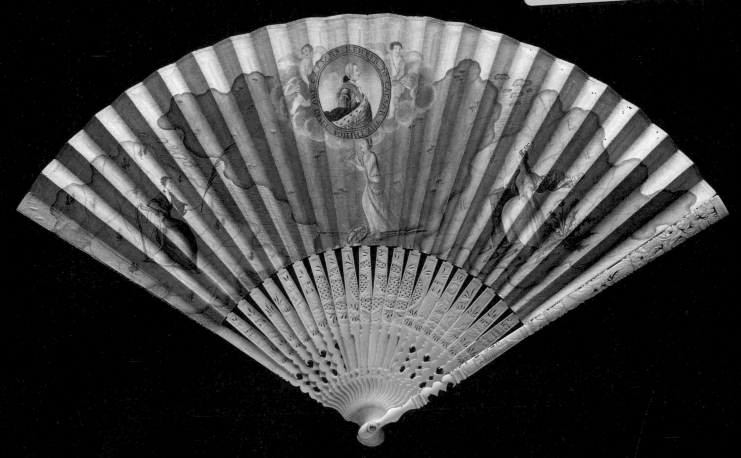

Bonnie
Prince Charlie
and the Jacobites

Bonnie Prince Charlie and ^{the} Jacobites

Edited by David Forsyth

National Museums Scotland

**Bonnie Prince Charlie
and the Jacobites**

Exhibition at

National Museum of Scotland
Chambers Street
Edinburgh EH1 1JF

www.nms.ac.uk

23 June to 12 November 2017

Investment managers

National Museums Scotland
would like to thank
Baillie Gifford Investment Managers
for their generous sponsorship
of this exhibition

Published in 2017 by
NMS Enterprises Limited – Publishing
a division of NMS Enterprises Limited
National Museums Scotland
Chambers Street
Edinburgh EH1 1JF

www.nms.ac.uk

Text, photographs and illustrations (unless other-
wise credited) © National Museums Scotland 2017

Catalogue format and additional material (as
credited)

Ownership of objects (as credited)

*No part of this publication may be reproduced,
stored in a retrieval system, or transmitted in any
form or by any means, electronic, mechanical,
photocopying, recording or otherwise, without the
prior written permission of the publisher.*

The rights of the contributors to be identified as
the authors of this book have been asserted by
them in accordance with the Copyright, Designs
and Patents Act 1988.

British Library Cataloguing in Publication Data
A catalogue record of this book is available from the
British Library.

ISBN 978 1 910682 08 1

Printed and bound in the United Kingdom by Bell
& Bain Limited, Glasgow
Book layout by NMS Enterprises Limited –
Publishing
Design of cover and title spreads by Mark
Blackadder.
Additional design by NMS Exhibitions and Design.
Photography by Photographic Studio, NMS
Collections Services.
Cover: (front) Painting entitled *Prince Charles
Edward Stuart* (1720–88), by Louis Gabriel
Blanchet (1705–72), *c.*1739, oil on canvas,
Royal Collection Trust / © Her Majesty Queen
Elizabeth II 2017, RCIN 401208 [Cat. no. 137];
and (back) Portrait of James Frances Edward
Stuart, King James VIII and III, by Antonio
David (1688–1766), by Antonio David (1680–
1737), 1730, oil on canvas, with grateful thanks
to The Pininski Foundation, Warsaw, Poland
[Cat. no. 112]; (background art and endpapers)
design by Studioarc, Edinburgh.

For a full listing of NMS Enterprises Limited –
Publishing titles and related merchandise:
www.nms.ac.uk/books

Contents

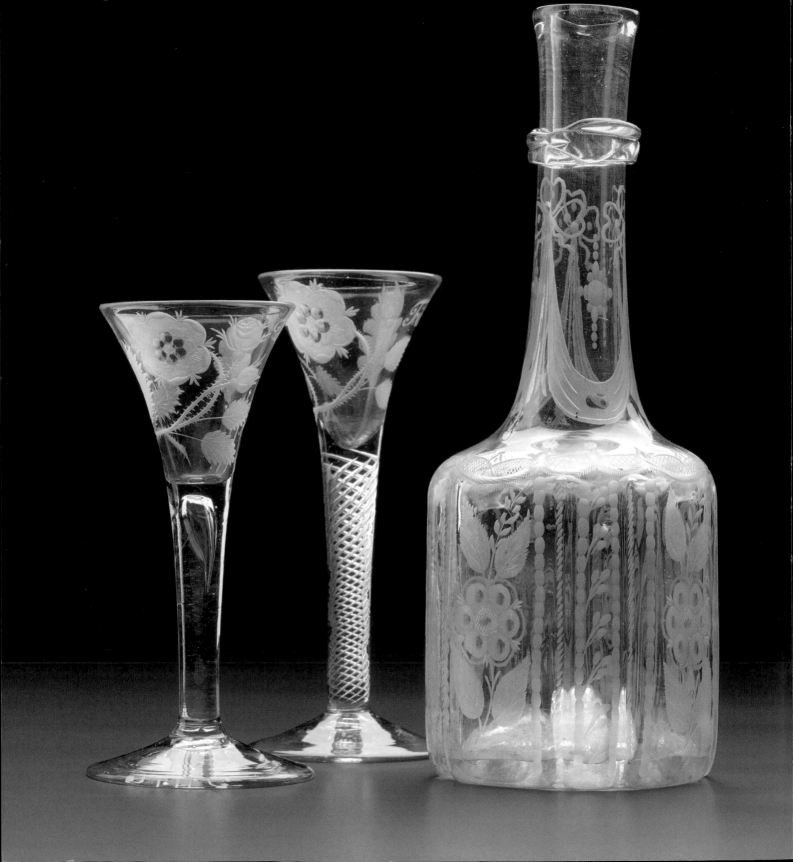

Foreword

BONNIE PRINCE CHARLIE AND THE JACOBITES IS THE LARGEST EXHIBITION TO BE held on the subject of the exiled Stuarts and their Jacobite supporters for many decades. Through a diverse and rich range of artefacts it illustrates the story of the Jacobite Stuart dynasty, its flight into exile and the subsequent attempts to reclaim the crown of the kingdoms of Scotland, England and Ireland.

The exhibition brings together around 350 objects, including jewellery, glassware, dress, weapons, paintings, maps and documents, drawn from the collections of National Museums Scotland and enriched by objects from the collections of many generous lenders. These loans, from Scotland, England, Ireland, France, Italy and the Vatican City, include objects from private lenders, some of whom have direct family links to these tumultuous historical events.

Like the exhibition, this accompanying book of essays aims to bring new perspectives to the Jacobite story as we understand it today through its surviving material and visual culture.

Dr Gordon Rintoul CBE
Director, National Museums Scotland

Preface

THE MATERIAL CULTURE OF THE JACOBITE CAUSE IS OF GREAT INTEREST FOR FIVE reasons. The first is quite simply its variety, beauty and sophistication, ranging as it does from gloves, teapots and tartan to drinking glasses, silver, stump and plasterwork of extraordinary complexity. The elaborate nature of Jacobite materiality was not only because it was a movement supported by the wealthy and aristocratic, even though they naturally bought and commissioned much of its upmarket material culture. It was for a second reason: that the material culture of the Jacobites (and their use of music and Latin tags) was designed to provide not only a vocabulary, but also (in the arrangement of gardens and internal décor) a syntax of political opposition to the British government and the Whig ascendancy. All the way back to Edward III in 1351, English treason and later sedition legislation (effectively extended to Scotland after 1708) had been based on language. To evade language, to codify it through objects, images and quotes from Horace and Vergil, images of Perseus or Medusa, tunes which suggested words to their hearers or the wearing of tartan, all placed the Jacobites beyond the risk of prosecution. This is why an irritated government banned tartan altogether from public use outside the British army after the 1745 rising.

The third reason why Jacobite material culture is important leads directly to the fourth. The Jacobite movement was at its peak in the first age of consumer manufacture, when glass and objects of all kinds became cheaper to produce as a result of a wide range of developments in mass production which can be seen in the society of the age more generally: for example, in the introduction of milled coinage in 1662. As a consequence, the language of opposition developed by the Jacobites became the basis for many other oppositional movements: the Whiteboys, the United Irishmen, the English Radicals, the Chartists, the French and Russian revolutions all used symbols and symbolism dependent on or similar to those used by their Jacobite predecessors. The white hat worn by Henry Hunt to address the vast crowd at Peterloo in 1819 was itself the descendant of that

worn in early 18th-century Jacobite productions of Otway's *Venice Preserv'd*, a play produced to celebrate the future James VII and II's return to London after the defeat of attempts to exclude him from the Crown.

The fifth and final reason for the importance of Jacobite materiality is that in its latter stages it was one of the first examples of the creation of public memory through precious places or relics of ownership: the roots of the culture of memorialisation, public celebrations and the associational relics of Victorian culture can all be found in the Jacobite era. Rob Roy's toddy or Charles Edward's shield were alike precious associational relics of their owners in a way that Walpole's boots or Clive of India's cutlery were not. Jacobite relics made that shift from a sacred language of preserved objects to a secular one. This shift was to characterise the creation of the souvenir, and with it the power of cultural memory to create a sense of identity located in particular people and places: the Burns Country, Goethe's Weimar, the Schiller Festival, and the population of public spaces by statues of great women or men, most usually men.

There are many fine essays in the collection that follows, which repay reading in their own right rather than being summarised here. Among the topics covered are Stuart court culture and etiquette, chivalric orders, weapons, art and tartan. Iconic images of the Jacobite leadership (such as that attributed to Allan Ramsay in Lucinda Lax's essay) formed the basis for prints, miniatures and sometimes medals. Rings, like the 'Four Peers' ring on show in the exhibition were, like double-sided or false loyalist fans – for example those that showed James 'VIII and III' in an oak tree rather than Charles II – ways of concealing political loyalties which were openly worn from all but intimates. There are so many complex elements to Jacobite culture and this exhibition is a great place to start. But it is also always worth remembering that what you see here also had a historical significance in the development and nature of European national identities and their expression long after the last Jacobite who fought in the rising of 1745 died in 1824.

Murray Pittock
Bradley Professor and Pro Vice-Principal
University of Glasgow

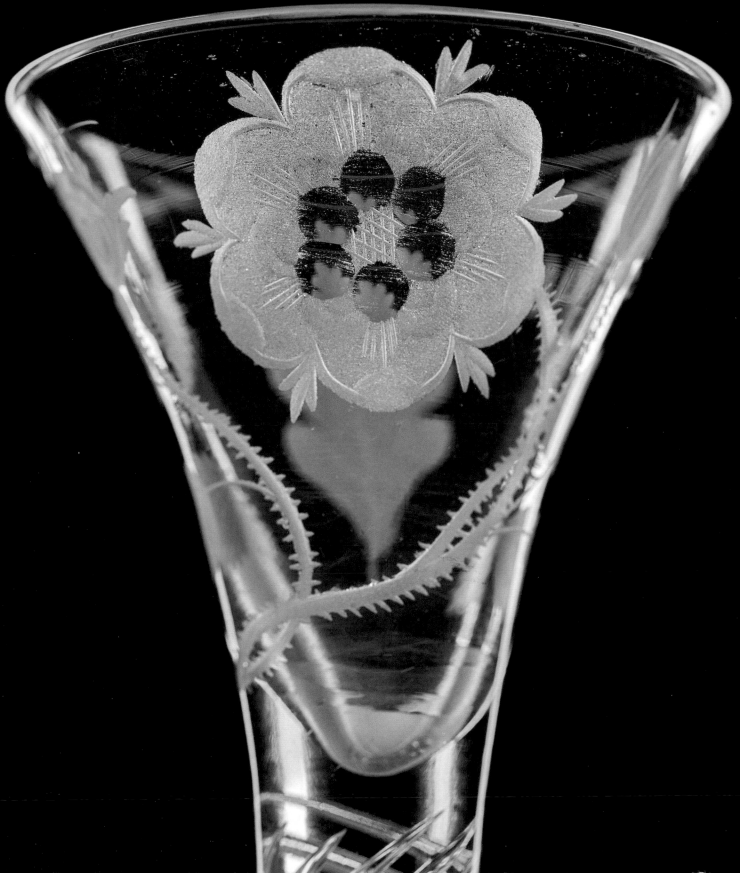

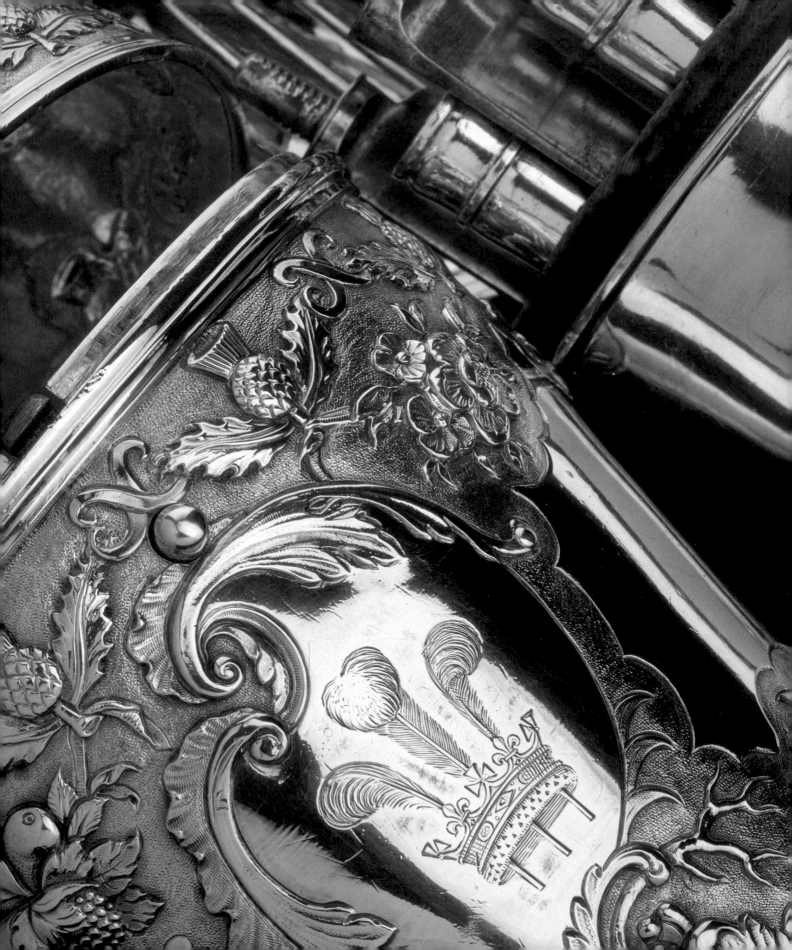

CHAPTER I

Bonnie Prince Charlie and the Jacobites

Narrative of an Exhibition

David Forsyth

THIS INTRODUCTORY CHAPTER CAPTURES AND CONTEXTUALISES A SELECtion of around 350 objects that have been brought together to realise the special exhibition *Bonnie Prince Charlie and the Jacobites* at the National Museum of Scotland, Edinburgh, in 2017. This volume of essays, published in support of the core exhibition, is not intended to be another narrative history of Jacobitism. Rather it has as its main focus the role of material and visual cultures as a means of examining the exiled Stuart dynasty and the Jacobite movement which emerged to support its cause.

As the custodians of a world-class collection of Jacobite material culture, most of the exhibition's inclusions have been drawn from the Museum's own resources. However, we also relied on the generosity of over forty separate lenders, from internationally-recognised institutions, regional and local museums, churches, and of course private individuals, without whom the exhibition would not have been as rich or as varied.

Objects chosen from the Museum's collections ranged from the familiar to the iconic, from pieces taken from the permanent galleries to some of the more obscure examples of Jacobite material culture, often little known outside academia or the collecting circles of Jacobite *cognoscenti*. Such treasures include the exquisite Edinburgh-made travelling canteen which belonged to Prince Charles Edward Stuart [Fig. 1.1] saved from the threat of export in 1984.

Exhibitions on the scale of this one allow museums to re-examine their collections. This is exemplified by a ring of the Order del Toboso [Fig. 1.2] which has remained unseen for over seventy years. A small but fascinating object, it provides evidence of a fraternal association composed of leading Jacobites at home and abroad, established during the time the exiled Stuart court had moved from France to Rome.[1]

Viccy Coltman reminds us in chapter 10, in her discussion of 'Material Matters', that 'not all material culture is Jacobite and not all Jacobite culture is material'. In a similar vein, not all the objects in this exhibition are intrinsically 'Jacobite'. Apart from an obvious need to adhere to impartiality and to strike a strict historical balance, this allows us to attempt to illustrate a historical narrative

Fig. 1.1, previous pages: Travelling canteen of Prince Charles Edward Stuart [detail]

A travelling canteen, possibly commissioned as a 21st-birthday gift for Prince Charles Edward Stuart from a Scottish supporter. Made by the goldsmith Ebenezer Oliphant, whose family were pro-Jacobite.

By Ebenezer Oliphant, Scottish, 1740–41, National Museums Scotland, H.MEQ 1584.1–16

CATALOGUE NO. 136

NOTE ON DATE CONVENTIONS:

Britain and Ireland remained on the Julian Calendar until the Calendar Act of 1751. This meant that the British Isles were 10 days behind the Continent in the 17th century, and 11 days behind for most of the 18th century. Most of the dates in this volume are based on the Julian Calendar. Where possible, when the new Gregorian Calendar has been used this has been designated by the abbreviation 'N.S.' for New Style (O.S. indicates Old Style). A further complication is the fact that Scotland changed the first day of the year to 1 January in 1600, while in England New Year's Day continued to be observed on Lady Day, 25 March, until the passing of the above act.

Fig. 1.2: Ring of the Order del Toboso

A ring associated with the Order del Toboso, an exclusively Jacobite fraternal association, whose membership included Charles Edward and Henry Benedict, the two Stuart princes.

18th century, National Museums Scotland, H.NT 253

CATALOGUE NO. 288

of a history that is, at times, contentious, the core of which stretches over 119 years. In this exhibition the objects of material culture were selected in order to tell this story of this dynasty – that is, its division through deposition, exile, and subsequent attempts to reclaim the crowns of the three kingdoms of Scotland, England and Ireland.

There is a developing interest[2] in Jacobite material culture from academia. Lucinda Lax from the Scottish National Portrait Gallery, Edinburgh, for example, casts new light in chapter 7 on 'The Lost Portrait of Prince Charles Edward Stuart' by Allan Ramsay, the only portrait of the prince painted in Scotland at the time of the 1745 rising. While in chapter 5, curators Helen Wyld and George Dalgleish examine 'Weapons fit for a Prince' and pose searching questions about a small but highly iconic group of objects identified as forming the surviving elements of a gift of full Highland dress given by a leading supporter to the prince. This gift sent to the exiled court is clearly Jacobite in association, conceived as a material link between a supporter at home and the young prince.[3]

Thus the analytical consideration of Jacobitism through the prism of material culture is no longer a mere search for prepossessing images to beautify monographs on the subject. Material culture as evidence can hold its own with more traditional documentary sources. Given the seditious link, in the view of the Hanoverian government and its supporters, to Jacobite associational culture, the elicit nature of this material culture ensures that it can be the only extant evidence for the covert activities of Jacobite sympathisers.[4]

Confronting the Myth

The exhibition begins, deliberately, with a grand portrait of a young man entering a room [Catalogue no. 1]. Just behind him stand two male attendants – discreetly supportive, one with his head bowed in reverence. The central figure is clad in tartan or plaid and is clearly an important figure. This is of course Prince Charles Edward Stuart, Regent to James VIII and III, who left a comfortable life in his family's exiled court to take charge of a military campaign to regain his father's crown. Despite the courtly gravitas, this is not the depiction of an actual historical event; it is an artistic construct by the artist John Pettie (1839–93), based on a fictional episode. This putative entry into a ballroom was described in the novel *Waverley* by the author Sir Walter Scott, himself a scion of Jacobitism on his mother's side.

Thus a 19th-century historicist painting of an imagined episode has come to grace innumerable tins of shortbread, which is in itself a product of a wider popular culture, partly encouraged by tourism to Scotland, with an output of almost

industrial proportions. As Murray Pittock has identified, the use of Jacobite imagery has become something of a perfect storm which has 'showed not only its power in the marketplace, but also the degree to which it has been conflated with the Scottish identity'.[5] All of this serves to reinforce the view that this 'Young Chevalier' is the epitome of Jacobitism, fuelling popular misconceptions and obscuring the wider and even more fascinating history of the Jacobite cause. Although as a counterpoise, in his book *The Invention of Scotland, The Stuart Myth and the Scottish Identity …* (1991), Murray Pittock points to a political edge to the figure of Bonnie Prince Charlie and to Jacobitism at the time of the Scottish Renaissance of the inter-war period.[6]

As with many aspects of the Jacobite story, there is an element of truth to Pettie's work: this scene is not entirely conjectural. Charles was indeed residing at the Palace of Holyroodhouse when a brief but vibrant Stuart court was re-established in Scotland between September and October of 1745. A seminal study by Robin Nicholson, *Bonnie Prince Charlie and the Making of a Myth …* (2002), further deconstructs the image, revealing that Pettie made no attempt to anchor his painting in its time and place as a complete reconstruction: 'Charles's clothes and appearance are wholly inaccurate (not even borrowed from Scott) … [and] what Pettie is depicting is not the eldest son of King James VIII & III in the year 1745, but "Bonnie Prince Charlie"' – and so the myth replaces the actuality.[7]

Jacqueline Riding also confronts this imagined scene head-on in her introduction to chapter 6, 'The Stuart Court at Holyroodhouse in 1745', before moving swiftly to a robust rebuttal of the 19th-century historian Andrew Lang's diminution that the short-lived court amounted to a mere 'little hour of royalty'. In this she points out the dynastic and propagandist significance of the establishment of such a court at this juncture.

The events of the ultimately unsuccessful attempt by Prince Charles to regain the throne of the three kingdoms for his father have been woven into romantic notions of Scottish history and Scottish identity.[8] This reinvention of Scotland and its Jacobite past has been aided and abetted by a variety of artistic constructs, most famously 'The Skye Boat Song'. The air, however, was first collected much later, in the 1870s. These lyrics were not the ones sung by the prince's rowing party on his real sea-borne flight from Benbecula to Skye.[9] These were in fact written in 1884 by Sir Harold Boulton, an English songwriter who found an affinity with Scottish folksongs and was keen to preserve traditional melodies with the addition of new lyrics. 'The Skye Boat Song' would become his most famous composition.

Although the entrance to the exhibition is designed to offer the visitor a familiar and romantic view, even down to a graphic backdrop of a mountainous Highland landscape, very quickly the narrative suggests that what follows may not be so familiar. The Jacobite story is far more complex and multi-layered.

Now, through the use of a graphic timeline and dynastic family tree, visitors will begin to discover that they are dealing with a period of time older and longer than the events that played out in just over a year between 1745 and 1746. Indeed the roots of this story lie nearly sixty years before, in the forced departure from the south coast of England of a royal family – James VII and II, with his queen consort and infant son, Prince James Francis Edward, father of the future 'Bonnie Prince Charlie' – rather than with the landing of a young prince on a Hebridean beach. The story of the attempts – five main challenges are identified in this exhibition – by the Stuarts and their supporters to regain the throne of the three kingdoms is of course much more complicated, and is part of wider European diplomacy, the plans for which were hatched far beyond Scotland.[10]

The Stuart Dynasty

At the heart of the Stuarts' sense of self-belief was their entrenched adherence to divine right monarchy. There is a clear indigenous Scottish expression of this contained in the Act of Supremacy of 1669:

> … *lykas his Majestie, with advice and consent of his Estates of Parliament, doth heirby enact, assert and declare, that his Majestie hath the Supream Authority and Supremacie over all persons and in all causes ecclesiastical within this Kingdom.*[11]

This belief is central to understanding the tenacity with which the exiled Stuarts held to their cause. After all, it was an ideology that led to civil war in the three kingdoms, to the exile, and to the ultimate downfall of the senior branch of the House of Stuart in 1688–89. Though such tenets are conceptual and seemingly intangible, the exhibition curators sought to tackle them head-on at the earliest opportunity.

A very rare survivor from the first half of the 17th century is a small gold ampulla [Fig. 1.3], possibly made by James Denniestoun for the Scottish coronation of Charles I, held at Holyrood on 18 June 1633. The ampulla was specifically commissioned to contain the holy oil with which the king was anointed – the most sacred part of a coronation ceremony.[12] The ampulla was used along with the Honours of Scotland, and similarly fell into disuse, although the ampulla remained in the possession of the Town Clerk of Edinburgh who originally commissioned it.

As an indication of further trouble between Charles I and his northern realm, there was much controversy around his High Anglican coronation ceremony. The rite of this ceremony, imposed by the king, was regarded as a propaganda exercise for his 'high' view of both monarchy and the

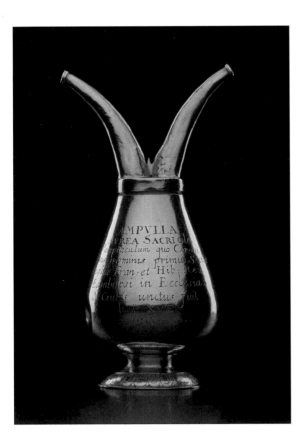

Fig. 1.3: Ampulla

Coronation ampulla of gold which held the sacred anointing oil for the coronation of Charles I at Holyroodhouse on 18 June 1633.

Possibly by James Denniestoun, Scottish, c.1633, National Museums Scotland, H.KJ 164

CATALOGUE NO. 2

church. This caused much disquiet among those Scots who were increasingly drawn to Presbyterianism as their preferred system of church polity.

King James VI and I had elucidated his view of kingship in his manual of absolutism, *Basilikon Doron*, where he upheld the theory of the divine right of kings: the absolutist idea that a monarch's authority to rule comes directly from God and that he or she is not subject to any earthly authority.[13] Charles likewise believed that the king had a divine right to rule, and as such he was the spiritual Head of the Church.[14] Presbyterians, however, could not accept this as their principal subordinate standard at that time, which claimed 'Christ Jesus [as] the only Head of the same kirk'. This would be their *crie de couer* in the rejection of an earthly supreme governor of the Kirk in the guise of Charles I in the subsequent Bishops' wars of 1639–40 and beyond.

Jacobite 'faith' would therefore become imbued with a strong sense of the cult of martyrdom running through it.[15] Adrienne Hynes, in chapter 8 on 'Faith and the Jacobite Movement', reveals material elements of the 'ecumenical' nature of the movement at the rising of 1745 with a sample of objects from a range of denominations. However, the key object in her discussion is the chalice and paten made for the Episcopal congregation of Appin. Likewise chapter 9 by Allan Macinnes, on the *Gaidhealtachd* – the themes of which punctuate this exhibition – demonstrates that Highland Jacobites were overwhelmingly Episcopalian, with a strong non-juring tradition, that is those who refused to take the Oath of Allegiance to King William III.

A silver Communion bread plate [Fig. 1.4] has been selected for this section to illustrate the complexities that surround religion. This plate contains the only known depiction of a 17th-century Scottish Communion service. Rather surprisingly the supplicant is shown kneeling in front of the Communion table, which is an image more redolent of Episcopalian or Catholic worship. This becomes less remarkable when it is explained that the set of Communion ware, to which this plate belongs, was commissioned in 1633 by the Rev. Thomas Sydserf of Trinity College Kirk in Edinburgh, from the silversmith Thomas Kirkwood of Edinburgh.[16] This date is not random – it coincides with the year of Charles's journey north to the country of his birth to attend his Scottish coronation. More tellingly, Sydserf was a keen supporter of the king's contentious and increasingly unpopular anglicising policies towards the Kirk.

Power to the Stuart dynasty was not merely abstract, it was also real. The steel harquebusier's or cavalryman's helmet from the Royal Collection [Cat. no. 4], made by Richard Holden in *c.*1660–88, represents the physical power of absolutism – a standing or permanent army. This was one of the pillars of this type of monarchy, which English parliamentarians and others saw as a key facet of the absolutist tendencies of the Stuart monarchy.[17] Those opposed to this extension of monarchical power looked fearfully to the arbitrary powers and aggrandising

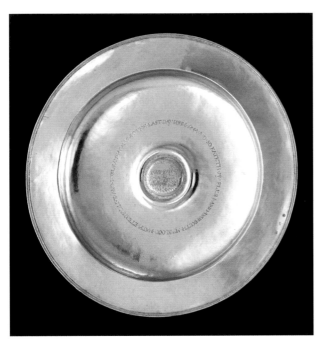
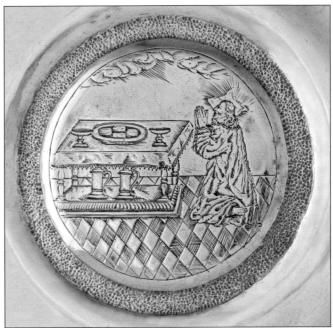

policies of the French king Louis XIV, who was cousin to the Stuarts and ruler of the Catholic superpower and absolutist state par excellence.

Dynasty Restored

The restoration of the Stuarts after the Cromwellian interregnum – or for Scotland the Cromwellian union – was a political entity that brought about a form of Anglo-Scottish union the Stuarts had sought since 1603.[18] This reign would be mired in controversy, for James, Duke of York and Albany, brother of the restored king, Charles II, had converted to Catholicism. This would set him on a collision course with many at court. England and Scotland, though by two very different routes, were now mainly Protestant, and were certainly so at their political core.

This section of the exhibition includes some rather special regal objects. One example is the toilet mirror from the musée du Louvre, département des Objets d'art [Cat. no. 7], which belonged to the 'commoner' Anne Hyde, first wife of James, Duke of York and, like her husband, a Catholic convert. Ironically this 'commoner' would go on to become the mother of two queens – Mary and Anne.

Two years later after Anne's death in 1671, James married Mary of Modena, also a Catholic. The faith of the new husband and wife caused further disquiet among Protestants. In the exhibition, Mary's personal faith and devotion is represented by the Mass book entitled *Enchiridion preclare ecclesiae Sarum*, from the collections of St John's College, Oxford [Cat. no. 8]. As with other devotional

Fig. 1.4: Communion bread plate and detail in centre of plate

One of two silver Communion bread plates from the Trinity College Church, Edinburgh. Thomas Sydserf, the minister, was a staunch follower of Charles I and the king's anglicising church policies. This plate was probably ordered to coincide with Charles's Scottish coronation in June 1633.

By Thomas Kirkwood, Scottish, c.1632–33, National Museums Scotland, K.2001.466.5

CATALOGUE NO. 3

books, it has become 'associated' with a royal personage. The Papacy held great hopes that Mary might play her part in bringing England back to the Catholic Church; as noted at the time, the Papacy looked forward to 'the great profit which may accrue to the Catholic faith in the above-named kingdom through [their] marriage'.[19] Similarly, from the collection of the Duke of Norfolk at Arundel Castle, the wedding ring of Mary of Modena [Cat. no. 48] transports Jacobite material culture from the artefactual towards, for some, the status of a relic. This translation of status is confirmed by the manner in which many of these objects were being collected by some of England's premier aristocratic Catholic families, such as the Fitzalan-Howards of Norfolk; while other examples of highly personal objects with royal provenance (sometimes even body parts) have been acquired by Catholic institutions.[20] Stonyhurst College in Clitheroe, Lancashire, for example, the Jesuit-founded independent boarding school,[21] who are a lender to this exhibition, has an important collection of Stuart relics. Many of them were smuggled back to England from the exiled court in France and Italy to encourage supporters at home.

As Duke of York and Albany, James spent time in Scotland at the Palace of Holyroodhouse, effectively exiled by Charles II during periods of turmoil such as the 'exclusion crisis', when James's Catholicism was a source of popular disquiet. After his accession, James VII and II saw fit to 'revive' Scotland's premier order of chivalry, the Most Ancient and Most Noble Order of the Thistle.[22] In chapter 3 of this book, 'Knights of the Thistle', Lyndsay McGill studies the Order and its relationship to the Stuarts. In the exhibition, from the private collection of the Grimsthorpe and Drummond Castle Trust, there is a rare survivor from the late 17th century, namely the robes of the Order of the Thistle that belonged to Sir James Drummond, 4th Earl of Perth [Cat. no. 11]. James was one of the first Knights of the Thistle alongside his brother John, 1st Earl of Melfort. Both were leading officials in the Scottish government of James VII and II, as Lord Chancellor and Secretary of State for Scotland respectively. As with their king, the Drummond brothers died in exile in France in the early years of the 18th century.

The close link between James's Catholicism and kingship is illustrated in a set of altar plate made for use in the chapel at the Palace of Holyroodhouse after its conversion for worship according to the Catholic rite in 1687 [Cat. no. 12]. Most of this plate was commissioned by the Earl of Perth, though once brought to Edinburgh it was added to from local sources, including an incense spoon [Fig. 1.5]. This act of Catholic regal restoration was prefaced by James granting, in August 1686, his Scottish Catholic subjects the right to worship in private.[23]

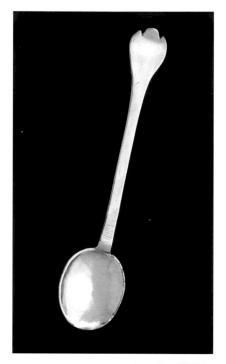

Fig. 1.5: Incense spoon

The spoon is engraved with an earl's coronet, thought to be for James Drummond, the Earl of Perth, who was responsible for acquiring altar plate for the Chapel Royal at the Palace of Holyroodhouse at the request of James.

By Walter Scott, Scottish, c.1686–87, IL.2009.17.4. Lent by the Congregation of the Ursulines of Jesus.

CATALOGUE NO. 12

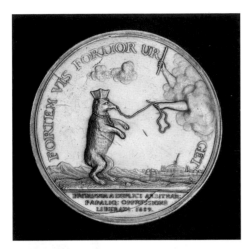

Fig. 1.6: Medal commemorating the offering of the crown to William of Orange

By Jan Smelzing, Dutch, 1689, National Museums Scotland, H.1992.1872, obverse and reverse

CATALOGUE NO. 23

Dynasty Divided

The Williamite invasion, and the events of the 'Revolution' in England of 1689, are illustrated in the exhibition with the emergence of commemorative pieces in support of the new Protestant Stuart ascendency. This is exemplified by a late 17th-century Delftware dish [Cat. no. 22], as well as some fine medals. Although the production of commemorative medals began with the arrival of James's son, Prince James Francis Edward Stuart, in June 1688, the use of this type of object as a means of disseminating propaganda intensified in the years of William III – particularly as the Low Countries had become something of a safe haven for satirists.[24] An example of this is the medal by the engraver Jan Smelzing [Fig. 1.6], a masterful celebration of the empty throne of 1688 that combines satire and allegory. Here the Papacy is represented as a marauding bear in the act of overturning two of three bee hives, which represent the three kingdoms.[25] Another medal, this time by George Bower [Cat. no. 24], an engraver to the Royal Mint, is a straightforward document in metal: William is shown on horseback, while his invasion fleet lies at anchor in Torbay. A badge with a miniature of William III in the Royal Collection [Cat. no. 25], is typical of a small diplomatic gift from the early-modern period. This would have been used to reinforce the accession of the new joint-monarchs, William and Mary.

To this section of the exhibition falls the initial Jacobite challenge of 1689–91, centred in the Highlands and dominated by personalities such as John Graham of Claverhouse, 'Bonnie Dundee'. A martyr to the Stuart cause, Dundee is the subject of a number of relics imbued with his memory, including the gloves made of kid leather, said to have been worn by him during this first Jacobite rising [Cat. no. 28].

A Court in Exile

One of the main curatorial aims in developing this exhibition was to ensure that the exiled court, and the European dimension, were brought to the fore in the narrative. This was intended to emphasise the point that the Stuart court was duly constituted and acted in accordance with courtly practice of the time.[26] Studies by the historian Edward Corp (chapters 2 and 4) – on the two principal exilic courts, at St Germain-en-Laye and in Rome, mirror the relevant sections of the exhibition. These sections relied heavily on our ability to borrow from other institutions. They include works by some of the leading court painters of the period, whose art portrays the public image of the exiled family to allies and supporters across Europe. Among such are Benedetto Gennari's charming portrait of the infant Prince James Francis Edward holding a parakeet [Cat. no. 37], the

group painting of the exiled royal family by Pierre Mignard [Cat. no. 38] that usually hangs at the Palace of Holyroodhouse, and the double portrait of Prince James Francis Edward and his sister Princess Louise Marie Teresa by Nicolas de Largillière [Cat. no. 52]. Edward Corp's chapters also emphasise the private use of such works of art, commissioned not merely for their supporters but also to hang in the family's own apartments.

This sequestered private side of court life is further explored through a small selection of religious books used by various members of the exiled Stuart family as aids to devotion, or for spiritual edification. These include a missal belonging to Princess Louise Marie [Cat. no. 43], an exposition of the Lord's Prayer presented to the young James Francis [Fig. 1.7] and, to represent the father of these royal children, a Book of Private Devotions of James VII and II [Cat. no. 41], which reveals the depth of his Catholic faith in the final years of his life. These papers helped to inform the first posthumous biography of James written by David Nairne, his Scots clerk at St Germain.[27] Interspersed with the king's thoughts on faith is a set of moral but very practical precepts with advice on a variety of topics, from diet to outdoor pursuits.

The Jacobite Challenges of James VIII and III

The death of James VII and II in 1701 and the passing of the Act of Settlement placed the House of Hanover in the frame as the dynasty set to replace Queen

Fig. 1.7: Manuscript of the Lord's Prayer

An explanation of the Lord's Prayer – *Explication de l'oraison dominicale présentée à monseigneur le prince de Galles* – presented to the young Prince of Wales, James Francis Edward Stuart.

By Berthault, 1692, The Royal Collection / © HM Queen Elizabeth II 2017, RCIN 1006013

CATALOGUE NO. 39

Anne on her death. At this juncture, the exhibition looks back to 1603 as a reminder of why the House of Hanover succeeded the Stuarts in 1714. A portrait of James VI and I by John de Critz [Cat. no. 57] is juxtaposed with two objects from the Royal Collection, both part of a silver-gilt basin and ewer set [Cat. no. 59] which belonged to Elizabeth Stuart, eldest daughter of James VI and I. Better known as the 'Winter Queen', Elizabeth was the mother of Sophia, Electress of Hanover and Queen Anne's nominated heir. Sophia, however, predeceased Anne by two months and so her son, George, Elector of Hanover and great-grandson of James VI and I, ascended to the throne.

Recognition of the young James Francis Edward as James VIII and III by King Louis XIV of France and Pope Clement XI – along with an increasingly unstable diplomatic situation over the accession in Britain – provided the backdrop to three Jacobite challenges between 1708 and 1719.[28] This dynastic claim is succinctly encapsulated in a broadsword with a silver half-basket hilt made by Henry Bethune, Edinburgh, in c.1715. The hilt was intended to be joined to an imported German blade, which is elaborately decorated with visual and even textual propaganda [Cat. no. 81]. Inspection reveals the figure of Scotland's patron saint, St Andrew, and 'Prosperity to Sc[h]otland and no Union' inscribed on one side; and a crown, crossed sceptres, and 'For God my Country and King James the 8' on the other. Although Scottish goldsmiths probably made silver sword hilts for imported German blades, very few seem to be marked. The Bethune sword is an excellent example of a pro-Jacobite sword produced with overtly anti-Union sentiment.[29]

Preliminary work on this exhibition allowed for assessment of the Museum's existing collections and an opportunity to review and fill gaps in the exhibition narrative. While the collections that represent the rising in 1745 are strong, the challenge in 1715 (or 'Fifteen') had been eclipsed in material terms, replicating its place in historiography as the 'orphan child' compared to its more glamorous successor.[30] An opportunity arose in 2013 to purchase a snuff box associated with a Jacobite prisoner from the Fifteen [Cat. no. 88], as well as the 'Preston Blunderbuss' [Cat. no. 84], a weapon recovered as a trophy after the eponymous battle in November 1715.[31] In addition, one of the most intriguing examples of the public profile in France enjoyed by Scots because of the exiled court, and by extension Jacobites, is an ivory snuff mull probably made in France, c.1715. This has been exactly carved in the form of a Highlander wearing a belted plaid and bonnet, replete with broadsword, pistol, dirk and targe [Fig. 1.8].[32] The image of the kilted Scot was thus not confined to Scotland itself, and may perhaps have been a consequence of the presence of Scots at the exiled court.

The Hanoverian side in this conflict is represented by a ram's horn powder flask [Cat. no. 87] bearing inscriptions that are clearly pro-government: 'Dunblain fight Nov 13 1715'.[33] This suggests that the owner fought at the Battle of Sheriff-

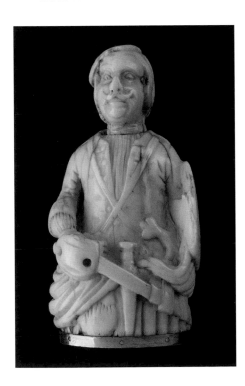

Fig. 1.8: Snuff mull

A snuff mull carved in the form of a Highlander fully armed with broadsword, pistol, dirk and targe, with a belted plaid and bonnet.

Probably French, c.1715, National Museums Scotland, H.NQ 217

CATALOGUE NO. 90

muir during the 1715 rising, which was often referred to in contemporaneous accounts as the 'Engagement near Dunblain'.[34] However, despite the battle's inconclusive result, the inscriptions on the powder flask continue with a series of pro-Hanoverian texts, some of which are boldly triumphalist in tone, including 'Ye Pretenderye Erl; of Mar & ye rest of ye Party run away to Perth'. Nevertheless, beyond its highly propagandist tone, the object articulates a concise narrative timeline of the principal events of the Fifteen.

As far as the surviving material culture is concerned, the medallic record of the challenges of James VIII and III provides both a material record of historical events and an insight into the masculinist world of 18th-century collecting. An object type medallic record is a prominent feature in this section of the exhibition, especially in the commemoration of the attempted invasion of 1708.[35]

The importance of kingship and authority, as outlined at the start of this chapter, also appears in this section with a display of the Scottish swords of Mercy and Justice [Cat. nos 78, 79]. The original catalogue states that the swords were 'carried before the old Pretender [James VIII and III] on his being proclaimed King of Scotland in 1715'. From the initial landing at Peterhead in north-east Scotland on 22 December [Cat. no. 99], the royal progress made its way to Aberdeen and Dundee before arriving at Scone Palace, Perth, where James set up a court in January 1716. Whether or not an actual 'coronation' took place, James and his entourage, which included George Keith, Earl Marischal, a leading supporter, would have displayed the appropriate trappings of royalty, despite the 'spartan' nature of the court.[36]

Of course the Stuart dynasty was not just about an exiled court. In the Palace of Whitehall in London, Queen Anne, daughter of James VII and II, lacked a surviving heir and would become the last reigning Stuart monarch. She had reconnected with elements of Stuart courtly culture, including the sacral view of monarchy that existed prior to the accession of her brother-in-law and sister, William and Mary. The Order the Thistle was reinstituted and an exquisite gold and enamel collar of the Ancient and Most Noble Order of the Thistle [Cat. no. 176], dating from the period of the passing of the Act of Union, illustrates Anne's recourse to Stuart traditions ignored by William and Mary. In her chapter on the 'Knights of the Thistle', Lyndsay McGill demonstrates that this collar, by London-based Scot, John Campbell of Lundie, was made to specifications stipulated by Anne's father in 1687. And Anne, unlike William and Mary, also did not baulk at instigating the 'Royal Touch'[37] – utilising metal coins or touchpieces [Fig 1.9] to cure scrofula, a form of tuberculosis – as a manifestation of the Stuart God-given divine right to rule.

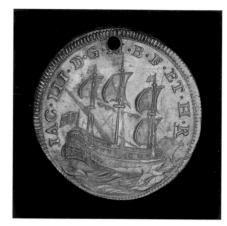

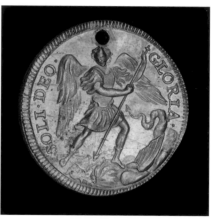

Figs 1.9: Gold touchpieces of James VIII and III

Both Anne and James continued the tradition of touching for the 'king's evil', to help those afflicted by scrofula, a form of tuberculosis.

1708, National Museums Scotland, H.1958.2051, obverse and reverse

CATALOGUE NO. 66

All Roads lead to Rome

After brief periods of exile in Bar-le-Duc, Pesaro and the Papal enclave of Avignon and Urbino in the Papal States, James VIII and III gravitated towards Rome, the city that would become the final destination of the exiled court. Though he sincerely believed Rome would only be a temporary stop on his way back to Britain – as emphasised by Edward Corp in chapter 4, and the corresponding section of the exhibition – the Eternal City was to become home to the court for almost half a century. For James it would be the city in which he would marry and raise his two sons; and the city too in which he died, unreconciled with his eldest son.

In terms of material evidence, around fifty portraits were painted during this period.[38] Given such an extensive output it is difficult to identify the most outstanding objects. However a pair of portraits of the two princes, Charles Edward and Henry Benedict, painted around 1739 by Louis Gabriel Blanchet (now part of the Royal Collection) [Cat. nos 137 and 138] must surely be among the star objects. These portraits emanated from the very heart of the exiled court, commissioned as they were by William Hay who was groom of the bedchamber to Prince Charles. The portrait of the Jacobite Prince of Wales exudes a sense of dynastic hope and purpose; he is shown with the senior chivalric orders of both Scotland and England and wearing armour. It is little wonder that Sir John Clerk of Penicuik could contend with conviction that this 'Rebellion took its rise chiefly in Rome'.[39]

It was also a period where significant material exchange came southwards from loyal and influential supporters at 'home'. This has its legacy in a small but very significant body of Jacobite material culture with direct links to the person of Prince Charles Edward.[40] Such treasures include the travelling canteen mentioned above: although its patron is anonymous, it comes clearly marked for the leading Jacobite goldsmith, Ebenezer Oliphant of Edinburgh, and it was a significant enough object for Charles to bring to Scotland with him in 1745.

Such objects also include the surviving accoutrements from one of two complete sets of Highland dress sent to Rome for the two young princes by James Drummond, 3rd Duke of Perth. New insights on these tokens of loyalty are discussed in chapter 5 by Helen Wyld and George Dalgleish, who draw attention to the startling similarities in the iconography between the targe [Cat. no. 133] in this set, and the Brodie sword from the collection of the National Trust for Scotland [135]. Traditionally the Kandler sword [134] and the targe have been linked as a pair, identified as part of James Drummond's gift to Prince Charles Edward. However, as chapter 5 reveals, when directly compared with the Brodie sword, the Kandler sword appears less bespoke, and even materially unrelated, to the almost totemic targe with its unique mix of classical and Scottish motifs.

Returning to the medallic record, it was not only the followers of the exiled kings who collected medals. James VIII and III himself had a leather medal case commissioned around 1725 to store his own collection. This case was acquired at auction by the Hunterian Museum of the University of Glasgow [Cat. no. 130].[41] The documentation which accompanies the box suggests that James 'kept it on his desk as a reminder of past glory'.

The Last Jacobite Challenge of Charles Edward Stuart

We began this exhibition with the imagined scene from court at the Palace of Holyroodhouse in the autumn of 1745. Now the route to claim the throne is laid out in this section. However, before Charles could reap the rewards of taking the capital of his family's ancient kingdom, he would experience at first hand the excitement of battle when faced with the full power of a Royal Navy 58-gun ship. After only two days at sea after embarking at St Nazaire, the prince found himself in the thick of the first engagement of the 'Forty-Five' on 9 July 1745. This was captured in a painting of 1780 by Dominic Serres the Elder entitled *Action between HMS 'Lion' and 'l'Elizabeth' and the 'Du Teillay', 9 July 1745*, now in the collections of the National Maritime Museum [Cat. no. 144].[42] Also featured here is a French-style cutlass reputed to have belonged to a crew member of the *Du Teillay* [Cat. no. 149], which was found in Coire nan Cnamha ('the corrie of the bones') in the Western Highlands. This has been lent to the exhibition from the collections of Clan Cameron Museum, adjacent to the seat of the Lochiel at Achnacarry, Inverness-shire.

Unsurprisingly, given the great interest in the story of Prince Charles Edward Stuart and the Forty-Five, this is the largest section of the exhibition, representing the short but crucial period of 14 months. It is also the part of the story around which a large and significant body of material evidence has been amassed; and many of these objects have an additional resonance of an imputed connection, or even a direct association, with Charles himself.[43]

A cluster of objects around the Battle of Prestonpans in November 1745 point towards the later religious interpretation of the conflict. Colonel James Gardiner, who fought and died during the battle, was commemorated by the manufacture of a practical object, namely a snuff box [Fig. 1.10]. The narrative attached to this box is that it was made from a thorn tree that grew near to the site where he received his fatal injuries. Gardiner would later become something of a Christian hero to 19th-century evangelicals.[44] Another, perhaps much cruder, attempt to construct a narrative around an object is a leather-bound pulpit bible alleged to have been taken from the Kirk of Prestonpans by victorious Jacobite troops after the battle [Cat. no. 159]. In an effort to sully the character of the Jacobite army, or in a blatant 19th-century attempt to rewrite history with sectarian overtones,

Fig. 1.10: Commemorative Snuff box

Made from part of a thorn tree near the place where Colonel James Gardiner was killed at the Battle of Prestonpans.

c.1745, National Museums Scotland, H.NQ 31

CATALOGUE NO. 156

a handwritten note was placed within the Bible as provenance to bolster claims that

> … *the Highland Army being largely Catholic, brought the Bible from the Presbyterian Church and threw it on a bonfire. It kept falling off and soldiers threw it up again with their broadswords, the marks of which can be seen, It was rescued by a young girl who was a servant at the manse and remained in her family until a descendant presented it to the Revd Walter Muir, then a Presbyterian minister in Edinburgh.*

This is an unusual example of the deliberate construction of an anti-Jacobite relic which, given its connection to the Presbyterian Church, may be considered somewhat contradictory.

The inclusion of contemporaneous documents in the exhibition brings a more immediate sense of language and opinions of the time, copper-plate handwriting notwithstanding. Such objects bring their own set of challenges, as their material integrity must be ensured while on display for such a long period. We include documents that chart the propaganda war, such as a government proclamation offering a £30,000 reward for the capture of the prince [Cat. no. 147] and a counter proclamation [148] from Charles, forced by his supporters to place a similar price on the head of George II, payable to anyone 'who shall seize or secure the Person of the Elector of Hanover'.

On a more personal level, among the documents borrowed courtesy of the Drambuie Collection of William Grant and Sons is a contemporary manuscript transcription of a letter from Charles to his father with news of the Jacobite victory against the forces of General John Cope at the Battle of Prestonpans. This letter has enabled Museum staff to re-examine some of the claims around objects in our own collections, including a lady's fan [Cat. no. 184] thought to have been used at the ball at Holyroodhouse to 'celebrate' the victory at Prestonpans. Indeed it is unlikely that such a ball took place, for the text of the letter reveals that any displays of 'public rejoicing' were expressly forbidden by the prince:

> *They might have become your friends & duti-Full subjects when had got their eyes open'd To see the true interest of their Country which I Am come to save not to destroy; for this reason I have discharged all public rejoicing ….*[45]

However, the re-emergence of a Stuart court in Edinburgh was not without material and visual evidence. Lucinda Lax states in chapter 7 that the production of Allan Ramsay's portrait of the prince at this key juncture was no mere 'distraction from military, political and strategic questions' which would naturally have dominated his time. On the contrary, far from a vanity project, it was vital to the

Jacobite court to project an image of a resurgent and legitimate dynasty. Lucinda Lax shows that the depiction of the prince in courtly dress rather than tartan – perhaps surprising, given the locus of the sitter – was a conscious attempt to project the prince to an English audience. Equally, the seemingly glaring omission of the wearing of his Scottish Order of the Thistle was a deliberate attempt to secure his acceptability with his subjects south of the Tweed. To enhance this projection, Charles is depicted wearing the Star of the Order of the Garter and a cloak lined with royal ermine, confirming his status as a true royal prince.

There were certainly presentations at the court during Charles's stay at Holyroodhouse, and many leading Jacobites, indeed non-Jacobites, hurried to Edinburgh to meet him. The exhibition features two dresses that have become associated with the putative Prestonpans victory ball. If these garments were worn at Holyroodhouse, they may have been hurriedly adapted for presentation at court. The arrival of the Jacobite court was, after all, unexpected.

One dress was reputedly worn by a leading Jacobite woman of her time, Margaret Oliphant of Gask [Fig. 1.11]. A graphic of a print from the British Museum, entitled *Scotch Female Gallantry* – which features in Jacqueline Riding's chapter – shows a group of adoring Edinburgh ladies flocking around the prince.[46] In reality, however, it is recorded that his response to those who came to see him was often cool and cursory.

Continuing this gendered approach to Jacobite material culture, there is a small pin cushion [Cat. no. 229] in the exhibition which acts as a reminder that women could articulate their adherence to a particular cause. The pin cushion represents that body of material described as 'semi-private' by the historian Jennifer Novotny, where objects were retained in non-overt places and only revealed within the safety of a coterie of shared allegiances.[47] The fan mentioned above is also in this category.

Moving away from a concentration on courtly and domestic spheres, a theme scattered throughout the exhibition is the connection between Jacobitism and the *Gaidhealtachd*. Allan Macinnes opens chapter 9 on this phenomenon with an unambiguous statement that the Highland clans were 'the military bedrock of Jacobitism in Scotland'. His lucid distillation of this theme within Jacobitism shows that there were complexities in the relationship between the clans and the Jacobite Stuarts. He emphasises that the overwhelming majority did not share the Catholic faith of their exiled king, as they adhered to Episcopalianism. Yet herein lies their political connection: although Protestant, they were outside the religious establishment, and as mainly non-juring Episcopalians they were thus

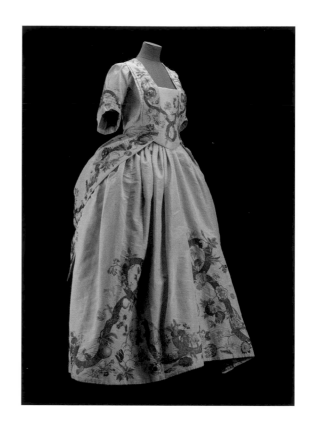

Fig. 1.11: Silk gown

This garment was reputedly worn by Margaret Oliphant of Gask when she attended court at the Palace of Holyroodhouse, and was probably adapted for the event.

*c.*1745, National Museums Scotland, A.1964.553 and A

CATALOGUE NO. 173

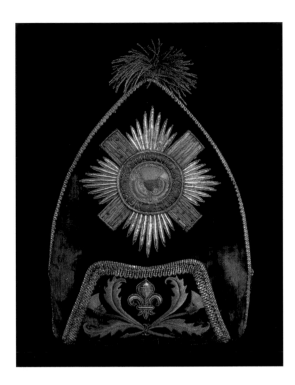

Fig. 1.12: Mitre cap of a grenadier officer of the Royal Écossais

The Royal Écossais regiment, sent to Scotland in 1745, was part of French support for the Jacobite campaign. This cap displays a mixture of Scottish and French national symbols, such as the thistle and *fleur-de-lys*.

Probably French, 1745, National Museums Scotland, M.1996.59

CATALOGUE NO. 191

bracketed with Catholics. This placed them beyond the toleration accorded by Parliament – see also Adrienne Hynes in chapter 8, in her exploration of the range of religious material culture – and allowed dynastic allegiance to trump any religious differences.

The bloody dénouement at the battle of Culloden is central to this penultimate section of the exhibition. It provides an opportunity to challenge received wisdom and to tackle the complexities and controversies of the battle and its aftermath. The narrative is delivered through a range of interpretative means, including the surprisingly bitter Gaelic lament from the young widow of the standard-bearer of Clan Chisholm, bemoaning Charles Edward's return. One of the great misconceptions is that the Jacobite army was made up of poorly organised, amateurish guerrillas. This was certainly not the case; the Jacobite army at the Forty-Five was formally organised according to the conventions of the time, and in recognition of the traditional Highland charge (used to great effect in earlier battles such as Killiecrankie in July 1689) a small array of targes is displayed [Cat. no. 197]. The traditional Highland shield, made up of two layers of wood laid across each other for strength, and covered in leather, was an essential part of the Highland warrior's kit.

Recent archaeological investigation has proved that weapons chosen by the Jacobite army included musketry.[48] In chapter 9 Allan Macinnes also examines the precarious military situation in the Highlands, and how weapons were in short supply during the 1745 rising. Perhaps this explains why an old flintlock musket such as the *Gunna Breac* [Cat. no. 210] would become associated with Culloden, although ultimately it would not appear to have been fired in anger at that battle. On the right-hand side of the musket's butt is a small silver plaque listing the 'battle honours' of the *Gunna Breac* in the service of the 'McDonalds'. This takes the musket back to Inverloich in 1645, although this may be a bit of a stretch – the inference is that all available firearms had to be pressed into service.

The traditional support of the clans is represented by the sword of Donald Cameron of Lochiel, 19th chief of Clan Cameron [Cat. no. 219].[49] The hilt was made by the leading Canongate goldsmith, Colin Mitchell, who supplied these to a swordsmith based in Stirling. Mitchell numbered among his clients other leading Jacobite clan chiefs such as MacDonald of Clanranald.

Support from France was also critical to the military campaign in 1745–46. An intriguing piece of evidence for this is a grenadier's mitre cap [Fig. 1.12], worn by an officer of the Royal Écossais, a regiment of the French army largely recruited in the Highlands. The officer was on board the French ship *l'Esperance* – a French privateer, engaged to carry supplies and troops – when it was captured by the Royal Navy on 25 November 1745. Almost a thousand French troops were like-

wise caught by the Royal Navy before they could even set ashore in support of James VIII and III, and his Prince Regent.

And what befell those who survived the Battle of Culloden? In the aftermath violent retribution was meted out to many, including members of the Jacobite élite. Among the most famous were the four peers executed at the Tower of London. Their deaths are commemorated in one of the most sought-after Jacobite relics – a 'Four peers' mourning ring [Cat. no. 230]. Such rings commemorate the deaths of the four Jacobite lords – Kilmarnock, Derwentwater, Balmerino and Lovat. Some suggest they were the work of Ebenezer Oliphant, maker of Prince Charles Edward's travelling canteen.

Also contained within this section of the exhibition are salutary reminders that not every Scot supported the rising in 1745. This might include, for some, the unsettling revelation that the reputation of the Duke of Cumberland as a 'Butcher' was not shared by all at the time. A Burgess ticket [Cat. no. 227], which conferred that highest of municipal rights, the Freedom of the City of Edinburgh, to the Duke of Cumberland on 3 January 1747, reminds us of the divisions within Scottish society in the aftermath of the Jacobite defeat at Culloden. In one sense this is a period where the material evidence jars with the prevailing trend, as argued by historians such as Chris Whatley who has warned against an over-emphasis on the influence of Jacobitism in this century.[50]

Perhaps there is a disconnect between the material evidence and the political reality of Scotland in the 18th century. While there is a paucity of consciously pro-government material culture to illustrate the Whig ascendancy, there is a seemingly endless supply of material relating to Jacobitism. Perhaps there was less need to construct a Whig material culture, although there are examples.[51] As with the early period of Jacobite material culture, reaching back into the 17th century from the time of the flight into exile by James VII and II and the Williamite invasion, certain Jacobite objects of the Forty-Five have been imbued with a status almost akin to medieval relics. As Murray Pittock has clearly identified, one explanation for the roots of this phenomenon was that 'the cult of relics was strongly linked with not only their [the Stuarts'] memorialisation but also their potential sanctity'.[52] This does have some resonance but, as Murray Pittock argues, it is the later and gradual decline of the inherent nature of Jacobite material culture from relic to kitsch that throws up interesting questions about the meaning of Jacobitism, and how it has come to be interpreted though its material culture.[53]

A document signed by King George II neatly draws this section to a close. It is a pardon for an individual – one Alexander Robertson of Strowan (or Struan) – who had taken an active part in the rising [Cat. no. 231]. Given Robertson's advanced years in 1745, he had effectively taken part in three Jacobite risings, including the events of 1690.

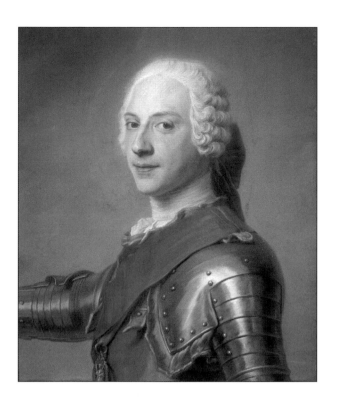

Fig. 1.13: Portrait of Prince Henry Benedict Clement Stuart (1725–1807)

This portrait depicts Prince Henry Benedict in armour and wearing the Order of the Garter.

Maurice-Quentin de la Tour (1704–88), 1746–47, oil on canvas, 82.55 x 71.12 cm, Scottish National Portrait Gallery, Edinburgh, PG 2954

CATALOGUE NO. 249

Kings across the Water

The final phase of the exhibition takes up the narrative of the prince after his flight from Scotland to the Continent and the peripatetic existence of these wilderness years. The themes that anchor this narrative include that of 'King, Claimant, Cardinal' – representing the ageing James VIII and III, Prince Charles Edward himself, and his younger brother Prince Henry Benedict who would, in time, become known as Cardinal York. Indeed, for the author of this introductory chapter, the revelation of this project has been the high repute in which Henry Benedict Stuart, Cardinal York, is still held, and the small but significant body of the surviving material culture associated with the Cardinal Prince.[54] As a historical figure, Henry has tended to remain in the shadow of his brother. However, as this final section unfolds, Cardinal York emerges as a successful Prince of the Church.

An insight into the way in which Cardinal York has been hidden can be witnessed in one of the first objects the visitor will see in this area, namely his portrait by Maurice-Quentin de la Tour [Fig. 1.13]. The re-identification of this painting by the art historian Bendor Grosvenor, previously thought to be that of Prince Charles Edward, has become a celebrated story in the art history of the exiled Stuarts.[55] Painted just prior to Henry Benedict's admission to holy orders in 1747, this event was a source of great disappointment to Charles as it signalled the end of the Stuart dynasty. For him it was an overwhelming sense of betrayal that he harboured for the rest of his life.

Another star object in the exhibition connected to Henry is the York (or Stuart) chalice and paten [Cat. no. 274]. This was left to the Vatican Basilica on his death in 1807 and is now in the collections of the Treasury Museum of St Peter's Sacristy, Rome. This altar set was commissioned by the cardinal from the workshop of the Roman goldsmith Luigi Valadier; the chalice is chased in gold, elaborately decorated and inset with jewels, poignantly said to be those of the Sobieski family that belonged to his mother, Maria Clementina.

As we move towards the conclusion to the exhibition, we come face to face with one of the most recognisable and collectable areas of Jacobite material culture – glassware. The title of this section consciously reflects the famous Jacobite toast to the king 'over the water', and our display shows some of the finest examples of Jacobite glassware drawn from the Museum's collections, alongside examples from the Drambuie Collection courtesy of William Grant and Sons, one of the world's most significant private collections of Jacobite-related material. The glassware contains hidden or coded signs and symbols that

signal their Jacobite sentiments – but only between those with shared allegiance.[56] While there are many copies of later date, the clandestine significance of the earlier pieces engenders great interest at auction among specialist collectors of this genre.

From the Drambuie Collection there is also a rare example of a Jacobite drinking glass, known as the Spottiswoode 'Amen' glass, one of only 37 known examples of such glasses [Cat. no. 247]. This is engraved with the cipher of James VIII and III, and has verses from the Jacobite anthem, the conclusion of which is always 'Amen', 'so be it'.[57]

From the Museum's collections there is an intriguing juxtaposition of two objects [Fig, 1.14; Cat. nos 263 and 264]. The first is a wine glass bearing an enamelled portrait of Prince Charles. One of a set of six glasses, it was commissioned in 1775 by Thomas Erskine, a future Earl of Kellie, for the Steuart Club, a group of high-ranking Jacobite supporters who met on 31 December in Edinburgh each year to commemorate the prince's birthday. Related to this wine glass is a second object, a letter written by the poet Robert Burns in 1787 accepting an invitation to dine at one of these occasions. This, as it turned out, would be the last time the Club was to meet while their Prince still lived. Charles Edward Stuart would be dead exactly one month later.

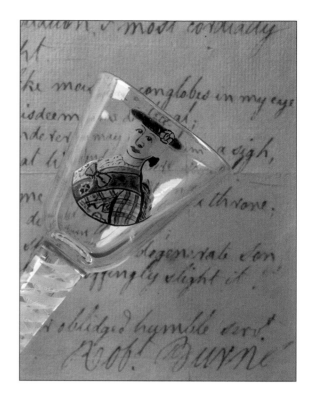

Fig. 1.14: Wine glass and letter

The letter was written by the poet Robert Burns in 1787, accepting an invitation to dine on the anniversary of the prince's birthday. The glass, one of six, was commissioned by Thomas Erskine, later 9th Earl of Kellie.

Letter, 1787; wine glass, c.1775, National Museums Scotland, H.OP 7 and H.MEN 94

CATALOGUE NOS 263 and 264

* * *

One of the more interesting phenomena around Jacobite Stuart material culture is the way in which objects have migrated back into the Royal Collection through various channels, both as donations and through active purchases. There is something of a sense of these objects being used to rehabilitate the relationship between the succeeding dynasties and their exiled Stuart relatives. Perhaps the most keenly felt expression of this sense of connection with the Stuart past was Queen Victoria, who declared that 'the Stewart blood is in my veins'.[58] This was, of course, a facet of the manufactured conflation of Jacobitism with Scottish identity, with which the visitor to this exhibition is confronted at the beginning.

Perhaps the most significant material acquisition was the transfer of the Stuart papers and private documents to the future George IV.[59] However, among the earlier objects to move to royal collection was an Italian majolica dish depicting the arms of Cardinal York which was part of the bequest to George III after the cardinal's death in 1807 [Cat. no. 272]. On a visit on 13 September 1847 to Cluny Castle, Aberdeenshire, a Gordon stronghold, the future Edward VII was presented with a ring, with a miniature of Prince Charles Edward. Unfortunately

there is no record of the prince's reaction to this commemorative token of an ancestor who had laid claim to the title of Prince of Wales.

In the 20th century, under the auspices of Queen Mary, a caddinet made by Luigi Valadier, which belonged to Cardinal York, formerly in the collection of the 11th Duke of Hamilton, was bought at auction in 1919 [Cat. no. 269]. Even though this object was evidence of the cardinal's residual claim to the throne, clearly the House of Windsor did not consider it to be an inappropriate acquisition. And this tradition of collecting Stuart material has continued with the present Queen, with a purchase in 1964 of a Vincennes broth bowl [Cat. no. 271]. This is thought to have been commissioned by, or for, Prince Charles Edward Stuart in 1748, a mere 18 months after his defeat at Culloden.

In the prefatory note to the catalogue of the Stuart exhibition of 1889 it was stated that 'the scope and aim of the Exhibition is purely historical, and the intention has been to illustrate as far as possible by pictures, personal relics, coins and medals … the fortunes, good or evil of that Royal House which played so great a part in the history of this country'.[60] This preface to an exhibition at the end of the 19th century works well both as a conclusion to our exhibition today and to this book. These royal connections above show the continuing resonance of Jacobite material culture and, as the essays in this book reveal, how it will continue to provide a source of evidence and point for debate on the subject.[61]

NOTE ON SPELLINGS:

In a work of this breadth with contributions from different disciplines, working across a range of sources, the reader will sometimes encounter some variations in spelling. This is especially the case with family names which were often not standardised. The spelling used in each case reflects the original source under examination by the individual author.

Notes

1. Steve Murdoch, 'Tilting at Windmills: The Order del Toboso as a Jacobite Social Network', in Paul Mond, Murray Pittock and Daniel Szechi; *Loyalty and Identity; Jacobites at Home and Abroad* (2010), pp. 229–42.

2. For encyclopaedic descriptions and examinations of specific groups of Jacobite material culture, see Geoffrey B. Seddon, *The Jacobites and their Drinking Glasses* (2001), Richard Sharp, *The Engraved Record of the Jacobite Movement* (1996) and Noel Woolf, *The Medallic Record of the Jacobite Movement* (1988). While a number of studies have emerged that provide a more critical appraisal of the place that material culture can take as bona fide source in Jacobite studies, see *inter alia* Guthrie, *The Material Culture of the Jacobites,* and Murray Pittock, *Material Culture and Sedition, 1688–1760: Treacherous Objects, Secret Places* (2013); while the doctoral thesis of Jennifer L. Novotny, *Sedition at the supper table: the material culture of the Jacobite wars, 1688–1760* (2013) and her subsequent publications including 'Polite War: Material Culture of the Jacobite Era, 1688–1760', in Allan I. Macinnes, Kieran German and Lesley Graham, *Living with Jacobitism, 1690– 1788* (2016), pp. 153–72, have helped to secure material cultural research on the agenda for Jacobite studies.

3. See also George Dalgleish and Dallas Mechan, *'I am Come Home': Treasures of Prince Charles Edward Stuart* (1985).

4. Paul Monod, *Jacobitism and the English People, 1688–1788* (1989), pp. 296–97.

5. Murray Pittock, *The Invention of Scotland, The Stuart Myth and the Scottish Identity, 1638 to the Present* (1991), p. 150.

6. Ibid, pp. 139–44.

7. Robin Nicholson, *Bonnie Prince Charlie and the Making of a Myth: A Study in Portraiture, 1720–1892* (2002), p. 126.

8. Murray Pittock, *The Myth of the Jacobite Clans* (1995), pp. 1–18, remains the most succinct and lucid examination of this phenomenon, although since this book was published the original Culloden Battlefield Visitor Centre (mentioned in this section) has been completely rebuilt and now houses a completely new and revitalised exhibition.

9. Frank McLynn, *Bonnie Prince Charlie: Charles Edward Stuart* (2003), pp. 283–84.

10. Eveline Cruickshanks, 'Attempts to Restore the Stuarts, 1689–96', in Eveline Cruickshanks, *The Stuart Court in Exile and the Jacobites,* (1995), pp.1–14, 1–2.

11. Acts of the Parliaments of Scotland VII, 554, c. 2.

12. David M. Bergeron: 'Charles I's Edinburgh pageant (1633)', *Renaissance Studies*, 6: 2 (June 1992), pp. 173–84.

13. National Library of Scotland, Basilikon Doron, shelfmark Ry.II.e.ii.

14. See the *Scots Confession 1560*: ch. XVI: 'The Kirk', various edns.

15. Daniel Szechi, *The Jacobites: Britain and Europe, 1688–1788* (1994), pp. 36–38.

16. George Dalgleish and Henry Steuart Fothringham, *Silver: Made in Scotland* (2008), cat. ref. 7.7, p. 148.

17. John Marshall, 'Whig Thought and the Revolution of 1688–91', in Tim Harris and Stephen Taylor (eds), *The Final Crisis of the Stuart Monarchy: The Revolutions of 1688–91 in their British, Atlantic and European Contexts* (2013), pp. 57–86. and John Brewer, *The Sinews of Power: War, Money and the English State 1688–1783* (1989), pp. 7–8.

18. David Allan, *Scotland in the Eighteenth Century* (2002), pp. 4–5.

19. A letter from Pope Clement X to his 'daughter', the 15-year-old Mary of Modena, quoted in Martin Haile, *Queen Mary of Modena: Her Life and Letters* (1905), pp. 20–21.

20. See Fig. 18 for the Stonyhurst relics in Guthrie, *The Material Culture of the Jacobites*, p. 127.

21. Jan Graffius, 'The Stuart Relics in the Stonyhurst Collections', *British Catholic History* 31: 2 (October 2012), pp. 147–69.

22. Kirsten A. Piacenti and John Boardman, *Ancient and Modern Gems and Jewels in the Collection of her Majesty the Queen* (2008), pp. 236–38.

23. Alastair J. Mann, *James VII: Duke and King of Scots, 1633–1701* (2014), p. 186.

24. Woolf, *The Medallic Record of the Jacobite Movement*, p. i.

25. Philip Attwood and Felicity Powell, *Medals of Dishonour* (2009), p. 16.

26. Edward Corp, 'The Jacobite Court at Saint-Germain-en-Laye', in Eveline Cruickshanks (ed.), *The Stuart Courts* (2009), pp. 250–51.

27. Edward Corp, 'James II and David Nairne: The Exiled King and his First Biographer', *English Historical Review* (2014), 129: 541, pp. 1403–4.

28. Christopher A. Whatley, *The Scots and the Union* (2006), pp. 2–4.

29. Murray Pittock, *The Myth of the Jacobite Clans: The Jacobite Army in 1745* (2009), pp. 1–29, 110–39.

30. Daniel Szechi, *1715: The Great Jacobite Rebellion* (2006), p. 2.

31. NMS X.2105.142 [Cat. no. 88] and X.2015.143 [84]. Lots 14 and 124 respectively in *Jacobite, Stuart & Scottish Applied Arts*, Lyon and Turnbull, Edinburgh, Wednesday, 13 May 2015.

32. The significance of this object has also been commented on by Jennifer L. Novotny, *Sedition at the Supper table*, p. 91.

33. Adrienne Breingan, '"Keep your powder dry": Mementoes of 1715', *Review of Scottish Culture* 27 (2015), pp. 1–8.

34. For example National Archives, SP 54/10/46A, 'Engagement near Dunblain Instant betwixt the King's Army under the Command of his Grace the Duke of Argyll, and the Rebels

commanded by Mar; and Breingan, '"Keep your powder dry", p. 3.

35. Edward Hawkins, Augustus W. Franks and Herbert A. Grueber (eds), *Medallic illustrations of the History of Great Britain and Ireland to the Death of George II*, vol. II (1885).

36. Murray Pittock, *Jacobitism* (1998), p. 46.

37. Stephen Brogan, *The Royal Touch in Early Modern England* (2015), pp. 191–200.

38. Edward Corp, *The King over the Water: Portraits of the Stuarts in Exile* (2001), p. 57.

39. Quoted in Jacqueline Riding, *Jacobites: A New History of the '45 Rebellion* (2016), p. 12, from John M. Gray (ed.), *Memoirs of the Life of Sir John Clerk of Penicuik* (1892), p. 176.

40. George Dalgleish and Dallas Mechan: *'I Am Come Home': Treasures of Prince Charles Edward Stuart* (1985), pp. 4–10.

41. Woolf, *The Medallic Record of the Jacobite Movement*, p. 76.

42. [http://collections.rmg.co.uk/collections/objects/11856.html] – accessed 29/4/17]

43. Hugh Cheape, 'The Culture and Material Culture of Jacobitism', in Michael Lynch, *Jacobitism and the '45* (1995), pp. 41–42.

44. Philip Doddridge, *The Life of the Honourable Col. James Gardiner: Who was slain at the battle of Prestonpans, September, 21st, 1745* (1812), pp. 195–214.

45. Drambuie Collection [N120822OT.14]. A contemporary manuscript transcription of a letter from Prince Charles Edward Stuart to King James VIII on the victory of the Battle of Prestonpans, 'sent from Pinky House near Edinr Sept 21 1745', fo. 1.

46. British Museum 1898, 0520.172, *Scotch Female Gallantry*, by Pierre Charles Canot, print on paper, 8 January 1745/46 [O.S.]. See Jacqueline Riding, chapter 6, fig. 6.8 in this volume.

47. Novotny, *Polite War*, p. 159.

48. Murray Pittock, *Culloden (Cùil Lodair)* (2016), p. 37.

49. Dalgleish and Fothringham, *Silver: Made in Scotland*, catalogue ref. 5.25, The Lochiel's Sword, p. 100.

50. Christopher A. Whatley, '"Zealous in the Defence of the Protestant Religion and Liberty": The Making of Whig Scotland, *c.*1688–*c.*1746', in Macinnes, German and Graham, *Living with Jacobitism*, pp. 55–70.

51. Such as the toddy ladle [Cat. no. 224].

52. Pittock, *Material Culture and Sedition*, p. 149.

53. Ibid., pp. 148–51.

54. Godfrey Evans, 'The Acquisition of Stuart Silver and Other Relics by the Dukes of Hamilton', in Edward Corp (ed.), *The Stuart Court in Rome: The Legacy of Exile* (2003), pp. 131–48.

55. Bendor Grosvenor, 'The restoration of King Henry IX: Identifying Henry Stuart, Cardinal York', *The British Art Journal*, IX, pp. 28–32.

56. Pittock, *Material Culture and Sedition*, pp. 134–47.

57. The exhibition also has an 'Amen' glass from the collections of National Museums Scotland (H.MEN 93, Cat. no. 91). See also Seddon, *The Jacobites and their Drinking Glasses*, pp. 185–229.

58. From 'Queen Victoria's Journal', 12 September 1875, quoted in Richard J. Finlay, 'Queen Victoria and the Cult of Scottish Monarchy', in Edward J. Cowan and Richard J. Finlay, *Scottish History: The Power of the Past* (Edinburgh: Edinburgh University Press 2002), p. 219.

59. Bernard W. Kelly, *Henry Benedict Stuart: Cardinal Duke of York* (London: R & T. Washbouke 1899), pp. 118–19.

60. *Exhibition of the Royal House of Stuart, 1899*, p. vii.

61. The author would like to acknowledge, and to extend his sincere thanks to Maureen Barrie, whose dynamic hard work and creativity has helped to tease out this complex narrative.

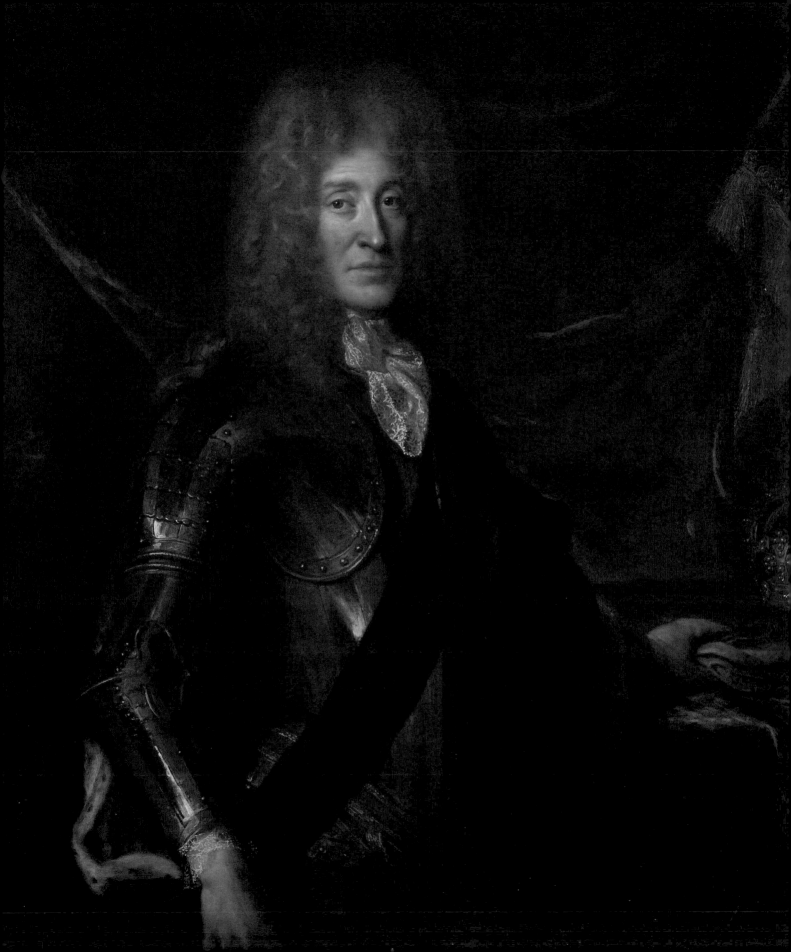

CHAPTER 2

Saint-
Germain-en-Laye

Edward Corp

THE ATTRACTIVE TOWN OF SAINT-GERMAIN-EN-LAYE AND ITS CHÂTEAU are situated on a plateau raised high above the river Seine, which winds its way around the hills to the west of Paris. The air is good, the view spectacular, and thus it is not surprising that it became one of the favourite residences of the kings of France during the 16th and 17th centuries. Paris was only about twelve miles away, and the surrounding area contained forests ideal for hunting. By the 17th century the royal domaine actually consisted of two separate châteaux: a large one (the *château-vieux*) which had been rebuilt in a renaissance style on medieval foundations, and a much smaller one (the *château-neuf*), where Louis XIV was born, which had been built on the escarpment of the plateau looking down to the river. The chief feature of the latter, which no longer exists, were its celebrated hanging gardens, dropping down the steep slope to the Seine below. The Stuarts and the Jacobites were able to benefit from the magnificent and extensive gardens, but they only actually occupied the *château-vieux*.

We do not know what impression the château made on the exiled James II and Queen Mary when they first arrived in January 1689. However, a visitor to Saint-Germain-en-Laye today, hoping to see the remains of the exiled Stuart court, is likely to be disappointed. The château still exists, as does the *grand parterre* of the formal garden on the north side. The celebrated *grande terrasse* still provides spectacular views eastwards towards Paris. But the royal apartments have been completely destroyed, the richly decorated chapel royal is now no more than an empty shell, and the main entrance has been blocked up. To rediscover the reality of the château, as it was when occupied by the Stuarts, the visitor needs some visual aids and quite a lot of imagination.

The château has five sides or wings of unequal length, built around a central courtyard. The north wing is the longest and overlooks the *grand parterre* and, beyond that, a large forest. The east wing still has a view of Paris in the distance, though the gardens on this side have been replaced by houses. The west wing overlooks the town of Saint-Germain, but on the south side the original main entrance and dependent buildings (including the stables, the *manège*, the kennels and a *jeu de paume* tennis court) have all gone. Finally, the west and south wings

NOTE

The two Stuart kings at Saint-Germain always referred to themselves as Kings of England rather than of Scotland, and were always styled by the French as *roi d'Angleterre*. Even the Scots at the court conformed to this usage. As a result the kings were always James II and James III, never James VII and James VIII, let alone VII & II or VIII & III. This was consistent with the practice of James VI of Scotland when he became James I of England, and styled himself King James I of Great Britain, *Magnae Britanniae Rex*.

are connected by the chapel royal, thereby completing what is in effect an irregular pentagon.[1]

The château contains four floors (the ground floor and three floors above), but very little basement space. When the Stuarts arrived in 1689 a large pavilion had recently been added to all of the five corners. Each of these five pavilions contained both a basement for the catering departments and another floor at the top, as well as extra rooms on each of the original floors, thus greatly increasing both the size of the building and the amount of accommodation within it. As these five pavilions, and the south-west wing beside the chapel royal, were destroyed in the second half of the 19th century, the château which the visitor can see today is much smaller than it was when occupied by the Stuarts. It also looks very different. And unfortunately three of the destroyed pavilions contained significant parts of the apartments once occupied by James II, Queen Mary and their children.

Saint-Germain was the second most important royal château in France, and had been the principal residence of Louis XIV and his court before he moved to Versailles in 1682. The royal apartments at Saint-Germain had therefore been planned and originally occupied by the French royal family. They were situated on the second floor above the ground, in the north and east wings, as well as the three pavilions at the ends of those wings. The south wing contained the royal nursery and apartments reserved for the governesses of the prince and princess. The west wing contained a large court theatre.[2]

The long north wing was divided in two by a central staircase [Fig. 2.1]. On

Fig. 2.1: *Vue du Vieux Chateau de S^T Germain en Laye*

The north wing of the Château de Saint-Germain as it was in the Jacobite period. The royal apartments were on the second floor, with a surrounding balcony. The grand staircase can be seen in the middle, between the apartments of James II (left) and the Prince of Wales, later James III (right). The west wing contained the court theatre.

By Jacques Rigaud (1680–1754), engraved *c.*1725, 32 x 49 cm, Bibliothèque nationale de France

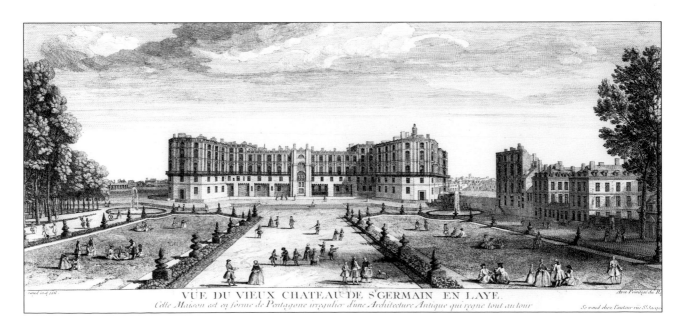

VÜE DU VIEUX CHATEAU DE S^T GERMAIN EN LAYE.
Cette Maison est en forme de Pentagone irregulier d'une Architecture Antique qui regne tout au tour

the north-east side was the apartment of the king; on the north-west was the apartment of the dauphin. Louis XIV's queen was given the east wing, with a separate staircase in the south-east pavilion, so that their apartments came together in the north-east corner. The dauphine had occupied a suite of rooms in the north-west pavilion, beyond those of the dauphin. It was these four apartments that were made available to be occupied by the Stuarts [Fig. 2.2].

At first, of course, Prince James and Princess Louise Marie were brought up in the nursery in the south wing, but it was understood that each of them would move into one of the royal apartments when they were seven years old, in 1695 and 1699 respectively. So James II and Queen Mary had to decide which of the four royal apartments would be occupied by themselves, and which by their children. And the choice was not straightforward.

It should be remembered that the royal apartments in English royal palaces normally contained more rooms than the ones in French palaces. In England there would normally be a sequence of guard chamber, followed by three rooms (presence chamber, privy chamber, withdrawing room) and then the bed-chamber, beyond which would be various private rooms (closets or cabinets, and an oratory or little chapel). In France, by contrast, there would normally be only one, or at most two rooms, known as antechambers, between the guard chamber and bedchamber. Saint-Germain was unusual among the French royal palaces in that each of the royal apartments contained a different number of antechambers.

The apartments of the king and the dauphine were the smallest and contained only one antechamber each, whereas the apartment of the queen contained two

Fig. 2.2: Plan of the second floor of the Château-Vieux de Saint-Germain

Showing the position of the royal apartments.

Adapted from the original plan, Bibliothèque nationale de France (Est. Va. 78c, t.2, B8553) / Archives dè Departementales des Yvelines, SQ19

39 Prince of Wales (1695–99)
Princess Louise Marie (1699–1702)
James III (1702–12)
40 Prince of Wales (1695–99)
Queen Mary (1699–1702)
James III (1702–12)
41 James II (1690–1701)
Princess Louise Marie (1702–12)
42 Queen Mary (1689–99)
Prince of Wales / James III (1699–1702)
Queen Mary (1702–18)
43 Prince of Wales (1689–95)
Princess Louise Marie (1692–99)

antechambers and that of the dauphin contained three. Despite its limited space, James II decided to occupy the apartment of the king, so Mary of Modena occupied the larger one of the queen which was beside it. When their son James left the nursery in 1695 he then occupied the largest one, that of the dauphin.

Four years later, when the princess left the nursery, Queen Mary wanted to have her daughter in rooms beside her own. She therefore put the princess in the apartment of the dauphine, and swapped her own apartment with that of her son. Mother and daughter, and father and son, but not husband and wife, therefore lived in adjacent apartments. The fact that the apartments of the king and the queen were no longer interconnected made it evident that they no longer slept together.[3]

When James II died in 1701, the queen decided to reallocate the apartments. She returned to her original apartment in the east wing, she put her daughter beside her in the apartment of the king, and moved her son, now James III, to occupy both the apartment of the dauphin and that of the dauphine, thereby providing him with an extremely large area in which to live. As there were household servants attached to each of the antechambers (only one for James II, but a presence chamber, a privy chamber and a withdrawing room for James III) this meant that the size of the king's household significantly increased after 1701.[4]

These accommodation details had implications for what the visitor to the château de Saint-Germain can see today. The bedchamber and private rooms of James II, including his private oratory, were all in the north-east pavilion, so they have totally disappeared. Similarly, the bedchamber and private rooms of James III, including his private chapel, were all in the north-west pavilion, so they too have disappeared.[5] All that remain of their apartments are their antechambers. By contrast, the rooms occupied for most of the time by the queen have survived, with the exception of her staircase and her guard chamber. There is absolutely nothing in the château today to indicate that the rooms in the north and east wings on the second floor once contained richly decorated royal apartments. All that the visitor can do today is walk through some of the spaces which once housed those rooms: the antechambers of James II and his son; both the bedchamber and the antechambers of Queen Mary.

If we think of the rooms in the Château de Versailles, only a few miles away, we realise what the apartments of the Stuarts at Saint-Germain might have looked like. They were decorated with tapestries from the French royal collection, and contained both chairs and stools (*fauteuils, carreaux* and *sièges pliants*) for the Stuarts and their courtiers. There were crystal chandeliers with gilded copper arms, various tables and newly-made mirrors. There were numerous paintings, notably portraits of the Stuarts themselves. The bedchambers were especially richly decorated, including one called the little bedchamber which was situated in the north-east corner between those of the king and queen. French kings and

queens admitted their courtiers to their bedchambers, so their beds were railed off with balustrades. English kings and queens, by contrast, only admitted a very few people to their bedchambers, so their beds did not need to be railed off. Therefore neither James II nor James III had a balustrade. Queen Mary, however, decided to please her French visitors by receiving them in her formal or state bedchamber and having a balustrade to separate her bed from the rest of the room. She actually slept in a smaller room beyond.[6] These are some of the things a modern visitor must try to imagine as he or she walks through rooms which now show no trace that they were once occupied by the Stuart royal family.

The same is true of the chapel royal which was entered in those days from the interior courtyard, although the royal family had a tribune or gallery facing the high altar which they could reach by passing through the theatre in the west wing. The chapel contained several paintings, most of which still exist, though no longer at Saint-Germain. The most important was Nicolas Poussin's *Last Supper* above the high altar, which is now in the Louvre; but there were others which can also be seen in the Louvre, in three provincial museums (Toulouse, Rouen and Limoges) and in a parish church in south-west France.[7] The chapel plate was especially rich and included chandeliers, gold and silver vases, two large crosses for the high altar (one of gold and one of silver), 36 large candlesticks and two silver fonts. There was also a crimson mohair carpet. The priests wore rich vestments and there were equally rich cloths and curtains which had been transferred to Saint-Germain from the chapels at Versailles and Marly.[8]

In addition to the royal apartments and the chapel, the château contained plenty of accommodation for the Jacobite courtiers. There were 78 separate apartments of various sizes, and one more when the nursery was no longer needed in 1699. Most of these (49 of them) were situated on the ground floor, the first floor and the third floor, but there were nine more on the top floor of the five corner pavilions, and some others for the intimate servants of the Stuarts beside or above their apartments.[9] The royal household, nevertheless, was much too large for everyone to be accommodated in the château. In 1696, for example, the Stuarts employed about 225 people, many fewer than they had employed in England before 1689, but about the same number as they had before 1685 when they were Duke and Duchess of York. Many of these servants had wives and children, and employed their own servants. There were also many pensioners, in others words Jacobites who lived at Saint-Germain without any employment but who were financed by the king or the queen. Putting all these together, the exiled court numbered about a thousand people, most of whom lived in the town where there was plenty of available accommodation, standing empty since the French courtiers had followed Louis XIV to Versailles.[10]

The exiled court had come to France from Whitehall, so most of the salaried servants were English. Of the 225 servants in 1696, 30 were Irish, 20 were French,

14 were Italian, and only eight were Scottish. As the years went by these figures changed a little. The number of French remained the same, and the number of Italians went down to ten. The number of Irish increased to over fifty, and the Scots to about twelve.[11] Most of the servants were Catholic, but there were always about twenty Protestants (Dissenters as well as Anglicans), some of them in important positions and close to the king.[12]

The court was financed by an annual pension of 600,000 *livres* from Louis XIV. The Stuarts, who also had their own sources of income, kept a little over one-third of the French pension (36 per cent) for themselves, and spent the rest on salaries and pensions. Because more and more people joined the court during the 1690s as pensioners, James II was obliged to reduce each individual pension in 1695. When James III succeeded as king in 1701, he retained his father's servants in addition to his own, and occupied the much larger apartment of the dauphin, necessitating additional servants so that each room could be properly staffed. The princess also needed extra servants as she grew up, so the size of the royal household steadily increased. In 1703 both the salaries and the pensions had to be retrenched. But as more money was received from the Pope and from the French clergy, and because the Stuarts sold some of their jewels to provide more pensions without substantially reducing the salaries of their servants, the household remained well paid and properly maintained as a truly royal court.[13]

The Stuarts themselves, retaining 36 per cent of the French pension, were able to live in considerable style and dress extremely well, particularly when they visited the French court at Versailles, Marly and Fontainebleau, or received (as they did very often) Louis XIV and the French royal princes and princesses at Saint-Germain.[14] They also maintained the English royal tradition of dining in state, and providing 'diet' (i.e. food for many of their courtiers) at the so-called gentlemen's table. James II commissioned many items from Parisian gold and silversmiths. These included three *couverts* (knives, forks and spoons) in solid gold, and many items in silver gilt including two caddinets, four more *couverts*, 35 plates, two salts and two salvers. For the gentlemen's table he ordered 55 silver plates.[15] Unfortunately none of these items, like the chapel plate, is known to have survived, though some of them were later taken to Italy and used at the Stuart court in Rome.

The Stuarts also spent a considerable amount of money on providing entertainment for their courtiers. They maintained a small group of musicians (singers and instrumentalists) who regularly performed Italian motets and sonatas in the chapel, as well as concerts of Italian cantatas and sonatas, and extracts from French operas, both in the theatre and in their apartments. The instrumentalists, of whom the most famous was the composer François Couperin, also performed at the court balls held during carnival seasons and to celebrate royal birthdays.[16] The courtiers, when not on duty, occupied themselves playing billiards, cards,

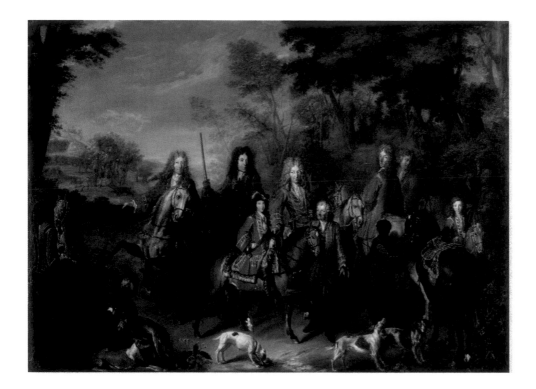

chess, and tennis in the *jeu de paume*. Outside pursuits included hunting in the forest [Fig. 2.3], walking in the gardens, riding along the *grande terrasse*, playing *boules*, going for picnics in the forest, and visiting Paris and Versailles.[17]

A number of objects have survived from the court. We have James II's ruby ring,[18] his glasses,[19] his gold and crystal buttons,[20] the handle of his cane,[21] and his crystal drinking glass.[22] We have Queen Mary's wedding ring,[23] one of her bed covers, one of her table cloths, and some of her Imari and Kakiemon porcelain.[24] We have some of their books, notably some prayer books for Easter week and two missals,[25] and some of the books and pamphlets published at the English printing press established in the town.[26] We have some 'touch pieces', handed out by James II in the chapel royal to people suffering from the king's evil (scrofula). And we have some gold, silver and bronze medals bearing the heads in profile of James II and his son, minted by Norbert Roettiers, engraver-general of the mint at Saint-Germain.[27] We also have some manuscripts. These include James II's Papers of Devotion,[28] the Advice which he gave to his son,[29] some household lists of salaries and pensions,[30] some political correspondence,[31] the private diary of one of their courtiers (which gives us precious details about the social life of the court),[32] and some of the music performed at the court.[33] We also have a very fine scagliola table which was commissioned by one of the queen's bedchamber women, a good example of the relative prosperity of the senior

Fig. 2.3: Painting entitled *The Return of James III from Hunting*

James III appears here with his governors and equerries. The other figures on horseback are (left to right): William Dicconson, under-governor; Lt General Dominic Sheldon, under-governor: 1st Duke of Perth, governor; Ralph Sheldon, equerry; Richard Biddulph, equerry; and Lord Edward Drummond, the 15-year-old son of the Duke of Perth. The man, dismounted, and greeting James on his return, is Robert Buckenham, aged seventy, equerry of the great stables, who taught the king to ride. The Château de Saint-Germain can be seen in the background on the left.

By Jacob Van Schuppen (1670–1751), painted in 1704, oil on canvas, 98 x 131 cm, Prussian Palaces and Gardens Foundation, Berlin-Brandenburg, Wolfgang Pfauder, F0082756

courtiers.[34] In addition to these, we have relics from the bodies of James II, Queen Mary and Princess Louise Marie, some of which are in the parish church.

The parish church of Saint-Germain, facing the west wing of the château and containing the tombs of hundreds of Jacobites, was destroyed during the second half of the 18th century. It was eventually replaced by the church which can be seen today, completed in 1827. The present church is much larger, with its high altar at the west end, whereas the church regularly visited by the Stuarts had its high altar at the east end, towards the château. It now has a plaque on the outside which claims that James II was buried within it.[35] This was indeed the king's intention, but in fact Louis XIV made other arrangements. James's body was to be embalmed so that it could be later taken back to Westminster Abbey, and the vital organs were to be distributed to various religious houses. Twenty-five hours after his death the body was cut open, the vital organs were removed and the body was embalmed. While this was happening people dipped pieces of linen in his blood, and others cut off some of his hair. Someone even cut off part of the flesh of his right arm.[36]

James II's embalmed body, placed in a coffin within two others and entrusted to the English Benedictine monks in Paris, was destroyed by French revolutionaries in 1794, but many of the relics have survived. There is a wax death mask, including the whole head as well as the face, which was made by the monks before the coffins were closed,[37] the dried flesh of his right arm, four of the pieces of linen dipped in his blood, and two cuttings of his hair. His heart, which was given to the Visitation nuns at Chaillot (Paris), is still preserved in a silver locket. His brain, which was given to the Scots' College in Paris, was in a lead box, hidden during the French Revolution and rediscovered in 1883. His intestines were divided into two parts and placed in gilt-bronze urns. One part was given to the English Jesuit College at Saint-Omer (near Calais) and is now in England (though no longer in the urn). The other was placed in the parish church of Saint-Germain, hidden during the French Revolution and rediscovered in 1824. It is all that actually remains of the king within the parish church today, and it is now buried in a side chapel with lead urns containing the complete intestines of Queen Mary and Princess Louise Marie.[38]

In addition to these physical remains of the Stuarts we have a great many of their portraits.[39] Some of them were commissioned by the Stuarts themselves to decorate the royal apartments, while others were to be sent away as diplomatic gifts or to stimulate the loyalty of the Jacobites in England and Scotland. We also know that several, probably many, of the Jacobite courtiers displayed portraits of the Stuarts within their own apartments in the château and the town.

Seven painters are known to have worked for the Stuarts at Saint-Germain. These included Benedetto Gennari and Nicolas de Largillière, both of whom had previously been employed in England. The others were Pierre Mignard,

François de Troy, Alexis-Simon Belle, Hyacinthe Rigaud and Pierre Gobert.

Gennari painted the queen and the prince in 1689 and 1690. Largillière painted the prince by himself, with his parents, and with his sister between 1690 and 1695. Mignard painted all the Stuart family in 1694, Rigaud painted James III in 1708, and Gobert painted the queen in 1713. These were all occasional commissions, whereas de Troy and Belle worked regularly for the Stuarts and became their official portrait painters. De Troy was employed from 1698 to 1704, and then again in 1711. Belle was employed so frequently from 1699 to 1712 that he bought a house in Saint-Germain and established his *atelier* there rather than in Paris.

The most important pictures were commissioned to be displayed in James II's antechamber. Largillière's large family portrait showing the king, queen and the prince was placed there in 1691. But the birth of the princess in 1692 meant that it needed to be replaced by a new family portrait showing her as well. In 1694, therefore, the Stuarts went to sit for the elderly Mignard at Versailles, after which it was this family portrait which provided a permanent royal presence in the king's antechamber, while Largillière's picture was moved to the queen's apartment, where it was presumably displayed in her presence chamber.[40]

In 1698, the year of the king and queen's silver wedding anniversary, François de Troy was commissioned to paint companion portraits of them both. The king was shown three-quarter length standing beside a table on which we can see the left side of his crown [Fig. 2.4]. The queen was also shown three-quarter length, but sitting in a chair beside the same table on which we can see the right-hand side of her crown. The portrait of James II was for Queen Mary, and was displayed in her apartment. That of the queen was for James, to be displayed in his.[41] As the painting of these portraits coincided with the queen's decision to move out of her original apartment, and no longer share a bedchamber with her husband, the two paintings were presumably placed in their respective bedchambers.

Apart from two portraits of the queen by Gennari (to be sent away to James II in Ireland), and one by Gobert (to be sent away to James III in Lorraine), the ones by de Troy were the only original and individual portraits of the king and queen painted after they went into exile. Other than these, the portraits commissioned by the Stuarts all showed the prince or the princess. There are, however, two double portraits of the children, one by Largillière of which several replicas have survived, and one by Belle. The original of the one by Largillière was displayed in James II's apartment, and is now in the National Portrait Gallery in London.[42]

Fig. 2.4: Portrait of James II (b.1633–1701)

This portrait, which shows the king wearing the Garter, was given to Queen Mary and displayed in her bedchamber.

By François de Troy (1645–1730), painted in 1698, oil on canvas, 137 x 106 cm, Barrett-Lennard Collection, Essex Record Office, by kind permission of the Corporate Custodian of Art, Essex County Council (ECC457)

Fig. 2.5: Portrait of James III (b.1688–1766)

This was the last portrait of the king to be painted before he left Saint-Germain to go to Lorraine.

By Alexis-Simon Belle (1674–1734), painted in 1712, oil on canvas, 136 x 107 cm, Government Art Collection, © UK Government Art Collection, GAC3534

We know of at least twenty original portraits of Prince James, both as Prince of Wales and then King James III, painted between 1689 and 1712; and eight of Princess Louise Marie painted between 1695 and 1710. Most if not all of these were produced with several replica copies and sent to England and Scotland, so that the image of the new king and his sister would become familiar to the leading Jacobites who had not followed the Stuarts into exile. Many of the portraits were also engraved in multiple copies so that the faces could be seen, and recognised, by a much wider public.[43] We cannot say which of these individual portraits were also on display in the château de Saint-Germain, although we do know that at least two of them could be seen in the royal apartments.

When Princess Louise Marie came of age in 1710, at 18 years old, she was painted by Belle three-quarter length with a crimson cloak over her white satin dress, and picking some orange blossom with her right hand.[44] Two years later, just before he left Saint-Germain in 1712, James III was also painted three-quarter length by Belle, wearing a breastplate over his coat, and with his left hand placed on a helmet [Fig. 2.5].[45] These two portraits belonged to the queen and were probably displayed in her apartment – although they might perhaps have been placed in the vacant apartments of the princess and of James III to maintain a permanent royal presence there. The portrait of James III is very well known. It was copied and engraved many times, and the original has fortunately survived. It is now in Bute House, the official residence of the First Minister of Scotland, having previously been at 10 Downing Street for two years.

The portraits of James II and James III all show the two kings as Knights of the Order of the Garter, the premier chivalric order of England. In most cases they are shown with the star of the Order on the right side of their chests, and with the medal or jewel of the order, the Lesser George, pinned to the bottom of a blue sash falling from the left shoulder to the right hip. However, in Mignard's portrait of James II in the family group, and in one of Belle's portraits of James III, the kings are shown wearing both the robes and the collar of the Garter.[46] The collar, from which is suspended the Great George with diamonds, has survived. It can be seen today with the Honours of Scotland in Edinburgh Castle.

It is interesting to observe that there is not a single portrait of the Stuarts at Saint-Germain which shows the insignia of the Order of the Thistle, the premier chivalric order of Scotland. This is because the two orders were regarded as incompatible, meaning that they could not be worn together. The Stuarts did, however, have a St Andrew jewel, which can also be seen in Edinburgh Castle. It would have been pinned at the bottom of a similar blue sash, which fell from the right

shoulder to the left hip – in other words, in the opposite direction to that of the Garter.[47]

There is another thing that we should notice about these portraits. James II and Mary of Modena are always shown as king and queen, in that they have a closed crown placed beside them. James III, by contrast, is never shown as a king, and there is not one of his portraits painted at Saint-Germain which includes a crown. This was a deliberate decision not to offend his half-sister Queen Anne, whom James hoped to succeed peacefully, and would only be changed after the accession of George I of Hanover in 1714.[48]

In addition to these portraits of the Stuarts painted at Saint-Germain, James II also owned a replica copy by Van Dyck of his triple portrait of 1635 showing James as a boy with his brother Charles (later King Charles II) and his sister Mary (later Princess Mary of Orange and mother of William III). The painting had originally belonged to Queen Henrietta Maria, and was given to James by the duc d'Orléans (brother of Louis XIV). It is now in a private collection.[49]

There must have been paintings other than portraits decorating the royal apartments, but unfortunately we know nothing about them. There are no surviving inventories to tell us what they might have been. We do know, however, that two of the leading Scottish courtiers had significant collections of paintings in their apartments. John Drummond, 1st Earl / 1st Duke of Melfort, had an important gallery of Italian pictures in his apartment, which was immediately below that of the queen in the east wing, with richly painted ceilings by Nicolas Loir.[50] And his brother James, 4th Earl / 1st Duke of Perth, had the family's collection of 72 paintings shipped from Scotland to France in 1707. They could be seen in his large apartment in the west wing, immediately below the theatre.[51]

In addition to the many portraits of the Stuarts, we have a surprising number of others which show the leading courtiers at Saint-Germain. Gennari kept a list of all the pictures that he painted, and it includes nine portraits of the exiled Jacobites before he left the court in 1692, though only two have survived. Neither de Troy nor Belle kept a list, but we know that each of them painted even more people than Gennari. We have at least ten Jacobite portraits painted by de Troy before the death of James II, and we know of at least 13 (of which eight have survived) by Belle after the accession of James III. We also have Jacobite portraits by Largillière, Rigaud and Jacob Van Schuppen.[52]

The people shown in these portraits include some of the most senior members of the court, such as the Marquess / 1st Duke of Powis (lord chamberlain) and two of his daughters painted by de Troy,[53] Viscountess Clare (lady of the bedchamber) also by de Troy,[54] and the 1st Duke of Berwick (James II's illegitimate son) by Gennari, de Troy, Rigaud and Belle.[55] Perhaps the most interesting are the ones owned by the Duke of Perth (governor of James III, then gentleman of the bedchamber). He had a portrait of his eldest son, later the 2nd Duke, by de

Troy,[56] and portraits of himself as a Knight of the Garter by both Largillière and Belle.[57] In 1704 he commissioned Van Schuppen to paint a large picture showing Perth himself and his youngest son Lord Edward Drummond (later 6th Duke), on horseback with James III and several other courtiers, with the château visible in the background [see Fig. 2.3].[58]

The other surviving portraits show people of a lesser social status in the royal household, such as the master of the queen's robes or the king's physician, in both cases with their families.[59] They provide evidence of what the people looked like and how they dressed, and thus bring us closer to the reality of a court which has left virtually no trace within the château at Saint-Germain today. They also bear witness to the relative prosperity of the Jacobite courtiers, who were able to commission their portraits from the leading painters at the French court.

This last point is important because it has generally been assumed that the Stuart court at Saint-Germain was both impoverished and exceptionally dull. In fact it was well financed and an extremely lively and pleasant place in which to live. As James III and his sister grew up, the court was increasingly dominated by the younger generation, including the children of the leading courtiers who, like them, had grown up in exile, many of them immortalised in the poems of Anthony Hamilton.[60] There was a rich musical life (it was the Stuart court which introduced Italian music to Paris and Versailles), and so many *divertissements* that some of the older courtiers became rather disapproving. Above all there was a spirit of optimism that James III, like his uncle Charles II, would sooner or later be restored, especially after the death of Queen Anne. It was not until this hope was undermined by the events of 1714–16 that the court at Saint-Germain began to change and the memory of what it had once been began to be lost.

In 1712 Princess Louise Marie died of smallpox, and James III left Saint-Germain to live in the Duchy of Lorraine, taking with him half of his household servants, and leaving the other half with nothing to do. Both the royal apartments in the north wing of the château were then left empty. Queen Mary was in bad health and mourning the loss of her two children, and often absent from court, at the convent of Visitation nuns at Chaillot. Even before the death of Louis XIV in 1715, the French princes and princesses stopped visiting Saint-Germain. The court entered a twilight phase, which ended with the queen's death in May 1718.[61]

The failure of all the attempts to restore James III, from the Franco-Jacobite expedition to Scotland in 1708 to the Battle of Culloden in 1746, condemned the reality of the Stuart court of Saint-Germain to oblivion and misrepresentation. Next it was the turn of the château to be transformed, until all trace of the Stuarts had disappeared, and not even Bonnie Prince Charlie, when living in Paris before and after his time in Scotland, came to see where his father and grandfather had lived.[62] Many Jacobites, however, were allowed to continue living in their grace and favour apartments, so the French court was never able to reoccupy the

building, even when hunting in the forest outside. In the 1750s the royal apartments, having stood empty for so long, were lent to some French courtiers who agreed to live alongside the remaining Jacobites. The most important of these was the princesse de Talmont, the former mistress of Prince Charles, who lived in the erstwhile apartment of the king for nearly twenty years. She completely redesigned and redecorated it, and even added an entresol, thereby effectively destroying the apartment as it had been when occupied by James II.[63]

The French Revolution finally destroyed the château as a royal residence. The building became successively a political prison, cavalry school, military barracks and a military prison. The 79 separate Jacobite apartments were converted into 542 small cells, and the royal apartments were completely gutted to create communal work-rooms for the convicts.[64] Finally the decision was taken to destroy the five pavilions, and the entire south-west wing beside the chapel, and replace the prison with a museum of national antiquities. Since the 1860s the lavishly decorated apartments occupied by the Stuarts – or at least those parts which survived – have been the repository of archaeological and other antiquities, today called the Musée d'Archéologie Nationale.

Notes

1. Edward Corp, *A Court in Exile: The Stuarts in France, 1689–1718* (2004, pbk 2009), chapter 2, 'The Château-Vieux de Saint-Germain'. This reproduces a contemporary map of the town, and some views of both the *château-vieux* and the *château-neuf* on pages 78–81.
2. Ibid., p. 82.
3. Ibid., pp. 93–94.
4. Ibid., pp. 94, 102, 125.
5. There are two photographs taken by Charles Marville which show the destruction of the north-west pavilion in 1862, reproduced in a special number of the *Revue de la Bibliothèque Nationale* devoted to 'Les Jacobites', no. 46 (winter 1992).
6. Corp, *A Court in Exile*, pp. 92, 94.
7. The paintings are all listed in ibid., pp. 97, 99.
8. Ibid., pp. 95–101. For the other chapels or oratories in the château, see ibid., pp. 101–102.
9. The plans of the basement and the first two floors are shown in ibid., pp. 82–88.
10. Ibid., pp. 105–106.
11. Ibid., p. 137. For a list of all the Scots at the court of Saint-Germain, see Edward Corp, 'Scottish People at the Exiled Jacobite Courts', in *The Stewarts* 22: 1 (2004), pp. 40–46.
12. Corp, *A Court in Exile*, pp. 150–57.
13. Ibid., pp. 118–22.
14. Ibid., ch. 6, 'The Stuarts and the Court of France'.
15. Ibid., p. 110.
16. Ibid., ch. 8, 'The court as a centre of Italian music'.
17. National Library of Scotland, MS 14266, the diary of David Nairne, 1655–1708.
18. James II's gold ring with a large ruby, set about with small rubies, is in Edinburgh Castle with the Honours of Scotland. His gold ring with a large emerald, set about with diamonds, is in the Victoria and Albert Museum, M.10, 1970.
19. Victoria and Albert Museum, W.5, 1970.
20. Sizergh Castle, Strickland Collection, V.2.
21. Stonyhurst College.
22. Musée Municipal de Saint-Germain-en-Laye, inv. 23.2.1.
23. Arundel Castle, Collection of the Duke of Norfolk.
24. Sizergh Castle, Strickland Collection, T.101, C.100, C.101, C.102.
25. James II's two copies of the *Office de la Semaine Sainte* (1690, 1700) are at Stonyhurst College and the National Library of Scotland. Two of Queen Mary's (1691, 1708) are both in the Royal Library; a third (1715) is in a private collection in Paris. The *Missale Romanum ex Decreto* of Queen Mary and Princess Louise Marie are respectively in the National Library of Scotland and Stonyhurst College. There are also two beautifully illuminated manuscript books presented to the Prince of Wales, *Explication de l'Oraison Dominicale* (Royal Library RCIN 1006013); and *The Variation of the Armes, and Badges of the Kings of England … until the present Yeare*, presented by James Terry (Athlone Herald of Arms) in 1697 (Biblioteca Apostolica Vaticana, Vat Lat 14937).
26. The English printing press at Saint-Germain was run by William Weston. His best-known publication was *The Psalmes of David*, translated from the Vulgat (1700), translated by John Caryll and David Nairne, but attributed only to Caryll. A second edition was published in 1704 as *The Psalms* [*sic*] *of David*, and twelve more editions had been published by 1986.
27. Noel Woolf, *The Medallic Record of the Jacobite Movement* (1988); Corp, *A Court in Exile*, pp. 185–86, 191, 298–99.
28. Trinity College, Dublin, MS 3529.
29. 'For my Son, the Prince of Wales', 1692, Royal Library, RCIN 1006012.
30. Royal Archives (RA), Stuart Papers (SP), RA SP 1/79 (1693); Sizergh Castle, Strickland Collection, R.4 (1696); RA SP 2/23 (1703); British Library, BL. Egerton MSS 2517 (1709); RA SP 8/92 (1715), RA SP 9/30 (1716), RA SP Box 3/89 (1717), RA SP 281/166 and Box RA SP 3/80 (1718).
31. The archives of the Stuart court at Saint-Germain (and Bar-le-Duc) were deposited in the Collège des Ecossais in Paris and destroyed during the French Revolution. However, a few papers survived, either because they were still being used when the court moved to the Papal States or because they were sent to Rome during the 1730s (Edward Corp, 'An Inventory of the Archives of the Stuart Court at Saint-Germain-en-Laye, 1689–1718', in *Archives*, vol. XXIII, 99, October 1998, pp. 118–46). They are now at Windsor Castle with the archives of the Stuart court at Rome.
32. National Library of Scotland, MS 14266, the diary of David Nairne.
33. The surviving music of Innocenzo Fede, the master of the music, is listed in Corp, *A Court in Exile*, p. 209.
34. The scagliola table-top was made in 1708 for Lady Strickland, and is illustrated in the *Sizergh Castle Guidebook* (2001), p. 12.
35. Corp, *A Court in Exile*, pp. 81, 348, 358.
36. Edward Corp, 'The Remains of James II', in *History Today* 51 (September 2001), p. 25.
37. The death mask is in a private collection, and there is a photograph of it in Edward Corp and Jacqueline Sanson, *La Cour des Stuarts à Saint-Germain-en-Laye au temps de Louis XIV* (1992), p. 148.
38. The flesh from the right arm is at Ushaw College (Durham); the four pieces of linen are at Ushaw College, Stonyhurst Downside Abbey and Sizergh Castle; the cuttings of his hair

are at Stonyhurst and Sizergh; his heart is at Chiddingstone Castle; and half of his intestines are at Stonyhurst. His brain was given to the Association of Scottish Catholic Bishops, but its present location is unknown.

39. Corp, *A Court in Exile*, ch. 7, 'The portraits of the Stuarts and their courtiers'. The portraits of the Stuarts are reproduced in Edward Corp, *The King over the Water: Portraits of the Stuarts in Exile after 1689* (2001), pp. 33–52, 110–11.

40. Largillière's family portrait has been lost, but Mignard's has survived in a private collection in England. Mignard's preliminary *modello* is in the Royal Collection.

41. De Troy portraits of the king and queen are, respectively, in a private collection and at Sizergh Castle, and are both reproduced in Corp, *A Court in Exile*, pp. 187–88; and Corp, *The King over the Water*, p. 37. The portrait of the queen has been cut and reduced in size from about 137 x 106 to 71.2 x 58.4 cm.

42. The double portraits are reproduced in Kathryn Barron, 'The British monarchy's collection of imagery and objects associated with the exiled Stuarts from the reign of George III to the present day', in Edward Corp (ed.), *The Stuart Court in Rome: The Legacy of Exile* (2003), pp. 149–64, pp. 158–59; as well as in Corp, *The King over the Water*, pp. 39, 44.

43. Richard Sharp, *The Engraved Record of the Jacobite Movement* (1996).

44. Belle's portrait of Princess Louise Marie is reproduced in Corp, *A Court in Exile*, p. 193; *The King over the Water*, p. 49; and *Sizergh Castle Guidebook*, p. 14.

45. Belle's portrait of James III is reproduced in Corp, *A Court in Exile*, p. 194; and *The King over the Water*, p. 51.

46. Belle's portrait of James III with Garter robes has not survived, but it was engraved by A. M. Horthemels (Sharp, *The Engraved Record*, p. 98). There is also a copy in a private collection, reproduced in Corp, *The King over the Water*, p. 111.

47. For the marquis de Dangeau's description of how the Thistle was worn at Saint-Germain, see Edward Corp, *The Jacobites at Urbino: An Exiled Court in Transition* (2009), p. 164.

48. Belle painted three portraits of James III at Bar-le-Duc in 1714, all of them before the death of Queen Anne (Corp, *A Court in Exile*, p. 293). They are reproduced in Corp, *The King over the Water*, pp. 52, 111). The first portrait of James III in which he is shown with a crown was painted by Antonio David in Rome in 1717.

49. Corp, *A Court in Exile*, pp. 93, 200. The painting is reproduced in Corp, *King over the Water*, p. 53. The original is in the Galleria Sabauda, Turin.

50. Corp, *A Court in Exile*, pp. 198–99.

51. Ibid., p. 197.

52. Details of the portraits of the Jacobites at Saint-Germain are given in ibid., pp. 182–85, 192–95, 196–97; and Corp, *The King over the Water*, pp. 102–3.

53. The portraits are at Powis Castle. The one of the Duke of Powis is reproduced in Corp, *A Court in Exile*, p. 107.

54. The portrait is at the Château de Breteuil (Yvelines, France), and is reproduced in ibid., p. 128.

55. The surviving portraits of Berwick are discussed in Edward Corp, 'James FitzJames, 1st Duke of Berwick: A New Identification for a Portrait by Hyacinthe Rigaud', in *Apollo* CXLI, 400, June 1995, pp. 53–60. The portrait by Gennari has not survived, but is known from an engraving.

56. The portrait is at Drummond Castle, where there is also a miniature copy by C. Tassis.

57. The portrait by Largillière is at Drummond Castle, reproduced in Corp, *A Court in Exile*, p. 115. The one by Belle is in a private collection, and was previously on loan to the Scottish National Portrait Gallery as PGL 223.

58. Jacob Van Schuppen, *The Return of James III from Hunting* (98 x 131 cm, 1704) (Neues Palais, Potsdam), reproduced in *The Journal of the Edinburgh Bibliographical Society* 1 (2006), p. 9.

59. Benedetto Gennari, *The Riva Family* (1689) (Pinacoteca Nazionale, Bologna, reproduced in Corp, *A Court in Exile*, p. 113); Jacob Van Schuppen, *The Waldegrave Family* (Walker Art Gallery, Liverpool). Francesco Riva was the master of the queen's robes, and Sir William Waldegrave was James II's physician.

60. Corp, *A Court in Exile*, pp. 136, 217–18, 225–26. Hamilton's poems were published in *Oeuvres mêlées en prose et en vers* (1731).

61. Corp, *A Court in Exile*, ch. 14, 'The court of Queen Mary at Saint-Germain, 1712–1718'.

62. Ibid., p. 344. In June 1747 Prince Charles visited the princesse de Conti at nearby Louveciennes 'to geat a sight of ye Castle of St Germans and ye anvirons' (RA SP 284/201, Charles to James III, 26 June 1747).

63. Corp, *A Court in Exile*, pp. 346–47, 355.

64. Ibid., pp. 354–55.

Opposite: *La Reception faite au Roy D-Angleterre par le Roy a S.[t] Germain en Laye le VII.[e], Ianvier 1689*

This engraving shows, from left to right, the Earl of Melfort, the marquis de Beringhen, the Duke of Berwick, James II with the medal of the Garter on his right hip, Louis XIV with the jewel of the Saint-Esprit on his left hip, the Dauphin and the duc d'Orléans.

Nicolas Langlois (1640–1703), engraved 1689, *Almanach Royal de 1689*, 32 x 49 cm, Bibliothèque nationale de France

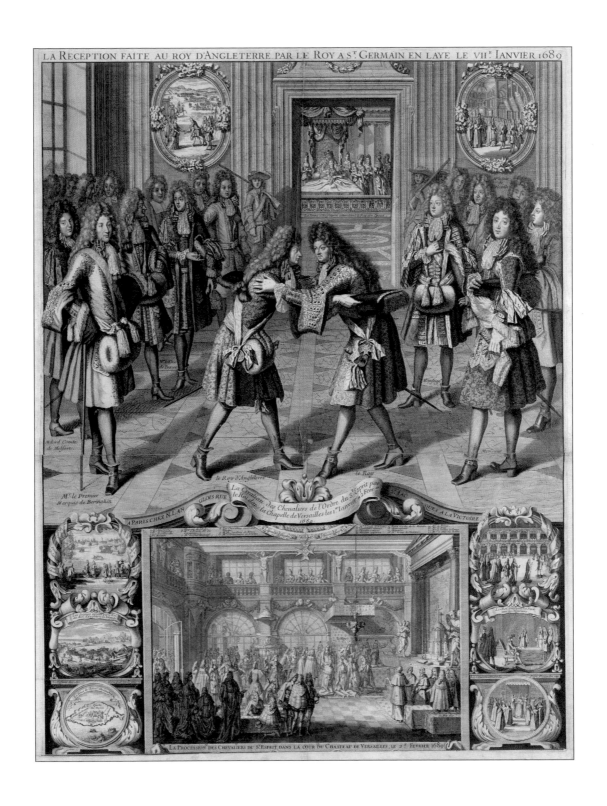

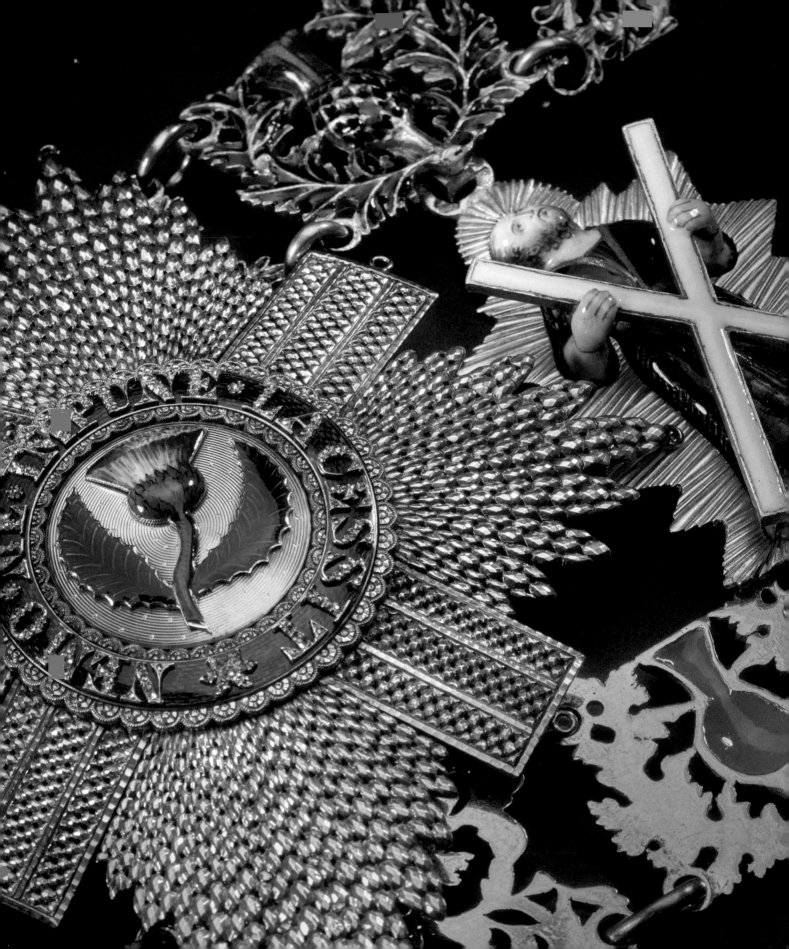

CHAPTER 3

Knights
of the Thistle
A Royal Quest for Loyalty
and Identity

Lyndsay McGill

ON 29 MAY 1687 – THE ANNIVERSARY OF THE BIRTH OF CHARLES II AND his accession to the throne – James VII 'revived' the Most Ancient and Most Noble Order of the Thistle.[1] Two years later the Scottish government declared that the Stuart king had forfeited the Scottish crown and in his place invited William of Orange and his wife Mary Stuart, daughter of James VII, to rule Scotland. However, the Thistle Order did not cease with the exiled king during this turbulent period. This chapter will look at how the Order of the Thistle continued to be used by the Stuarts in the following decades to promote their identity, as well as to foster and reward loyalty through the Thistle insignia. In addition, understanding the perceived medieval origins of this Order is necessary if one is to attempt to comprehend why the royal Stuarts – namely those in exile – felt it necessary to adopt the insignia of the Order as a visual signature. Imagery, objects and ideology, when mixed together, created an effective campaign tool during the first half of the Jacobite century. Not all conflicts were fought on the battlefield and thus the Order of the Thistle was thrust into this tempestuous time primarily as a Stuart aide-de-camp.

Many orders of chivalry (sometimes referred to as orders of knighthood) have their origins in the medieval period, and James VII of Scotland was an ardent promoter of the ancient beginnings of the Scottish Order. In the Order's original *Statutes*, which were written by the monarch, James stipulated that he was 'Reviving' the Order of the Thistle. He explained that King Achaius, a legendary Scottish king from the late 8th/early 9th century, instituted the Order and that

> … *by general consent of ancient and modern historians, and by several other authentic proofs, and documents, and records of that Kingdom, that the said Most Ancient and Noble Order of the Thistle continued in great glory and splendour for many hundreds of years* ….[2]

Today this documentary evidence is lacking, but there are traces of royal thistle heritage witnessed through a legacy of material culture. During the 1470s James III of Scotland (also a Stewart) adopted the thistle as a royal emblem, a move first witnessed on coinage [Fig. 3.1].[3]

Page 42, Fig. 3.5: Collar and star of the Order of the Thistle, and St Andrew

National Museums Scotland, M.1992.1 and 2 and H.NC 429

CATALOGUE NO. 62

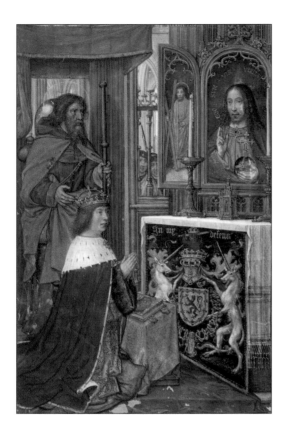

Fig. 3.2: The Book of Hours, given by James IV to his wife Margaret Tudor

Maker unknown, c.1503, Austrian National Library, Vienna, ÖNB/Wein, Cod.1897, fol.24b

Fig. 3.1, opposite, above: Silver groat of James III (r.1460–80), c.1482–84

National Museums Scotland, H.C4239 (reverse)

Fig. 3.4, opposite, below: 60 shilling pattern with collar of the Order of the Thistle, 1688

National Museums Scotland, H.C538 (reverse)

Under the reign of his son, James IV (r. 1488–1513), The Book of Hours, a devotional book given by the king to his wife Margaret Tudor, depicts James IV at prayer. Interestingly, at the front of the altar there is a collar of thistles with a badge of St Andrew, Scotland's patron saint, encircling the Royal Arms of his father [Fig. 3.2].[4]

Then, in c.1538, James V was painted with his new wife, Mary of Guise, wearing a collar of linked thistles, together with the badge of St Andrew [Fig. 3.3, page 46].

The material remains thus show three generations of Stewart kings using the thistle as a royal emblem, and that it was closely associated with the Stewart Royal Arms as seen in the James IV Book of Hours. However, despite the Stewarts using the collar of thistles, there is no documentary evidence at this point to say that any official Order existed. Indeed it is not until almost 150 years after the James V painting that the first reference to an actual Thistle Order is found, i.e. that mentioned by James VII in his *Statutes*. Furthermore, under James in 1688, there were also plans to introduce a 60 shilling piece [Fig. 3.4] with a collar of the Order of the Thistle surrounding the Royal Arms on the reverse,[5] not wholly dissimilar to that seen in the Book of Hours. This ancient and hereditary connection between the crown and its flower is potentially one of the reasons why the Stuarts, notably James VIII, continued to use the Order while in exile, a subject that will be considered later under 'Identity'.

It is worthwhile mentioning at this point that the Thistle's counterpart in England is the Most Noble Order of the Garter, founded in the medieval period under King Edward III in 1348. After the parliamentary union of Scotland and England in 1707, the Garter became the highest order of chivalry in Great Britain, while the Thistle remains the premier order of Scotland to this day. The Garter, like the Thistle, was also used by the Stuarts to promote an identity while in exile. As monarchs of Scotland, England, and then Great Britain, they were Sovereign Knights of both.

The Order of the Garter is distinctive with its red and blue colour scheme, and insignia comprised of a collar of linked roses and knots together with a badge of St George, and a breast star depicting the red cross of St George, England's patron saint. In 1798, 18 years after the Society of Antiquaries of Scotland was established – a precursor of National Museums Scotland – the Society was gifted a blue ribband. This ribband, or sash, was said to have belonged to Prince Charles Edward Stuart and formed part of his Order of the Garter insignia. While this cannot be proved, nor disproved, the date of its acquisition is interesting and it is amongst the earliest donations to the Museum.

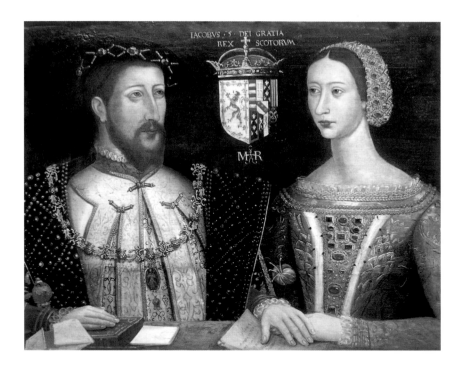

Fig. 3.3: James V (r.1513–42) and Mary of Guise (b.1515–60)

Artist unknown, painted in *c*.1538, from the Collection at Blair Castle, Perthshire, Scottish National Portrait Gallery, Edinburgh

The Insignia

Entry into a chivalric order was highly coveted. Once admitted you were expected to wear, at certain times, the uniform and insignia of that order. How clothing and emblems were to be worn was stipulated in the organisations' statutes, essentially their rule book. An impressive Thistle uniform is preserved at Drummond Castle from the revival period, believed to have belonged to Sir James Drummond. In addition to the clothing, one of the most striking pieces of Thistle insignia is the collar [Figs 3.5].

Under James VII, he specified in the *Statutes* that:

> *About the shoulders is to be worn the Collar of the order, consisting of Thistles and Sprigs of Rue going betwixt, at the middle of which, before, is to hang the Saint Andrew of gold, enamelled with his Gown green, and the Surcoat purple, bearing before him the Cross of his martyrdom enamelled white, or if diamonds, consisting of the number of thirteen just*[6]

This particular collar of the Order of the Thistle was produced under the rule of Queen Anne (r.1702–14), but remains true to the design stipulated under her father, James VII. It is comprised of gold and enamel, with 34 links of alternating thistle heads and the plant rue fashioned in the form of a cross. Despite the collar being unmarked, it is believed that the maker was the Scottish goldsmith John

Figs 3.5, opposite, left and right: St Andrew, and the collar of the Order of the Thistle

St Andrew, by John James Edington, 1825–26; collar, by John Campbell of Lundie, *c*.1707–8, National Museums Scotland, M.1992.1 and 2

CATALOGUE NO. 62

Fig. 3.6, opposite, below: Breast badge or star

By Thomas Wirgman, *c*.1820, National Museums Scotland, H.NC 429

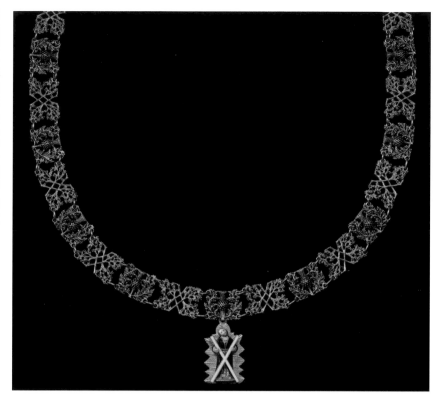

Campbell of Lundie. In 1692, Campbell settled in London and founded the bank now known as Coutts. Although involved in banking, Campbell still continued his business as a goldsmith, and between 1707–8 he was given the privileged commission, under Queen Anne, of making ten Thistle collars, of which only three survive today.[7]

Intriguingly, the enamel and gold badge of St Andrew that forms part of the collar is of a later date. It was made by the London goldsmith, John James Edington, and dates to 1825–26. Albeit a much later piece, the figure of St Andrew remains true to the original *Statutes* in terms of colour and form, with his green gown, purple surcoat and his white cross. Queen Anne did however stipulate in her edition of the *Statutes* that all collars and St Andrews had to be returned to the Sovereign at the death of a Knight, a practice later continued by the Hanoverians.

Material remains of the Order of the Thistle from the first half of the 18th century, and even later, are rare. In addition to the collar and St Andrew, there was an embroidered breast star, with a 'Thistle of gold upon a field, blue'.[8] While an early breast star is absent from the Museum's collections, there is one that dates to *c.*1820 [Fig. 3.6]. Made by the London jeweller Thomas Wirgman, it consists of silver, gold and enamel. The Latin motto on the green enamel is set with diamonds and reads, '*Nemo me Impune lacessit*', which translates as 'no one attacks

me with impunity', a motto adopted by James VI of Scotland and now very much synonymous with Scotland.

Despite being of early 19th century in date, this breast star is an example of the continuation of the first material stars stipulated in the 1687 *Statutes*, although the thistle is now seen 'upon a field of Gold',[9] a change made under George I. Curiously, the Museum's breast star appears to be a transitional piece, as it has both eyelets and pin. The eyelets allow the star to be sewn onto a coat – the traditional way when the breast star was made of material – but by about the 1830s sewing of the breast star onto the garment had fallen out of fashion. Precious metal was now popular, and with an increase in weight the pin evolved, a much more convenient and secure way of attaching. This piece therefore shows continuity from the late 17th century, but also highlights the development of fashion, and the individual taste of a monarch.

In addition to the collar and breast star, James also requested that the Knights have a jewel to be worn on a ribband around the neck.[10] His daughter, Anne, continued the same style of jewel, but added her own twist as to how it would be worn: 'That the Jewel of the said Order is to be worn at a green Ribband over the left shoulder, cross the body, and tied under the right arm'[11]

Anne also decided to add a medal to the insignia, which was to be, '... all of Gold, being the Saint Andrew, bearing before him the Cross of his Martyrdom with a Circle round, on which to be the motto of the Order, and at the lower part of the Circle, between the joining of the words, a Thistle, and to be worn on a Green Ribband, as the Jewel, at times when the Jewel is not worn'.[12]

When fully attired, a Knight of the Thistle was a grandiose figure. Sir John Drummond, 1st Earl of Melfort, was one of the first to be knighted into the Order and is spectacularly depicted, fully robed, by Sir Godfrey Kneller in *c*.1688 [Fig. 3.7]. Likewise, Sir John Murray, 1st Duke of Atholl, displays his knightly status in his portrait by Thomas Murray in 1705 [Fig. 3.8]. Atholl was a supporter of Anne and was appointed into the Order in 1704, while his father had aligned himself with James and had been one of the first Knights alongside Melfort.

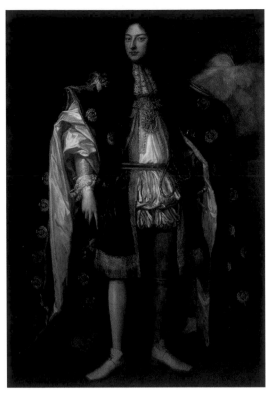

Fig. 3.7: Sir John Drummond, 1st Earl of Melfort (1649–1714), Secretary of State for Scotland and Jacobite

By Sir Godfrey Kneller (1646–1723), painted in 1688, oil on canvas, 243.7 x 147.2 cm, Scottish National Portrait Gallery, Edinburgh, PG 1083

Loyalty

The Order of the Thistle, from its initial conception, was used as a tool for fostering and rewarding loyalty. James VII was a Catholic monarch set on re-establishing religious toleration for those of the Catholic faith. With this in mind he created his Letter of Indulgence, a move for broader religious freedom which

Fig. 3.8: Sir John Murray, 1st Duke of Atholl (1660–1724)

By Thomas Murray (1663–1735), painted in 1705, oil on canvas. From the Collection at Blair Castle, Perthshire.

could only be passed through Parliament with support from the powerful Scottish élite. The first Knights of the Thistle were those men who had proven their loyalty to their king and backed the Letter of Indulgence. They were:

> Sir James Drummond, 4th Earl of Perth,
> Lord Chancellor of Scotland
> Sir John Drummond, 1st Earl of Melfort,
> Secretary of State for Scotland
> Sir George Gordon, 1st Duke of Gordon,
> Governor of Edinburgh Castle
> Sir John Murray, 1st Marquess of Atholl,
> Keeper of the Privy Seal
> Sir James Hamilton, later 4th Duke of Hamilton
> Sir Kenneth MacKenzie, 4th Earl of Seaforth
> Sir George Douglas, 1st Earl of Dumbarton
> Sir Alexander Stewart, 5th Earl of Moray,
> Secretary of State for Scotland[13]

The privilege of belonging to a medieval chivalric order was also exploited by both James VII's son, James Francis Edward Stuart (the 'Old Pretender), and his daughter Anne who came to the throne in 1702. Interestingly, there arose a situation whereby both half-brother and sister were simultaneously appointing Thistle Knights: Anne as the reigning monarch of Great Britain, and James from his exile in France, supported as the titular monarch by Louis XIV. The issuing of Thistle Knighthoods was a duty that could easily be performed from across the water, thereby allowing James to perform his kingly duty with little cost or difficulty.

Both half-brother and sister continued with this Order because, for the most part, it largely ensured and encouraged loyalty from Scotland's powerful élite as well as acting as a reward. In the case of the 4th Earl of Panmure in 1716, it is recorded in the *Calendar of the Stuart Papers* that he was awarded the Thistle Knighthood for 'services to his late father [James VII] and to himself, and particularly of his levying a regiment, and behaving so gallantly at Sheriffmuir to the great danger of his life'[14] – 'Sheriffmuir' referring to the Battle of Sheriffmuir on 13 November, which was part of the 1715 Jacobite rising.

However, it should be noted that James's efforts were not as prolific in this area as Anne's. In the Marquis of Ruvigny and Raineval's *The Jacobite Peerage*, the Marquis lists James VIII's fifteen appointed Knights, which include his own son, Charles.[15] If you quantify the 'reign' of James from the date of his father's death in 1701 to his own death in 1766, and consider the deaths of the Thistle Knights

over the years, it becomes apparent that his appointments were few. At certain times there were only three Jacobite Knights of the Thistle.

Anne's coronation was held on 23 April 1702; within a year she had revived the Order which had lapsed under her predecessors, William and Mary. On 4 February she began her Thistle Knight appointments after months of preparation:

4 February 1704
> Sir John Campbell, 2nd Duke of Argyll, resigned in March 1710 because he was created a Knight of the Garter

7 February 1704
> Sir John Murray, 1st Duke of Atholl, died 1724
> Sir William Johnston, 1st Marquess of Annandale, died 1721
> Sir James Scott, commonly called Earl of Dalkeith, died 1705
> Sir George Hamilton, 1st Earl of Orkney, died 1737
> Sir James Ogilvy, 1st Earl of Seafield, died 1730

30 October 1704
> Sir William Kerr, 2nd Marquess of Lothian, died 1722

30 October 1705
> Sir Charles Boyle, 4th Earl of Orrery, died 1731

10 August 1706
> Sir John Erskine, 23rd Earl of Mar, attainted 1715
> Sir Hugh Campbell, 3rd Earl of Loudon, died 1731

25 March 1710
> Sir John Campbell, 2nd Earl of Stair, who presumably received Argyll's collar following his resignation, died 1747

17 January 1713
> Sir David Colyear, 1st Earl of Portmore, died 1730

Anne's reign was brief – she died in 1714 – and yet it is evident from the above list that the Order was close to full for the majority of the time. She was also issuing the Thistle to the *crème de la crème* of Scottish aristocracy, and by doing so surrounding herself with some of the most powerful men in the country. James, on the other hand, while not appearing to use the Order to its full potential in terms of capacity, was still using it to reward loyalty. He honoured Panmure's allegiance after the 1715 rising and, like Anne, also opted to bestow the honour

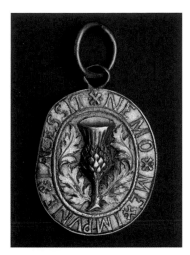

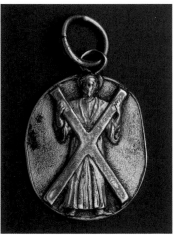

Fig. 3.9: Order of the Thistle jewel or badge

Late 17th or early 18th century, National Museums Scotland, K.2001.716

CATALOGUE NO. 45

on influential men like the Duke of Perth and Duke of Hamilton, those individuals who would be able to strengthen the Jacobite cause back at home.

Loyalty, nevertheless, can be severely tested during times of unrest and the actions of the 5th Duke of Hamilton highlight the complexities of allegiance. In 1726 Hamilton, a supporter of the Hanoverians, was created a Knight of the Thistle by George I. Some years later, he switched sides in favour of the Stuarts. He thereby joined James in exile and on 27 July 1740 was appointed a Jacobite Thistle Knight. He was therefore in the unusual position of having been a Knight in both camps.[16]

While it can be argued that both Anne and James were keen promoters of the Order of the Thistle, the same cannot be said for Prince Charles Edward Stuart. The turbulent Jacobite years were effectively over by the 1760s, and as he was the last of the exiled Stuarts the bestowing of Orders could not help his cause. He only made two appointments: one in 1768 to John Caryll, 3rd Baron Caryll of Dunford and his loyal Secretary of State; the other in 1784, when he appointed his own daughter Charlotte, the Duchess of Albany, the first female member of the Order.[17]

Material culture supporting the issuing of the Order of the Thistle from over the water is almost non-existent. So far the only possible object of insignia associated with the exiled court is a small gilt brass badge [Fig. 3.9] that came into the collections of National Museums Scotland in 2001. The badge is an anomaly because while it largely conforms to the jewel pattern described in 1687 *Statutes*, it does not follow the rules exactly – the St Andrew side is not enamelled. This, together with the rudimentary provenance provided by the previous owner – that it was acquired in Europe – has led some to believe that it was potentially made on the Continent. While numerous theories exist surrounding the history of this object, none at present can wholly deny or confirm that this badge or jewel was part of the exiled Stuart Thistle insignia.

Identity

Identity for an exiled monarchy is essential, and this was something at which the Stuarts were masterful. During the Jacobite century, the Stuarts created a style of portrait akin to a visual signature that became easily recognisable throughout Europe.[18] As part of this signature, James VIII and Prince Charles were frequently depicted wearing the Order of the Garter and/or the Order of the Thistle. Written on 8 April 1716 in the *Stuart Papers*, two months after James had left Scotland following the 1715 rising, James addresses the Knights of the Thistle, stating how he will wear his regalia:

Being resolved to wear on our own person the ribbon and medal of
the Order of the Thistle as well as that of the Order of the Garter …
that the ribbon and medal shall be worn in the manner that anciently
were round the neck with the medal or jewel hanging on the breast,
and that the colour of the ribbon shall be green ….[19]

A painting of James by Martin van Meytens in 1725 shows him wearing the blue sash of the Garter, but also the ribband of the Thistle with the medal as described in the *Stuart Papers* [Fig. 3.10].

This address by James to the Knights is interesting because you can only be a member of one Order at any given time – invariably the highest Order – and therefore you can only wear the insignia of one.[20] If adhering to the custom at that time, James should only be wearing the Garter. However, James saw himself as the rightful monarch and, as only divine kings could do, he changed the system to suit himself; a change made on the back of fleeing Scotland and leaving his allies. Therefore his introduction of wearing the Thistle insignia as well as the Garter, may have been an act of loyalty to his ancestral land.

The reference to the colour of the ribband in his address to the Knights – 'and that the colour of the ribbon shall be green' – is also significant. In the original 1687 *Statutes,* the ribband around the neck was to be a 'purple-blue'; however, when Anne revived the Order she changed the colour from purple-blue to green, thereby making a distinction between her appointments and those of her half-brother.[21] Interestingly, James finally adopted the alterations made by his sister in 1716 and enforced it upon his Jacobite Thistle Knights. In the *Stuart Papers,* the Duke of Mar has the duty of writing to the Duke of Perth, informing him of the changes with the simple explanation: '… his Grace [the Duke of Perth] and all their countrymen will be convinced that due regard has been had to the Order, and that it gains rather than loses by what has been done.'[22] Perhaps James felt it necessary to keep the Order as uniform as possible during this difficult time, to help maintain its premier status at home and abroad. However, having two 'monarchs' issuing the Thistle, together with different styled insignia, could have diminished its prestige, and many Knights in Britain were already anxious about the dual issuing of the Orders.

Prince Charles Edward Stuart and his brother Prince Henry Benedict also, at times, conformed to the Stuart signature portrait encompassing the Scottish and English Orders as set by their father. This image of displaying both Orders in a British context was unique to the Stuarts and they alone fostered and perpetuated this look [Figs 3.11, 3.12].

Fig. 3.10: Portrait of James VIII and III (r.1701–66)

This half-length portrait of James VIII and III shows him wearing armour, the sash of the Order of the Garter, and badge of the Order of the Thistle.

Martin van Meytens the Younger (1695–1770), painted in 1725. On loan from the Drambuie Collection by kind permission of William Grant and Sons, PGL 1606

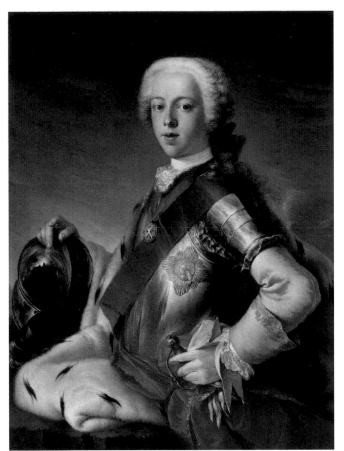

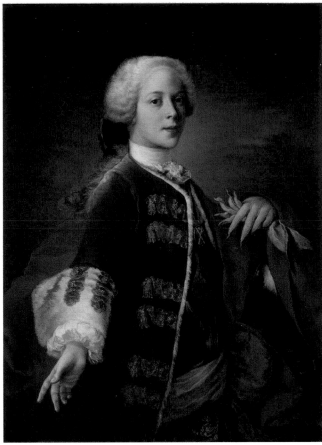

Fig. 3.11, left: Painting entitled *Prince Charles Edward Stuart* **(1720–88)**

By Louis Gabriel Blanchet (1705–72), painted in c.1739, oil on canvas, 119.5 x 95 cm, Royal Collection Trust / © Her Majesty Queen Elizabeth II 2017, RCIN 401208

CATALOGUE NO. 137

Fig. 3.12, right: Painting entitled *Prince Henry Benedict Stuart, later Cardinal York* **(1725–1807)**

By Louis Gabriel Blanchet (1705–72), painted in c.1739, oil on canvas, 119.8 x 95 cm, Royal Collection Trust / © Her Majesty Queen Elizabeth II 2017, RCIN 401209

CATALOGUE NO. 138

In the collections of National Museums Scotland there is an object without a figurative image, but which, through its motifs, can be identified as belonging to a Stuart. The silver travelling canteen made by Ebenezer Oliphant in 1740–41 [Figs 3.13] is believed to have been a 21st-birthday present for Prince Charles Edward Stuart.[23] It has been chased with bands of linked thistles, a central cartouche engraved with the three-feathered badge of the Prince of Wales and, on the cover, there is a depiction of St Andrew surrounded by the motto '*Nemo Me Impune Lacesset*'. The iconography is indicative of the Order of the Thistle; and as it is wrapped around the Prince of Wales badge, there is a strong emphasis on the connection between the monarchs of Scotland and the Thistle. The message is that they are intrinsically linked and have been since James III in the 15th century. Therefore, when James VIII decided to portray himself and his sons wearing dual insignia just after the end of the 1715 rising, it is possible that he wished to display and emphasise his royal heritage and his divine right as the true monarch of Scotland. His decision was calculated; and while his reasons are mere

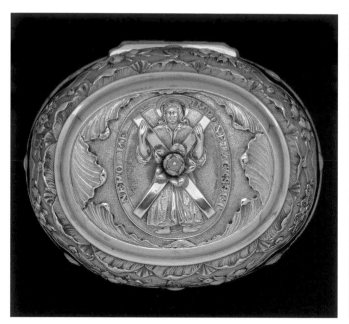

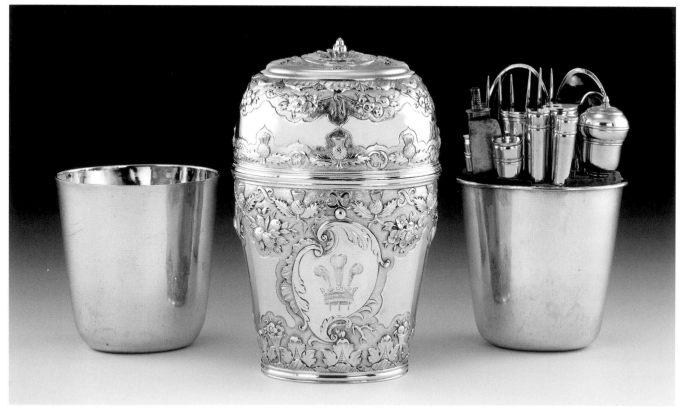

speculation, the material evidence reveals a long and historic connection between Scotland, the thistle and the monarch, a connection that James would be acutely aware of. The Stuarts therefore employed a range of tactics while fighting to regain their kingdom. These included formulating and presenting a strong and legitimate identity, with which the Order of the Thistle assisted.

In summary, the Most Ancient & Most Noble Order of the Thistle was established for political reasons in 1687 and continued to be used as such by the Stuarts during the first half of the 18th century. As an entity it encompassed material culture and an ancient belief that was used to engage and honour loyalty and display hereditary right. The exiled Stuarts desperately needed to maintain their legitimacy to the British throne and, from afar, imagery was one of the most effective ways to do so. They ran an effective propaganda campaign and were strategic in their decisions. The reason behind the wearing of the dual Orders in the wake of the failed 1715 rising, may very well have been to emphasise their loyalty to and authority over Scotland, even in defeat. The insignia, together with its symbolism, was therefore a potent promotional tool of Stuart ancestral right and of their sovereignty. In addition, when James VII gave the Order of the Thistle a medieval ancestry, this astute move – together with all the pomp and circumstance, ceremony and insignia, and its unfaltering connection to the monarch – created an environment that attracted the nobility.

The privilege of being knighted into a regal assembly was tremendous. Ancient knights pledged an oath of loyalty to their feudal superior or king, and the chivalric knights of the late 17th to early 18th century were adhering to that legacy. They too were assigning their loyalty to their monarch and so an Order was far more than a mere membership. Those knights were expected to come to the aid of their lord at his request, especially during times of war and conflict when loyalty was most tested. The Stuarts had been sovereigns of Scotland for over three hundred years, and during the turbulent Jacobite decades they were prepared to engage and utilise aide in a variety of ways, including using a 'revived' medieval Order of chivalry, to regain their sovereignty.

Figs 3.13, opposite: Silver canteen of Prince Charles Edward Stuart

By Ebenezer Oliphant, 1740–41, National Museums Scotland, H.MEQ 1584.1 to 16

CATALOGUE NO. 136

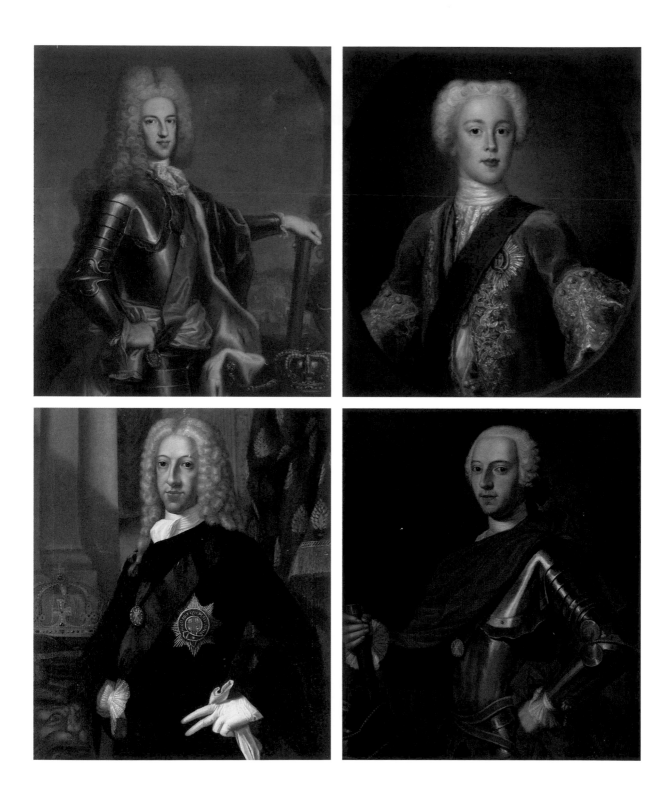

Acknowledgement

With thanks to Charles J. Burnett and Russell Malloch.

Notes

1. Order of the Thistle, *Statutes of the most Ancient and most Noble Order of the Thistle* (1978), p. 1.
2. Ibid., p. 1.
3. Charles J. Burnett, 'The Collar of the Most Ancient and Most Noble Order of the Thistle', in *The Journal of the Orders and Medals Research Society* 26 (1987), p. 150.
4. Charles J. Burnett and Helen Bennett, *The Green Mantle* (1987), p. 4.
5. Burnett, 'The Collar of the Most Ancient and Most Noble Order of the Thistle', p. 154.
6. Order of the Thistle, *Statutes*, p. 5.
7. George Dalgleish and Henry Steuart Fothringham, *Silver: Made in Scotland* (2008), p. 169.
8. Order of the Thistle, *Statutes*, p. 6.
9. Ibid., p. 20.
10. Ibid., p. 6.
11. Ibid., p. 16.
12. Ibid.
13. Burnett and Bennett, *The Green Mantle*, p. 7.
14. Historical Manuscripts Commission, *Calendar of the Stuart Papers belonging to His Majesty the King, preserved at Windsor Castle*, 2 vols, vol. II (1902), 1716, April 8.
15. Marquis of Ruvigny and Raineval, *The Jacobite Peerage: Baronetage, Knightage and Grants of Honour …* (1904), p. 194.
16. Taken from the National Museums Scotland object file: research by Charles Burnett.
17. Marquis of Ruvigny and Raineval, *The Jacobite Peerage: Baronetage, Knightage and Grants of Honour …*, p. 194.
18. Edward Corp, *The King Over the Water: Portraits of the Stuarts in Exile after 1689* (2001).
19. Historical Manuscript Commission, *Calendar of the Stuart Papers*, vol. II (1902), 1716, April 8.
20. R. J. Malloch, 'The Order of the Thistle' in *Journal of the Heraldry Society of Scotland* I (1977), pp. 40-41.
21. Order of the Thistle, *Statutes*, pp. 6 and 16.
22. Historical Manuscript Commission, *Calendar of the Stuart Papers*, vol. II (1902), 1716, April 8.
23. George Dalgleish and Dallas Mechan, *'I am come home', Treasures of Prince Charles Edward Stuart* (1985), p. 4.

Opposite, clockwise: Portraits of James VIII and III, and his son Charles Edward Stuart, displaying the Orders of the Thistle and Garter

Portrait of James III (b.1688–66)

By Antonio David (1680–1737), painted in 1717, oil on canvas, 134 x 95 cm, Fundación Casa de Alba. Palacio de Liria.

Painting entitled *Prince Charles Edward Stuart* (1720–88), *eldest son of Prince James Francis Edward Stuart*

By Antonio David (1680–1737), painted in 1732, oil on canvas, 73.4 x 60.3 cm, Scottish National Portrait Gallery, Edinburgh, PG 887

Painting of Prince Charles Edward Stuart (1720–88)

By Cosmo Alexander (1724–72), painted in 1752, 77.5 x 74.9 cm. On loan from the Drambuie Collection by kind permission of William Grant and Sons, D.324

Portrait of James VIII and III, the Old Pretender (1688–1766)

By Cosmo Alexander (1724–72), painted in 1749, 99.2 x 76.2 cm, © 2017 Christie's Images Limited

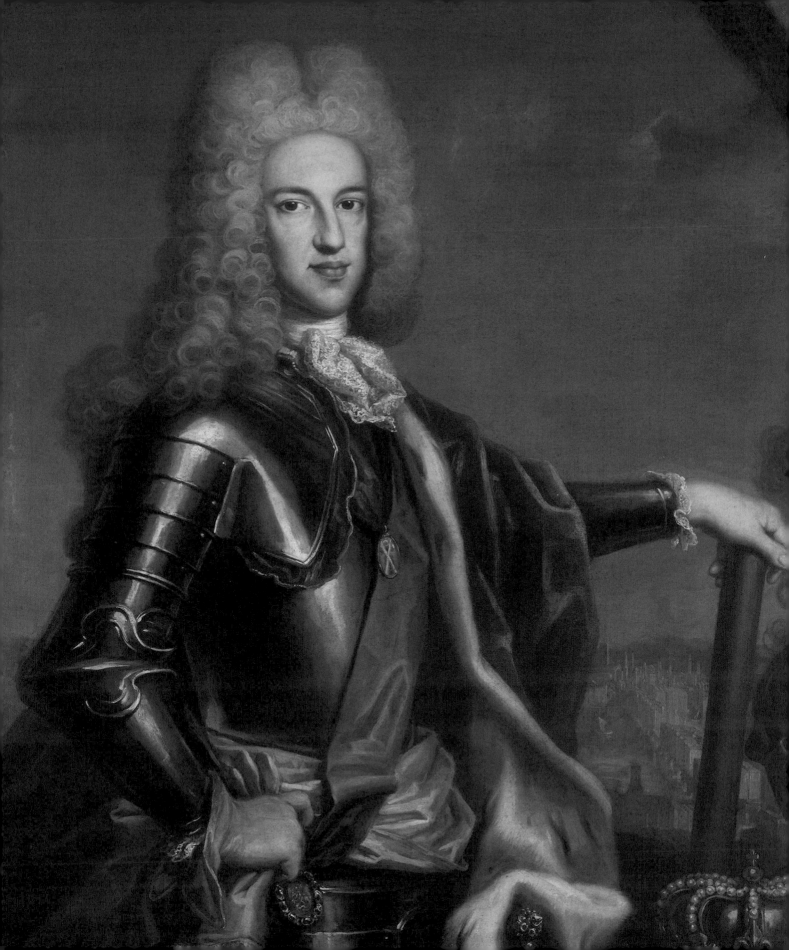

CHAPTER 4

All Roads
lead to Rome

Edward Corp

THE EXILED STUART COURT HAD TWO PERMANENT HOMES, AT SAINT-Germain-en-Laye in France until 1712, and at Rome in the Papal States after 1719. During the intervening seven years it experienced a relatively peripatetic existence, moving first to Bar-le-Duc in the Duchy of Lorraine (1713–15). The failure of the Jacobite rising in Scotland in 1715 obliged the Duke of Lorraine, under pressure from the Regent of France, to ask James III to leave his duchy and take refuge with the Pope at Avignon, a papal enclave within France (1716–17). Then further pressure from the regent forced James to leave Avignon and cross the Alps into Italy. He travelled via Bologna, stopped in Pesaro for two months,[1] visited the Pope in Rome for five and a half weeks,[2] and then went to Urbino in the Papal States (1717–18). The winter weather at Urbino, however, was unexpectedly cold, so at the end of 1718 James moved his court again, this time to Rome. In retrospect we can see that, unless he were to regain his thrones, James was bound sooner or later to end up in the papal city.

At first even Rome was regarded as no more than a temporary location. In February 1719 James went to Spain to join an expeditionary force which was to sail to England. It was only when the Spanish fleet had been destroyed by a storm, and a diversionary rising in Scotland had been defeated, that James reluctantly returned to the Papal States.

While he was in Spain, James was married by proxy to Princess Clementina Sobieska, a granddaughter of King John III of Poland. He met her and solemnised his marriage at Montefiascone in September 1719, immediately after his return.[3] When he and Clementina reached Rome in November, James was still hoping to be there only temporarily, while awaiting the next restoration attempt. But that also failed, and in 1724 he accepted that Rome was to be his permanent home.

We need to bear in mind the continued Jacobite hopes for an imminent restoration if we are to understand the choice of the building in Rome which was to house the exiled court. It was initially regarded as no more than a temporary home, like the ones at Bar-le-Duc, Avignon, Pesaro and Urbino.

There was of course no available royal palace in Rome, nor was there a vacant apostolic or papal palace. So James and his senior courtiers had to select a building

Page 58, Fig. 4.6: James III (1688–1766)

By Antonio David (1680–1737), painted in 1717. Fundaciòn Casa de Alba. Palacio de Liria.

from among those which just happened to be available in the winter of 1718–19. After several weeks of indecision, they settled on one which belonged to marchese Giovanni Battista Muti, and for which the Pope agreed to pay the necessary rent.[4]

The new Stuart royal palace in Rome, called the Palazzo del Re, is not especially impressive by Roman standards, and is disappointing for visitors today. But to evaluate it properly we need to know what James required when selecting his new temporary home. And we need to know how it has been altered since it was occupied by the Jacobite court.

James was looking for a large aristocratic house, known as a *palazzo*, which was situated relatively close to the Quirinale where the Pope lived. He wanted it to have an enclosed and private garden, and he wanted it to be large enough to house all, or nearly all, of his courtiers. For security reasons, however, he did not want any part of the building to be occupied by anyone else. This considerably narrowed his choice, because the largest Roman family *palazzi* tended to contain additional apartments which were rented out, and often had shops on the ground floor bringing in more rental income. They were therefore inappropriate, however impressive, whereas the smaller *palazzo* of marchese Muti was of the correct size. It was in the piazza dei Santi Apostoli close to the Quirinale, it had a private garden, and it could be occupied exclusively by the Jacobite court.

The building is in a bad condition today, with shops and a restaurant on the ground floor. Its garden has been built over, and an additional storey has been added, thereby destroying the harmony of the architecture. Moreover, the large interior courtyard, where carriages would collect and deposit the Stuarts and their important visitors, has been significantly reduced in size by an unattractive extension on the east side.

The *palazzo* is also a rather peculiar shape, resulting from the way that the Muti family had built and expanded it during the previous century.[5] It was actually regarded at the time as three separate buildings (called 'the King's Palaces'),[6] which had been brought together around a central courtyard. The entire west wing was occupied by the so-called *palazzo grande*, a large two-storey building containing impressive rooms with frescoed ceilings [Fig. 4.1]. The east wing was divided in the middle by a large entrance, and contained two small palaces, or *palazzetti*, of unequal size. The larger one was in the northern half of the east wing, and also extended along the north wing to join the *palazzo grande*. The smaller one was in the southern half of the east wing, and extended along the south to the *palazzo grande*. The two *palazzetti* contained three storeys, but their floors were on different levels to those of the *palazzo grande*, so it was necessary to go up or down a few steps when passing between them.

The apartments of the king and the queen were in the *palazzo grande*, whereas those destined for their children, Prince Charles and Prince Henry, were in the north-east *palazzetta*. The walled garden was to the north of the building,

separated by a little alley and accessed by going over a bridge. The chapel, rather surprisingly, was situated on the bridge, and it was there that Prince Charles was baptised on 31 December 1720.[7]

At Saint-Germain the apartments of the king and queen had been arranged so that they came together, with a little bedchamber situated between their larger state bedchambers. This was not possible in the Palazzo del Re, so the royal apartments were on different floors. The king's was on the first floor, and the queen's immediately above it on the second, with a small staircase at the south end connecting the two bedchambers. Each one was entered from the north end of the *palazzo grande*, and contained a guard chamber and four antechambers (two small and two large) before the bedchamber [Fig. 4.2].

During 1719 the entire building was cleaned, painted and decorated, and the royal apartments lavishly furnished. We know nothing about the original decoration of the queen's apartment above, but James retained the pre-existing frescoed ceilings in both his bedchamber and his two larger antechambers. However, for his gallery, which looked down the length of the Piazza dei Santi Apostoli, the Pope commissioned Giovanni Angelo Soccorsi to paint an entirely new ceiling. In the centre there was a framed oval showing two *putti*, one holding a sceptre, the other the royal crown of England. At the west end of the gallery there was a seated lady, dressed in white, who represented *La Religione Cattolica*; and at the east end, beneath a white dove, there was another seated lady, also dressed in white but with a yellow cloak, representing *La Fede*. The eventual triumph of the rightful King of England would thus be brought about with the help of the Catholic religion and faith.

Fig. 4.1: West façade, Palazzo del Re, Rome

The king's apartment was on the first floor, and the queen's apartment on the second floor. The nine windows on the right-hand side provided light for the royal apartments, whereas the four on the left illuminated rooms used for other purposes. The king's third and fourth antechambers, and his bedchamber and gallery, had high ceilings, lit by the smaller windows above, whereas his second antechamber had a mezzanine floor above. The chapel royal [see Fig. 4.3] was behind the four windows on the left-hand side of the second floor.

19th century, Archivio de Stato di Roma. Courtesy of the Italian Ministry of Cultural Property and Archives.

Fig. 4.2, opposite: Plan of the first floor, Palazzo del Re, Rome

The plan shows the position of the king's apartment on this floor. The chapel was on the second floor.

Adapted from an original plan, Archivio de Stato di Roma. Courtesy of the Italian Ministry of Cultural Property and Archives.

In 1724, when it had become clear that the Palazzo del Re was now the permanent residence of the exiled court, the Pope ordered that various works should be carried out to make the building more suitable. For three months the Jacobites were obliged to vacate the building, and when they returned they found the *palazzo* 'quite an other thing than it was'.[8] In particular the queen was given all the rich furnishings that had been recently purchased for the private apartments of the previous Pope. There was also an entirely new chapel in a much more convenient position, using some of the space at the north end of the queen's apartment. In addition there was a new secret staircase giving direct access from beside the south entrance of the *palazzo grande* to the king's gallery and cabinet above. This meant that British and Irish 'Grand Tourists', whose visits to the exiled king would be regarded as treasonable, could do so secretly, without having to go up the grand staircase and pass through the guard chamber and the antechambers.

In the following years the royal apartments were regularly redecorated and refurnished at papal expense, and maintained as befitting James III's royal status. No one visiting the Stuart court in Rome was left in any doubt that it was a truly royal court.

This last point was essential for reasons of prestige. In France, where the

Stuarts had lived in a royal château, and where there had been no queen, Mary of Modena had always been given precedence over all the French princesses, including even the Dauphine. Similarly James III, after the death of his father, had always been treated (at least in theory) as the equal of Louis XIV and superior to the Dauphin. In Rome, where James and Clementina were the only people recognised as monarchs by successive popes, they took precedence over everyone except the Pope himself. A very small minority of the cardinals and princes disliked this and kept away from the Stuart court, but the great majority (and this included the French and Spanish ambassadors) had no hesitation in treating James III as a *de jure* king and giving him full royal honours.[9] When they visited the court, which they did very frequently, they expected to be impressed by its magnificence. Their own *palazzi*, in some cases, might have been larger and more impressive to behold from outside, but their own apartments were not necessarily better furnished and decorated than those of King James and Queen Clementina.

Not surprisingly the building which housed the exiled court was known as the Palazzo del Re. It became normal in the 19th and 20th centuries for historians to refer to it erroneously as the Palazzo Muti, but to the people living in 18th-century Rome it was simply the Palazzo del Re (or Palazzo Reale), because the great majority readily accepted that James III was the rightful King of England (*re d'Ingilterra*), while those who did not were obliged to conform. Moreover the Muti family actually owned two adjacent *palazzi*, so after 1719 the name Palazzo Muti referred exclusively to the one which was *not* occupied by the Stuarts. Finally, it should be noted that ownership of the Palazzo del Re passed to another Italian family with a different name in 1730.[10]

No one visiting the Palazzo del Re today will be able to find any evidence that the building was once an impressive royal court occupied by the exiled Stuarts. The royal apartments in Rome, just like the ones at Saint-Germain, were gutted and destroyed by their subsequent occupants, but at the time they contained chandeliers, mirrors, tapestries, paintings and 'magnificent tables of rare marble'. The king's third antechamber (his Presence Chamber) contained a canopy, or *baldachino*, over a throne,[11] while his bedchamber housed an impressive large state bed surrounded by serge curtains. It probably also contained a balustrade, because James had adopted the French practice of receiving important guests in his bedchamber, as well as allowing people to pass through it to reach his gallery. The bedchamber had twelve chairs and a green damask sofa, on which he sat when receiving his visitors.[12] But no trace of any of this remains today. All that has survived are three of the original frescoed ceilings placed there by the Muti family, and a small part of the ceiling in the king's gallery, painted for him by Soccorsi. Unlike the rooms at Saint-Germain, which are in a public museum and can be freely visited, the ones in Rome are occupied by the private offices of an Italian company and cannot be seen without special permission.

Fig. 4.3, opposite: *The Baptism of Prince Charles in the Chapel Royal of the Palazzo del Re, 31 December 1720*

This is the new 1724 chapel, whereas Prince Charles had been baptised in the original chapel. Left to right: the cardinal protectors of Ireland, Scotland and England, standing behind Cardinal Annibale Albani; James III; Lord Richard Howard; Lord William Drummond; Antonio Ragazzi (parish priest, Santi Apostoli), Father John Brown with two boys, behind Sebastiano Bonaventura (Bishop of Corneto and Montefiascone); the Princesse des Ursins kneeling and holding Prince Charles; six Roman and Jacobite ladies (two kneeling); the Principessa di Piombino and three Roman ladies; four Roman and Jacobite gentlemen; and four cardinals behind Don Carlo Albani.

By Antonio David (1680–1737), painted in 1725, oil on canvas, 243.9 x 350.3 cm, Scottish National Portrait Gallery, Edinburgh, PG 2511

The queen's apartment on the second floor is even more disappointing. In addition to its rich decoration and furnishings, the bedchamber once contained eleven 'great pictures'.[13] This was the room in which Prince Charles was born, but at some point it was divided in two, with a new partition wall running from head to foot right through the middle of where the queen's bed was once situated. As for the prince's apartment in the north-east *palazzetta*, we do not even know exactly which rooms he occupied, let alone what they looked like.

We do, however, have a painting which shows us part of the new chapel royal [Fig. 4.3], created in 1724. It is now in the Scottish National Portrait Gallery in Edinburgh, and shows the baptism of Prince Charles at the end of December 1720[14] – though that had actually taken place in the original chapel situated on the bridge which led to the garden. We cannot see the chapel plate, which was provided by the Pope,[15] nor can we see the painting by Giuseppe Chiari which the Pope gave to James as a present[16] – but we can see the rich red damask hangings decorated with gold. On the altar are clearly visible six large gold candlesticks that belonged to the king, and which had previously been in the family's private little chapel at Saint-Germain.[17] In addition to the king and officiating bishop, the painting shows several cardinals, two of the Pope's nephews, and some of the Italian ladies who frequented the court.[18] The picture was painted in 1725 by

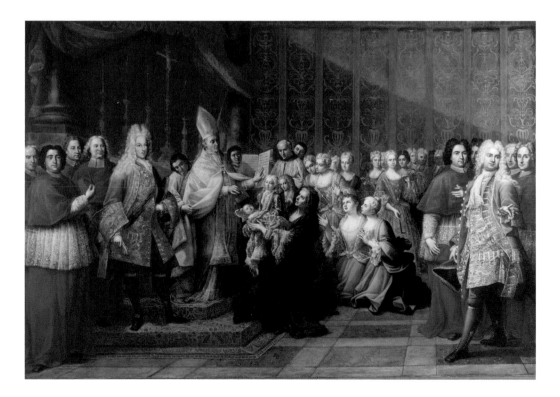

Antonio David, and is the only visible evidence that gives us any idea of what the court looked like at the time.

In addition to the royal apartments, the Palazzo del Re contained 61 others of various sizes, mainly in the north-east and south-east *palazzetti*. In 1720, for example, there were 83 servants employed in the royal household, of whom 65 were accommodated in the *palazzo*, four of them with their spouses. The court was even more cosmopolitan than it had been at Saint-Germain. The 83 servants included English, Irish, French, Scots, Italians, and even Germans and Swiss. Two of the English and six of the Scots were Protestant; all the rest were Catholic. At that time there were also 19 pensioners attached to the court, most of whom were Scottish and Protestant. In total, therefore, the court consisted of about 120 people, including children and the servants of the senior courtiers,[19] whereas there had been about a thousand people at Saint-Germain.

As the years went by, the balance of nationalities gradually changed as people died, retired and were replaced by new recruits. At first the senior posts tended to be reserved for people from England, Scotland, Ireland and France, while the household below stairs and the stables were increasingly staffed by locally recruited Italians who did not need to be accommodated in the Palazzo del Re. That began to change in the late 1720s. In 1730 there were still 70 servants who were not Italian. By 1740 there were 57, by 1750 only 19, and by 1760 only 14, of whom only eleven were the king's own subjects. As one would expect, the servants were nearly all Catholic, but there were always several Protestants. Finally, the size of the household also fluctuated. As Prince Charles (Prince of Wales) and Prince Henry (Duke of York) grew up, new servants had to be recruited, so that the overall number of courtiers increased from about 120 to about 135 by the early 1730s. The death of the queen in 1735 meant that the size of the royal household was reduced. By the early 1750s, after Prince Charles had left Rome and Prince Henry had become a cardinal, James III was only maintaining about one hundred, most of whom were Italian.[20]

Since leaving Saint-Germain in 1712 James had determined to keep his household as small as possible, and its organisation had gradually changed, particularly during the peripatetic years prior to its arrival in Rome. In part this was because James was short of money when he first arrived in Italy: the papal pension on which he now relied was much smaller than the previous French one. But the main reason was because he wanted to maintain absolute control over his court, and this was to have a decisive impact on his relations with the queen and on the upbringing of the Stuart princes.

At Saint-Germain Queen Mary had controlled her own household, which was entirely separate from that of the king. And until Prince James was seven years old, and was given his own separate household, she had also appointed and employed all the servants who worked for her son. At Rome James III was not

willing to grant Queen Clementina the same independence. He felt that she was too young and inexperienced (she was only 18 years old when Prince Charles was born), so he decided that he would himself appoint and control all her servants. Apart from the ones in her bedchamber, where Clementina would if possible be served only by the wives of his own servants, she would have to share the servants of her husband. This would not only keep the size of the overall household, and thus the payment of salaries, as small as possible; it would also keep to a minimum the amount of accommodation required. Above all it would ensure that all the servants remained answerable to the king and not the queen, and it would deny Clementina any control over the upbringing of her children before their care was entrusted to men.[21]

Queen Clementina increasingly resented this arrangement. Two things particularly annoyed her. The apartment on the second floor of the *palazzo grande* was not actually called the 'queen's apartment' but the 'king and queen's apartment', as she did not have her own household.[22] In addition she was not permitted to employ a small group of aristocratic personal servants (ladies of the bedchamber, and gentlemen of the chamber) as Queen Mary had done at Saint-Germain, and to which she felt that her royal status entitled her. Moreover her only lady of rank was someone whom she thoroughly disliked and whom the king imposed on her. This was Marjory, the wife of the king's Scottish Protestant favourite John Hay, Earl of Inverness, and she and her husband both behaved disrespectfully towards the queen. Moreover Clementina deeply resented being served and accompanied by a Protestant with whom she did not even share a common language.[23]

What brought trouble to a head, however, was the way James managed the upbringing of her elder son, Prince Charles. Instead of handing over the little boy to the care of men at the age of seven, as was normal, the king handed him over when he was only four and a half.

James had good reasons for doing this, but they were not likely to impress the queen. A nursery had been created in the north-east *palazzetta*, where the future Bonnie Prince Charlie was looked after by one woman, one chambermaid and a nurse (he was not given a governess). This arrangement should have continued until December 1727, but in March 1725 the queen gave birth to her second child, Prince Henry. This meant that a new team of women needed to be recruited, while two and three quarter years later the original team would be dismissed and replaced by a team of men. This would not have been a problem in a normal court, established in its home country. Nor would it have been a problem for the Stuart court when in exile at Saint-Germain, where the Jacobite community was much larger and access to England much easier. But for a court experiencing a second exile, a long way away from England and where recruitment was difficult, it seemed unnecessarily wasteful. James therefore made the

practical but very insensitive decision to avoid having to recruit, pay and accommodate a new team of women by bringing forward from December 1727 to September 1725 the moment when the care of Prince Charles would be entrusted to men. There would be a short period of six months during which the women would look after both Charles and the newly-born Prince Henry. Then the handover would take place, and the women would care for Henry only.

In September 1725 Charles left the nursery, moved into his own apartment, and was given a team of male servants. Queen Clementina was outraged. So too were the women who were forced to stop looking after the little prince. Most of the men selected to look after him were not objectionable in themselves, but the prince was given a governor whom the queen hated. He was James Murray, Earl of Dunbar, the Protestant brother of Marjory, Lady Inverness, and he had frequently been rude to Clementina in the past. He now refused to let the queen see her own son without himself remaining in the room with them.[24]

The result was a total breakdown in the relations between the king and the queen. The woman who until then had been responsible for looking after Prince Charles was openly rude to the king and was dismissed. So in November the queen had a furious row with her husband and suddenly left the court, taking refuge in the convent of Santa Cecilia, on the other side of the river in Trastevere. She said that she would not return until the king agreed to let her have her own household, with the power both to appoint and dismiss her own servants, and to retain control over the upbringing of her son until he was seven years old. In particular she demanded that Lord Dunbar and Lady Inverness should be dismissed, and also that the latter's husband (whom she blamed, rightly, for influencing the king and treating her in an offensive and familiar manner) should be sent away from the court.[25]

It took nearly two years before the king and queen were prepared to compromise. During that period the queen remained in the convent, and James, aware that the Pope was supporting the queen because Dunbar and the Invernesses were Protestant, decided to move his court to Bologna. From September 1726 to January 1729 the Palazzo del Re remained unused, looked after by a skeleton staff of eleven of the king's servants.[26]

The compromise, when it was finally reached in July 1727, was not very satisfactory and did little to heal the breach between James and Clementina. The queen was finally given her own separate household, headed by two Italian ladies of the bedchamber, two Italian gentlemen, and a 'first gentleman' (equivalent to lord chamberlain) who was the Scottish Earl of Nithsdale. Although Lord and Lady Inverness left the court, Prince Charles, now only a few months short of his seventh birthday, continued to have Lord Dunbar as his governor. Prince Henry was entrusted to the Countess of Nithsdale as his governess, but it was understood that he too would be handed over to a second team of men under

Dunbar as governor when he was still only four years old, in 1729. As the ladies and gentlemen selected to be in attendance on the queen were chosen for her by the king, this was less of a compromise than a victory for James. Clementina agreed to leave the convent and join the court at Bologna in July 1727, but she bitterly resented her failure to achieve what she wanted. She was now 25 years old and retreated into a life of austerity and excessive religious observance. She began to eat less and less, and was probably anorexic, with the result that she became emaciated and her health steadily deteriorated.[27]

This disagreement between the king and the queen had financial implications, because the Pope was angry that James had left Rome and in consequence temporarily reduced the Stuart pension. The compromise of 1727, whereby Clementina came out of the convent and rejoined the court, meant that the pension was once again paid in full; and so, at the beginning of 1729, the king, the queen and the princes, accompanied by all their servants, returned to the Palazzo del Re.[28]

It is often believed that the Stuart court in Rome was short of money, but in fact it was well financed by successive Popes. From 1717 to 1724 James III's papal pension was 10,000 *scudi* per annum. It was then increased to 16,000 *scudi* in 1724, reduced to 14,000 in 1727, and finally settled permanently at 16,000 in 1730. In addition to his regular pension, James was frequently given presents. These included 10,000 *scudi* at the election of each new Pope, and so many other payments that by the late 1730s James's income from the Pope had risen to about 22,000 *scudi* per annum.[29] Other presents included valuable paintings and plate bequeathed to him by his friends, such as when the Principessa di Piombino left him plate worth 66,000 *scudi* in 1733.[30] With all the rent and repairs of the Palazzo del Re covered by the *Camera Apostolica*,[31] and a much smaller household, particularly after the death of the queen in January 1735, James III was able to spend a lot of money on entertaining his friends and on maintaining himself and his two young sons in a style appropriate to their royal status. For example, he dined in his apartment at a table set for ten people, some of whom were his own senior courtiers. If he invited too many cardinal or princes, then his courtiers would make room by moving to a second table where they would still be fed at the king's expense.[32]

During these meals James continued to use the gold *couverts*, the gilt caddinets, the gilt salts and a large gilt basin and ewer which he had previously used at Saint-Germain, but he now also had a large collection of porcelain sent from France with which to set his table. None of the king's plate has survived, but there is in a private collection a silver *ecuelle*, or porringer, with its cover, which belonged to the queen.[33] There is also one remaining item from the king's collection of Vincennes porcelain. It is a very fine broth basin with cover and stand bearing his arms, dated *c.*1748–52, now in the Royal Collection.[34]

Unlike the court at Saint-Germain, which was located in a small town and where the Jacobites had to provide their own entertainment, the court at Rome was situated in the middle of a large city where entertainment of all kinds was readily available. Life at the court was consequently highly agreeable, with the leading Jacobites enjoying easy access to the social gatherings and concerts throughout the city, and to the operas during the carnival seasons. The court also attracted the many British and Irish Grand Tourists, Hanoverians as well as Jacobites, who came to Rome. They wanted to socialise with people who spoke English, to attend Protestant services officiated by Anglican chaplains, and to be looked after by English-speaking doctors. The Palazzo del Re therefore served in effect as a surrogate British embassy, also providing passports and general diplomatic protection.[35]

The Palazzo del Re was an important cultural centre in its own right, because James III employed a master of the music who organised concerts and balls in his gallery and apartment.[36] While the princes were young, and during the declining years of Queen Clementina, these occasions became less frequent, but that changed in 1738 and 1739 after Prince Charles achieved his majority. The court was then unquestionably at its most brilliant, and this phase lasted until 1744 and 1745, during which time Prince Henry also came of age. Concerts, which some regarded as the best in Rome, were organised once or twice each week, and performed by some of the ablest musicians and singers in the city, attended by the cream of Roman Society. In addition there was a ball once a week during the carnival seasons, and others to celebrate royal birthdays and St George's day.[37] These balls were designed to show off the young princes to maximum advantage, at a time when Great Britain and France were moving towards a renewal of war, and thus making a restoration of the Stuarts with French help once again a real possibility for the first time since 1712.

Among the objects which have survived from the court in Rome, we have the insignia of the Orders of the Garter and Thistle, brought from Saint-Germain but worn by James III in Rome, and several books from the king's library in the Palazzo del Re.[38] We have two manuscript *Books of Hours* which belonged to Queen Clementina,[39] and the great Sobieski sapphire which she brought to Rome, which is now mounted on the reverse side of the Imperial State Crown.[40] We also have most of James III's personal and political correspondence and some of his household papers.[41] There are also many medals in gold, silver and bronze showing the portraits in profile of the four members of the family.[42] Finally there are the following two interesting items specifically associated with the young Prince Charles.

In 1739 the 3rd Duke of Perth and his brother Lord John Drummond gave a present to Prince Charles that consisted of a pair of pistols, a dagger, a Highland shield, a breastplate and helmet, and a sword. In the following year they

also gave him a 'complete [Highland] dress'. The sword, made by a silversmith in Perth named James Brown, has recently been identified and is now in a private collection.[43] The Highland costume has not survived, but it can still be seen in a painting by William Mosman. Prince Charles began by wearing the costume at some of the balls in the Palazzo del Re, and then created quite a stir during the following years by also wearing it to public balls elsewhere in the city.[44] Mosman's portrait, which shows Prince Charles wearing the Highland costume, was painted just before the artist left Rome to return home at the beginning of 1740, and is now in the Scottish National Portrait Gallery. It is the first of the many portraits which associate Prince Charles with Scotland, but the only one to have been painted when he was still in Rome.[45]

Although it is unlikely that Mosman's portrait was painted for James III, the king did commission a great many portraits, some to decorate the Palazzo del Re, others to be given away. Most of these portraits have survived, some in multiple copies, and many of them as miniatures.[46] In addition, several of them were engraved and thereby achieved a very wide circulation.[47]

From 1717 until his death in 1737, the official portrait painter of the Stuart court was Antonio David, who painted several portraits of the king and queen between 1717 and 1723, and another of the queen when in the convent. He then

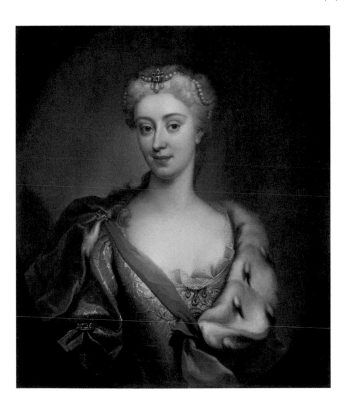

Fig. 4.4: Queen Maria Clementina Sobieska, mother of Prince Charles Edward Stuart

This is a copy of the portrait painted by Martin van Meytens in 1725,

By Antonio David (1680–1737), painted in 1730, oil on canvas, 167.6 x 116.8 cm. With grateful thanks to the Pininski Foundation, Warsaw, Poland.

CATALOGUE NO. 113

concentrated on painting the princes, starting with Charles as a child between 1723 and 1726. His best known portraits are the companion ones of Charles and Henry, painted in 1729 and 1734. The 1729 portraits are the best known, because James told David to show the boys as a little older than they really were, so that he could go on making copies for several years. The ones in the Scottish National Portrait Gallery, for example, were made in 1732.[48]

In addition to David, James employed ten other painters between 1718 and 1744–45, when the two princes left for France.[49] Francesco Trevisani painted the king once and the queen twice in 1719–20. His portrait of James III is especially interesting because it shows the king wearing his Garter robes, with the collar and Great George which are preserved in Edinburgh Castle. The original version is in the Palace of Holyroodhouse, but Trevisani painted a replica which can be seen in the Scottish National Portrait Gallery.[50]

The next painter employed by James III was Girolamo Pesci, who painted full-length companion portraits of the king and queen in 1721, shortly after the birth of Prince Charles, to be displayed in the royal apartments. The one of the queen shows her seated on a throne and holding the baby prince. It is the earliest portrait of Bonnie Prince Charlie.[51]

In 1725 James commissioned companion portraits of himself and Clementina from Martin van Meytens (the Younger), which are both busts. The one of the queen was displayed in James's bedchamber on the first floor; the one of the king in their shared bedchamber on the second floor.[52] Clementina is captured at her most beautiful, aged 23, just before Charles was taken from the nursery and his care entrusted to men [Fig. 4.4]. His mother left the court and never looked the same again. She stopped eating properly, became thinner, and increasingly wasted away until her early death when only 32. The result was that James stopped commissioning new portraits of her, preferring instead to have copies of this one.[53] The most famous copy was made in mosaic by Pietro Paolo Cristofari, and was included in the monument to Queen Clementina in St Peter's Basilica. Since it was unveiled on the tenth anniversary of her death, in January 1745,[54] it has been seen by countless millions of people.

After the death of David in 1737, James commissioned new portraits of himself and the two princes from Jean-Etienne Liotard, portraits of the princes only by Louis Gabriel Blanchet [Fig. 4.5], and again of himself and the princes by Domenico Duprà. Most of these were given away as presents, and it was during these years that the king began to order sets of portraits, showing all four members of the family, and always using the one of Clementina by Meytens to complete each set. Their purpose was no longer to decorate the Palazzo del Re, but rather to stimulate loyalty to the Jacobite cause, to introduce the princes to the people of the three kingdoms, and make them instantly recognisable pending a restoration.

These were not the last portraits of the Stuarts to be painted in Rome, but they were the last to be produced before Prince Charles left for France in 1744, followed the next year by Prince Henry. Charles was then painted in Scotland, and both brothers sat for new portraits in France, but after the Battle of Culloden James III lost interest in commissioning portraits of his family in Rome.

It had been planned for many years, in fact since 1732, that Prince Henry would become a cardinal if it became clear that there was unlikely to be a Stuart restoration.[55] Culloden convinced James III and Prince Henry, though not Prince Charles, that this moment had arrived. In 1747, therefore, Henry left France and returned to Rome, where the Pope agreed immediately to make him a cardinal. Henry was thenceforth known as the Cardinal Duke of York, or more simply as Cardinal York, and he or his father commissioned four new portraits of him in 1747–48 wearing his ecclesiastical robes.[56] These were definitely not for circulation to the Jacobites in Great Britain.

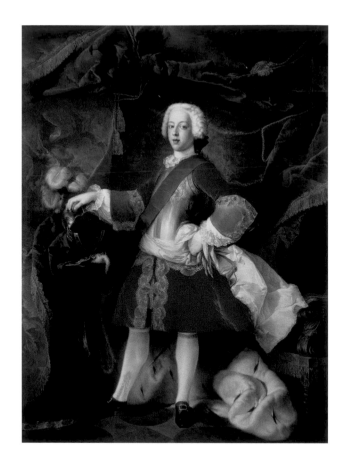

Fig. 4.5: Portrait of Prince Charles Edward Stuart (1720–88)

The portrait shows the 17-year-old prince with the Garter only, and not the Thistle, one year before he was given a set of Highland weapons by the 3rd Duke of Perth and Lord John Drummond.

By Louis Gabriel Blanchet (1705–72), painted in 1737–38, oil on canvas, 190.5 x 141 cm, © National Portrait Gallery, London, NPG 5517

Fig. 4.6: Portrait of James III (b.1688–1766)

This portrait was painted during the first visit to Rome by James III, and was the first to show him wearing the Thistle as well as the Garter, and with the closed crown of a king beside him. It was sent as a gift to Queen Mary at Saint-Germain.

By Antonio David (1680–1737), painted in 1717, oil on canvas, 134 x 95 cm. Fundaciòn Casa de Alba. Palacio de Liria.

As part of the festivities at the Stuart court celebrating Henry's promotion a false façade, or *facciata*, was erected against the east wing of the Palazzo del Re, immediately outside the north-east *palazzetta* where Henry and his brother had lived before they went to France. The design of the *facciata* set up against parts of the *palazzo* was recorded in a large painting by an unknown artist named Pubalacci, but with a crowd of people in the foreground added by Paolo Monaldi and Louis de Silvestre. Among the people, and almost certainly painted by Silvestre, the new cardinal can be seen greeting his father, behind whom are standing the senior Jacobite courtiers.[57] It is the only painting we have showing the outside of the Palazzo del Re when occupied by the Stuart court, and is now in the Scottish National Portrait Gallery.[58]

Later that same year Cardinal York moved into the apartment of the queen on the second floor, which had been standing empty for twelve and a half years.[59] He lived there until 1764 and made it a brilliant social centre, where he hosted a weekly salon called a *conversazione*. In this way the Palazzo del Re maintained its social distinction, and continued to provide concerts performed by some of the best musicians in the city. Meanwhile, downstairs, his father, James III, became increasingly depressed and his health began to decline.[60]

One reason for the king's depression, apart from the failure to achieve a restoration, was Prince Charles's refusal to return to Rome. The prince did, however, maintain a permanent presence in the king's apartment in a large family group portrait, which unfortunately has not survived. We do not know when or by whom it was painted, but it showed James and Clementina with their two sons, just as the large family group by Mignard showed the four members of the Stuart family at Saint-Germain.[61]

The Stuart portraits painted in Rome are of interest for what they tell us about the family's attitude towards Scotland. Until 1717 James III, like his father James II, regarded the Scottish Order of the Thistle as incompatible with the English Order of the Garter. As the Stuarts always wore the Garter, that meant that they never wore the Thistle. In the aftermath of the 1715 rising, however, and to show his appreciation of the Scots, James decided that they should thenceforth become compatible. The Lesser George of the Garter would be worn, as before, at the bottom of a blue sash worn from the left shoulder to the right hip. The St Andrew jewel of the Thistle would now be worn in the middle of the chest, suspended from a green ribbon worn around the neck [Fig. 4.6].[62] There is not a single French portrait of either James II or James III which shows them without

the Garter or with the Thistle. By contrast there are no Italian portraits of James III in which he is not shown with both the Garter and the Thistle.[63]

There were not many Scots at the Jacobite court in Rome, though the few who were there were particularly important. And it is a curious fact that all the surviving portraits painted in Rome of the members of the court show Scottish people.[64] As far as we know, it was only the Scottish courtiers who commissioned portraits of the Stuarts for themselves.[65] One of them, Sir William Hay, is worth identifying because it was he who commissioned a well-known set of four Stuart portraits from Blanchet.[66] The one of the king in profile is now in the National Portrait Gallery in London, and that of the queen (the largest and more original of all of the copies after Meytens) is in a private collection. The portraits of the princes are the ones which are now in the Royal Collection on permanent display in Holyroodhouse.[67] They show them aged 18 and 14, as they were when a Stuart restoration was still anticipated, and both wearing the Thistle over the Garter sash.

The Stuart court came to a sad end. When Prince Charles eventually returned to Rome, shortly after the death of his father, he was not recognised as the rightful king of the British kingdoms. He lived the rest of his life either in Florence or in Rome, where he died in 1788 with no legitimate children. Cardinal York died in 1807, bringing to an end the legitimate male line of the Stuarts. But at least their physical remains, unlike those of the family at Saint-Germain, were not desecrated. There is a monument to James III and his sons in St Peter's Basilica, opposite the monument to Queen Clementina, and all three of them are buried in the crypt below.[68] The embalmed body of the queen is still in her monument, and there is a second monument in the church of the Santi Apostoli, immediately beside the Palazzo del Re, which contains her intestines.[69] Finally, there are cuttings from the hair of all four Stuarts preserved in private collections.[70]

The exiled Stuarts suffered the fate of most 'losers' in history. In retrospect their defeat began to seem inevitable, the memory of their court was quickly lost, and the buildings in which they lived were therefore regarded as of no special interest. But to contemporaries the Palazzo del Re in Rome, like the Château de Saint-Germain in France, housed an impressive royal court whose occupants were expected, sooner or later, to return in triumph to the British Isles.

Notes

1. There are two large paintings showing James III and his five most senior courtiers during their journey. They are both reproduced in Edward Corp, *The Jacobites at Urbino: An Exiled Court in Transition* (2009), pp. 14, 16; and Edward Corp, *The King over the Water: Portraits of the Stuarts in Exile after 1689* (2001), pp. 110–11. They are Giuseppe Maria Crespi, *The Meeting of James III and Don Carlo Albani on the Banks of the River Panaro outside Bologna, 13 March 1717* (1717) (National Gallery, Prague); and Antonio Gionima, *James III being received by Cardinal Gozzadini at the Archbishop's Palace at Imola, 16 March 1717* (1717) (Castel Sant'Angelo, Rome).

2. While he was in Rome in 1717 James III sat for a three-quarter length portrait by Antonio David. It was the first to show him with a crown and with the Order of the Thistle. It is now in the Palacio de Liria in Madrid, but David made twelve bust copies in 1718, some of which have survived. The original is reproduced in Corp, *The Jacobites at Urbino*, p. 24; and Corp, *The King over the Water*, p. 57.

3. For the exiled Stuart court between 1712 and 1719, see Edward Corp, *A Court in Exile: The Stuarts in France, 1689–1718* (2004), chs 12 and 13; and Corp, *The Jacobites at Urbino*, chs 3–13. James III's marriage at Montefiascone in 1719 was recorded in a large painting of 1735 by Agostino Masucci, which is now in the Scottish National Portrait Gallery, Edinburgh (PG 2415). There is a smaller version in the cathedral of Montefiascone, and an engraving by Antonio Friz. For the painting, see Corp, *The Jacobites at Urbino*, p. 139; and Corp, *The King over the Water*, p. 73. For the engraving, see Richard Sharp, *The Engraved Record of the Jacobite Movement* (1996), pp. 213–14.

4. Corp, *The Jacobites at Urbino*, pp. 117–21; Edward Corp, *The Stuarts in Italy: A Royal Court in Permanent Exile* (2011), pp. 43–44.

5. The Palazzo del Re is described in more detail in Corp, *The Stuarts in Italy*, ch. 2.

6. Royal Archives (RA), Stuart Papers (SP), RA SP 98/131, 'an inventory of goods in the King's Palaces at Rome', October 1726.

7. The baptism of Prince Charles by the Bishop of Corneto and Montefiascone is recorded in the parish register of the church of the Santi Apostoli (Archivio Storico Vicariato di Roma, Santi Apostoli, vol. 12, p. 130). He was confirmed twice by Pope Benedict XIII, on 6 March 1725 when the Pope also baptised Prince Henry (ibid., p. 171), and again in the Sistine Chapel on 4 July 1729 (Corp, *The Stuarts in Italy*, p. 34).

8. National Archives, SP 85/13/f.118, Edgar to Clephane, 28 November 1724.

9. Corp, *The Stuarts in Italy*, chs 3 and 12.

10. Ibid., pp. 37–39, 354.

11. There had presumably been a throne and canopy in the king's apartment at Saint-Germain, but they are not mentioned in the available archives (see Corp, *A Court in Exile*, pp. 92–93).

12. Corp, *The Stuarts in Italy*, pp. 321–22.

13. Ibid., p. 385.

14. PG 2511. It is reproduced in Corp, *The Stuarts in Italy*, p. 57; and Corp, *The King over the Water*, p. 73.

15. Corp, *The Stuarts in Italy*, p. 56.

16. The painting by Giuseppe Chiari is entitled *La navicella di San Pietro con la virtù Teologali* (170 x 122 cm) and is now in the *episcopio* at Frascati. It shows St Peter steering a small boat during a storm at sea, accompanied by Faith, Hope and Charity (the theological virtues), observed and protected from above by the Holy Trinity.

17. Corp, *A Court in Exile*, p. 102; *The Stuarts in Italy*, p. 52.

18. The names of most of the people are given in Corp, *The Stuarts in Italy*, pp. 57, 64.

19. Ibid., pp. 121–22.

20. Ibid., pp. 122–28, 132–34, 188–93, 307–19, 335–37, 340–45.

21. Ibid., pp. 131–34.

22. Ibid., p. 132. To distinguish between the king's apartment on the first floor, and the 'king and queen's apartment' on the second floor, the former was referred to as 'the king's low apartment' (ibid., p. 111).

23. Ibid., pp. 142–48.

24. Ibid., pp. 156–63.

25. Ibid., pp. 164–67.

26. Ibid., pp. 28–32, 75–77, 175–87. While the court was at Bologna it occupied the Palazzo Fantuzzi and the adjacent Palazzo Ranuzzi-Cospi. The two buildings were connected by a specially built bridge over the street which separated them (ibid., p. 179).

27. Ibid., pp. 188–93, 195, 214, 220–21.

28. Ibid., pp. 207–08.

29. Ibid., pp. 18, 21, 25, 33, 215–16. The sum of 22,000 *scudi* was approximately equivalent to 110,000 *livres*, whereas the French pension at Saint-Germain had been 600,000 *livres*. By restricting the size of the royal household James III was able to live and entertain in Rome as he had at Saint-Germain.

30. Ibid., p. 241.

31. The annual rent of the Palazzo del Re was 1632 *scudi*. The amount spent on maintenance and repairs varied from year to year, reached nearly 1300 *scudi* in the 1730s, and settled at 600 *scudi* after 1740 (ibid., pp. 26, 44, 216, 226).

32. Ibid., p. 253.

33. Ibid., pp. 383–84.

34. Ibid., p. 385. The Vincennes porcelain is reproduced in Kathryn Barron, '"For Stuart blood is in my veins" (Queen

Victoria): the British monarchy's collection of imagery and objects associated with the exiled Stuarts from the reign of George III to the present day', in Edward Corp (ed.), *The Stuart Court in Rome: The Legacy of Exile* (2003), p. 160.

35. Corp, *The Stuarts in Italy*, pp. 3–7.

36. During the 1720s the master of the music was Innocenzo Fede. He was succeeded in the late 1730s by Giovanni Costanzi (ibid., pp. 78, 249, 271–72, 274).

37. Ibid., pp. 251–52.

38. James III's books were inherited by Prince Henry and are now nearly all in the Vatican Library. They include two 16th-century *Books of Hours* (Vat Lat 14935, 14936) and a Polish prayer book of 1685 (Vat Lat 15144). For further details, see Marco Buoncore and Giovanna Cappelli (eds), *La biblioteca del Cardinale* (2007).

39. Royal Collection, RCIN 1142248 (the Sobieski Book of Hours, *c.*1420–25), and RCIN 1005087 (a French Book of Hours, *c.*1500, reproduced in Barron, '"For Stuart blood is in my veins" (Queen Victoria)', p. 152; and the replica in Corp, *The King over the Water*, p. 58, p. 150).

40. The Sobieski sapphire in the Imperial State Crown is reproduced in Barron, '"For Stuart blood is in my veins" (Queen Victoria)', p. 152; and the replica in Corp, *The King over the Water*, p. 58, p. 153.

41. In his will James III divided his papers between his two sons. Prince Charles was given papers covering the years up to 1744, as well as his own letters to his father after that date. Cardinal York was given all the rest (Corp, *The Stuarts in Italy*, pp. 386–87). The two collections were amalgamated during the 19th century and are now known as the Stuart Papers (SP) in the Royal Archives (RA), which are located at Windsor Castle.

42. Noel Woolf, *The Medallic Record of the Jacobite Movement* (1988); Corp, *The Stuarts in Italy*, pp. 80, 89, 104–5, 283–84. James III's medal case, made in Rome, *c.*1725, was sold at Bonham's, Edinburgh, on 2 May 2012, and is reproduced in Woolf, *The Medallic Record*, p. 76. Various other items which belonged to James III are listed in Corp, *The Stuarts in Italy*, p. 386.

43. Graeme Rimer, 'A fine Silver-Hilted Jacobite Sword from the Stuart Court in Exile, perhaps a Sword of Bonnie Prince Charlie', in *London Park Lane Arms Fair* [catalogue, Spring 2016], pp. 110–13.

44. Corp, *The Stuarts in Italy*, p. 252.

45. PG 1510. Mosman left Rome in 1740. As his portrait of the prince was copied from a recent one by Blanchet of 1739, which remained in Italy, it must have been painted before he left the city.

46. Corp, *The Stuarts in Italy*, chs 5 and 14; Corp, *The King over the Water*, pp. 57–93.

47. Sharp, *The Engraved Record*, pp. 80–99, 102–104.

48. PG 887, 888. Corp, *The Stuarts in Italy*, p. 279; *The King over the Water*, pp. 68–69.

49. The painters were Francesco Trevisani (1719–20), Girolamo Pesci (1721), Martin van Meytens (1725), Lucia Casalini Torelli (1726–27), E. Gill (1727–28), Giovanna Fratellini (1728), Agostino Masucci (1735), Jean-Etienne Liotard (1737–38), Louis Gabriel Blanchet (1737–39) and Domenico Duprà (1740, 1742).

50. Corp, *The Stuarts in Italy*, pp. 98–99. The replica was painted for the Jacobite Duke of Mar. The original is reproduced in Barron, '"For Stuart blood is in my veins" (Queen Victoria)', p. 152; and the replica in Corp, *The King over the Water*, p. 58.

51. Corp, *The Stuarts in Italy*, pp. 99–100. The painting is reproduced on p. 102.

52. Ibid., p. 111. The original paintings by Meytens have been lost. The portrait of the king is known from the copies by Gill and David, and the one of the queen from copies by Gill, David, Giovanni Paolo Panini, Blanchet, Lodovico Stern, Duprà and (as a miniature) Veronica Telli.

53. New portraits of the queen, however, were painted by Pierre-Charles Trémolières in 1730 (194 x 147 cm; private collection), and Domenico Muratori (twice) in 1734 (lost, but known from engravings). It is not clear who commissioned these three portraits, all of which show Clementina kneeling before an altar.

54. Corp, *The Stuarts in Italy*, pp. 228–29.

55. Ibid., pp. 219–20, 229–30.

56. Ibid., pp. 230–31, 299–300. Two of the portraits were by Domenico Corvi, and one each by Blanchet and Anton Raphael Mengs, all reproduced in Corp, *The King over the Water*, pp. 88–89. The last original portraits of James III were painted by Mengs in 1748.

57. Edward Corp, 'The Facciata of Cardinal York: An Unattributed Picture in the Scottish National Portrait Gallery', in *Journal of the Scottish Society for Art History* 15 (2010), pp. 33–38. The *facciata* was designed by Clemente Orlandi and engraved by Claude-Olivier Gallimard in 1747. The large picture was then copied from the engraving in 1748, with the figures added in the foreground.

58. PG 3269. It is reproduced in Corp, *The Stuarts in Italy*, p. 233; and Corp, *The King over the Water*, p. 84.

59. The painting of the *facciata* was therefore displayed in the former queen's apartment on the second floor (Corp, *The Stuarts in Italy*, p. 261).

60. Ibid., pp. 261–63, 340–44, 348.

61. Ibid., p. 306. The dimensions were *c.*171.5 x 73.5 cm.

62. Corp, *The Jacobites at Urbino*, pp. 24–25, 87; Corp, *The King over the Water*, p. 55.

63. This statement needs to be qualified. The 1719 portrait by

Trevisani shows the king wearing his Garter robes (not the blue sash of the Order), the one by Liotard does not extend far enough down the king's chest to show the St Andrew medal, and the one by Blanchet of 1741 has the green ribbon and medal of the Thistle obscured by a red ermine-lined cloak. Prince Charles nearly always wore the Thistle under the Garter until 1738, when he was painted by Blanchet with the Garter only and not the Thistle (NPG 5517, Fig. 4.5). After he received his Highland weapons and costume in 1739–40 he nearly always wore the Thistle over the Garter. Oddly enough he was painted by Ramsay in Scotland with only the Garter, and by La Tour in Paris in 1747 with the Thistle below the Garter. In his final portrait of 1786, by the Scottish artist Hugh Douglas Hamilton, he is shown with only the Garter.

64. There are no known portraits of any English or Irish, let alone French or Italian courtiers. The 18 portraits of the Scots are listed in Corp, *The Stuarts in Italy*, pp. 376–77. They include one of Lord Inverness (Trevisani, 1724), three of Lady Inverness (Trevisani 1719, David twice in 1723), and one of Lord Dunbar (Trevisani, 1719). For a list of all the Scots at the court in Rome, see Edward Corp, 'Scottish People at the Exiled Stuart Court: Part II', in *The Stewarts* 23: 1 (2008), pp. 12–21.

65. Inventories of the pictures of Lord Dunbar and Lord Inverness are in RA SP Box 4/2/28 and 29.

66. Sir William Hay was a captain in the Russian navy who joined the court in 1726 and was appointed groom of the bedchamber the following year. He left the court in 1741, but returned in 1744 to become the king's *maggiordomo*. He was created a baronet in 1748, and retired to France in 1751. His portrait of 1739 by Duprà is in the Scottish National Portrait Gallery, Edinburgh (PG 1565).

67. Hay commissioned Blanchet to paint original portraits of the princes in 1739, to copy the portrait of the queen by Meytens in 1740, and (shortly after his departure) to paint a portrait of the king in 1741 based on a drawing by Francesco Ponzone (Corp, *The Stuarts in Italy*, pp. 291, 295–96). They are all reproduced in Corp, *The King over the Water*, pp. 78–81, and the one of Prince Charles in Barron, '"For Stuart blood is in my veins" (Queen Victoria)', p. 152; and the replica in Corp, *The King over the Water*, p. 58, p. 161.

68. Prince Charles was buried in Frascati cathedral, beneath a white marble funerary monument, in 1788. His heart and intestines are still there, in a small urn placed under the floor below the monument. His body, however, was moved to the crypt of St Peter's in 1807, to join those of his father and brother.

69. The monument in the church of the Santi Apostoli was said to contain both the intestines and the heart of the queen, but in fact her heart was kept by the king in his chapel in the Palazzo del Re (Corp, *The Stuarts in Italy*, p. 222). It has disappeared without trace.

70. According to the catalogue of *The Royal House of Stuart Exhibition* held at the New Gallery, London, in 1889, there were two locks of Prince Charles's hair, both of them cut off in 1737. They were at Harrow School (no. 508) and in the Royal Collection (no. 535).

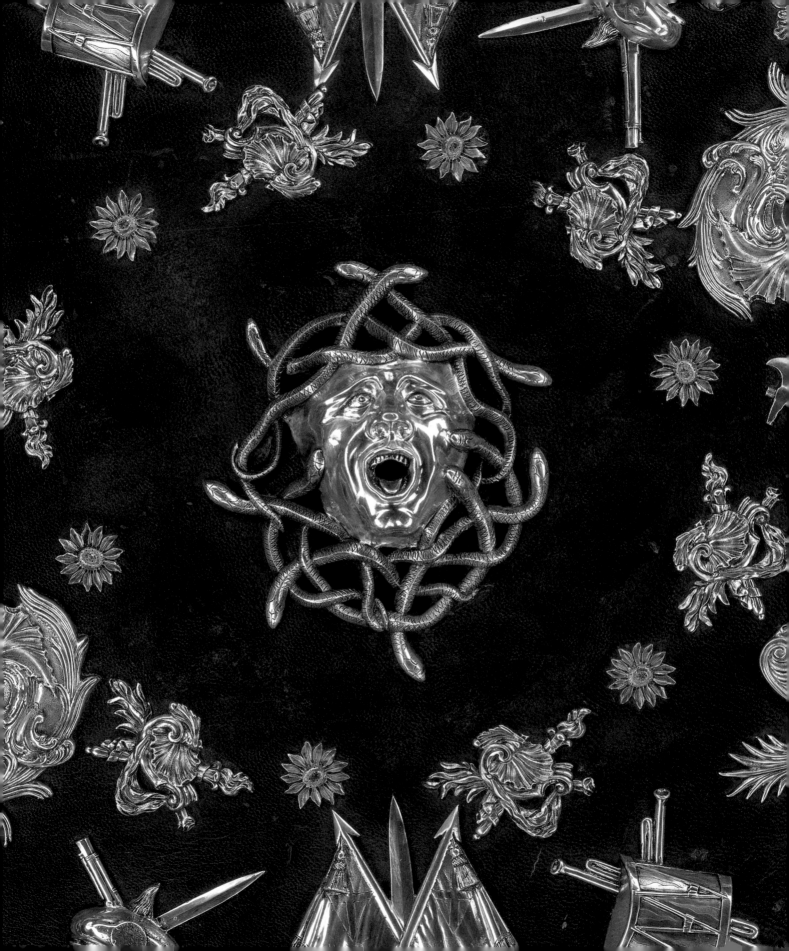

CHAPTER 5

'A slim sword in
his hand for battle'
Weapons fit for a Prince

*Helen Wyld and
George Dalgleish*

IN HIS BOOK *THE MYTH OF THE HIGHLAND CLANS*, MURRAY PITTOCK QUESTIONS just how 'Highland' Prince Charles's Jacobite army was. It is clear, however, that certain elements in Gaelic society in Scotland looked to *Tearleach Mac Sheumais* to raise up and deliver both the Gael and Scotland from Hanoverian oppression. The instrument of this deliverance was undoubtedly to be the sword in the hand of the true-born prince. Gaelic poetry makes it clear that the sword, whether a backsword or broadsword, was the weapon of the leaders of clan and people.[1] The line quoted in the title to this chapter is from Alexander Mac-Donald's 'Song to the Prince' and is a remarkably accurate description of the elegant silver-hilted backsword long thought to be Prince Charles's own. This sword – along with a magnificent silver-mounted targe – are now in the collections of National Museums Scotland. As another silver-hilted sword has more recently come to light, this article seeks to re-examine the provenance and meaning of these undoubtedly princely weapons, and how they contributed to the creation of Charles's 'Highland' image.[2]

Page 78, Figs 5.5 a–c: Detail of Targe

Maker unknown, *c.*1739–40, National Museums Scotland, H.LN 49

CATALOGUE NO. 133

A Princely Gift

The two swords and targe relate to the gift of Highland clothes to the prince by James Drummond, 3rd Duke of Perth. In February 1738 James Paterson, a Jacobite operative then in the employ of the King of Sardinia, wrote to the court in Rome:

> *When I was in Scotland the Duke of Perth told me he was resolved to make a present to HRH the Prince of Wales of a Highland Dress with all the necessary accoutrements, and desired me, if it was possible, to get it ready against the time I went away, to carry it along with me. On my arrival at London I found the broad sword already done, which I believe is the finest of that sort that ever was wrought, the dirk and target, Mr Gernegan assured me will be done the beginning of next month, but what I am afraid will not be so soon finished is the embroidery on the tartan clothes, which is to be done in Paris. I have not yet*

received the tartan, tho' I expect it every day from Scotland. In the meantime I wish your Lordship would do me the favour to order the princes measure to be sent to me that I may get it done as soon as possible.[3]

Further correspondence shows that a 'beautiful pair of pistols, decorated with gilded flames, a dagger, and a Highland shield', recently received as a present from the Duke of Perth, were being shown off by the prince in Florence early in 1739; a cuirass, helmet and other armour arrived in August that year,[4] and finally, in December 1739, the Highland clothes themselves came from Paris.[5] In early 1740 there is mention of a similar suit of clothes to be made for Charles's brother, Henry – an important detail, which could explain why two elaborate silver swords have survived today. Charles certainly wore the new suit of clothes to the carnival in Rome at Easter 1741, and it was hoped that Henry's clothes would follow in time for the next year's celebrations. A description of the carnival ball from the British government spy the Baron de Strosch, alias John Walton, adds detail to the character of the prince's clothes and arms:

[The prince] *dazzled in the costume of a Scottish Highland officer, with a suit checked in diverse colours and adorned with embroidery and different coloured jewels of a value of more than forty thousand scudi, according to connoisseurs. The suit came from France. However the bonnet, shield, and arms came as a present from Scotland last year. Connoisseurs have observed that the jewels were not bought in Rome, having certainly been made and assembled by a jeweller in London or Paris, and far surpassing in beauty anything similar that the Italians could make.*[6]

This is the earliest account of the prince wearing the Highland dress which was to become central to his image during the 1745 campaign. The decision to wear these clothes at a masquerade, combined with their clearly dazzling quality, suggests an element of fancy dress; however the gift had a far more serious function.

James Drummond, 6th Earl and 3rd Duke of Perth (1713–46), and his brother John, later 4th Duke (1714–47), were prominent Jacobite supporters, and frequent visitors at the court in Rome. Their father, the 2nd Duke of Perth, had fought in the 1715 Jacobite rising, and died in exile in 1720; James and his brother were then taken to France by their mother to receive a Catholic education. Both were active in plotting the 1745 campaign. In 1741 the Duke of Perth headed the list of Scottish nobles known as 'The Association', who signed a treaty with ministers of the French king, pledging to raise 20,000 men from the Highlands to restore the Stuarts to the British throne.[7] Perth was keenly aware of the need to raise support for the cause in Scotland, particularly among the Highland clans. His and his brother's correspondence contains frequent references to portraits and medals of the two princes, showing an awareness of the role of images in

securing loyalty in a country the prince had never set foot in. The gift of Highland clothes and arms was part of the same strategy.

The Significance of the Gift

Although the image of a tartan-clad 'Bonnie Prince Charlie' is now ubiquitous, it only became current during the 1745 campaign, and gained popularity through images produced and circulated during and after the rising. Earlier representations of the two princes follow the conventions of European portraiture, showing them in court dress, or latterly in ceremonial armour, wearing the chivalric orders of the Garter and the Thistle but with no other national signifiers.[8] The Duke of Perth's gift suggested an alternative identity for the prince, and one which had a strategic political motivation. The tartan clothes – and no less so the sword, targe, pistols and dirk – were potent signifiers of a distinct cultural identity which the prince would later assume, and which would be essential to generating support for a planned invasion.

Although much of the correspondence relating to the gift is light-hearted in tone – reports that the prince 'looks better in them than in any Clothes he ever wore'[9] – there are also hints at the deeper meaning of such attire. In his letter of thanks for the gift in February 1740, Charles solemnly informs the Duke of Perth that the 'value & esteem I have for my friends like whom I shall be dressed, will make me wear it with satisfaction'.[10] Later, in 1744, the Duke of Perth refers to the gift in similar terms:

Fig. 5.1: *John Drummond, 4th Titular Duke of Perth (1714–47)*

By Domenico Duprà (1689–1770), 1739, oil on canvas, 61.5 x 46.6 cm, Scottish National Portrait Gallery, Edinburgh, PG 1597

> *You may remember the kind of cloaths I sent you some years ago and I suppose you also know that I think it is my greatest honour to be and to be looked upon as one of those that have a right to wear that kind of garb.*[11]

It is significant that Perth reminds the prince of the cultural importance of Highland dress on the eve of the invasion. 'Those that have a right to wear that kind of garb' were precisely those on whom the Prince would rely for his initial support on landing in the Western Highlands: the clan chiefs and their followers. Perth was convinced, and sought to persuade Charles, that the 'Highlanders are as good as any regular forces … there is no troops in Europe but they have the advantage of in the day of battle …'. In this long memorandum he goes on to extol the virtues of their method of fighting and the weapons they carry, which give them an advantage 'when by having penetrate into the ennemys rank they come to a close engagement or what the French call *la meleé*'. He was concerned

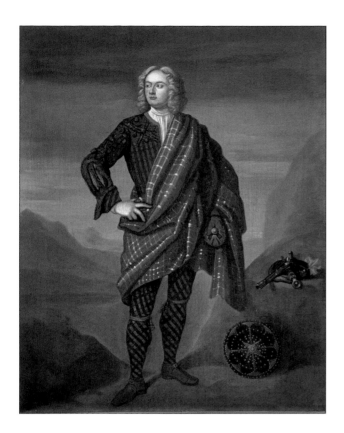

Fig. 5.2: *Andrew Macpherson of Cluny (1640–66), 15th Chief*

Attributed to Richard Waitt (d.1733), *c.*1725, oil on canvas, 76.2 x 64.1 cm, Scottish National Portrait Gallery, Edinburgh, PG 1546

that the Highlanders were not as well regarded as they should have been among the other Jacobite plotters and continued:

I also believe that if they were better knowen the rest of the traders [a loosely coded word for those who might rise for the Stuarts] *would more willingly venture in copartnership with them for many will venture their stock with people whom they esteem and look upon as people of mettle and sharpness …. I am persuaded it will encourage the english traders to join in the project.*[12]

Perth was undoubtedly trying to craft an image for Charles as a natural leader of the clans and therefore supplied him with the requisite dress and weapons to achieve this.

The clothes themselves, described in various sources as a 'habit montagnard' and as 'tartan clothes', almost certainly consisted of trews or breeches (more practical for riding on horseback than the belted plaid), an embroidered coat and waistcoat, and a plaid thrown over the shoulder. Comparison can be made with a portrait of the Duke of Perth himself dressed in tartan jacket with breeches, stockings and a plaid, and a half-length of his brother Lord John Drummond, painted in Rome in 1739 by the Stuart court portraitist Domenico Duprà, wearing a tartan jacket and waistcoat with gold lace trim and a plaid [Fig. 5.1].[13] A number of contemporary images survive of Highland chiefs in similar attire: for example the young John Campbell, son of Lord Glenorchy (*c.*1708), a posthumous portrait of Andrew Macpherson of Cluny (*c.*1725) [Fig. 5.2], and James Fraser of Castle Leathers (*c.*1720) – the latter a known Hanoverian sympathiser. Of equal importance to the dress in these images are the arms the sitters carry: a basket-hilted sword; a targe, often prominently displayed; pistols and a dirk. All these weapons were part of the Duke of Perth's gift to the prince, which was intended to align him with an established image of a Highland chief.[14]

While the two princes seem to have worn their Highland clothes only on special occasions, such as the carnival while in Rome,[15] from soon after his arrival at Glenfinnan in 1745 this became Charles's usual attire. One of the most detailed description of Charles dressed in Highland clothes relates to his triumphal entry into the Palace of Holyroodhouse in September 1745:

He wore a blue velvet bonnet, bound with gold lace, and adorned at top with a white satin cockade, the well-known badge of his party. He had a short tartan coat, on the breast of which hung the star of the order of St Andrew. A blue sash wrought with gold came gracefully over his shoulder. He wore small-clothes of red velvet, a pair of military boots and a silver-hilted broadsword.[16]

Later, on the march to Derby, the prince went 'on foot at the head of the clans with his target over his shoulder'.[17] Verbal descriptions are backed up by visual evidence. The earliest representation of the prince in Highland dress was Richard Cooper's satirical 'Wanted Poster' of 1745 [Ch. 6, Fig. 2], where he is shown in a tartan coat, breeches and plaid, with checked stockings, and a sporran, dirk and basket-hilted sword at his belt. Although 'official' portraits continued to represent the prince in court dress, the popular image of the tartan-clad prince took hold from 1745. It is telling that in the most oft-repeated of these images, including the so-called Harlequin portraits, the basket-hilted sword and Highland targe feature prominently [Fig 5.3]. It is now possible to show that these widely-circulated images referred to actual weapons carried by the prince during the 1745 campaign.

The Kandler Sword

James Paterson's 1738 letter, quoted above (p. 80), mentions a 'Mr Gernegan' as the supplier of the silver broadsword, targe and dirk. He can be identified as Henry Jernegan (c.1688–1746), a goldsmith-banker from an established Catholic family who operated in Covent Garden, London. Jernegan is known to have worked extensively for Jacobite and English Catholic clients in the early part of the 18th century, and may even have loaned money to James VIII and III, making him an obvious choice for such a commission.[18] Jernegan's most famous creation, a silver wine cooler, was made by the silversmith Charles Kandler (d.1778), a Catholic immigrant from Germany, whom Jernegan used for many of his most prestigious silver commissions. The silver sword belonging to National Museums Scotland bears the mark of Charles Frederick Kandler, a close kinsman of Charles who took over his workshop in 1735 and who continued to work closely with Jernegan. They were undoubtedly part of a close-knit Jacobite network, with possible Scottish connections: Charles Kandler's original partner was James Murray, who died in 1727, and Charles Frederick worked for a number of prominent Catholic clients such as the Duke of Norfolk and the Earl of Shrewsbury. The cast silver hilt is also marked with the Leopard's Head for London and a poorly-struck date letter, almost certainly an 'e' for 1740–41 (the assay office changed its date letter in May each year). This is hard to explain if the Kandler sword is the one mentioned in Paterson's letter; but could indicate that this was the sword made for Henry Benedict, whose Highland clothes were made a year later than his brother's. The fact that the hilt is marked at all is curious, as this meant submitting it to the official scrutiny of the Assay Office in Goldsmiths' Hall and thus possibly drawing

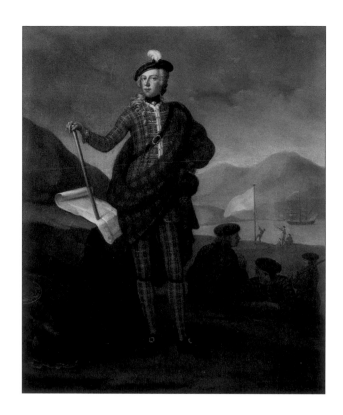

Fig. 5.3: Portrait of Prince Charles Edward Stuart

By E. Gill (fl.1720–c.49), c.1748, oil on canvas, 61 x 60 cm, © 2017 Christie's Images Limited

Figs 5.4 a–c, opposite: Broadsword

Hilt made by Charles Frederick Kandler (d.1778), c.1738–41, steel blade with gilded decoration, solid silver hilt, 95 cm (total length), National Museums Scotland, H.MCR 2 (and details)

CATALOGUE NO. 134

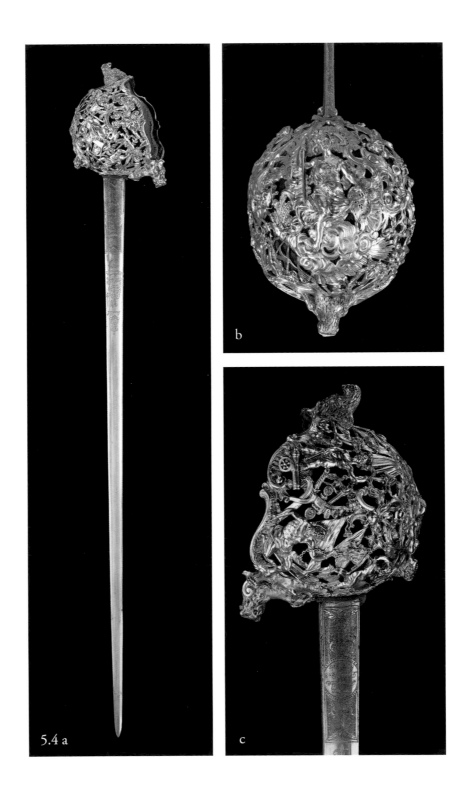

5.4 a

b

c

attention to it as a gift for the Jacobite prince. As we will see below, the targe and the other sword are unmarked.

Interestingly, the iconography on the Kandler sword [Figs 5.4 a–c] is the most general of the three objects – indeed it could have safely been submitted to the Assay Office without exciting any suspicion. A central female figure emerging from clouds in a burst of light could be interpreted as Britannia, who often appears in both Jacobite and Hanoverian propaganda. She was used equally by the Hanoverian regime.[19] A small face on her breastplate could be a Medusa's head, which appears more prominently on the targe and the second sword. To either side are a proliferation of figures and martial symbols including a warrior on horseback, a chained prisoner, putti firing cannon and blowing trumpets, and Roman military standards, flags, swords, bows and arrows, and pistols, all linked by delicate scrolling forms and shellwork. An eagle forms the pommel of the hilt, with weapons and trumpets fanning out from it, and a lion forms the guard. Neither animal is typically seen in Jacobite imagery, but both are standard warlike symbols. On each side of the blade there are two engraved and gilt cartouches with the inscriptions '*Ne me tire jamais sans raison*' / '*Ne me remette point sans honneur*' ('Draw me not without reason' / 'Sheath me not without honour' – frequently found on 18th-century sword blades), and a small armed figure labelled 'Haniball'.

The Kandler sword is first documented in the collection of King George IV. An inventory of his Carlton House residence includes a sword with a 'silver basket guard and hilt' which 'belonged to the Pretender'; and the inventory even goes on to include the mottos engraved on the blade. A later annotation notes that the sword has been 'Given away to Mr MacDonald', meaning Ranald George MacDonald, Chief of Clanranald (1788–1873).[20]

In 1822 Robert Mudie wrote that Clanranald had intended to appear with the sword at George IV's reception in Edinburgh, but was prevented from doing so by the death of his uncle. Mudie goes so far as to argue that it was Clanranald's frequent appearances at court that had first excited George IV's interest in tartan, and that on giving him the sword the king had said: 'I will always be happy to see you in that dress. This sword belonged to the unfortunate Chevalier, and I now give it to you, as the person best entitled to wear it.'[21] In fact, George had shown an interest in his Jacobite cousins and Highland dress in particular long before this. He and his brother Augustus, Duke of Sussex, were first recorded wearing Highland dress in 1789.[22] The Duke of Sussex was so captivated by this Jacobite heritage that when he became President of the Highland Society of London in 1806, he had a copy made of the Kandler sword then in his brother's collection and is depicted wearing it in the Wilkie portrait of him in the Royal Collection.[23] It was Clanranald's grandson, Angus Roderick MacDonald, 23rd Chief, who bequeathed the sword to the National Museum of Antiquities of

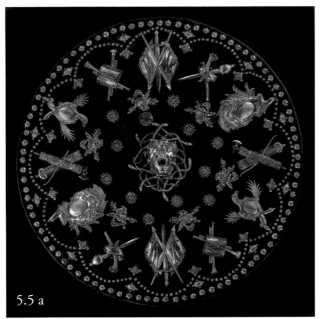

Figs 5.5 a–c: Targe

Maker unknown, Scottish, c.1739–40, wood, leather and jaguar skin, with silver mounts (London), 48.3 cm (diameter), National Museums Scotland, H.LN 49

CATALOGUE NO. 133

Scotland in 1944, along with a group of family and Jacobite relics. By this point a story had emerged that the sword was presented to the prince by the city of Glasgow, or by the Western Jacobites, and that it was abandoned on the battlefield at Culloden and found by Cumberland's army.

The Targe

In contrast to the Kandler sword, whose iconography is generalised, the targe [Figs 5.5a–c] is imbued with complex and very specific iconography which, as we shall see, is continued in the second silver sword. The targe's construction follows the standard Highland type, with two layers of boards set at right angles to one another and covered with tooled leather.[24] Interestingly, the back of the targe is covered with exotic jaguar skin in place of the more usual deerskin [Fig. 5.5b]. Its exact significance is unclear, but cloaks lined with leopard skin were occasionally worn over armour in portraits of the period – both James VIII and III and Charles were represented in this way.[25]

The targe was almost certainly constructed in Scotland – the knowledge and skills to make such an object would not have existed elsewhere – while the silver mounts, which replace the more usual studs and plates of brass, were made and added in London. There are no signs of a maker's mark or hallmarks on any of the silver mounts, although it is possible that these may be on the underside of the mounts.

In the centre of the targe is a cast representation of the Gorgon Medusa's head,

her mouth open to reveal her teeth, and complete with snakes for hair – according to legend a countenance so hideous that those who beheld it were turned to stone, which lead to its being used on shields and other military apparel as a protective talisman. In this case the threat is made real, as Medusa's mouth is threaded to take the spike typically mounted on the centre of a Highland targe. This reference may be intended to highlight the parallels between the circular form of the traditional Highland targe and the round shields used by the great warriors of antiquity, and is part of a broader alignment of the Stuarts with classical exemplars.[26] In a portrait of 1725, James VIII and III is shown wearing a breastplate with a gorgon's head at the neck [see Ch. 3, Fig. 10]. Even more suggestively, Robert Strange's engraving after Ramsay's recently-rediscovered portrait of Charles, painted at Holyroodhouse in 1745, includes a circular, studded shield adorned with a gorgon's head [Fig. 5.6]. The print was made at some point between 1745 and 1749, and since Strange fought with the Jacobite army in the 1745 rising, the Medusa shield in his print could refer to an actual targe carried by Charles.[27]

The remainder of the targe is decorated with various cast-silver martial symbols: trumpets and a drum; a sword and crossed flags, decorated with saltires and thistles; crossed pistols and swords with scotch bonnets; and a fasces – the ancient Roman symbol of unity and military authority – with a bow and quiver of arrows. On the badge on the front of one of the bonnets is an image of St Andrew carrying his x-shaped cross, or saltire – the badge of the Order of the Thistle [Fig. 5.5 c]. This could refer either to Prince Charles or to the Duke of Perth: Charles was made a Knight of the Thistle shortly after his birth, while Perth received his Knighthood on 15 May 1739.[28] It is perhaps significant that the figure of St Andrew is likewise chased on the cover of the prince's silver travelling canteen, also made as a gift to him in 1740–41 [Ch 3, Fig. 13].[29] The second bonnet's badge has a very rubbed representation of a ducal coronet and the motto 'Gang Warily', this time undoubtedly for the Duke of Perth [Fig. 5.5 c].

There are also smaller ornaments and studs in the form of sunflowers, shells and acanthus leaves; the sunflower, whose face follows the course of the sun, was a motif often used by the Stuarts to indicate devotion. Four rococo cartouches with engraved emblems, surrounded by palm fronds signifying victory, add further to the iconography of the targe. The first has the motto 'PRO REGE ET PATRIA' ('for king and country'), with an armoured hand grasping a sword, in anticipation of the planned Jacobite rising. The second has the motto 'DEO IUVANTE' ('God helping') above an arm holding Jupiter's lightning bolt, indicating that the Jacobite cause is divinely sanctioned. The third has the inscription 'RURSUS

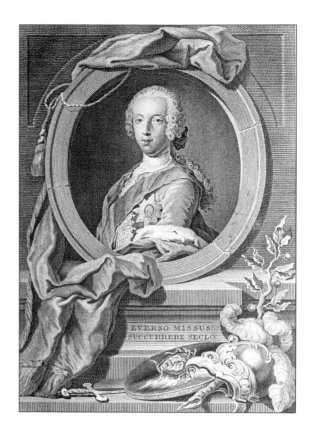

Fig. 5.6: Prince Charles Edward Stuart (the '*Everso missus*' print)

By Robert Strange (1721–92), 1745, line engraving on paper, 28.7 x 20.2 cm, Scottish National Portrait Gallery, Edinburgh, SP IV 123.20

CATALOGUE NO. 161

ORIETUR AD GLORIAM' ('again it will rise to glory'), with a sun rising over the sea; and the fourth is inscribed 'PREMITUR NON OPPRIMITUR', with a smiling sun bursting through clouds. This last device appears in an emblem book compiled by the Jesuit priest Claude-François Menestrier, published in Paris in 1682, with the explanation 'it is hidden, but does not suffer from it; calumny can blacken the best people, but will not oppress them forever'.[30] The sun was an ancient symbol of kingship, and early Jacobite medals produced in France frequently use the device of the sun rising or breaking through clouds to symbolise the return of the Stuarts after a period of eclipse or adversity.[31]

The Brodie Sword

Although the targe and the 'Kandler' sword have long been associated with one another, the style, imagery and the workmanship of the third of these princely weapons – the so-called Brodie sword [Figs 5.7a–c] – suggests an even closer link to the targe. Neither the targe nor the Brodie sword is marked (although the marks could be concealed), yet the distinctive bold modelling on both objects suggests that they could be by the same maker – they are very different to the fine and delicate style of the Kandler sword. The iconography of the Brodie sword and the targe is also closely linked. Most obviously, the sword's richly moulded solid silver hilt, made from pieces of silver cast and soldered together (as opposed to a single piece, as in the Kandler sword), centres around a central Medusa's head, depicted in a very similar way to the central cast on the targe, the snakes' heads twisting around the blade as a guard. To either side are military trophies, including swords, guns, standards, a club of Hercules (continuing the classical theme) and a quiver of arrows crossed with a fasces, the latter very similar in form to those on the targe. A dolphin's head helmet forms the pommel of the sword, a possible allusion to the French term '*Dauphin*' ('heir to the throne').

Accompanying the Brodie sword is a scabbard with matching silver mounts which continue the iconography: on the mouthpiece [Fig. 5.7 b] we find the same shield with Medusa's head, this time seen in profile, accompanied by a fasces, an olive branch symbolising peace, and a belt hook in the form of a cornucopia symbolising plenty. On the crampet [Fig. 5.7 c] a crossed fasces and quiver of arrows appear on one side, and on the other a thistle entwined with a rose, a widely-used Jacobite motif representing the kingdoms of Scotland and England. While the imagery on the sword itself is warlike, that on the scabbard implies the unity, peace and prosperity that will ensue once the battle is over, the sword has been sheathed, and Stuart rule in Britain is restored. Such pointed symbolism complements the emblematic cartouches and saltire badge on the targe, to create an unmistakable message: these weapons were made to serve a prince coming to reclaim his kingdom.

5.7 a

b

c

The targe is documented as being in the collection of the Macpherson of Cluny family until sold in 1928. This can be verified thanks to a small silver decorative stud in the West Highland tradition that was attached to the surface, possibly as a replacement for a lost sunflower mount. This stud is quite out of keeping with the rest of the decoration, but matches the studs on a very rare medieval West Highland belt also in that family's possession.[32] Earlier document-ation on how the targe came into the family's possession is frustratingly sparse. It is, however, extremely likely that it was among Prince Charles's personal pos-sessions which Ewen Macpherson of Cluny rescued from the prince's baggage waggon, abandoned in the shambles after Culloden. Cluny, initially a reluctant Jacobite, eventually raised and commanded a regiment in the prince's army. He was not present at Culloden, having been sent to guard the passes from Badenoch. He later spent nine years hiding from government troops, before being called to Rome by Prince Charles to account for his part in the disappearance of the Locharkaig Treasure, a large sum of French gold sent too late to aid the rising. In a remarkable memorandum sent to Charles, Cluny protested his innocence of any fraud with the gold and further gave an impassioned plea concerning his care of other items entrusted to him:

> I may further add that had not I and my people been active in it the very night of Culloden the waggon and all it contained [would have] fallen prey to the first comer, for I found it on the high road deserted by every person, so His R.H.'s personall dress which it contain'd was sent him, and the Plate I have given orders

Figs 5.7 a–c: Backsword

Backsword, solid silver hilt, maker unknown, London, c.1739–41, steel blade indistinctly marked 'ANDREA FERRARA', later plated in silver, 98 cm (total length); scabbard, leather with silver mounts

National Trust for Scotland, Brodie Castle / photographer John Paul

CATALOGUE NO. 135

to send how soon a safe method of conveying, can be found, and I am certain it will be delivered unhurt by me or any of my people.[33]

This document could explain the disappearance of the prince's 'Highland Clothes', which may have been among the 'personal dress' returned to him in Rome. What Cluny meant by the prince's 'Plate' is difficult now to know, but in the idiom of the time this would certainly have included silver vessels and possibly other precious items. There are no further references to Cluny sending this 'Plate' on to Rome; and indeed Cluny never managed to return home to Scotland, dying eventually in Dunkirk in 1764. It is possible, therefore, that the targe was among this plate and remained in Scotland entrusted to Cluny's descendants when it finally emerged in the collection at Cluny Castle in the 19th century.

Of the three surviving objects, the Brodie sword is the only one to have no recorded provenance before the 20th century.[34] Family tradition holds that it came to Brodie Castle via Elizabeth Brodie (1794–1864), who married the future 5th Duke of Gordon in 1813 and on his death became Duchess of Gordon in her own right. The story is plausible as a quantity of goods from Huntly Castle came to Brodie through her in the mid-19th century. Moreover, the Duchess herself had an interest in the history of the 'Forty-Five', Jacobite relics, and the part her husband's family had played in the rising (Gordons fought on both sides). A scrap of tartan survives at Brodie with a letter to the Duchess from her husband, the Duke of Gordon, explaining that it was worn by Charles at Culloden; there is also a Garter sash, also said to have belonged to the prince, left to her by the Duchess of Richmond and Lennox.[35] One further clue lies in the sword itself. Its high-quality steel blade, with the remains of a stamp 'Andrea Ferrara' common to many of its type imported to Scotland in the 18th century, shows definite signs of use, but has been plated in silver. Such treatment strongly suggests that at some point in its history it has been treated as a relic.[36]

These remarkable weapons are typical of much Jacobite material culture, presenting as many questions as answers to the enquirer. Why, for example, are there two swords: was one Henry Benedict's – as part of his Highland clothes given by the Duke of Perth – and brought to Scotland by his brother Charles along with his own sword? Could one of the swords, both of whose early provenance is undocumented, have remained in Rome in Henry's possession? They are, however, completely unlike the many other 'relics' supposedly associated with Prince Charles in that they are of magnificent quality – truly weapons fit for a prince.

Acknowledgements

Documents in the Royal Archive (RA) are quoted with the kind permission of Her Majesty Queen Elizabeth II.

Notes

1. Murray Pittock, *The Myth of the Jacobite Clans: The Jacobite Army in 1745*, 2nd edition (2009), pp. 163–64.
2. For scholarship to date on the three objects, see George Dalgleish and Dallas Mechan, *'I am Come Home': Treasures of Prince Charles Edward Stuart* [exhibition catalogue] (1985), pp. 8–10; *The Swords and the Sorrows*, exhibition catalogue (National Trust for Scotland 1996), nos. 1:49, 4:1.
3. Royal Archives (RA), Stuart Papers (SP), RA SP/MAIN/205/15. Letter from James Patterson, Boulogne, to James Murray of Stormont, titular Earl of Dunbar, in Rome, 20 February 1738.
4. '… une paire de beaux pistolets, ornees de flames d'or, un poignard, et un bouclier a la Montagnard': 'John Walton' [Baron Philip de Strosch, British spy on the Stuarts' activities] to the Duke of Newcastle [Secretary of State], Florence, 23 February 1739; 'John Walton' to the Duke of Newcastle, Rome, 16 August 1739, National Archives (NA), State Papers Foreign, SP 98/41
5. 'I profit of This occasion to send you the Princes Highland Cloas [*sic*], which you would be so good as to Remitt to his Royal Highness, and the Letter here inclosed. Ther is Like-wise a Collection of Scoth [*sic*] Country Dances': John Drummond to James Edgar, Paris 12 December 1739, RA SP/MAIN/218/147.
6. 'L'aine y brilla dans une masque d'officier des montagnards Ecossais avec un habit en echiquier des divers couleurs orne des broderies et des bijous de diferents couleurs de la valeur de plus de 40 mille scudi, selon l'estimation des connoiseurs. Cet habit est venu de France. Mais le bonnet, bouclier et l'accompagnement des armes lui est venue en present d'Ecosse l'anne passe …. Les connoiseurs ont observe que les joyaux … n'ont pas ete achete a Rome, ayant ete certainement mis en oeuvre et assortie par quelque jouaillier de Londres ou de Paris, cela surpassant beaucoup en beaute ce que les Italiens savent fairent en ce genre', 'John Walton' to the Duke of Newcastle, Florence, 18 February 1741, in the National Archives (NA), State Papers Foreign, SP 98/43.
7. John Sibbald Gibson, 'Drummond, James, styled sixth earl of Perth and Jacobite third duke of Perth (1713–1746)', *Oxford Dictionary of National Biography* (Oxford: Oxford University Press, 2004); online edition, May 2006: [http://www.oxforddnb.com/view/article/8072, accessed on 5 February 2017].
8. Robin Nicholson, *Bonnie Prince Charlie and the Making of a Myth: A Study in Portraiture, 1720–1892* (2002), ch. 3.
9. RA SP/MAIN/229/125, James Edgar to John Drummond, 29 December 1740.
10. RA SP/MAIN/220/133, copy letter from the prince to the Duke of Perth, 17 February 1740.
11. Quoted in Nicholson, *Bonnie Prince Charlie and the Making of a Myth*, p. 62, p. 62.
12. RA SP/MAIN/317/1, Duke of Perth to Prince Charles, 23 December 1744.
13. Private collection; National Galleries of Scotland, PG 1597.
14. See John Telfer Dunbar, *The Costume of Scotland* (1981), pp. 40–49; Hugh Cheape, *Tartan: The Highland Habit* (1991), pp. 18–25.
15. According to an English spy at Holyrood in 1745, Charles was 'always in his Highland habit'; Robert Chambers, *History of the Rebellion of 1745–6*, 7th edition (1869), p. 145.
16. John Home, *History of the Rebellion*, quoted in Chambers *History of the Rebellion of 1745–6*, p. 102.
17. Quoted in Dalgleish and Mechan, *'I am Come Home'*, p. 8.
18. Peter Cameron, 'Henry Jernegan, the Kandlers and the client who changed his mind', *The Silver Society Journal* 8 (Autumn 1996), pp. 487–501.
19. Neil Guthrie, *The Material Culture of the Jacobites* (2013), p. 62.
20. 'Scotch, one Edged Blade with Gilt ornaments. White Fish Skin Gripe with Gilt wire, Silver Basket Guard and Hilt most Elegantly Carved and Embossed with a variety of figures Beasts and Trophies. The Guard lined with leather and Red Velvet. Black Scabbard Silver Chape Stampt in Trophies'. Remarks: 'This sword belonged to the Pretender. On the blade is engraved the following words *Viz Ne me Tire Pas Sans Raison Ne me Remette Point Sans honneur* N.B. This Sword given away to Mr. Macdonald'. A. V. B Norman, 'Prince Charles Edward's Silver-hilted Sword', *The Proceedings of the Society of Antiquaries of Scotland* 108 (1976–77), pp. 324.
21. Ibid., p. 326.
22. Vesey Norman, 'George IV and Highland Dress', *Review of Scottish Culture* 10 (1988), p. 5.
23. Royal Collection Trust, RCIN 405420. The replica sword, along with other Highland dress and accoutrements belonging to the Duke of Sussex are now in the collection of the Scottish Tartans Authority, and are on long-term loan to National Museums Scotland. Another replica from Perth's gift to the prince does in fact survive. A targe in the collections at Warwick Castle is decorated with silver mounts clearly cast from the targe in the collections of National Museums Scotland. While it would be interesting to speculate that this was

also made for the Duke of Sussex, unfortunately there is no
documentary evidence to support this.

24. Dalgleish and Mechan, *I am Come Home'*, p. 8; James Drum-
mond, *Ancient Scottish Weapons* (1881), pp. 16–18.

25. Scientific analysis of the jaguar skin and the tacks holding it
on, suggest that it is original. Portrait of James VIII by Alexis
Simon Belle, *c.*1716, Weiss Gallery (illustrated in Nicholson
2002, facing p. 64); engraving after a now lost portrait of
Charles by Philippe Mercier, see Richard Sharp, *The Engraved
Record of the Jacobite Movement* (1996), no. 227.

26. Murray Pittock, *The Invention of Scotland: The Stuart Myth
and Scottish identity, 1638 to the present*, original edition (1991),
pp. 57–62; Guthrie, *The Material Culture of the Jacobites*, pp.
63–64.

27. Timothy Clayton, 'Strange, Sir Robert (1721–1792)', *Oxford
Dictionary of National Biography*, (Oxford: Oxford University
Press, 2004); online edition, September 2015:
[http://www.oxforddnb.com/view/article/26638, accessed on
5 February 2017].

28. Marquis of Ruvigny and Raineval, *The Jacobite Peerage,
Baronetage, Knightage and grants of honour* (1904), p. 194.

29. George Dalgleish, 'The Silver Travelling Canteen of Prince
Charles Edward Stuart', in Alexander Fenton and Janken
Myrdal (eds), *Food and Drink and Travelling Accessories;
Essays in Honour of Gosta Berg* (1988), pp. 168–84.

30. '*Le Soleil cache dans des nüages. PREMITVR NON OPPRIM-
ITVR. Il est cache, mais il n'en souffre pas. La Calomnie peut
noircir les plus gens de bien, mais elle ne les accable pas toûjours.*'
Claude-François Menéstrier, *La Philosophie des Images* (1682),
p. 93.

31. Guthrie, *The Material Culture of the Jacobites*, pp. 69–74;
Noel Woolf, *The Medallic Record of the Jacobite Movement*
(1988); Sharp, *The Engraved Record of the Jacobite Movement*,
nos. 118, 119, 120 and 121.

32. *Important Medieval and Renaissance Works of Art and
Celebrated Stuart Relics* [exhibition catalogue] (23 May 1928).

33. Marion F. Hamilton (ed.), 'The Locharkaig Treasure', *Miscel-
lany of the Scottish History Society*, 35, pp. 158–59, quoting from
Cluny Macpherson to Charles Edward Stuart, 8 Sept 1755,
RA SP/MAIN/359/28.

34. Further research is required in the extensive archive held at
Brodie Castle, NRA770.

35. See *The Swords and the Sorrows* [exhibition catalogue] (1996),
nos. 8:3–8:4.

36. The authors are grateful to Colin Fraser for this suggestion.

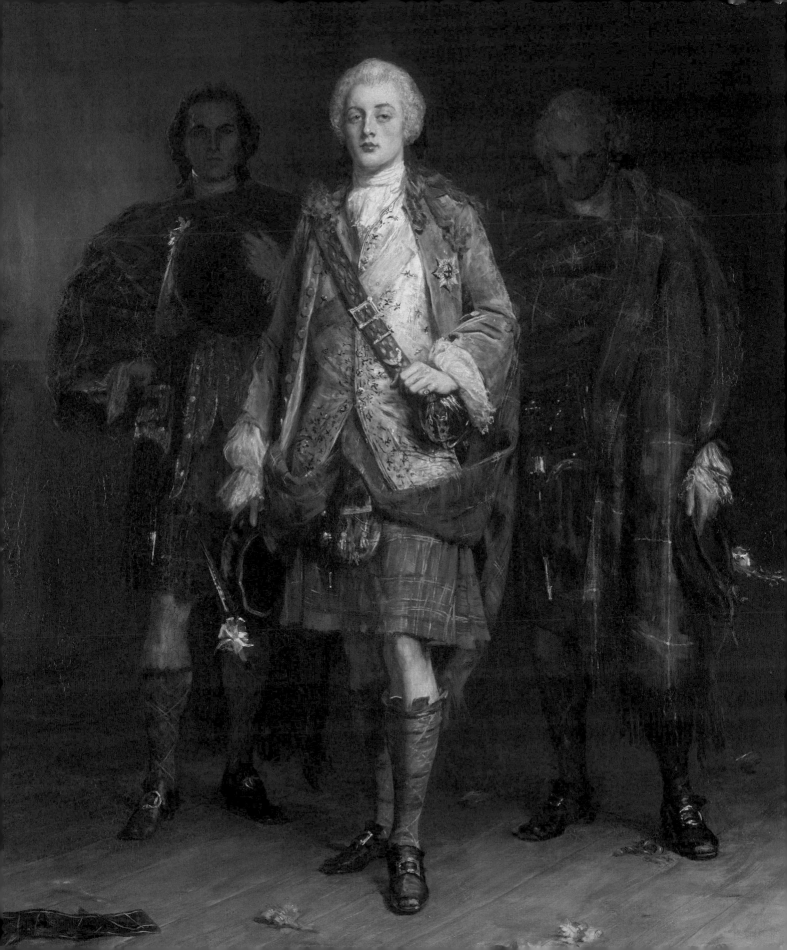

CHAPTER 6

'His little
hour of royalty'
The Stuart Court at
Holyroodhouse in 1745

Jacqueline Riding

side of Edinburgh, towards Holyrood in the east. Lord Strathallan was leading, Prince Charles behind on horseback flanked by David Wemyss, Lord Elcho and James Drummond, Duke of Perth, with Lord George Murray on foot at the head of the infantry. En route the prince was welcomed by crowds of supporters. Even though, for the vast majority of the local population, this was the first time they had seen Charles in the flesh, descriptions of him 'in highland dress' as he and his army advanced towards the capital were already in circulation via eyewitness accounts, private post (although much was intercepted) and particularly local newspapers. It is also likely that a new image produced by the Edinburgh-based engraver Richard Cooper, and known as the 'Wanted Poster' [Fig. 6.2], was in circulation just prior to the prince's arrival in the city. In this image Charles is depicted in a tartan jacket, plaid, breeches and hose, sporran and dirk, with a dark neck stock and plumed bonnet. The subscript refers to the bounty of £30,000, which had been announced by the Lords Justices in London (in King George's absence) on 1 August. The prince holds in his right hand his father's 'Manifesto' to his British subjects, which was read out at Glenfinnan and soon after printed and distributed. This image, the first recorded representation of Charles in Highland garb, coupled with the eyewitness and printed descriptions, certainly began the close association between the prince and tartan.

Charles and his retinue continued on to the southwest of Salisbury Crag, and then made their way through the hollow between the Crag and Arthur's Seat, all the while avoiding the Castle's fire. As they moved down through the steepest part of the park, Charles dismounted and continued on foot, 'but', as Lord Elcho later wrote, 'the Mob out of Curiosity, and some out of fondness to touch him or kiss his hand, were like to throw him down'.[4] As soon as he arrived at the bottom of the incline, he remounted his horse, according to the Edinburgh High School master Andrew Henderson, 'amidst repeated Acclamations, which he received with a continued tho' irregular Smile'.[5] Henderson observes:

> He was a tall, slender young Man, about five Feet ten Inches high, of a ruddy Complexion, high nosed, large rolling brown Eyes, long visage, red-haired, but at that Time wore a pale Periwig. He was in Highland Habit, had a blue Sash, wrought with Gold, that came over his Shoulder.

In contrast to Cooper's 'Wanted Poster', Henderson goes on to state that Charles wore 'red Velvet Breeches' and that 'being in his Boots I could not observe

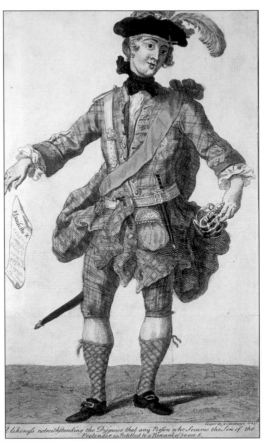

Fig. 6.2: Prince Charles Edward Stuart (1720–88), eldest son of Prince James Francis Edward Stuart ('Wanted Poster')

This satirical portrait of the Prince is known as the 'Wanted Poster'.

By Richard Cooper the Elder (1701–64), 1745, hand-coloured etching on paper, 33 x 19.1 cm, Scottish National Portrait Gallery, Edinburgh, SP IV 123.49

his Legs'.[6] John Home, a recent divinity graduate and later historian of the rising who was among the crowds in the King's Park, observed that the 'figure and presence of Charles Stuart were not ill suited to his lofty pretensions'. According to Home, while Charles stood in the Duke's Walk, 'one of the spectators endeavoured to measure shoulders with him; and said he was more than 5 feet 10 inches high'. As seen in both Henderson and Home's descriptions, the prince's unusual height is one detail that is invariably mentioned by eyewitnesses. Home continues, 'He was in the prime of youth, tall and handsome', 'he wore the Highland dress … and on his breast the star of the order of St. Andrew. Charles stood some time in the park to shew himself to the people; and then though he was very near the palace, mounted his horse, either to render himself more conspicuous, or because he rode well, and looked graceful on horseback.'[7] Charles's efforts to 'shew himself to the people', while crucially demonstrating his excellent horsemanship, a metaphor for statecraft, reveal his understanding of the basic principles of regal public display and interaction. The prince and his retinue then rode through St Anne's Yards, which lay to the south of the Abbey and Palace of Holyroodhouse (locally 'the Abbey' signified both), in Lord Elcho's words, 'Amidst the Cries of 60,000 people, who fill'd the Air with their Acclamations of joy. He dismounted in the inner court.'[8]

Despite his extraordinary success, according to witnesses Charles did not appear in any way victorious. Some might consider this appropriate restraint given the circumstances. Andrew Henderson, however, suggests that he wore an uneasy, fixed smile throughout the entire final stages of his journey to the palace. Fellow Whig, John Home, observed that the Jacobites present 'were charmed with his appearance: they compared him to Robert the Bruce, whom he resembled (they said) in his figure as in his fortune'. Yet, he continues:

The Whigs looked upon him with other eyes. They acknowledged that he was a goodly person; but they observed, that even in that triumphant hour, when he was about to enter the palace of his fathers, the air of his countenance was languid and melancholy: that he looked like a gentleman and a man of fashion, but not like a hero or a conqueror. Hence they formed their conclusions that the enterprize was above the pitch of his mind; and that his heart was not great enough for the sphere in which he moved.[9]

Meanwhile Alexander MacDonald, the famed Gaelic poet, observed 'indeed the whole scene, as I have been told by many, was rather like a dream, so quick and amazing seemed the change', concluding 'tho no doubt wise people saw well enough we had much to do still'.[10] Surely Charles was wise enough to realise this too.

Venerable Pile

In the early 18th century, the Palace of Holyroodhouse was described by Daniel Defoe as 'a very handsome Building, rather convenient than large'.[11] A quadrangle in structure, the entrance or west façade [Fig. 6.3] fronting the outer courtyard contains two main storeys, with tall windows on the principal floor and turrets at each end. The north turret was built by James V in 1534–35.[12] Charles's great-uncle, Charles II, had ordered a major remodelling of the building in the 1670s by the great Scottish architect William Bruce, which included the western frontage, the interior quadrangle, the addition of a turret to the south, and new, richly decorated royal apartments for the king and his consort, Queen Catherine of Braganza. As a result, the palace had some remains of the 16th-century building, but was predominantly 17th century in appearance. Jutting out from the north side, and slightly disturbing the elegant symmetry of the front façade, was an extension that, in 1745, was within the apartment occupied by the Dukes of Hamilton and Brandon (see below). This extension was later pulled down on the orders of George IV.[13]

According to Lord Elcho, that first evening and throughout the night a large crowd was gathered in the courtyard of the palace who cheered energetically whenever the prince could be seen at a window. It is not surprising that the appearance of a Stuart prince in Edinburgh and in residence at the Royal Palace of Holy-

Fig. 6.3: '*Holyrood House*'

After Edward Blore (d.1789), published on 1 January 1820, Royal Collection Trust / © Her Majesty Queen Elizabeth II 2017, RCIN 702906

roodhouse should have created such rejoicing among the Jacobites in the city. At the same time, as we shall see, Charles's presence clearly stimulated interest, even excitement, in citizens who were no supporters of the Catholic Stuarts. The last royal occupants of the palace had been the prince's grandfather and grandmother James VII and II and Mary of Modena, when Duke and Duchess of York during James Stuart's three-year period as his brother's Viceroy in Scotland between 1679 and 1682. It is worth stressing that in 1745 James's vice-royalty and associated court was just within living memory. Prior to that, since James VI had personally united the crowns of Scotland and England in 1603, and, soon after, journeyed to London (returning once in 1617), the late Stuart kings were, excepting the occasional visit for a coronation, very much absent.

In the intervening years, since Charles II's major redevelopment followed by his brother's occupancy, the condition of the palace, abbey and environs had visibly declined. In addition, over time, large areas of the palace had been granted to certain aristocratic families. Some of the apartments came with an official role, such as that of the Duke of Argyll who was Heritable Master of the Royal Household at Holyrood. But the chief resident of the palace was the Duke of Hamilton and Brandon as hereditary keeper, a position granted to his ancestor by Charles I in 1646 (and which the current duke still holds), who then occupied what had been the Queen's Apartments within the front or western range of the building.[14] It was in the Hamilton Apartments that Charles would now live, conduct business and hold court.

The vacated Hamilton suite was accessed through the main entrance to the palace, turning right through a colonnade, to a door, which opened on to William Bruce's majestic staircase. Above is the ornate plaster ceiling featuring angels holding the Honours of Scotland. At the top of the stairs, the vestibule leads on to the immediate right to the 'King's Apartments' (the south wing and adjoining east wing). In 1745 this area was in a particularly shabby state. However, walking directly forward, the visitor entered the 'Queen's Apartments', now the rooms of the Hamilton dukes. Only a few years before Charles's arrival, some of the palace's auxiliary areas, such as 'Necessary Houses' and 'Slaughter Houses', had been repaired, while others, particularly the Hamilton Apartments, had received a significant upgrade by order of James Hamilton, the 5th Duke (1703–43). Despite his protestations in a letter to George II (c.1740), that he had been barbarously 'misrepresented' by rumours 'of my having been to see the Pretender under the disguise of an Abbys Dress'[15] during a recent trip to Rome, in fact the 5th Duke was a Jacobite Knight of the Garter, a secret honour reserved for the most loyal.[16] And this affiliation was continued by his son, James George (b.1724), whom Lord Elcho visited in the autumn of 1744 and found to be 'a very zealous partisan of the House of Stuart'.[17] However, the 6th Duke missed all the excitement of Charles's arrival in Edinburgh. On 20 August the *Caledonian Mercury*

reported that he had been in London for a few days 'and will soon set out on his Travels'.[18] Despite their absence in the event, it is tempting to suggest, given their contact with the exiled Stuart court, that the Hamiltons were preparing for such a change of circumstances. Even if a coincidence, it was through this timely refurbishment that the prince could not only live very comfortably during his stay at the palace, but had suitably opulent surroundings as befitted the Stuart heir apparent and Regent to his father.

These apartments, formed of a sequence of connected rooms, ran from the main staircase to James V's north turret, and then beyond into the later extension.[19] The first two rooms – roughly where the current dining room and adjoining store room are now located – might accommodate groups of people simply milling about, or individuals awaiting an audience with the prince. The next (or third) room continued to act as an anteroom before the visitor entered the prince's private rooms immediately ahead. From this lobby you could view, through a doorway to your immediate right, the entire length of the Long Gallery within the northern range of the palace. This oblong room was described by the author Daniel Defoe as 'very remarkable, being adorned with the Pictures of all the *Scots* Kings from *Fergus* I. to *James* VII. inclusive, by masterly Hands. Those Kings that were eminent, and all the Race of Stuarts, are in full Length.'[20] These portraits of real and mythical Scottish kings were all painted between 1684 and 1686 by Jacob de Wet II and were originally framed and hung on the walls, rather than fixed into the panelling as now. In the autumn of 1745, this room is where the evening entertainments occurred – the 'ballroom' as depicted by John Pettie.

Continuing forward from the lobby, the visitor entered what was originally the 'Queen's antechamber', used by Charles as a dining room. To the west of the dining area was a door leading to the 'Queen's bedchamber', now the prince's withdrawing room and council chamber. The two smaller 'turret' rooms at the outer corners were possibly used by Charles as a 'closet' or study, and a plan room. Elizabeth Seymour Percy, Duchess of Northumberland, writing on 7 August 1760, recorded her stay at the palace in these rooms, observing: 'The lodgings very good and handsome; our Drawing Room, the Place where the young Pret[ende]r. kept all his Plans.'[21] Walking straight on through the little dining room, the visitor passed, via another doorway, into the extended area of the Hamilton wing, within which was another antechamber, the Duchess's dressing room, and finally the Duchess's, now the prince's, bedchamber.

The refurbishment of these interiors by another great Scottish architect, William Adam, from 1738 to 1742, had been extensive. It included new wooden flooring, sash windows, plaster ceilings, wall panelling, marble mantles and chimney-pieces, and wall hangings. In the Duchess's dressing room and bedchamber, both with windows overlooking the outer or front courtyard as well as the gardens to the north, white or dove-coloured marble fire surrounds were

Fig. 6.4: The King's Bedchamber in the Palace of Holyroodhouse

Royal Collection Trust / © Her Majesty Queen Elizabeth II 2017, RCIN 177975

installed, along with 'Dutch piggs' or tiles to embellish the fireplaces, ornately carved frames for the over-door paintings, and elegant pier-glasses provided by Francis Brodie of Lawnmarket.[22] In the alcove of the bedchamber was a magnificent, carved-wood canopied bed, covered in crimson silk damask with matching drapes [Fig. 6.4]. This bed, for many years mistaken for the one used by Mary, Queen of Scots, can still be seen in the palace. By tradition, some of the interiors at Holyroodhouse were hung with large tapestries, and Arras tapestries were also on view in the Hamilton rooms.[23]

In addition, these apartments would have been hung with hundreds of paintings – modern and old masters. A mid-18th-century inventory of the pictures, probably connected to the William Adam refurbishment, offers a good idea of what would have been covering the walls of the prince's rooms and adjoining areas. Located among the seascapes by 'Van der Velde' (an artist family patronised by Charles's grandfather James VII), landscapes and biblical scenes, were portraits of the late Stuart kings from James VI and Charles I, to Charles II (by Sir Peter Lely) and James VII (by Nicolas de Largillière and a full-length by Sir Godfrey Kneller [Fig. 6.5]): the latter a figure that Charles must have known intimately from portraits at the Palazzo del Re, yet had never met. In any case, the last Stuart king's presence was given greater poignancy and resonance located within the dynasty's ancient palace, rather than their place of exile. The rooms above Charles's council and dining rooms within James V's tower (also part of the Hamilton suite), were once occupied by Mary, Queen of Scots, and a portrait of the queen is included

in the inventory, described as 'verry curiously painted on Wood'. In the 'Dutches's bed Chamber', the inventory lists a half-length of Queen Anne, Charles's aunt, and a 'head' of her son the Duke of Gloucester, who had died aged eleven in 1700. Both are attributed to Sir Godfrey Kneller.[24] Curiously, this room also contains a whole length portrait of Philip II of Spain, the 'Armada' king and consort of Mary Tudor, and an 'Anna Bullen by Holben on wood'.[25] Anne Boleyn's husband, Henry VIII, appears listed in what is described as 'the Reed Room', alongside his first queen, Catherine of Aragon.[26] The Hamilton pictures, therefore, covered the 17th-century Stuart succession, including Queen Anne who had ascended the throne as a result of her father's 'abdication' or 'forfeiture', and even their Tudor forebears.

In Sir Walter Scott's famous novel of the rising of 1745, *Waverley; or, 'Tis Sixty Years Since* (1814), the hero, Edward Waverley, arrives at the palace, 'this venerable pile', just before the Battle of Prestonpans. He is first escorted to the long gallery, which, the author tells us, 'served as a sort of guard-chamber, or vestibule, to the apartments which the adventurous Charles Edward now occupied in the palace of his ancestors', and then on to 'a presence-room fitted up with some attempt at royal state'.[27] Later in the novel, the prince is described as walking from the long gallery or ball room 'to another suite of apartments, and assuming the seat and canopy at the head of a long range of tables, with an air of dignity mingled with courtesy which well became his high birth and lofty pretensions'.[28] With the phrase 'lofty pretensions' Scott betrays one of his sources as John Home's *History of the Rebellion* (already quoted), published just twelve years before. Crucially Scott knew the Palace of Holyroodhouse intimately and, as Andrew Lang confirms, the author had also spoken to people who knew the prince, some of whom, no doubt, had visited the palace in the autumn of 1745. Scott's novel, therefore, should be viewed as a useful, if not vital, potential source for historical detail.

The description of a 'presence-room', which appears to be within the prince's private rooms, as 'fitted up with some attempt at royal state', suggests that furnishings of a royal nature had been gathered from other parts of the palace and assembled in this room. The later description of a chamber containing a chair of state, canopy and tables may be the prince's dining room, or potentially, given the reference to 'another suite of apartments', the King's Apartments. A palace inventory of 1714 lists a number of state chairs, footstools, cloths and canopies upholstered in crimson, black or blue velvet, and decorated with gold and silver thread.[29] Some of these must have remained in the palace as symbols of the royal

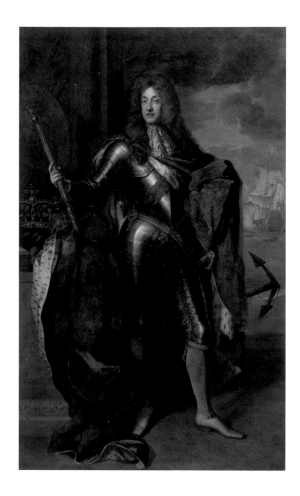

Fig. 6.5: King James [VII and] II when Duke of York

By Sir Godfrey Kneller, Bt (1646–1723), painted in 1684, oil on canvas, 245.6 x 144.2 cm, © National Portrait Gallery, London, NPG 666

presence and authority, as Sir Walter Scott intimates. The inventory of furnishings was in the possession of James Steuart, who was Keeper of the King's Wardrobe in Scotland in 1745. One of Steuart's assistants, Patrick Lindesay, was in Edinburgh and even joined the Jacobite army, so it is likely that Lindesay would have eagerly assisted in making the prince's stay not only comfortable, but regal. Lord Elcho, certainly no enthusiast of the prince at the time he was writing, recalled Charles lived at Edinburgh 'with Great Splendour and Magnificence'.[30] The chairs of state with accompanying canopies and cloths of state denoted authority, precedence and status, and some could easily have been placed in one of the prince's apartments, to add a touch of majesty to these rooms.

Aside from furniture and furnishings, the apartments would have been equipped with items such as silver cutlery, glassware and porcelain dining services. But Charles too would have arrived with his own equipage, much of it purchased in Paris prior to his departure for Scotland. A letter sent by the prince's former tutor, Sir Thomas Sheridan, to John William O'Sullivan (dated 2 May 1745 [N.S.]) includes an order for O'Sullivan to purchase plates, dishes, 'knives forks & spoons, with a soupe spoon & two *cuielleres a ragout* [stew spoons]'.[31] A single account from the celebrated Parisian silversmith, Jacques Roettiers, which includes *'cuillieres a potage'* and *'deux Chandeliere'*, amounts to 13,698 *livres*. The two chandeliers cost 24 *livres*, which, given the size of the total bill, hints at the mass of silverware in the prince's baggage.[32] Charles had also brought with him from Rome a solid silver and silver-gilt travelling canteen, made by Ebenezer Oliphant of Edinburgh, which neatly contained 31 pieces of dining equipment, including two cups, cutlery, a cruet set and a corkscrew/nutmeg grater [Catalogue no. 136]. However, despite being surrounded by such finery, this did not deter some of the local Jacobite ladies from leaving gifts, as Samuel Boyse writes: 'Several Ladies of his Party furnished him with Plate, China, and Linnen for his Apartments.'[33] Aside from Patrick Lindesay, the Duke of Hamilton's housekeeper (possibly the 'Rotson' mentioned in the palace documentation) would have maintained the rooms whether the Duke was resident or not. And it is likely that the prince's own servants, accompanied by a guard and aides-de-camp, would have formed an advance party the morning of 17 September, in order to inspect the prince's accommodation and make preparations for his imminent arrival. From his time in Edinburgh onwards, the task of managing the prince's domestic needs – when he and a sizable entourage of cooks, valets and aides-de-camp (about eighty in total) were constantly on the move from place to place and from building to building – was in the hands of James Gib, who entered the prince's service as 'Master-Houshold and provisor for the Prince's own Table'.[34]

My Palace of Holyroodhouse

Charles's time at Edinburgh immediately fell into a fairly regular pattern, partly to encourage internal discipline (which included regular courts martial) and to signal that this was an orderly, focused and well-managed team (not the clueless desperadoes of anti-Jacobite propaganda), but also, as seen with his father's daily regime in Rome, to promote visibility and allow the people access to this 'alternative' royal dynasty. In other words, whether hastily pulled together or not, this was a court. The prince held council every morning at 10 o'clock. Colonel John William O'Sullivan, now the Jacobite army's Adjutant General and Quarter Master General, records 9 o'clock, although he is probably referring to the *levee*, a reception in the prince's private rooms for his senior officers and advisers, and held prior to the council meeting.[35] According to James Maxwell of Kirkconnell, it was in Edinburgh that the council was formalised and that the 'members that composed it in the beginning were the Duke of Perth, Lord George Murray, Lord Elcho, the Secretary [John Murray of Broughton], Sir Thomas Sheridan, Mr. Sullivan, and the Highland chiefs; by degrees all the colonels of the army were admitted'.[36]

Charles's father had been proclaimed King James VIII in absentia at the Mercat Cross at midday on 17 September, just as the prince was settling in to his new residence less than a mile away. The prince may have ventured covertly into Canongate and even beyond, as he had done while in Paris to Versailles, but, due to the looming presence of the Castle and its guns, he made no formal visit during his time in Edinburgh, nor did he parade along the main thoroughfare (as memorably portrayed by David Niven). Following the reading of the Commission of Regency, Declaration and Manifesto before a large crowd consisting of both euphoric Jacobites and sullen Hanoverian loyalists, no one could be in any doubt as to who was now, for the time being, in charge. From thereon, Charles issued proclamations from 'my Palace of Holyroodhouse', including a directive that there should be no celebrations after the Battle of Prestonpans – the defeated (in his mind) being equally his father's subjects, albeit deluded into acts of treason – and several declaring the Act of Union between Scotland and England void.

There was also the crucial business of raising men for the Jacobite army, as well as money to pay the troops and supply it with the necessary food and equipment. From Holyrood, Charles sent a commission to Alexander Robertson 'of Strowan', 'empowering and authorising' him 'to raise in arms all your Tennants vasalls & followers and in Case of their refusal you are hereby impowered to use them with all vigour and severity such as raising their cattle destroying their goods & effects at your discretian [*sic*]'.[37] In similarly robust tones, under Charles's orders, his principal private secretary, John Murray, sent a letter to the Collector of Customs at Perth, ordering him to pay the money 'due upon the said [custom-

house] books to his Majesty'. This he must comply with 'upon pain of High Treason, and military Execution [martial law] to be done against your person and effects'.[38]

While at Holyrood, Charles also received petitions and petitioners. One David Gregory wrote to Charles on 26 September, addressing him as 'Prince of Wales, &c Regent of Scotland, England, France & Ireland' regarding his ships and cargo, and specifically 'the Recovery of said Ships & Cargo being detained by the Usurper [meaning King George] his Officers in a singular degree of Oppression'. Gregory had written, only six days after the surprise victory at Prestonpans, because of 'His Highness['s] known Clemency'.[39] One instance of a petition in person is recorded by Patrick Crichton and involved a local Quaker and brewer, Thomas Erskine, son of the Rev. Philip Erskine of Parsonfield, Northumberland. Erskine had been 'robbed and plundered' by some of the prince's men and took his complaint to Holyroodhouse where, 'in the blunt plain way of that people he said "freind [sic] Charles, [King] George his men when they came took a parte but thy men have taken all from me, Charles thow art seeking a crown but this is not the way to obtain it".' This must have been the first time that this royal prince had been called plain 'Charles' rather than 'Your Royal Highness' by anyone other than a member of his immediate family. Apparently in response to this plain-speaking petitioner, the 'Prince said if he cowld know and poynt owt who had done this he showld have redress', to which, Crichton continues, 'Erskin answered "Charles thow owght to know thy men and keep them in order I am not conserned [sic] to know thy friends," and so he was dismissed'.[40]

If staying overnight at the palace, rather than sleeping under canvas in the field, Charles would then ride out from Holyrood to Duddingston, where the majority of the Jacobite army was encamped. Alexander Carlyle, son of the minister of Prestonpans, recalled visiting Holyroodhouse twice 'about 12 o clock to wait till the Prince should come out of the Palace, and Mount his Horse to Ride to the East Side of Arthur Seat to Visit his Army. I had the Good Fortune to see him both Days, one of which I was close by him, when he walk'd thro' the Guard to take his Horse.' Alexander offers a familiar description of the prince as being 'a Good Looking Man of about 5 Feet 10 Inches. His Hair was Dark Red and his Eyes Black' while 'his Countenance [was] Thoughtful and Melancholy.'[41] Charles certainly had much to be thoughtful about. Colonel John William O'Sullivan later described Charles's dedication to the task in hand, in particular overseeing the daily drilling of his troops. He states that the prince

... was up every day of his life before day, his orders given & his affaires of the Cabinet finished, eat a bit and went to the Camp, wch was near the Kings Park, where he employed the rest of the day, in exercising the men, makeing 'um march, seeing the Guards mounted, made several General reviews, in short every thing,

[that] *cou'd contribute to form 'um. He lay commonly in the field, as well to acoustom the men to Camp, as the officers.*[42]

The prince's presence at the camp was another opportunity for him to 'shew himself'. Magdalen Pringle, who was in her teens in 1745 and the daughter of a staunchly Whig family, wrote to her sister Tib, declaring:

O lass such a fine show as I saw on Wednesday last. I went to the Camp at Duddingston and saw the Prince review his men. He was sitting in his Tent when I came first to the field. The Ladies made a circle round the Tent and after we had Gaz'd our fill at him he came out of the Tent with a grace and Majesty that is unexpressible. He saluted all the Circle with an air of grandeur and affability capable of Charming the most obstinate Whig and mounting his Horse which was in the middle of the circle he rode off to view the men. As the circle was narrow and the Horse very Gentle we were all extremely near to him when he mounted and in all my Life I never saw so noble nor so Graceful an appearance as His Highness made, he was in great spirits and very cheerful; which I have never seen him before.[43]

This adoration, welcomed at first, must have become very wearisome indeed as the weeks passed by. But despite the extreme pressure Charles was under, he continued to maintain an air of affability and politeness, no doubt aware that (whatever his state of mind) he could never let the charm offensive slip.

In fact, the prince's high spirits, as reported by Magdalen on 13 October, may have been caused by the imminent arrival of Alexandre de Boyer, marquis d'Eguilles of Aix en Provence, a lawyer by profession and a protégé of the French minister, the marquis d'Argenson, who arrived at Holyroodhouse on 14 October as an envoy and observer from the French court. D'Eguilles was accompanied by some money and troops but, more importantly, protestations of love and support from Charles's dilatory cousin, King Louis XV. French support, by way of an invasion force (to the south-east of England), was crucial to the prince's plans. Charles and his council described the newcomer as the 'French Ambassador', a title that, in their minds as least, signalled that this was a legitimate court.

In addition to describing his charming manners and attractive physical appearance, Magdalen observes that the prince was wearing 'a Blue Grogrum Coat' trimmed with gold lace, a red waistcoat similarly decorated, and breeches. He was also wearing the Garter star. His hat, a modern tricorn which had replaced the blue bonnet, was adorned with a white feather and a white cockade, and was also trimmed with gold lace. Magdalen observes, 'I don't believe Cesar was more engagingly form'd nor more dangerous to the liberties of his country than this Chap may be, if he sets about it'. She then concludes, 'he looks much better in

Lowland than in Highland Dress'.[44] In being seen in both styles, Charles was clearly aiming to appeal to as broad a Scottish following as possible (and succeeding, if Magdalen's adoring comments are anything to go by), and this conscious alternation in his dress continued throughout most stages of the campaign. While at Manchester, for example, at the end of November, Lord Elcho records that Charles was so taken by the welcome he had received there 'that he thought himself sure of Success, and his Conversation that night at Table was, in what manner he should enter London, on horse-back or a foot, and in what dress'.[45] As the prince knew all too well, appearances really did count. He was also aligning his 'orders' with his dress: the Order of the Thistle with Highland dress, the Garter with 'Lowland' or modern dress.

According to Lord Elcho, after reviewing his troops the prince returned to the Abbey, 'where he received the ladies of fashion that came to his drawing room. Then he Sup'd in publick, and Generaly their was musick at Supper, and a ball afterwards.'[46] Public dining was particularly associated with the French court. Charles had first-hand experience of the conventions that regulated the life of King Louis at Versailles through covert visits to the palace, while living in Paris, just prior to setting out for Scotland [Fig. 6.6]. On one memorable occasion, the prince attended a masque ball in the February of 1745, under the very noses of the king, the extended Bourbon royal family, ministers and court.[47] Further, some of the

Fig. 6.6: Masked Ball at the Gallerie des Glaces, 17th February 1745, Versailles

By Charles Nicolas Cochin II (1715–90), 17 February 1745, pen, ink and watercolour on paper, Louvre, Paris, France / Bridgeman Images, XIR71348

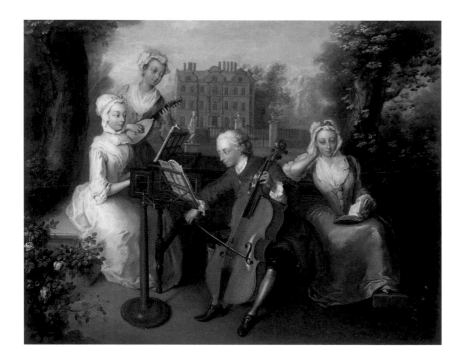

prince's companions, the Duke of Perth for one, had been educated, or had lived in exile, in France: replicating such court customs would be second nature. During public dining, even if there is no direct interaction between the prince and his audience, every comment he made to his companions would be heard, recorded and disseminated. Such a circumstance was recounted by Andrew Henderson, who recalls that Charles, 'to win the Hearts of the Populace, he admitted all to see him dine, during which Time he frequently said, "if I succeed, *Scotland* shall be my *Hanover*, and the Palace of *Holyroodhouse* my *Herenhausen*".' This reference to King George's routine visits to his German domains appears to confirm Charles's desire, if successful in the restoration of the Stuarts to all their former kingdoms, to spend the majority of his time in London, but with the promise of regular, extended visits to Scotland and Holyroodhouse – a vast improvement on recent Stuart and then Hanoverian performance.

It is no surprise that Charles enjoyed listening to music, as Lord Elcho recalled, as he 'supped', and we can imagine a small ensemble playing during such public appearances. Charles was a talented musician, with the 'bass viol', a form of 'cello, his favoured instrument. Incidentally, this was a talent shared with his Hanoverian cousin, Frederick Louis, Prince of Wales [Fig. 6.7]. In 1742 James Edgar, private secretary of Charles's father, observed that Charles would spend most days hunting, but 'at night after a days strong fatigue [he] sits down and diverts himself with musick for an hour or two, as if he had not been abroad, and plays his part upon the Bass Viol extremely well, for he loves and understands

musick to a great degree'.[48] Charles was also a regular and highly visible attendee of opera and musical entertainments in Rome, alongside his father and brother, and musical concerts were frequently performed at the Palazzo del Re.[49] Charles de Brosses recalled attending concerts at the Stuart court, during which Charles and Henry both participated. At one such event, he notes that the repertoire included Arcangelo Corelli's 'Christmas Concerto' ('la note dinatale').[50] Even while incognito in Paris, Charles had written to Edgar concerning some un-named sheet music for Henry: 'I send it as a rarety; for except this that is here, all the musick in Paris is not worth a straw; the Duke is acquainted with the author, but I am very shure he has not this work which is extremely fine. I can say so for I heard it plade one evening at Obrions [a Jacobite agent].'[51]

Some in Charles's immediate circle were concerned at this punishing daily regime, and believed that he required temporary distraction. Colonel O'Sullivan states that 'The Prince, while he was at Edenbourg, never took or employed a moment for his pleasure'. He continues:

> *People seeing H.R.Hs. continually occupied & wou'd at utmost spend four hours in his bed, imagined to divert him, & as a great many Ladys us'd to come & pay their Court, when he suped at the Abbey, they propos'd a Bal to those Lady's, thinking the Prince wou'd take pleasure in it wch he consented to. The Prince went to see the Lady's dance, made them complymts on their dance & good grace, & retired; some gents followed him, & told him, yt they knew he loved danceing, & yt the Ball was designed for him to amuse him; 'Its very true,' says the Prince, 'I like danceing, & am very glad to see the Lady's & yu divert yr selfs, but I have now another Air to dance, until that be finished I'l dance no other.' It was very strange yt a Prince of that age who really liked danceing, & fowling, never thought of any pleasures, & was as retired as a man of sixty.*[52]

O'Sullivan was writing to Charles's father a few years after the event, but his description chimes with other observers, such as Henderson and Home, in so far that the prince was clearly aware of the enormity of his task and appeared thoughtful or occupied – 'melancholy' as the opposition would have it – as a result. His resistance to 'pleasures' or distractions, when it did not serve a direct or obvious purpose, is consistent. It is also believed that when young he had sworn a vow of chastity, which, along with his devotion to his primary task, the restoration, was offered in exchange for his success.[53]

The Blessed Object

Given the extraordinary events at Holyroodhouse in the autumn of 1745, it is surprising that there is little extant evidence, aside from written descriptions

and communications, of Charles's time there. However, in addition to Richard Cooper's 'Wanted Poster', there are two further images that can be directly related to this period: one created by the prince's enemies and one on the order of the prince himself. Regarding the former, it was a key aim of the anti-Jacobite propaganda to undermine the legitimacy of Charles's claim and to win over popular opinion by exaggerating his otherness: stressing, on the one hand, his birth and upbringing in Rome as a Catholic – an important distinction in a predominantly Protestant Great Britain – the sponsorship of his family in exile by successive popes, and, on the other, his widely-reported wearing of Highland garb. Charles is not recorded as attending any divine service during the campaign. He was keen, however, to display tolerance for all Christian worship and even to distance himself from his Catholicism. A Stuart hinting at a willingness to convert for the sake of his country – as his ancestor Henry IV of France before him – was not a concept that the British government could allow to gain popular currency. As has already been noted, throughout the rising in 1745, Charles strategically alternated his appearance from that of a fashionably-dressed European prince to that of a tartan-clad Highland chief. In so doing, he was clearly attempting to answer the expectations of what was – at the beginning of the campaign at least – a predominantly Highland Jacobite army, while at the same time responding to the urgent need to appeal to, and ultimately win over, the majority of Britons, many of whom (Lowlanders and English alike) considered the Highlander (as represented through their traditional dress, the tartan plaid) a barbaric anachronism. Magdalen Pringle's aside, 'he looks much better in Lowland than in Highland Dress', is an indication of this outlook.

There was a further aspect to the prince's appeal that the opposition eagerly alighted on. As the various descriptions and particularly Magdalen Pringle's full account reveal, Charles certainly had a pronounced impact on women. Soon after the Battle of Prestonpans, a broadsheet was circulated purporting to be the contents of a letter by Miss Christian Threipland, a member of a staunch Jacobite family from near Perth. In this letter Charles is described as 'the blessed Object', 'a Gift from Heaven', *'Top of Perfection'* and *'Heaven's Darling'*. The publishing of the letter clearly aimed to highlight the fervour that Charles was stimulating in some of his female followers and, by association, to ridicule the prince himself. For a 'conquering hero', as the Jacobites saw him (according to John Home), might enjoy the love and admiration of his people, but only a preening fop would encourage such foolishness. Furthermore, the use of terms such as 'blessed Object' and 'Heaven's Darling' is suggestive of 'Sacred Majesty', a cornerstone of Jacobite literary and visual culture, while their usage here is akin to the response of an ecstatic saint in the presence of divinity. To some, particularly members of the Presbyterian Kirk, such phrases might smack of papism.

A print by Pierre Charles Canot, entitled *Scotch Female Gallantry* [Fig. 6.8],

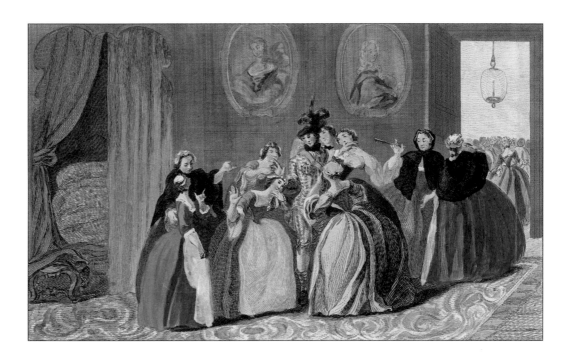

Fig. 6.8: *Scotch Female Gallantry*

By Pierre Charles Canot (1710–77), 8 January 1745–46, hand-coloured etching on paper, 21.3 x 28.7 cm, © The Trustees of the British Museum, 1898,0520.172

published on 8 January 1745/46 [O.S.] meshes together these various guises: the foreigner, the fop, the papist. The scene is apparently the prince's bedroom, suggesting an intimate levee or gathering held in his private chambers, while an open door to the right reveals an entertainment occurring in a large adjoining room. This seems to partly align with Lord Elcho's description of Charles receiving the 'ladies of fashion' in his drawing room (rather than his bedroom), and that afterwards a ball was held. The subscript confirms that this scene is intended specifically to represent an event within Charles's court at Holyroodhouse by the opening line, 'To Edinburgh Charley came'.

In Canot's engraving, a bevy of admiring females surround the central figure of the prince, or 'tall staring youth'. On the wall behind are a pair of aristocratic portraits, possibly signifying the prince's mother and father, as they are facing away from each other: James Francis Edward and Maria Clementina had been famously and, to some, scandalously estranged for most of their marriage. To the left, one bed curtain is pulled theatrically to one side, to reveal the invitingly plump bolster and mattress covered in a richly flowered silk. The women present, some dressed in the black masquerade cape or 'domino' most famously associated with Italian carnivals, are teasingly tiptoeing about the prince, in the hope of stealing a kiss or, given the proximity of the bed, something more. The reference to the masquerade is pertinent, as British travellers to Rome, up to 1743, had reported in their journals and letters home, sightings of the prince at masked balls during the carnival season. On one famous occasion, as reported by John

Russell, Charles was 'dressed in a Scotch Highlander's habit, with a bonnet, target, and broad sword; and adorned with jewels to the value of 100,000 Roman crowns'.[54] One woman standing at the doorway seems to be beckoning to another woman to join them. The prince appears, like his younger self in Rome, as an exotic creature, separated from his male companions and 'on display' in a side room, to be clucked over, fondled and flirted with. The feather and bonnet, the dark neck stock, Garter star, tartan short coat, breeches and hose are all seen in Cooper's 'Wanted Poster', which, by now, would have been known well beyond Edinburgh, and certainly acted as one model for Canot's image.

But Canot's print, I would argue, goes a significant step further than simply ridiculing Charles's 'gallant' female supporters, by suggesting that the prince was feminine or unmanly himself. Charles's tartan plaid coat is fitted so tightly across his torso, narrow waist and curvaceous hips, that it now mimics the bodices of the swooning women. This continues down to his ample thighs wrapped snugly in tartan breeches. In this way the figure of the Stuart prince becomes reminiscent of another 'Italian import' who were, likewise, desirable to the more impression-able female Britons: the Castrati singers of Italian opera. Canot's subscript not only draws attention to Charles's Roman Catholicism, but establishes his close association with the papacy itself by declaring that 'Charley' had 'bow'd, and kis'd the Papal Toe'. Castrati were also associated with the papacy. Young boys of eight were castrated so that their 'pure' singing voices could, as adults, embellish the Sistine Chapel choir and a few, like Carlo Maria Michelangelo Nicola Broschi, known as Farinelli, became international singing stars of the royal courts and opera houses of Europe. Crucially, a characteristic of the castrati was their unusual height (one of the effects of castration before puberty), as well as the high female singing pitch belted out from powerful male lungs. In Joseph Goupy's print of c.1734 [Fig. 6.9], the central figure of either Farinelli or Senesino towers over the soprano Francesca Cuzzoni. Their clasped hands suggests an affecting love scene, and Cuzzoni in response, like the 'Scottish Nymphs' in Canot's engraving, gazes up adoringly at her beau.

And more damning still, in the engraving attributed to Hubert Gravelot of c.1740 [Fig. 6.10], a castrato, either Farinelli or Monticelli, is shown lolling in an Italian landscape like an oriental potentate on a low-lying peacock 'throne', a cat playing with his severed testicles, while the singer's muse caresses what remains. Returning to Canot's print, the artist has exaggerated the plumes on top of Charles's head to relate more directly to a theatrical headdress (as sported by the singer), while the elegant curve of the castrato's half bare leg is echoed in Canot's depiction of the prince. Within the subscript of *Scotch Female Gallantry* is the sexual innuendo, 'And last the waddling Jennet came, And with his Finger cool'd her Flame'. The verse goes on to warn 'English nymphs' not to succumb to the prince's poisonous charms.

Fig. 6.9: Etching of the Castrato Farinelli or Senesino

Satire on the popularity of masquerades and the decline of the Italian opera in London, with caricatures of the singers Francesca Cuzzoni, the tall thin 'scarecrow' Farinelli or perhaps Senesino, and the impressario Heidegger.

By Joseph Goupy (1689–1769), 1730–40, etching on paper, 33.3 x 20.9 cm, © The Trustees of the British Museum, 1868,0808.3572

Fig. 6.10: Satire on a Castrato singer, Farinelli or Angelo Maria Monticelli

Attributed to Hubert François Gravelot (1699–1773), 1730–40, etching on paper, 23.4 x 27.6 cm, © The Trustees of the British Museum, 1868,0612.1199

In addition to images directly relating to castrati, Canot must also have called upon popular knowledge of other recent examples of graphic satire, including the artist William Hogarth's *A Rake's Progress* (published 1734) and, more topical still, *Marriage A-la-Mode*, published only six months before Charles's arrival in Edinburgh. In the *Countess' Levee* [see *Marriage-A-la-Mode*, Fig. 6.11], a gathering held in her bedroom, a woman swoons as a castrato warbles on, while Countess Squanderfield arranges a clandestine meeting at a masquerade ball with her lover, Lawyer Silvertongue. In fact, in Canot's image Prince Charles becomes worse than a foreign fop, he is emasculated; while the moral rectitude of his female admirers, swooning with desire, is also in question.

Leaping forward to the June of 1746, while a fugitive, Charles gives a boost to the idea of his effeminacy, and even degeneracy, by disguising himself – apparently at Flora MacDonald's insistence, but nonetheless willingly – as the Irish servant, Betty Burke. The subscript to the famous mezzotint by John Michael Williams [Fig. 6.12] states: 'Routed, o'er Hills the young Adventurer flies, And in a Cottage sinks to this Disguise.' The key word here is 'sinks'. Meanwhile, the idea of the cosseted, effeminate Italian continued, as Horace Walpole wrote in August 1746: 'We know nothing certainly of the young Pretender, but that he is concealed in Scotland, and devoured with distempers: I really wonder how an Italian constitution can have supported such rigours!'[55] The effeminate Italian import, now masquerading as a Highland Laddie, was firmly entrenched in anti-

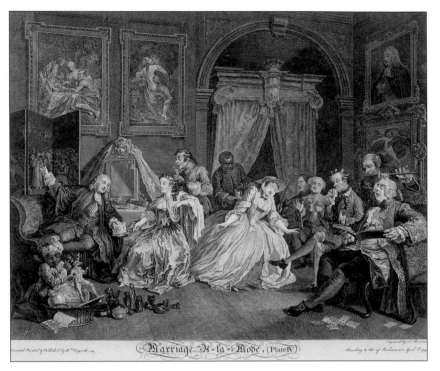

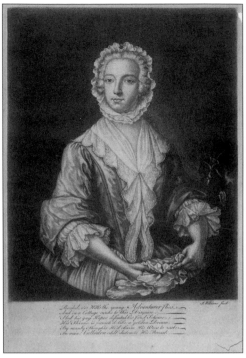

Jacobite visual culture. One example is the post-Culloden print, *The True Contrast*, which crudely balances the fleeing, cringing 'Italian Bravo' with the coolly determined 'British hero', the Duke of Cumberland [Fig. 6.13].

However, it was not as a Highland chief that Charles chose to be depicted while in Edinburgh. On 26 October, Allan Ramsay, the now famous London-based portrait painter, received a note from Colonel John Roy Stuart requiring his presence at Holyrood 'to take his Royal Highnesses Picture'. The brief note concludes 'so I expect you'll want no further call',[56] suggesting, given the times, some understandable hesitation on Ramsay's part. The portrait is almost certainly the painting recently acquired for the Scottish National Portrait Gallery [see Chapter 7]. In contrast to Richard Cooper's image and the countless eyewitness descriptions of him in Highland garb, Charles is here immortalised as a modern man of the European social and political élite, in a pale lilac velvet coat with silver lace, a gold waistcoat, his wig neatly 'buckled', powdered and tied with a ribbon, from which white curls tumble down his back. This ensemble of lilac, silver and gold is more luxuriant still than the prince's blue, red and silver-trimmed attire, as described by Magdalen Pringle, and indeed, here Charles is much more than a 'man of fashion': he is a European, or perhaps more accurately, British prince, signalled by the red velvet train, trimmed with ermine, which is draped over his left arm, and the blue Garter sash with Garter star. He is depicted

Fig. 6.11, left: *Marriage A-la-Mode (plate IV)*

After William Hogarth (1697–1764), 1745, etching on paper, 38.5 x 46 cm, © The Trustees of the British Museum, 1857,0228.67

Fig. 6.12, above: Prince Charles Edward Stuart (1720–88) as Betty Burke

By John Michael Williams (1710–c.80), c.1746, mezzotint on paper, 29 x 22.6 cm, Scottish National Portrait Gallery, Edinburgh, SP IV 123.23

Fig. 6.13: *The True Contrast / The Royal British Hero / The Fright'ned Italian Bravo*

in a manner that a majority of the British population at this time, in tandem with Magdalen Pringle, would have considered suited him, and them, 'much better'.

In fact, prior to his arrival in Scotland, official images of the prince were, without exception, variations of this portrait type.[57] Such Stuart 'Court Art', as earlier established by painters such as Sir Anthony van Dyck under Charles I and Sir Peter Lely under Charles II, continued to be created, copied and circulated throughout their exile.[58] Louis Gabriel Blanchet's 1739 portrait of the still teenage Charles [Catalogue no. 137] represents, in bearing and symbolism, an appropriate image of princely poise: a young man who is 'equally qualified', as Secretary John Murray declared, 'to preside in Peace and War'.[59] The heavy swathes of rich ermine, the gold and silver armour, and the badges of the Chivalric Orders of the Garter and Thistle, are all worn with ease and entitlement, and, as a backdrop, the 'Stuart sun' is, at last, rising. The prince's steady gaze and the languid gesture of his right hand act as a reminder, to whoever stands before him, that our natural loyalty is to the true British royal prince and, by association, the true British royal dynasty: 'true' by divine not mere parliamentary right. Similarly, in the Ramsay portrait, Charles stares out in a direct manner, enveloped by royal symbolism and luxury, but with an expression that is less autocratic than that of his younger self. The expression is still regal, but perhaps more desiring of, or appealing to, our loyalty, than demanding or expecting of it. Further, he appears much older than the six years separating the two images might suggest. We could therefore detect that the

weight of responsibility, as well as the rigours of a military campaign, have matured him both in experience and outlook, as well as appearance.

The timing of the Ramsay portrait, with all its covert and overt signals, is the key as to why Charles is shown in this manner: indeed, the very purpose of its creation. The prince left Holyroodhouse on 31 October *en route* to England. There is anecdotal evidence that Charles had images of himself, which he distributed as gifts to his supporters and admirers during the advance to London. Katharine Thomson, writing in the mid-19th century, recalls a tradition in her own family regarding her grandmother from Derbyshire, who was presented with a 'picture' by Charles himself and then 'kept the portrait of the Prince behind the door of her bedchamber, carefully veiled from any but friendly inspection'.[60] It is very unlikely that Charles had a stock of painted portrait miniatures to distribute to his followers. Unlike previous restoration attempts, when there would have been time to prepare such gifts (in any quantity at least), the 1745 rising was totally improvised and kept completely secret from everyone including the prince's father, excepting a tiny, select group of Jacobites. Charles's long stay at Edinburgh was the first opportunity for an up-to-date portrait to be produced and then, potentially, replicated. Given the change in his appearance, an image that better reflected his maturity, as well as his royalty, would have even greater impact on his general appeal and ultimately, it would be hoped, his campaign.

This small-scale portrait by Ramsay, the face probably produced in one swift sitting, appears to be the prototype for a sequence of engravings, including mezzotints, attributed to Robert Strange. A mezzotint plate could be produced at great speed, unlike a copper plate, and as a result mezzotints, often crudely executed, were quickly turned around to capitalise on topical events and personalities, such as visiting royals or celebrities: Charles was arguably both. Besides which, Robert Strange joined the prince at Edinburgh and was therefore on campaign with him throughout, making it very likely that such a mezzotint was indeed produced [Chapter 7, Fig. 5]. What is clear is that when Charles had the choice, prior to the pursuit of his ultimate goal, London, he fell back on the standard, i.e. pre-1745, court portrait style, rather than something reflective of his more recent persona, the tartan-clad Highland Chief. This image was intended to shore up the ardour of the Jacobite faithful and, crucially, to encourage, by the simple act of looking upon his 'blessed' face, conversion to the Stuart cause.

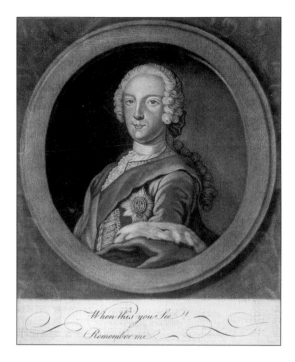

Fig. 6.14: Portrait of Prince Charles Edward Stuart ('*When this you See! Remember me*')

This mezzotint is currently catalogued as 'after Phillip Mercier', but could be after the Allan Ramsay portrait. Unlike the mezzotints attributed to Robert Strange, which have the subscript 'The Young Pretender', this engraving, with its 'Remember me' message, is clearly a Jacobite image.

Anonymous, after Philip Mercier, mezzotint on paper, 18.8 x 15.0 cm, © The Trustees of the British Museum, 1902,1011.7038

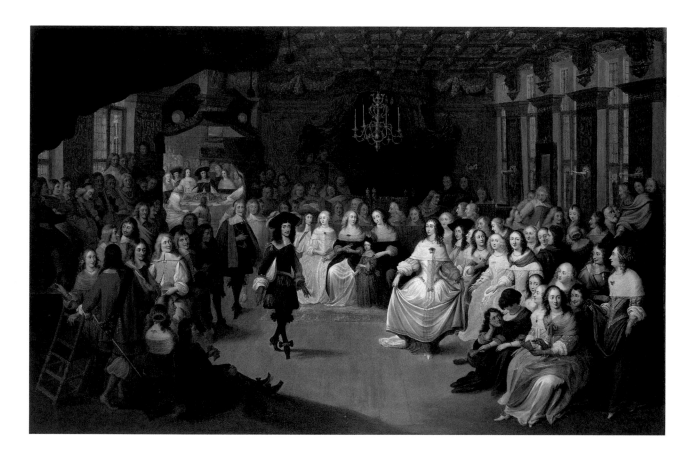

Fig. 6.15: Charles II dancing at a Ball at Court, c.1660

The painting depicts Charles Stuart at a ball in The Hague, prior to his return to England.

By Hieronymous Janssens (1624–93), painted in c.1660, oil on canvas, Royal Collection Trust / © Her Majesty Queen Elizabeth II 2017, RCIN 400525

Bonnie Prince

In 1889 an exhibition entitled 'The Royal House of Stuart' at the New Gallery on Regent Street, London, brought together hundreds of objects – mainly paintings and 'relics' – relating to the history of the Stuart dynasty. The core of this exhibition was lent by its patron, Queen Victoria, who was doubtless keen to promote her Stuart credentials.[61] Among the exhibits were Blanchet's portrait of the young Charles Edward in armour, and a painting from the Royal Collection depicting Charles II at a ball in The Hague, just prior to him setting sail for England in 1660 [Fig. 6.15]. Might John Pettie, seeing this other Charles Stuart at a ball in celebration of his dynasty's restoration, sense the tragic resonances for another would-be king? The exhibition certainly demonstrated the history of the later Stuarts, from Charles I to Henry Benedict, Cardinal York (Henry IX) via Charles Edward Stuart, as ripe with pathos and portent. In his depiction of the prince, Pettie must also have sought inspiration from the well-known eyewitness accounts, such as that of John Home, who described him as 'a man of fashion' rather than 'a hero or a conqueror'. Pettie's Bonnie Prince only looks capable of

leading an army of Highlanders by sheer dint of his 'divine right', rather than any aptitude for military strategy, or prowess with the broadsword that hangs at his side. Pettie may also have been aware of the reports of those British 'Grand Tourists', visiting Rome in the 1740s, who described Charles's appearances at masquerade balls, most pertinently as a bejewelled adolescent clan chief. Not unlike, we can imagine, the dazzling youth of history, Pettie's prince awaits the adoration due to him, while resting his hand, with little assurance, on the sword's hilt: a gesture which, like his overly fancy – or 'fancy dress' – costume, and in contrast with the rugged Highland garb and burly presence of his companions, suggests a character better suited to the ballroom than the battlefield. Pettie has softened the prince's face still further by ignoring the many accounts – let alone the portraits that confirm this to be the case – describing Charles's dark-brown eyes, presenting them instead as pale blue: possibly his model, and son-in-law, Hamish McCunn's eye colour, but in any case a decision that is historically incorrect.[62]

Collectively it is this absence of the 'conquering hero' that vexed one prominent art critic in 1892. In his review for *The Art Journal*, Claude Phillips wrote, 'It is difficult to imagine a rendering of a popular theme at once more melodramatic and more dispiriting in its absence of true fire than Mr. John Pettie's "Bonnie Prince Charlie" (R.A.)'.[63] Clearly Phillips would have preferred Pettie's prince to display more confidence, even bravado, at this 'high point' of his campaign. The prince's decorative rather than functional/martial attire does little to assist here. Of course the historic Charles, in 1745, did not know that his time at Holyrood would turn out to be a rare 'high' point. Andrew Lang, echoing Claude Phillips sentiments, observed:

> *Mr Pettie's picture of 'Bonnie Prince Charlie', in the Royal Academy, is no doubt a learned work, and the Prince is 'bonnie' enough. But he is rather pretty than beautiful, a* petit-maître, *with a weak, foolish, fair face, and beautiful hair under his wig. This is not he who would fain have led the charge at Gladsmuir* [Prestonpans]*, whose heart broke at Derby, who, by little fault of his own, did not fall at Culloden.*

Lang goes on to refer to an unnamed image of the prince, which he states was executed just prior to the 1745 rising, as being 'beautiful, like the face of a poet', tinged with 'melancholy': 'He has found that his royalty is a ghost of old faith, and his crown a crown of air.'[64] So for Lang an aura of heroic melancholy was acceptable, even desirable. What evidently offends both Phillips and Lang is that Pettie's prince is delicate rather than virile, more the effete foreign fop than the heir to Wallace and the Bruce.

In fact, the key to Pettie's interpretation is an author who would have been crucial to the late Victorian public's recognition of both subject and meaning –

Sir Walter Scott. Pettie's nephew and biographer, Martin Hardie, wrote in 1909 that 'he was powerfully affected by the novels of Scott, by his richness of romance and stirring incident, his masterly portrayal of character, his glow of life and colour'.[65] In *Waverley*, confirmed as Pettie's inspiration by Hardie, the reader and the eponymous hero first encounter Charles almost by accident, emerging from a group of Highlanders.[66] Later, in the chapter entitled 'The Ball', Scott uses the context of the prince's court at Holyroodhouse to present a figure of such regal dignity, courtesy and humility that even a skeptical reader would find themselves willingly beguiled by him. The ball at Holyroodhouse is therefore a stunning example of Scott's facility to reanimate history, to let it 'glow' with 'life and colour', while defining the 'stirring incident'.

There is nothing humble about the artist's rendition of the 'Bonnie Prince'. However, here too Scott provides the answer, for the author was no infatuated admirer of the historical Charles or his cause. In *Tales of a Grandfather* (first published in 1828) Scott aims to avoid the 'exaggerated praise' of the prince's followers as well as the 'disparaging language' of his opponents, yet argues that the prince had been exclusively trained up, by ill-advised tutors,

> … *in those absurd, perverse, exaggerated and antiquated doctrines of divine hereditary right, and passive obedience out of which had arisen the errors and misfortunes of the reign of his ancestor, James the Second of England. He had been also so strictly brought up in the Roman Catholic faith, which had proved so fatal to his grandfather; and thus he was presented to the British nation without any alteration or modification of those false tenets in church and state so obnoxious to those whom he called his subjects, and which had cost his ancestor a throne.*[67]

This adherence to regal prerogative, coupled with a 'temper naturally haughty and cold', led to a profound indifference to the suffering of his followers, and 'an indulgence in rash and sanguine hopes'. Worse still, the prince showed little concern for the suffering his madcap scheme had caused his followers. For it was 'the duty of every subject to sacrifice everything for his Prince, and if this duty was discharged, what results could be imagined too difficult for their efforts?'[68] Such inherently negative character traits, Scott continues, were 'carefully veiled' by his adherents in Scotland and England.[69] The artist's own opinion is suggested by his nephew's comment, 'The contrast between the prince with his fair, but rather weak, sensual face, and his two stalwart Highland supporters, is cleverly enforced'.[70] We can presume that Pettie's sympathies lay – like Scott's – with the loyal Highland clans, and not, the artist and author might say, with a self-centred, self-indulgent and ultimately uncaring prince who, when the time came, would abandon them to their fate.

Conclusion

In spite of all his demonstrable leadership, courage and personal allure, the historical Charles was neither in appearance nor in character the heir to the Scottish warrior-heroes of the past. Pettie's interpretation is consistent with this historical fact. But aloofness and self-centredness were hardly rare traits in princes of the *ancien regime*. Yet whatever his faults or the legitimacy, or otherwise, of his aims, we cannot allow this reading of his character to cloud the true meaning and significance of Charles's time at Holyrood. The prince's 'little hour of royalty' was actually a self-conscious display of 'royal' government, and even majesty. In Charles's mind, indeed in the mind of his father and his followers, and like his grandfather before him, the prince was residing at Holyroodhouse in the capacity of regent in the absence of the king. As the Jacobite prince regent, Charles must be seen to be the dignified physical and symbolic presence of his royal father, and, as such, maintaining a court, with all the trappings and events associated with it – including a direct engagement with visual culture – was crucial. Such regal accoutrement would be seen as a visible statement of that reality. Certainly the prince's very presence in the palace, and his army's swift and bloodless occupation of the capital of Scotland, was an indication of how far King George's authority had collapsed. Further, the prince's time at Holyroodhouse not only aimed to establish him as a fitting, legitimate claimant or, indeed, the true heir apparent to the British throne, but, more fundamental still, it acted as an indication, or dress rehearsal, for a restored Stuart dynasty. As even Sir Walter Scott later playfully observed: 'The Court at Holyrood was in those halcyon days of Jacobitism so much frequented by persons of distinction, that it might almost have been supposed the restoration had already taken place.'[71] Charles's residency at Holyroodhouse should be restored to its true status as the last Stuart court in Great Britain.

Acknowledgements

I am very grateful to David Forsyth for the opportunity to reassess, revise and build on the research and ideas which I first explored in the short article, 'Charlie will come again', *History Today* 61:4 (April 2011), pp 42–48; and in *Jacobites: A New History of the '45 Rebellion* (2016).

The Cumberland (CP) and Stuart Papers (SP) in the Royal Archives (RA) are quoted with the kind permission of Her Majesty Queen Elizabeth II.

Notes

1. They are thought to be Donald Cameron of Lochiel and Alexander Forbes, 4th Lord Pitsligo: see Deborah Clarke and Vanessa Remington, *Scottish Artists 1750-1900: From Caledonia to the Continent* (2015), p. 162.

2. Andrew Lang, *Prince Charles Edward Stuart: The Young Chevalier* (1900; new edition 1903), pp. 2–3.

3. Frank McLynn, *Charles Edward Stuart: A Tragedy in Many Acts* (1988). The biography was republished in 2003 as *Bonnie Prince Charlie: Charles Edward Stuart*.

4. David Wemyss (Lord Elcho), with a memoir and annotations by The Hon. Evan Charteris, *A Short Account of the Affairs of Scotland in the Years 1744, 1745, 1746* (1907), pp. 258–59.

5. Andrew Henderson, *The History of the Rebellion, 1745 and 1746* (1753), 5th edition, pp. 50–51.

6. Andrew Henderson, *The History of the Rebellion, 1745 and 1746* (1748), 2nd edition, pp 25–26.

7. John Home, *The History of the Rebellion* (1802), pp. 99–100.

8. Weymss (Elcho), *A Short Account of the Affairs of Scotland*, p. 259.

9. Home, *The History of the Rebellion*, p. 100.

10. Alexander MacDonald, 'Journall and Memoirs of P. C. Expedition into Scotland … By a Highland Officer in his Army', in George Lockhart (from manuscripts in possession of Anthony Aufrere), *The Lockhart Papers: Containing Memoirs And Commentaries upon the Affairs of Scotland from 1702 to 1715 …*, in 2 vols (1817), vol. 2, pp. 479–510, 489.

11. Daniel Defoe, *A Tour Thro' the Whole Island of Great Britain …*, 3rd edition, 4 vols (1742), vol. 4, p. 86.

12. Rosalind K. Marshall, 'The Palace of Holyroodhouse', *The Court Historian*, 1:3, published online, 22 October 2014, pp. 2–6, 3.

13. The extension is described as having been 'lately pulled down', in *Finance Accounts, &c. of the United Kingdom … for the year 1831*, vol. 26 (1832).

14. Deborah Clarke, *The Palace of Holyroodhouse* [Official Souvenir Guide] (2010), p. 17.

15. National Register of Archives for Scotland (NRAS) 2177, Hamilton Papers, Bundle 1053, Letter from the 5th Duke of Hamilton to George II, *c*.1740.

16. Edward Corp, *The Stuarts in Italy: A Royal Court in Permanent Exile 1719-1766* (2011), p. 369.

17. Henrietta Tayler (ed.), *A Jacobite Miscellany: Eight original papers on the Rising of 1745-6* (1948), p. 138.

18. *Caledonian Mercury*, 20 August 1745, p. 2. The Duke had arrived in London on 10 August.

19. My thanks to Deborah Clarke, Curator of Holyroodhouse, for information on the room sequence as it appeared in 1745.

20. Defoe, *A Tour Thro' the Whole Island of Great Britain*, p. 87.

21. James Greig (ed.), *The Diaries of a Duchess* (1926), p. 20.

22. NRAS 2177, Hamilton Papers, Bundle 873, 'Accounts 12 September 1740 to February 1741', refers to 'Making and putting up spurs for the Hangings in the Dressing room (Duchess); '4 carved frames for Pictures above the Doors in the Bed Chamber'; 'Marble Chimney Dove Collour', 'Dutch piggs' and 'the Glasses by Mr Brodie'.

23. The accounts for the palace refurbishment mention several times costings for 'puting up the Arrass hangings' by 'upholsterers', see NRAS, Hamilton Papers, F/1/908, dated 1738.

24. NRAS, Hamilton Papers, F/1/1064, 'Account of pictures at Holyroodhouse', p. 2, no. 18, 'Q: Ann half length by Sr G Kneller', and no. 19, 'The Duke of Gloster a head by Ditto'. There is a version of the latter in the Royal Collection.

25. Ibid., 'Account of pictures at Holyroodhouse', p. 3, no. 25, 'Philipus 2d Rex 'His [?] leaning upon fame' 'a Whole length'; and p. 4, no. 42, 'Anna Bullen by Holben on wood'.

26. Ibid., 'Account of pictures at Holyroodhouse', p. 11, 'In the Reed Room above stairs', no. 166, 'Henricus Octavus by Holbein on wood half length', and no. 167, 'Katherin of Spain a half length on wood a fine pictur'. A description of the palace published in 1819 refers to a 'James VI', 'Philip II' and 'Henry VIII' located in the 'Mary Queen of Scots' area of the Hamilton Apartments: see Charles Mackie, *Historical Description of the Monastery or Chapel Royal of Holyroodhouse: with a Short Account of the Palace and Environs* (1819), pp. 96–97.

27. Sir Walter Scott, *Waverley; or 'Tis Sixty Years Since*, 3 vols (1814), vol. 2, p. 254–57.

28. Ibid., pp. 315–16.

29. A. Francis Steuart, 'The Plenishing of Holyrood House in 1714', *Proceedings of the Society of Antiquaries*, 62 (1927–28), p. 188.

30. Weymss (Elcho), *A Short Account of the Affairs of Scotland*, p. 306.

31. RA [Captured Stuart Papers] CP/MAIN/2/321, Sheridan to O'Sullivan, Fitz-James, 2nd May 1745, N.S. [21 April O.S.].

32. RA [Captured Stuart Papers] CP/MAIN/2/349–352.

33. Samuel Boyse, *Historical Review of the Transactions of Europe … To which is Added an Impartial History of the Late Rebellion*, 2 vols (1747), vol. 2, p. 89.

34. Henry Paton (ed.), *The Lyon in Mourning*, 3 vols (1896), vol. 2, p. 115. Gib notes that at Moy Hall the 'household' alone was 'about seventy at least', see p. 137.

35. Philip Stanhope (Lord Mahon), '*The Forty-Five*' (1851), p. 71: 'Before the Council, Charles always held a levee.'

36. James Maxwell of Kirkconnell, *Narrative of Charles Prince of Wales' Expedition to Scotland in the Year 1745* (1861), pp. 54–55.

37. RA [Captured Stuart Papers] CP/MAIN/5/313, Commission from Charles to Alexander Robertson, 'Given at Holyroodhouse', 27 September 1745, O.S.

38. RA CP/MAIN/5/314, John Murray to the 'Collector of the Customs, Perth', Holyroodhouse 27 September 1745, O.S.

39. RA [Captured Stuart Papers] CP/MAIN/5/309.

40. The Woodhouselee Manuscript, *A narrative of events in Edinburgh and district during the Jacobite occupation, September to November 1745 from original papers in the possession of C. E. S. Chambers* [attrib. to Patrick Crighton] (1907), p. 82.

41. James Kinsley (ed.), *Alexander Carlyle. Anecdotes and Characters of the Times* (1973), pp. 79–80.

42. A. Tayler and H. Tayler (eds), *1745 and After* (1938), p. 88.

43. Tayler, *A Jacobite Miscellany*, p. 40.

44. Ibid., pp. 40–41.

45. Weymss (Elcho), *A Short Account of the Affairs of Scotland*, pp. 332.

46. Ibid., p. 306.

47. RA SP/MAIN/262/160, Charles to James Fitz-James, 14 February 1745, N.S.

48. RA SP/MAIN/245/46, James Edgar to Balhaldy Albano, 1 October 1742, N.S.

49. See Edward Corp, *The Stuarts in Italy, 1719–1766*, pp. 250–51.

50. Charles de Brosses, *Lettres Historiques et Critiques sur L'Italie*, 3 vols (1799), vol. 2, letter XVIII, pp. 335–66, p. 363: '… ils ont une fois la semaine un concert exquis: c'est la plus parfaite de Rome. Je n'y manque jamais. Hier, j'entrai pendant qu'ont exécutoit le fameux concerto de Corelli, appelé la notte dinatale'. Charles Klose translates this as, 'once a week they give a concert, by far the best in Rome, and at which I never fail to be present. Yesterday, I entered the room as they were executing the celebrated composition of Corelli, the Notte di natale.' Translation from Charles Luois Klose, *Memoirs of Prince Charles Stuart, (count of Albany) commonly called the Young Pretender; with notices of the rebellion in 1745*, 2nd edition, 2 vols (1846), vol. 1, p. 117.

51. RA SP/MAIN/260/150, Charles to James Edgar, Paris, 14 December 1744, N.S.

52. Tayler and Tayler, *1745 and After*, p. 88.

53. L. L. Bongie, *The Love of a Prince* (1986), pp. 176–77.

54. John Russell, *Letters from a young painter abroad to his friends in England* (1748), 'Letter XIX, To Mrs R. Rome 2nd December 1741 [N.S.]', pp. 72–75, p. 74.

55. Horace Walpole to Horace Mann, Arlington Street, London 12 August 1746, O.S., in W. S. Lewis, *Correspondence of Horace Walpole*, 48 vols (1937–83), vol. 19, 1955, pp. 293–97, p. 295.

56. RA CP/6/269, John Roy Stuart to Allan Ramsay, Holyroodhouse, 26 October 1745, O.S.

57. For a survey of the iconography of Charles Edward Stuart, see Richard Sharp, *The Engraved Record of the Jacobite Movement* (1996), pp. 110–22; and Robin Nicholson, *Bonnie Prince Charlie and the Making of a Myth: A Study in Portraiture 1720–1892* (2002), pp. 32–92.

58. See Paul Monod, *Jacobitism and the English people, 1688–1788* (1993), pp. 70–92; Edward Corp, *A Court in Exile: The Stuarts in France, 1689–1718* (2004), pp. 180–201; Corp, *The Stuarts in Italy, 1719–1766*, pp. 96–120 and 277–306; and Neil Guthrie, *The Material Culture of the Jacobites* (2016).

59. Anon., *Genuine Memoirs of John Murray, Esq, Dublin, 1747* (1747), p. 9.

60. Mrs [Katherine] Thomson, *Memoirs of the Jacobites of 1715 and 1745* (1845), pp. 136–37.

61. *Exhibition of the Royal House of Stuart* (1889) [exhibition catalogue]. Exhibition held at The New Gallery, London.

62. Clarke and Remington, *Scottish Artists 1750–1900*, p. 162.

63. *The Art Journal: New Series* (1892), p. 220.

64. Andrew Lang, 'At the Sign of the Ship', in *Longman's Magazine*, vol. 20: 117 (1892 [1 July]), pp. 325–31, p. 330.

65. Martin Hardie, *John Pettie R.A., H.R.S.A.* (1908), p. 172.

66. Ibid., p. 172; and Hardie's introduction in *John Pettie R.A., H.R.S.A.* (1910), p. 7.

67. Sir Walter Scott, *Tales of a Grandfather*, 3 vols (1842; first published 1828), vol. 3, p. 154.

68. *Ibid.*, pp. 154–55.

69. *Ibid.*, vol. 3, pp. 186.

70. Hardie's introduction in *John Pettie R.A., H.R.S.A.* (1909), p. 137.

71. Scott, *Tales of a Grandfather*, vol. 3, p. 218.

Tartan Frock Coat (detail)

This coat is understood to have been worn by Prince Charles Edward Stuart during his time in Scotland. Its style is from the period.

Mid-18th century, National Museums Scotland, K.2002.1031

CATALOGUE NO. 178

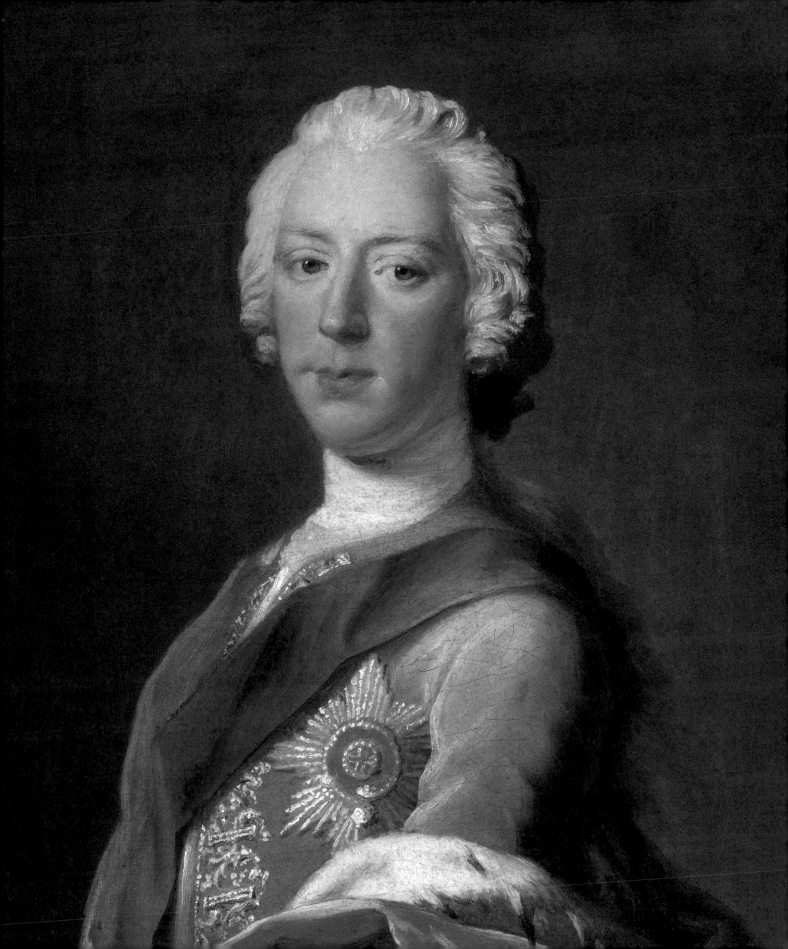

CHAPTER 7

The Lost Portrait
of Prince Charles
Edward Stuart

Lucinda Lax

ON 26 OCTOBER 1745, ONE JOHN STUART DASHED OFF A LETTER TO 'MR Allan Ramsay, painter'. The writer was a member of the inner circle of Prince Charles Edward Stuart – probably either Colonel John 'Roy' Stuart, a prominent Jacobite military leader (to whom the letter is attributed by an old inscription), or another John Stuart who acted as the prince's valet and who would later be raised to a Jacobite baronetcy. The letter was written at the Palace of Holyroodhouse, where Charles had taken up residence after landing in Scotland in the hope of raising enough support to reclaim his family's lost thrones. It contained what sounds very much like a royal command from the prince: 'Sir, you're desired to come to the palace of Holyroodhouse as soon as possible in order to take his Royal Highness's picture so I expect you'll wait no further call.'[1]

Until recently, no portrait of the prince by Allan Ramsay (1713– 84) had been convincingly identified, meaning that the picture that resulted from this commission was generally assumed either never to have been executed or to have been lost.[2] In 2014, however, that assumption was dramatically brought into question when Bendor Grosvenor directed attention to a small oil-on-canvas portrait that had been hanging, almost undisturbed, for some two centuries at Gosford House, the East Lothian seat of the Earls of Wemyss and March [Fig. 7.1].[3] Showing the prince at half-length in court dress with an ermine-lined cloak, it had been lent in 1946 to a major exhibition of Jacobite artefacts but had otherwise attracted little notice.[4] In considerable part this no doubt reflected its unusually small scale, measuring little more than 26 by 21 centimetres. Nevertheless, the painting is very much in Ramsay's style, exhibiting many characteristics that are typical of his work from the mid-1740s onwards. The rendering of the wig is especially revealing, with its distinctive creamy curls of paint that form a sharp contrast between light and shade. The rather warm blush of the sitter's skin is also significant: it is a frequent result of Ramsay's unique approach to painting his

Page 126, Fig. 7.1: Portrait of Prince Charles Edward Stuart

By Allan Ramsay (1713–84), painted in 1745, oil on canvas, 26.8 x 21.8 cm, Scottish National Portrait Gallery, Edinburgh, PG 3762

CATALOGUE NO. 160

By Hugh Douglas Hamilton (c.1739–1808),
painted in c.1785, oil on canvas, 25.7 x 22 cm,
Scottish National Portrait Gallery, Edinburgh PG
622

**Fig. 7.3, below: Bust of Prince Charles
Edward Stuart**

After Jean-Baptiste Lemoyne (1704–78), c.1747,
plaster, 48.3 height, Scottish National Portrait
Gallery, Edinburgh, PG 594

sitters' faces, which involved modelling all the features in red before applying a layer of lighter paint to create the flesh tones.[5] Grosvenor also drew attention to the background of the canvas, with its distinctive, slightly rough or pimply texture, which is also characteristic of Ramsay's earlier works. No less significantly, an early catalogue of the paintings in the Wemyss collection, probably dating from the early 19th century, lists the painting as 'Ramsey [*sic*] – Portrait of Prince Chas. Stewart', providing further documentary evidence for the attribution.[6]

Subsequent comparison of the picture to other depictions of Prince Charles suggests, moreover, that the painting is likely to have been based on a life sitting given by the prince. Of particular significance in this respect is the rendering of Charles's lower lip, which is shown as markedly protuberant in the painting. This feature was usually minimised by the prince's other portraitists, who evidently sought to make his features conform as closely as possible to contemporary ideals of masculine beauty; but the accuracy of Ramsay's depiction appears to be confirmed by less flattering later portraits such as Hugh Douglas Hamilton's likeness from 1785 [Fig. 7.2]. In addition, there is a strong overall resemblance between the prince's appearance in the painting and in a portrait sculpture executed soon after in Paris by Jean-Baptiste Lemoyne [Fig. 7.3]. This is especially notable, as Lemoyne's bust was recognised by contemporaries as an especially convincing and vivid likeness. It would seem difficult to explain how Ramsay could have made such accurate inferences about the prince's real appearance without actually having painted him from life. Taken together then, this evidence strongly supports Grosvenor's identification of the work as the missing portrait produced by Ramsay in response to John Stuart's letter. This identification was subsequently accepted by a panel of independent experts who were consulted when the painting was offered to the nation in lieu of inheritance tax, after which it was allocated to the Scottish National Portrait Gallery.

The discovery of a new portrait of 'Bonnie Prince Charlie' was as exhilarating as it was unexpected. Not only has a previously neglected work by one of Scotland's greatest painters been restored to its proper place, but the country has also regained a unique image of the young prince in the midst of the dramatic events of 1745. Indeed, at the time John Stuart's letter was written, the young prince had just achieved what almost all had assumed was a near impossibility. With little more than determination, his considerable personal charisma, and a generous helping of simple good fortune, he had managed over the course of a few short months to rally the Highland chiefs to his cause, seize Edinburgh and defeat a superior British army at Prestonpans. Now, at the very moment Ramsay was being summoned to Holyroodhouse, the prince was considering his next move, confident that his astonishing success in Scotland heralded the imminent defeat of the incumbent – and in Stuart eyes illegitimate – Hanoverian dynasty.

Ramsay's portrait gives us a vivid insight into the prince's physical appearance

and psychological outlook at this momentous time. Fittingly, it shows Charles at his most glamorous and self-confident. Drawing himself up to his full height and leaning back with an air of command, he fixes the spectator directly and authoritatively with the gaze of his amber eyes. His hair is powdered and dressed in curls, but loosely enough to give a sense of almost raffish negligence, with the long waves of his ponytail tumbling down his back. He is dressed formally in court dress, with his velvet coat (now faded to a greyish mauve but probably originally a regal purple or deep red) edged with sumptuous embroidery of silver thread. The Garter sash and star adorn his breast, and a cloak of red velvet and royal ermine is draped loosely over his shoulder, affirming his princely status. It is a compelling and superbly observed image of the prince at the height of his hopes of regaining the Stuart dynasty's lost thrones.

Appropriate though Ramsay's portrait may have been to the prince's unprecedented success, the decision to commission it at that particular time would seem to be somewhat surprising. In late October, Charles was preoccupied with vital strategic challenges, knowing that every minute that passed gave the Hanoverian monarchy more time to raise its own forces to oppose him and, potentially, seize back his recent gains. What motivations were so pressing that Charles would contemplate taking up valuable hours sitting for Ramsay when he might be expected to be preoccupied by preparing for the next stages of his ambitious campaign to restore his family's fortunes? What was the purpose of this new image of the prince, and why was it commissioned at this moment? It is on these questions that this chapter will focus, first by seeking to reconstruct the intentions that underlay the production of Ramsay's portrait, and then, through doing so, demonstrating the central role played by visual imagery in the promotion of the Jacobite cause.

As a starting point it is first helpful to explore the image in more detail, as it exhibits a number of features that might seem surprising for a portrait by a Scottish artist of a prince who had just seized the Scottish capital. The most striking is the absence of almost all explicit indicators of Scottishness. Most obviously, there is no sign of tartan, even though Charles had entered the city clad in the tartan of a Highland warrior and had taken to wearing a tartan waistcoat 'and britches of the same' as his usual daytime dress while in residence at Holyroodhouse [Fig. 7.4].[7] Less obviously, but perhaps even more remarkably, he is not wearing the badge of the Order of the Thistle, the premier Scottish order of knighthood. This was in spite of the fact that Charles's father had expressly allowed the Thistle to be worn together with the Order of the Garter, meaning there was no reason in principle why the Thistle should have been omitted.[8] Indeed, almost all the

Fig. 7.4: Prince Charles Edward Stuart (1720–88), eldest son of Prince James Francis Edward Stuart

Richard Cooper the Elder's hand-coloured etching of the prince from 1745 (known as the 'Wanted Poster') shows him in the guise of a tartan-clad Highland warrior.

By Richard Cooper the Elder (1701–64), 1745, hand-coloured etching on paper, 33 x 19.1 cm, Scottish National Portrait Gallery, Edinburgh, SP IV 123.49

official portraits of both Charles and his younger brother, Prince Henry Benedict Stuart, produced from the late 1720s onwards, show them with both their premier orders of chivalry. Why, then, was it omitted here?

Another striking feature of the portrait is its unusually small size. It is in fact by far the smallest finished portrait in Ramsay's entire output, and much smaller than his standard half-length format of 76 by 63.5 centimetres. Why should a portrait presumably intended to glorify a triumphant warrior be on such a small scale? Indeed, why is his identity as a military leader almost completely occluded, with no explicit reference whatsoever to the prince's recent achievements of the kind that might be expected in the wake of such remarkable events? A battle scene, for example, could have been incorporated in the background, as was typically done in portraits of successful soldiers. Why, then, is he shown as a civilian, rather than as a triumphant general?

To begin to explain these features we need to think more about their significance in relation to the prince's situation in late October 1745. The absence of the Order of the Thistle or of references to tartan suggests that the portrait was not primarily aimed at a Scottish audience. Rather, the relative prominence of the Garter star – the premier English Order of Chivalry – suggests that the portrait was in fact conceived primarily to represent Charles Edward as an English prince.

The likelihood of this is increased by his mode of dress at Holyroodhouse. As we have seen, he frequently wore tartan in the daytime, usually accompanying this with the Order of the Thistle; but in the evenings he tended to prefer conventional court dress and the Order of the Garter, as if to stress that his Scottish and English identities were complementary but distinct.[9]

The reasons for this become clearer when we consider the strategic issues that were in play at precisely the time Ramsay was summoned to Holyroodhouse. The prince was considering his next steps with his advisors: should he bed down in Scotland and attempt to secure the country for his cause; or should he make another bold move and attempt to march on London before the Hanoverian king, George II, could raise a strong enough force to oppose him? It was well known that, even though the chiefs of his Highland army were reluctant, the prince himself, as well as his French adviser, the marquis d'Eguilles, strongly favoured the second option. At the war cabinet to decide strategy for the campaign held on 30 October, this view prevailed, and preparations for the army to depart began immediately afterwards.[10] The prince left Edinburgh for Carlisle at the beginning of November, thus inaugurating the ill-fated descent into England that would culminate less than six months later with his disastrous defeat at Culloden. And so, the commissioning of the portrait occurred at the precise moment the prince was taking the decision to make his move towards London.

When the timing of the picture is taken in combination with the absence of the Thistle, then we can surmise that the decision to command Ramsay to paint

his portrait was directly connected with Charles's impending attempt to seize the English throne. Even more significant in this regard, however, is the existence of a print that clearly relates closely to Ramsay's painting [Fig. 7.5]. This print is the work of Sir Robert Strange (1721–92), at that time a young Edinburgh printmaker who had recently completed his apprenticeship with the city's leading engraver, Richard Cooper (1701–64).

Like Ramsay's portrait, Strange's print has traditionally been dated to the period when the prince was resident in the city in late September to October 1745.[11] This dating of the print has recently been disputed, but its origin during the 1745 rising is defensible on stylistic grounds, as it belongs to a distinctive group of Edinburgh prints – all datable to the same period – that drew for their composition on a series of portraits of 'Illustrious Persons of Great Britain' engraved by the leading Dutch portrait engraver, Jacobus Houbraken (1698–1780).[12]

Moreover, its origin during rising of 1745 is attested by a previously neglected early source.[13] Shortly after Strange's death in 1792, a correspondent wrote to *The Gentleman's Magazine*, a popular periodical of the time, to add detail to an obituary that had appeared in the previous month's issue. 'Mr. Strange,' the anonymous writer explained, 'first began business as an engraver at Edinburgh, where he served his time and soon showed he had good talents for that art.' He went on to recount:

Fig. 7.5: Prince Charles Edward Stuart (the 'Everso missus' print)

By Robert Strange (1721–92), 1745, line engraving on paper, 28.7 x 20.2 cm, Scottish National Portrait Gallery, Edinburgh, SP IV 123.20

CATALOGUE NO. 161

In the year 1745 [Strange] *was in a very respectable situation for a young artist at Edinburgh, and was soon engaged as engraver to the young Pretender,* Prince Charles. … *Mr Strange gained great reputation by engraving a print of the young Pretender, which was* then *esteemed a master-piece of the art, and is now thought and spoke of respectably by good judges. It is a half-length in an oval frame, on a stone pedestal, on which is engraved,* Everso missus succurrere seclo. … [T]*his print added so much to his* [Strange's] *reputation and fame, that he had not only his levees, at his lodgings in Stewart's Close, attended by the officers, courtiers, and ladies, of the Prince's army and court, but even by many friends of the Government, of the grave and important kind, who make a point of encouraging merit on all occasions.*[14]

If this account is accurate, it would seem that Strange was closely connected with the prince and his court, and therefore that he is likely to have produced his print in 1745 in response to a direct commission, just as Ramsay did his painting. Indeed, it seems reasonable to assume that both commissions formed integral

components of a single greater project. At the heart of Strange's engraving is a depiction of the prince that clearly derives directly from Ramsay's portrait. Although the engraving is relatively stylised, both images show the prince in the same pose and in the same clothing, with many fine details appearing to be nearly identical. The obvious explanation for the resemblance is that Ramsay's painting was intended, from the beginning, to be the model for Strange's print.

It is perhaps for this reason that Ramsay avoided explicitly warlike imagery in his portrait. If the portrait was to represent Charles Edward as a legitimate English prince, it would be more fitting to show him in the guise of a civilian than as a warrior forced to seize back his birthright in the face of serious resistance. The same factors may also help account for the unusually small scale of the image. A small image could clearly be completed with far more rapidity than a full-scale painting, enabling it to be sent to Strange for engraving as soon as possible. Even more significantly, because engravings are generally small-scale works, it was usual to produce reduced scale versions of full-size paintings if they were to be copied by the engraver.[15] These were often drawings, but ideally they were paintings that recorded fully the balance of light, shade and colour in the original. Indeed, the English portraitist Sir Joshua Reynolds seems to have employed a copyist, John Powell, specifically for the purpose of providing small replicas of his finest paintings for the engraver to work from.[16] The execution of such a small-scale painting would have made the process of transferring the image into engraved form a great deal easier, once again saving precious time.

Though the resemblance between Ramsay's painting and the print is obvious, there are nevertheless significant differences between them. Whereas Ramsay's painting presents the prince in a notably simple, straightforward way, Strange's print is remarkable for its elaboration and rich symbolic content. The portrait is set in a monumental cartouche that stands on a base in which the motto 'Everso missus succerrere seclo' is inscribed in bold Roman letters. In the foreground we see various accoutrements symbolic of military achievement: a helmet, a shield, a sword and an olive branch, denoting victory or the attainment of peace. By attempting to decode this iconography in more detail, we can begin to understand better the motivations that led to the production of both the print and the portrait by Ramsay that was its original model.

The key to understanding the image is the motto. The text is taken directly from the coronation medal of Charles II and means 'sent to restore the ruins of the age' [Fig. 7.6]. It is a paraphrase of a celebrated passage from the *Georgics* of the ancient Roman poet, Virgil: 'Gods of my country, Heroes of the land, you, Romulus, and you, mother Vesta, who guard the Tuscan Tiber and the Palatine of Rome, at least do not prevent this young prince from succouring a world in ruins!'[17]

Fig. 7.6: Coronation medal of Charles II

Designed by Thomas Simon (1618–1665), 1661, hammered and chased silver, 2.9 cm (diameter), © The Trustees of the British Museum, M.7478

The choice of this phrase for Charles II's coronation medal is highly significant. Charles II was crowned only when he was able to return to the British Isles as a result of the collapse of the Commonwealth, a period of Republican government that had begun after the execution of his father, Charles I, in 1649. Throughout his period of absence, the rights and duties usually reserved for the monarch had been exercised first by a 'Lord Protector', the parliamentary general Oliver Cromwell, and then, briefly, by Cromwell's son, Richard. When it became clear that Richard Cromwell did not possess sufficient authority to keep control of the Parliament and the army, Charles was able to return to and reclaim the thrones of England, Scotland and Ireland. The 'Restoration' of Charles II was therefore portrayed as a return to order, stability and continuity after the collapse of the increasingly unstable and unpopular Protectorate. In such a context, it would have seemed highly appropriate that the newly restored king could be poetically portrayed as the divine youth of Virgil's poem who had come to succour a ruined world.

No less importantly, the same passage in Virgil's poem had also been alluded to more recently in the artistic productions of the exiled Stuart court in Rome. The Stuart court was supported both financially and morally by the Papacy, and an important aspect of this was that the Stuarts were able to make use of the services of the Papal medallists, Ottone and Ermenegildo Hamerani. The Hamerani brothers created a series of superb medals on behalf of the Stuarts to promote their cause both within the British Isles and more widely. Such medals could be used to celebrate important events such as weddings and christenings of members of the Stuart family. They could also be used to send coded messages to both friend and foe. This is exemplified in a medal that shows Prince Charles Edward with his younger brother, Henry Benedict [Fig. 7.7]. The inscription is '*Hunc saltem juvenum*' ('do not prevent this youth …'), alluding to an earlier part of the same text from Virgil's *Georgics* as the *Everso missus* plate.[18]

Horace Walpole saw the medal being minted in 1741 and immediately recognised its likely meaning:

Sure this adds weight to my suspicions. Unless intended to usher his expedition, why strike a medal on the boy? If the father was just dead, it might be proper. It seems too to agree with what you told me of Cardinal Tencin's having prevailed upon the Pretender to resign his pretensions to his son, in case of any enterprise. Has it not an appearance?[19]

In other words, Walpole saw that the striking of the medal was intended to signal that the Stuarts were intent on regaining their thrones in the near future, most

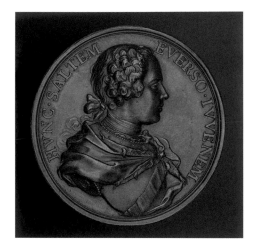

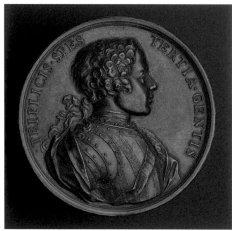

Fig. 7.7: Medal of Prince Charles, the Young Pretender, and his brother Prince Henry

Probably by Ermenegildo Hamerani, *c*.1737, bronze, 4.5 cm (diameter), National Museums Scotland, H.R. 126

CATALOGUE NO. 126

probably by means of some kind of invasion led by the young Prince Charles.

The recurrence of the motto in Strange's engraving therefore appears to be a deliberate double reference both to Charles II's coronation medal, and also to the 1737 medal commemorating the two princes, with its implicit message about a future expedition to the British Isles. It was clearly, then, produced in anticipation of the fall of London to the Stuart cause. At this point Charles expected to rule the kingdoms of Scotland, England and Ireland as his father's prince regent. The tone of the plate is therefore triumphalist – it is intended to commemorate a 'second Restoration' that would parallel that of Charles II in 1660 and fulfill the promise of renewal implicit in the Papal medal. This, incidentally, further reinforces the case for respecting the traditional dating of the print to 1745. Charles Edward's campaign was to meet its tragic end at Culloden in the spring of 1746. By this point the optimistic expectation of an imminent Restoration was long gone, and such imagery would no longer have been appropriate.

In order to be able to draw so confidently on Stuart iconography, the designer of the *Everso missus* print must clearly have had a sophisticated grasp of the imagery produced by the Stuart court. This suggests that it is more likely to have originated within Charles Edward's immediate circle – and perhaps even with Charles Edward himself – rather than with Strange or Ramsay. The portrait and the print can now be seen as components of a single, coherent and co-ordinated propaganda project intended to ensure that an 'authorised' image of the young prince was ready for distribution in the wake of the anticipated seizure of the English capital.

The commissioning of these carefully designed visual representations almost certainly took place at the highest level in Charles Edward's court, alongside and even as part of the military and political decision-making process. As such, Ramsay's portrait and Strange's engraving conform to practices that were deeply characteristic of the exiled Stuart court. Almost from the moment that James II and VII fled his kingdoms following the 1688 uprising, he sought to ensure that the creation and dissemination of portrait imagery of himself and his family could be continued almost without interruption. Portraits were commissioned from the finest artists that the increasingly cash-strapped Stuarts could afford – Benedetto Genari, Nicolas de Largillièrre, François de Troy and Alexis-Simon Belle, among others, when the court was in France in the years immediately before and after 1700; Antonio David, Francesco Trevisani, Girolamo Pesci, Martin van Meytens, Domenico Duprà and Jean-Etienne Liotard during the time the court was based in Rome; and then, when Charles Edward and Henry Benedict were in Paris in the late 1740s, Louis Gabriel Blanchet, Maurice-Quentin de la Tour and François Lemoyne.[20] These portraits were then reproduced in great numbers: as straightforward replicas, either by the artists themselves, their studio assistants, or professional copyists; as copies in other media, such as miniatures or medals; or as fine

engraved prints, a relatively economical means of reproduction that served to make imagery of the Stuart dynasty as widely accessible as possible. In this way, the exiled Stuarts were not only able to provide a focus for their followers' loyalty, respect and affection, but were also able to show through such imagery that – even in the difficult circumstances of exile – they were able to sustain the dignity and magnificent manner of living expected of the royal line.

Ramsay's portrait of Prince Charles Edward fits this pattern precisely. Far from being a distraction from military, political and strategic questions that loomed large at Holyroodhouse in late October 1745, artistic creation was absolutely central to the prince's ambitions. It was a vital component in the long and sustained propaganda campaign waged by the Stuarts to assert their claim to be the legitimate monarchs of Scotland, England and Ireland. Charles Edward, as a prospective prince regent, knew that he too had to project an image that conformed to people's deeply engrained ideas of what a ruler should look like. Upon it depended his chances of securing the support he needed to displace the Hanoverian regime and gain acceptance as the rightful ruler, the agent of a second Restoration of the Stuart monarchy. To that end, he and his advisers set out to ensure that Scotland's finest painter produced a suitably impressive new portrait of the prince, and that this portrait was reproduced as a refined and symbolically appropriate print. The failure of Charles Edward's subsequent attempt on London ultimately deprived the artistic project of its immediate political purpose. Fortunately, however, the recent rediscovery of Ramsay's portrait means that we are once again able to bring ourselves face to face with the brief but glorious moment when Jacobite hopes were at their apogee.

Notes

1. Royal Archives (RA), Cumberland Papers (CP), RA CP/MAIN/6/269, John Roy Stuart to Allan Ramsay, Holyroodhouse, 26 October 1745, O.S.

2. See, for example, Robin Nicholson, *Bonnie Prince Charlie and the Making of a Myth: A Study in Portraiture 1720–1892*, appendix 2, p. 137.

3. For Grosvenor's own account of the discovery and its significance, see Bendor Grosvenor, 'Bonnie Prince Charlie Returns to Edinburgh', *Country Life* ccx: 19 (11 May 2016), pp. 122–25.

4. Scottish National Appeal for Boys' Clubs, *Second Centenary Loan Exhibition of Jacobite Relics and Rare Scottish Antiquities, August 31st–September 30th, 1946, under the Auspices of the Scottish National Appeal for Boys' Clubs* (1946), no. 290, p. 44.

5. Rica Jones, 'Painting a Face All Red at the First Sitting: Ramsay's Technique for Portraits, 1725–60', in Mungo Campbell (ed.), *Allan Ramsay: Portraits of the Enlightenment* [exhibition catalogue], (2013), pp. 111–15, 126.

6. Gosford House, manuscript, 'Catalogue of Pictures at Wemyss House'; undated, but possibly part of a probate inventory drawn up after the death of Francis Charteris, Lord Elcho (1749–1808). I am most grateful to the Earl of Wemyss and March for giving me permission to consult this document, and to Hilary Wilkie, the archivist at Gosford House, for her invaluable help and support.

7. Robin Nicholson, 'The Tartan Portraits of Prince Charles Edward Stuart: Identity and Iconography', *British Journal for Eighteenth-Century Studies* 21: 2 (1998), pp. 145–60, 148–49.

8. Grosvenor, 'Bonnie Prince Charlie Returns to Edinburgh', p. 125.

9. Jacqueline Riding, *Jacobites: A New History of the '45 Rebellion* (2016), pp. 178–79.

10. Walter Biggar Blaikie, *Itinerary of Prince Charles Edward Stuart from his Landing in Scotland July 1745 to his Departure in September 1746 …* (1897), pp. 22, 23.

11. Robert Chambers, *Biographical Dictionary of Eminent Scotsmen* (1835), vol. 4, pp. 311–13.

12. Thomas Birch [author], George Vertue and Jacobus Houbraken [engravers], *The Heads of Illustrious Persons of Great Britain* (1743–51).

13. The dating of Robert Strange's print to 1745 was tentatively called into question by Donald Nicholas in *The Portraits of Bonnie Prince Charlie* (1973), p. 24; Nicholas's suggestions were taken up and developed more forcefully by Nicholson in *Bonnie Prince Charlie and the Making of Myth: A Study in Portraiture, 1720–1892*, pp. 70–71. For a detailed defence of the traditional dating, see Lucinda Lax, 'The Bonnie Prince in Print: Robert Strange's *Everso missus* Portrait and the Politics of the '45', *Journal of the Scottish Society for Art History* 22 (forthcoming 2017).

14. 'N.L.L', letter to the editor dated 6 August 1792, *The Gentleman's Magazine* 62, part 2 (August 1792), pp. 703–4.

15. For the importance of preparatory drawings for engravings, see Thomas W. Gaehtgens and Louis Marchesano, *Display and Art History: The Düsseldorf Gallery and Its Catalogue* (2011), especially pp. 18 ff.

16. For examples of Powell's reduced copies, see George Scharf, *Catalogue Raisonné, or a List of the Pictures in Blenheim Palace; with Occasional Remarks and Illustrative Notes* (1861), p. 34; and Scharf, *A Historical and Descriptive Catalogue of the Pictures, Busts, &c. in the National Portrait Gallery* (1888), p. 134.

17. Virgil, *Georgics* 1: 498; translation based on H. Rushton Fairclough (translator): *Virgil. Eclogues, Georgics, Aeneid*, Loeb Classical Library, vol. 63 (1916), p. 115.

18. Neil Guthrie, *The Material Culture of the Jacobites* (2013), pp. 83–84.

19. Horace Walpole to Horace Mann, 2 May 1740, quoted in Neil Guthrie, 'Johnson's Touch-piece and the "Charge of Fame": Personal and Public Aspects of the Medal in Eighteenth-century Britain', in J. C. D. Clark and Howard Erskine-Hill (eds), *The Politics of Samuel Johnson* (2012), p. 103.

20. For a comprehensive discussion of the exiled Stuarts' iconography, see Edward Corp, *The King over the Water: Portraits of the Stuarts in Exile after 1689*, exhibition catalogue (2001).

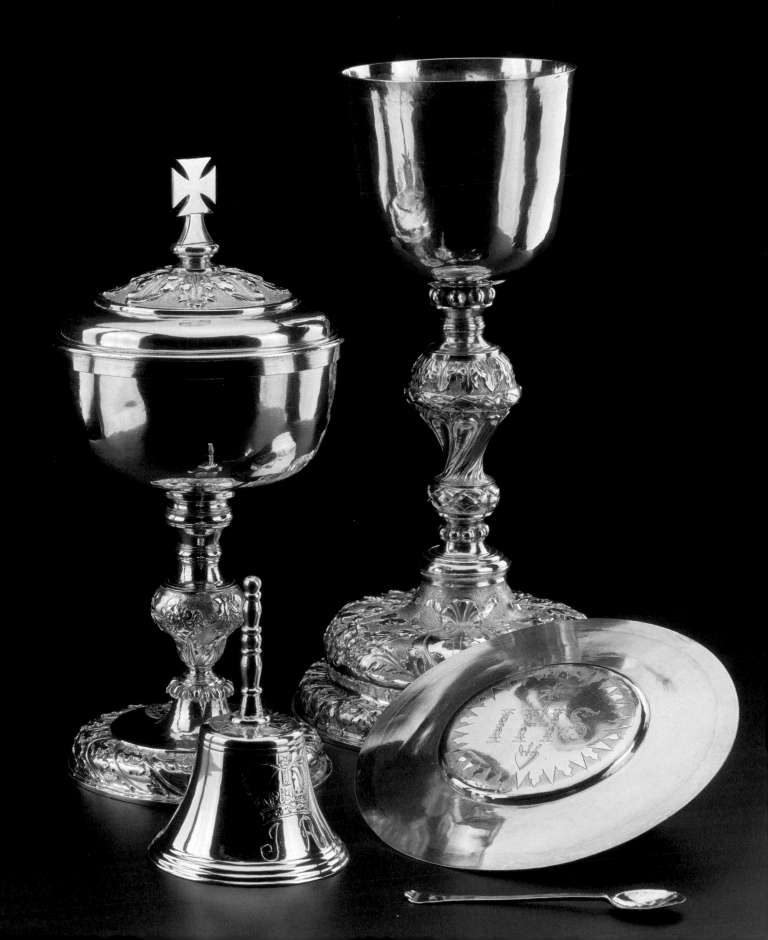

CHAPTER 8

True Religion
Faith and the Jacobite
Movement

Adrienne Hynes

IN 1688 JAMES VII AND II, A CATHOLIC MONARCH, WENT INTO EXILE AND was replaced by his Protestant daughter Mary and her husband, William of Orange. This deposition and constitutional crisis was caused by the birth of a male heir to James VII and II and his queen, Mary of Modena, Prince James Edward Francis Stuart, which secured the likelihood of a Catholic succession to the throne of a mainly Protestant nation. Combined with James's political moves to appoint and protect members of the Catholic faith, conflict of religious beliefs was fundamental to the Stuart loss of the British throne. This clash of faiths had a lasting impact on British and European history. The Jacobite movement was born and James and his descendants entered into an exile that was to last for a century. The relationship between Protestantism, Catholicism and the Stuart dynasty was a complex one, intertwined with ideas of monarchy and politics, and was heavily impacted by conflict within the faiths themselves. Historically the Stuarts had believed in absolute monarchy justified by the firm belief in their God-given right to rule.

The Stuart court in exile was at the mercy of the religious and political land-scape of Europe. James VII and II and his followers were dependent on the Catholic French monarchy, and for the next two generations the family relied deeply on the support of the papacy. For those remaining in Britain and Ireland, religion was used as a vehicle for persecution of possible Stuart supporters. Following the flight of James, Catholicism experienced a backlash and faced renewed persecution. Within the Scottish Church, division over ecclesiastical government had formed two conflicting groups: the Episcopalians who favoured the role of bishops, and the Presbyterians who believed in a system of presbyteries as a biblical basis for church governance.

The aftermath of the 1689 Revolution was crucial for the Church in Scotland and it was against this background that the loyalties and political allegiances, which contributed to the Jacobite movement and its opposition, were formed. In 1689 the Scottish Parliament passed the Claim of Right, which stated that James VII and II had forfeited the crown, and that he had undermined the Protestant faith. William III was therefore recognised as the rightful king. Bishop

Fig. 8.3 and page 138: Holyrood altar plate

Lent by the Scottish Roman Catholic Hierarchy
CATALOGUE NO. 12

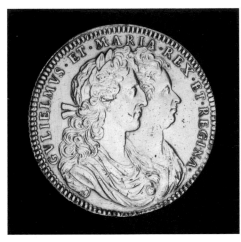

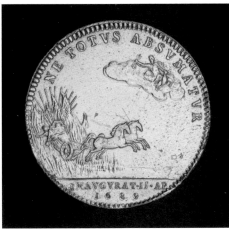

Fig. 8.1: Medal commemorating the coronation of William and Mary in London, April 1689

By James or Norbert Roettier, French, c.1689, National Museums Scotland H.R 72, obverse and reverse

CATALOGUE NO. 21

Alexander Rose of the Scottish Episcopal Church was summoned down to London to address William on the situation in Scotland. When he was asked whether the Episcopalians would swear an oath to support the crown, Rose answered, 'I will serve you sir as long as law, reason or conscience shall allow'.[1]

Despite the Claim of Right, some of the Episcopalian clergy were unwilling to swear an oath to the new monarch when their loyalty had already been sworn to King James. This was not a concern restricted to Scotland: in the Anglican Church in England there were also members of the clergy who were 'non-jurors', including William Sancroft, Archbishop of Canterbury, who refused to crown William and Mary [Fig. 8.1].[2]

Unsatisfied with Bishop Rose, William restored Presbyterianism as the established national Church of Scotland in 1690 and persecution of episcopal ministers began. Those Episcopalians involved in teaching at the University of St Andrews were expelled, and there were attempts to remove ministers from their parishes – although this was not altogether successful.[3] William also ratified Acts against Catholicism dating from 1609 and 1625, broadening them in 1700 to include the Catholic laity for the first time, although it is unclear how vigorously these were enforced.[4]

The suppression of religious groups presenting a threat to the crown meant that, by the 18th century, two disenfranchised groups existed in Scotland who saw the restoration of the exiled Stuarts as the way in which they too could be restored to their rightful place within Scottish religion. There was no formal alignment between the Scottish Episcopalians and the Catholic Church, and both continued to establish churches and to protect their faith despite the prevailing nature of Scottish religion. Consequently, nearly all of those involved in the Jacobite challenges in Scotland belonged to these two distinct faiths, with the vast majority associated with the Episcopal Church. A level of tension existed between the exiled Catholic monarchs and their Protestant followers in England, Scotland and Ireland. Catholics and Protestants alike attempted to persuade the Stuart monarchs to secure their position within the British Isles if a restoration of the throne were to take place.[5]

It should further be noted that affiliation with either Episcopalianism or Catholicism was not always a precursor for active Jacobitism. Episcopalians made up the majority of the Jacobite forces in both the 1715 and 1745 risings; however, many also chose not to be involved. In the same way that single-minded loyalty to the rightful kings across the water was not always the motivation for Jacobitism, religion was not always an influencing factor. Opportunism and personal gain were valid reasons why individuals joined the campaigns.[6] Presbyterians were also not entirely excluded from the Jacobite cause, although their

involvement was significantly less visible. Clan relationships, family ties and clan politics extended beyond the borders of the different faiths, highlighting how complex the situation was in Scotland. For example, in the 1715 campaign one-third of the clergy who participated in Aberdeenshire and Banffshire were Presbyterian.[7] An example from the 1745 campaign is the regiment of Clan Cameron in which three members of the clergy enlisted: one Episcopalian, one Catholic and one Presbyterian.[8] There was no formal alignment between the Scottish Episcopalians and the Catholic Church, but family ties and Highland politics led to toleration and alliance between the two faiths.[9]

Faith was clearly still central to the Jacobite movement, and the material culture associated with this aspect of the cause gives a fascinating insight into the role of religious belief and observance in the lives and campaigns of the Stuart monarchs and their supporters. Exploring religious material culture associated with the Stuarts, and both the clergy and laity of the Episcopal and Catholic Churches, highlights this, as well as showing the enduring significance of objects created for religious ceremony and devotion. Communion ware is particularly important for its symbolism within the celebration of the Eucharist and its ability to validate faith and power for the Stuarts themselves. The faith of the key protagonists, however, is only one aspect of the story, and the material culture also tells the story of the Jacobite followers.

Symbols of Faith

Monarchy, faith and power were ideals embedded into the Stuart dynasty. The accession of James VI and I in 1603 to become King of Scotland, England and Ireland, realised the full potential power of the Stuarts as they succeeded in achieving what others before them had failed to do. The Stuart monarchs' belief in the strength of their dynasty, and their firm belief in their right to rule, was key throughout the generations of the Stuart line. Faith was also intrinsic on both a personal and public level, particularly for James VII and II. James was the younger son of Charles I and therefore second in line to the throne. While still the Duke of York [Fig. 8.2], he secretly married Anne Hyde who later converted to Catholicism. After her death he went on to marry the Catholic Mary of Modena in 1673.[10] The date of James's own conversion to Catholicism remains unknown, but in 1676 he refused to partake in Easter Communion in the Church of England and he was widely accepted as a Catholic convert.[11] The controversies over his marriages and Catholicism met with criticism that only intensified on the death of his brother Charles II in 1685, when James became a Catholic monarch in an intensely Protestant nation.

As king, James established new Catholic royal chapels across his kingdoms, including a chapel within the medieval abbey church adjacent to Holyroodhouse

Fig. 8.2: Painting entitled *James VII & II (1633–1701) when Duke of York*

By Sir Peter Lely (1618–80), *c*.1665, oil on canvas, 126.1 x 102.1 cm, The Royal Collection / HM Queen Elizabeth II 2017, RCIN 403224

CATALOGUE NO. 5

in Edinburgh where – during periods of exile from London – he had spent a significant amount of time prior to becoming king. A temporary chapel was put in place within the palace itself while extensive works were carried out. The new chapel was elegantly furnished with a throne for the king and stalls for the Knights of the Order of the Thistle.[12] Alongside the furnishings of the chapel there was also a need for Communion plate to be used in celebrating the sacrament of the Eucharist by James and the court. The completion of the chapel, however, coincided with the 1689 Revolution and the arrival of William of Orange; within a month both the palace and chapel were sacked by rioters.

During the attack on the chapel much was destroyed; however, a set of silver Communion plate was rescued by one of the resident chaplains, David Burnet. The rescued items comprised two chalices and patens used for the wine and the bread during the celebration of the Eucharist, a monstrance for displaying the host, a ciborium for storing the host, a thurible used for burning incense, an incense boat and a Sanctus bell that was rung during Mass at the elevation of the host.[13] Some of these elaborate pieces [Figs 8.3 and page 138] bear the king's royal cipher – 'JR', from the Latin *Jacobus Rex* – with his Scottish regnal number 'VII', emphasising the connection between the monarchy and the celebration of the Eucharist according to the Catholic rite. Common religious symbols, including a cross and a heart pierced with nails, decorate a paten, while the other pieces are embossed with acanthus leaves. With the exception of the Sanctus bell, the various components were made in London. The makers' marks 'WF' and 'GC' are so far unidentified, but were most likely the same goldsmiths who worked on the simultaneous refurbishment of the royal chapel in Westminster.[14] The Sanctus bell was made in Edinburgh by a goldsmith called Zacharius Mellinus; while it is engraved with a crowned 'JR', it is less elaborate than the other pieces and bears no religious motifs. It is possible that it was a replacement for a missing bell.

The story of the altar plate, itself also sent from London, provides an insight into the plight of Catholicism in the aftermath of the king's exile. These religious objects were part of the symbolic statement made by James not only of the importance of his own personal faith, but also of the significance of Catholicism for his reign as king, despite the predominantly Protestant nature of the country over which he ruled. In a letter written in 1694 to the French king Louis XIV, James asserted that frequent Communion is essential to unite with God and to find 'comfort, support and succour', leaving no doubt that he considered this a vital sacrament.[15] The fact that plate was rescued from rioters demonstrates the significance of religious objects as a representation of a crucial element of Catholic

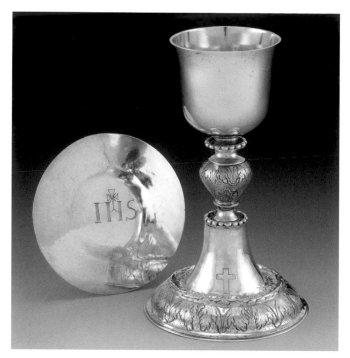

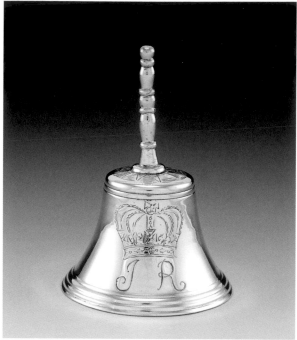

worship. The chaplain David Burnet escaped from the mob of rioters across the Forth to Fife and made his way to the safety of Banffshire, where the Duke of Gordon offered some protection to fellow Catholic adherents. Burnet made a sudden transition from his position of chaplain at Holyroodhouse to hiding in a hut among the heather in the North of Scotland, a lifestyle that many of the 'missionary' priests would lead throughout the 18th century. The rescue of the sacred plate was reported to the exiled court in St Germain-en-Laye, although the pieces remained safely hidden in Scotland, serving as a tangible reminder of the hope for the Catholic Church that had blossomed under the rule of James VII and II. The Communion plate, however, also represents both the demise of this hope and the demise of James himself. For many, his close relationship with the Catholic Church was a direct threat to the security of the Protestant position in both Scotland and England, a threat that was brought to a head in the birth of James VIII and III. This issue of religion had a lasting impact for the Stuart dynasty, preventing them from maintaining the throne after the death of Queen Anne, James's half-sister. The Act of Settlement in 1701 ensured that the throne was inherited by a Protestant monarch, deliberately moving power out of the reach of the Stuart family and into the hands of the Hanoverians.

The significance of James's personal faith, particularly in later life, has been scrutinised by historians. As Duke of York he had been recognised as a distinguished soldier; however, after the Revolution and his second exile to France,

Figs 8.3, right and left: Chalice and paten, and Sanctus bell of the Holyrood altar plate

When James VII and II converted the Chapel Royal for Catholic worship in the Palace of Holyroodhouse in 1687, the Earl of Perth was responsible for furnishing it and a full suite of silver altar plate was acquired.

Chalice and paten, English, *c*.1686, silver, 28.5 cm (height); Sanctus bell, by Zacharius Mellinus, Scottish, 1686–87, silver. Lent by the Scottish Roman Catholic Hierarchy, IL.2009.16.1 and 2, and IL.2009.16.4.

CATALOGUE NO. 12

James became withdrawn and focused on his own devotion to God. Greatly influenced by the lifestyle and teaching of religious orders, he fostered close relationships with the Jesuits in France as well as with a Cistercian monastery at La Trappe, which he frequently visited. His own papers of devotion were published after his death in 1704 as *The Pious Sentiments of the Late King James II of Blessed Memory* by Lewis Innes of the Scots College in Paris, an institution that was central to the ongoing Catholic mission in Scotland.[16] These sentiments were a combination of thoughts and letters written by James during his time in exile and show key elements of his faith.

Throughout these writings James outlined the benefit of withdrawing from the world in order to attain a life of faith. He was particularly concerned with the need for temperance and sobriety, and voiced his disapproval of entertainment such as balls and plays. Gambling was another evil which, he argued, left its players either depressed or reckless in pursuing success, attributing his caution of these entertainments to the grace of God, which brought him out of his youthful follies. Alongside this, he also demonstrated his gratitude to God for delivering him from the various trials he encountered, and for revealing to him the *'True religion'*.[17] It is clear too from his writings that he considered his sufferings as king to be a result of his sins and that he longed for death to finally allow him to be in God's presence. Scattered among these aspects of faith, upon which James frequently deliberated, are observations on the stories of Old Testament kings and the repeated rebellion of the Jews against God. In light of James's personal situation as an exiled king overthrown by his own subjects, it is likely that he found some resonance in these stories of revolt and judgement. Retreating further into Catholicism after his second exile offered James a level of stability in uncertain times. Despite his belief in his divine right to rule, the king also relied heavily on the idea of providence. Arguably this is what allowed him to accept his situation in exile and to justify his withdrawal from court life.

It is certainly clear that James's conversion was genuine. When urged by his Protestant friends to renounce Catholicism, James replied in a letter to Lord Dartmouth, 'I hope God would give me his grace to suffer death for the true Catholic religion as well as banishment'.[18] While James was not a martyr, he did sacrifice his throne for a faith in which he firmly believed. This had a lasting impact on the life of his son and grandsons, who also lived their lives in exile.

Faith in the Family

James VIII and III continued to adhere to Catholicism after his father's death in 1701. He was recognised as king by Louis XIV of France while still a minor and continued to have a close affiliation with the French court until his return from the failed Jacobite rising in 1715. James had been keen to prove himself in a

military capacity, particularly after the disastrous 1708 Jacobite attempt when the French commander who accompanied him forbade his landing in Scotland.[19] In 1715 James did manage to get to Scotland, albeit after most of the action had already taken place at the battles of Sheriffmuir and Preston. He then remained there for only a matter of weeks, during which time the non-juring Episcopal clergy of Aberdeen (those who refused to swear an oath of allegiance to George I) made an address to him conveying their loyalty to the Stuart dynasty: 'It has been, still is and shall be our care to instil into the minds of the people true principles of loyalty to your majesty.'[20]

James responded by assuring the clergy that he would offer them his favour and protection. He was committed to religious toleration and throughout the remainder of his life held a delicate balance between his own Catholic beliefs, his reliance on the papacy and his need to reassure his Protestant subjects. In 1718 the king wrote an indignant letter in response to pressures placed upon him to commit to restoring Catholicism to the British Isles in the event of his return to the throne, stating,[21] *'Je suis Catholique, mais je suis Roy, et des sujects de quelque religion soient doivent etre egalement protegés'* ['I am Catholic, but I am King and the subjects of whatever religion should have equal protection'].

Religious tolerance was key for James, who expressed frustration when both Catholics and Protestants demanded exclusivity. This struggle became particularly evident when the exiled court took up residence in Rome and was almost entirely financially supported by the papacy. Clement XI permitted James to have two Protestant chaplains at the Palazzo del Re and Anglican services were held there not only for the Protestant members of the royal household, but also for any Protestants residing in or visiting Rome. This was an important connection for James as British travellers taking part in the 'Grand Tour' visited his court and were able to attend Protestant services.[22] Managing the pressures from both sides was not an easy task for him, particularly during the period of separation between himself and his wife Maria Clementina Sobieska, whom he married in 1719. Maria Clementina was a Catholic princess whose absolute devotion to her Catholic faith was coupled with self-deprivation. Her relationship with James was turbulent and in 1725, after the birth of Prince Henry Benedict, a rift in their relationship led to the departure of Clementina from the royal household to the shelter of a nearby convent. The conflict between James and Clementina revolved around the members of the royal household who held influence over their eldest son Prince Charles Edward Stuart, but the ramifications went far beyond the domestic sphere. Prince Charles had been placed under the care of the Protestant Earl of Dunbar, a favourite of James. James hoped to appease his Protestant subjects by ensuring that Charles was not solely under the influence of Catholicism. Clementina, supported by both the papacy and the Spanish royal family, was hostile to Dunbar's influence.[23] Court politics and allegiances were a strong influ-

ence on the separation, but religion was at its centre. For the duration of the conflict, the then Pope Benedict XIV withdrew support for James, reducing his pension and removing the Protestant chaplains at the Palazzo del Re.[24] The couple were eventually reunited in 1728, although Clementina became more withdrawn and fasted continuously, damaging her health until her death in 1735 at the age of 32.

In contrast to Clementina's life of abstinence, when Prince Charles made his entrance into society he pursued entertainment at balls and operas, often dancing until the small hours of the morning. He was brought up as the rightful Prince of Wales and trained to be a military leader, confident in the field of action. Adherence to Catholicism was not a priority for Charles and his attitude towards organised religion has been described as contemptuous.[25] In a clandestine visit to Britain in 1750, Charles converted to Anglicanism in a last bid to convince the Protestants of the country that he was fit to accede to the British throne. This took place at a ceremony in London where Charles formally apostatised the Catholic faith in which he was raised.[26] His brother Henry Benedict, on the other hand, became a well-respected cardinal of the church in Rome, maintaining the close relationship between his family and the papacy.

One aspect of monarchy and faith that was carried through from James VII and II, all the way to Charles Edward and Henry Benedict, was the ceremony of 'touching to cure the king's evil', the disease medically known as scrofula. Touching for the king's evil was believed to be a divine gift invested in the kings of England and France: in England this began with Edward the Confessor in the 11th century. The ability to cure the 'king's evil' was used by subsequent monarchs to reinforce their right to rule. The exiled Stuarts also claimed this gift as part of their royal inheritance passed down through their ancestors. James VIII and III is known to have held these religious ceremonies in both France and Italy. According to an account dating from 1722, while James was in Lucca he touched for the king's evil every Thursday at a special service presided over by a member of the Dominican order.[27] Prayers were recited and an extract from the gospel was read while sufferers were brought to James to receive healing. Charles touched for the king's evil upon request while staying at Holyrood in 1745; however, it appears he did so reluctantly and without much ceremony.[28] Henry is recorded as touching for the king's evil in the town of Frascati in the years after the death of his father and brother.[29]

The touchpieces which were distributed by the Stuarts in exile were a traditional design based on the earliest examples issued by Edward IV of England in the 15th century, with a depiction of the Archangel Michael and a ship in full sale on the reverse. No Jacobite imagery was used, though the title of the king was present in abbreviated form asserting the royal claim.[30] Typically a ribbon was threaded through a small hole at the top of the touchpiece, as in the example

illustrated in Fig. 8.4. Occasionally touchpieces were sent to sufferers, acting as a vehicle for the healing power transferred from the king's touch. The symbolism was powerful, although the ceremony was not without its critics, even among supporters of the Stuarts. Many Protestants were suspicious of a ceremony that strongly resembled Catholicism.[31] In 1719, however, Jacobites in London were accused of trying to uphold the divinity of James VIII and III with stories that he had healed scores of diseased people.[32] Touching for the king's evil emphasised the Stuarts' belief in their divine right to rule. For those who came to be healed, it was an act of faith or driven by the need for a cure. For the Stuarts in exile it was a combination of political advantage and faith, and played an important role for James in particular, who was committed to holding the touching ceremonies.

The faith and religious adherence of the Stuarts was a key element in the Jacobite movement. It defined political allegiances throughout Europe and effected relationships with Jacobite supporters. The faith of the key protagonists, however, is not enough to understand how the wider movement and the intricacies of the complex religious composition of the clergy and laity aligned with Jacobitism in the three kingdoms. A few powerful objects associated with the Jacobite challenge in 1745 show the significance of religion for those, both Catholic and Protestant, who joined the cause to support Prince Charles.

The Catholic Mission in Scotland

Following the Williamite Revolution and the subsequent Jacobite challenges to reclaim the throne, there were renewed attempts by the Scottish State to suppress the Catholic Church. The *Congregation de Propaganda Fide* (Congregation for the Propagation of the Faith) had been established in the 17th century by the papacy to recover the faithful who had been lost through the Protestant Reformation.[33] *Propaganda* funded the missionary effort in Scotland; and the Scots Colleges in Europe, originally established to educate the sons of the Catholic nobility, produced priests to tackle the mission field. Between 1653 and 1753 the number of Catholic priests increased from five to forty and the number of Catholics also grew; however the main emphasis was on sustaining and protecting Catholicism in Scotland rather than converting the masses.[34] To a certain extent the clergy were protected by influential lay persons such as the Duke of Gordon in Aberdeenshire, but persecution meant they were often on the move, sleeping rough, hence the nickname 'heather priests'.[35] As mentioned previously, in 1701 legislation was issued to extend persecution of the laity as well as the clergy. The 'Act for Preventing the Growth of Popery' barred Catholics from holding official posts and prevented children from inheriting, thus targeting the landed aristocracy who offered protection to priests. A notable example where this had an impact for Scottish Catholicism was the conversion of the Duke of Gordon's

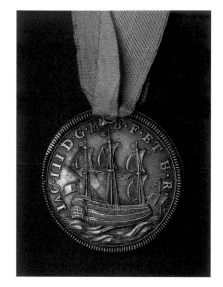

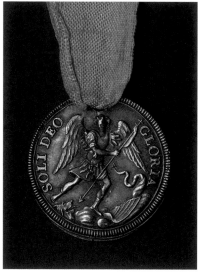

Fig. 8.4: Touchpiece of James VIII and III

A silver touchpiece with its white ribbon, obverse and reverse.

National Museums Scotland, NMS H.NT 242.10

CATALOGUE NO. 128

wife, Henrietta, after the duke's death in 1728. Henrietta converted to Episcopalianism along with her children, thus ensuring their inheritance. While she continued to offer tolerance to Catholics under her jurisdiction, it was a significant loss to the mission.[36]

The Morar Vestments

The Catholic clergy came out as strong supporters of the Jacobite cause during the 1745 challenge, despite the reservations of the Vicar-Apostolic of the Highlands, Hugh Macdonald, who advised Prince Charles to return to France when he landed in Moidart that year.[37] As a result of their involvement in the rising, 15 priests were captured, two of whom died while imprisoned and the remainder were sent into exile abroad. The reprisals against the whole of the Catholic population had a devastating effect for the religion in Scotland.[38] Surviving as a powerful reminder of the Catholic clergy and their involvement in the rising is a set of vestments owned by the Roman Catholic Diocese of Argyll and the Isles and particularly connected with the parish of Morar. Vestments were regarded as an important part of the liturgy in the Catholic Church, and robes dedicated to the celebration of Mass added to the sense of ceremony during this significant sacrament. This set of vestments [Cat. no. 212], which date from the mid-18th century, include a chasuble, stole and maniple, as well as various altar cloths. The high quality blue silk with a floral brocade pattern was most likely repurposed from a lady's dress donated to the church. During the 16th and 17th centuries, vestments were increasingly made from fashionable materials. Coloured silks with rococo inspired floral designs became much more common than the heavily embroidered designs of previous centuries.[39] As fashions changed quickly, it was common for women to donate, or even sell, their silk dresses for use as vestments, which in turn was a more economical way for the church to acquire fabric.[40]

Much of the story behind the Morar vestments is still unclear; however, the enduring association with one particular priest, Allan Macdonald, has ensured their survival. Macdonald was a member of the Catholic clergy who was on mission in Scotland when Prince Charles Edward Stuart arrived in 1745. Originally from Stoneybridge in South Uist, he studied first at the small forbidden seminary at Eileen Ban in Morar and was subsequently sent to the Scots College in Rome with the intention of completing his studies. He left the college before he was ordained as a priest and briefly attended the Scots Colleges in Paris and Douai before returning home to Scotland.

Macdonald became involved in Scalan, the successor seminary to Eileen Ban, which was intended to train boys from a young age for the hard life of a missionary in Scotland. While at the college Macdonald became involved in a dispute between the Lowland and Highland students, leading to his eventual dismissal.[41]

In 1742 Macdonald was finally ordained as a priest and in 1745 joined Prince Charles Edward Stuart as his chaplain, enlisting in the army under the name of 'Captain Graham'.[42] No documentary evidence connects Macdonald to the vestments, but his role as chaplain to the prince would have required the appropriate attire. As chaplain he certainly would have been responsible for administering Mass and preaching as required, though during battle Macdonald carried a sword and pistol.

Prior to the Battle of Falkirk, Macdonald supposedly rode along the front line blessing the men before they charged.[43] In the aftermath of Culloden, he was captured – along with another priest, Alexander Forrester – after accompanying Prince Charles to South Uist. They were imprisoned and then exiled to France where they found refuge at the Scots College in Paris. Allan Macdonald would return to the Scottish mission field two years later.[44]

The Scottish Episcopal Church

As outlined above, the Episcopal Church in Scotland experienced a significant amount of discrimination during the 18th century, yet retained support in some regions. Episcopal ministers were removed from their parishes after episcopacy was banned in 1689, although in some areas, particularly north of the Tay, ministers remained in post for many years.[45] In 1709 an Anglican minister, James Greenshields, who had sworn an oath of loyalty to Queen Anne, was imprisoned in Scotland and appealed to Westminster for help. This resulted in the 1712 Act of Toleration which gave freedom to Episcopal clergy who were willing to take an oath swearing allegiance to Anne and renounce the Jacobite cause. A division was thus created between the juring clergy who were prepared to swear the oath to Anne and who led 'qualified' congregations, and the non-juring who refused to give up their support to the exiled Stuarts. This was not a definitive division, however, as juring Episcopal clergy sheltered non-jurors, accommodating them within their congregations, allowing non-juring clergy to preach.[46] The involvement of many Episcopalians in the rising of 1715 did not help the cause of the non-jurors, and in 1719 another act was passed forbidding non-juring Episcopal clergy from officiating to any congregation larger than nine people under the penalty of six months imprisonment.

Nevertheless, non-juring Episcopal congregations continued to exist, such as the church of Old St Paul's in Edinburgh. The registers of this church date from 1735 and were kept by a Reverend William Harper. These are particularly useful in identifying members of the laity who attended the church for sacraments such as Baptism. Notable names recorded include Robert Strange, the engraver of the image of Prince Charles Edward [Cat. no. 161], Ebenezer Oliphant the goldsmith who created the seditious travelling canteen gifted to Prince Charles Edward

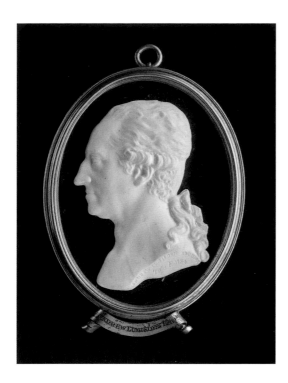

Fig. 8.5: Miniature of Andrew Lumisden

This miniature by James Tassie is inscribed and dated 'Andrew Lumisden Esquire, Tassie F. 1784'. Lumisden was private secretary, at different times, to both James VIII and II and Prince Charles Edward Stuart.

By James Tassie (1735–99), 1784, National Museums Scotland, H.NT 241.13

CATALOGUE NO. 182

for his 21st birthday, Andrew Lumisden [Fig. 8.5], the prince's personal secretary, and Thomas Ruddiman, publisher of the Jacobite supporting newspaper *Caledonian Mercury*, who eventually became chief librarian of the Advocates Library in Edinburgh.[47] As well as meticulously recording the names in the church registers, Harper also noted the prince's victory at Prestonpans, followed by the phrase 'Glory to God in the highest' written in Greek.[48]

Support for Jacobitism is also evident in another congregation in Appin in the Highlands. A Communion chalice and paten made for the Parish of Appin in 1722–23 by the Edinburgh-based goldsmith James Tait, has been a treasured possession of the congregation throughout the last two centuries, where it continued to be used in the Eucharist. The importance of Communion ware as religious objects has already been discussed in relation to the Holyrood altar plate, and the ongoing use of the Appin chalice reinforces this. At the Reformation, Protestants had rejected the Catholic doctrine of transubstantiation, where the bread and wine were believed to transform mystically into the body and blood of Christ during the Eucharist. Emphasis was also placed on the celebration of the sacrament as a community, with a move towards vessels that were similar to those used in domestic circumstances.[49] Despite this, Communion was a sacrament that was received fairly infrequently, particularly in the north of Scotland, and in most areas it was an annual event.[50]

In contrast to the Holyrood altar plate, the Appin chalice and paten are simple and undecorated, apart from the inscription 'The Parish of Appin 1723'. This Communion ware does not display the political symbolism of the royal Holyrood plate; rather its significance rests within its sacramental role. The shape of chalice reflects a style adapted in the 16th century which was influenced by the shape of secular drinking cups.[51] The chalice was used to administer Communion on two notable occasions in the 18th century. According to a report written by an informant at Fort William in 1731, the Episcopal minister John McLauchlan had recently preached and administered the sacrament at a gathering of over five hundred people. The writer, whose name has subsequently been removed from the document, asserted that McLauchlan was laying the foundation of another Jacobite rising. Many of those who attended celebration had supported the challenge in 1715 and there were rumours of an imminent French and Jacobite invasion. The writer saw this Episcopal celebration of Communion as a declaration of support for the Jacobite movement and described McLauchlan as a 'bold, lawless, non-jurant, highflying Episcopal itinerant'.[52]

McLauchlan went on to serve as a chaplain in the Jacobite army of Prince Charles Edward Stuart. In a letter to Bishop Forbes, the compiler of *The Lyon in*

Mourning, McLauchlan claims he was the only Episcopal clergyman at the Battle of Glasdmuir (Prestonpans) and states that he accompanied the prince to Derby, Falkirk and Culloden. According to his letter, he acted as chaplain to the prince and had a commission to be chaplain-general to all loyal clans. It is reputed that McLauchlan took the Appin chalice with him on this campaign and used it to administer to the Jacobite army, and that it was rescued from the field of Culloden in the aftermath of the battle.

While the legacy of objects associated with the Jacobites has meant that the vestments from Morar and chalice from Appin have been treasured over the centuries, it is useful to note that objects of religious significance were not confined to the Jacobite forces. An example of this is the Gaelic bible [Fig. 8.6] carried at Culloden by a Highland soldier of the British army, Alexander Anderson, who fought and died during the battle. Anderson served in the Argyll Militia, a regiment organised by Clan Campbell who were Hanoverian supporters. This version of the bible was known as 'Kirk's bible', named after the Episcopal clergyman Robert Kirk who adapted an Irish Gaelic bible for use in Scotland. Due to the increasing differences in Irish and Scottish Gaelic, Kirk's bible was instrumental in distributing an intelligible version of the scriptures in the Highlands. Printed in 1690, it included a vocabulary section to help readers understand some of the unfamiliar Irish Gaelic words and phrases.[53] A new translation into

Fig. 8.6: Gaelic Bible carried by a government soldier at Culloden

18th century, National Museums Scotland, M.L1930.173

CATALOGUE NO. 213

Scottish Gaelic was not attempted until 1767. This bible serves as a reminder that despite the romantic image of the Gaelic-speaking Highlanders supporting the exiled Stuart kings, religious and political divisions existed throughout the Highlands, and throughout the rest of Britain.

The Legacy

These religious objects demonstrate the complexity of faith within the Jacobite movement. However, their status as treasured artefacts also shows how the material culture associated with the Jacobite campaigns has been preserved for its connection to Prince Charles and his faithful Jacobite followers. In 1746 an Episcopal minister Robert Forbes, later to become Bishop of Ross, began recording witness accounts of the Jacobite campaign in Scotland, possibly as a result of his imprisonment during the actual events.[54] The collection of letters, accounts and relics associated with the flight of Prince Charles is particularly valuable in recording the experiences of Jacobite supporters in the aftermath of Culloden. Association of objects with Prince Charles was enough to imbue them with an almost religious significance, which may have appealed to Bishop Forbes and to many others. Accounts contained in *The Lyon in Mourning* [Fig. 8.7] highlighted the role of the Episcopal clergy, including the aforementioned John

Fig. 8.7: *The Lyon in Mourning*

Robert Forbes work, *The Lyon in Mourning*, is an extensive collection of letters, accounts and relics relating to Prince Charles Edward Stuart's time in Scotland and the aftermath of the Battle of Culloden.

Compiled by Robert Forbes, 1746–75, The National Library of Scotland, Adv.32.6.19 vol 4

CATALOGUE NO. 216

McLauchlan associated with Appin, and the tragic story of the young clergyman Robert Lyon who was executed for his involvement in the rising.[55] Forbes did not discriminate, however, and also included tales of the Catholic clergy who were directly involved with the prince. *The Lyon in Mourning* was the life work of Bishop Forbes, and despite the threat of persecution he remained a staunch Jacobite until his death in 1775, a few years before the Scottish Episcopal Church formally cut all ties with the exiled Stuarts.

In 1747, a year after his brother's defeat at Culloden, Prince Henry Benedict joined the Catholic Church as a cardinal-deacon. It was a move perceived by his brother Charles as a betrayal of the dynasty and himself, as Henry was the Stuart family's last direct male heir. Henry and his father both believed the opportunity for restoration had passed and that the Jacobite cause was over. Such a strong family affiliation to the papacy ensured that the Stuart claim could not realistically be pursued. As Cardinal York, Henry rose to have great influence within the Catholic Church and was made *vice-cancelliere* in 1764, a position that came with the enormous Palazzo del Cancelleria.[56]

James VIII and III died in 1766, estranged from Charles who had refused to return to Rome. James was given an elaborate royal funeral in Rome and buried at St Peter's Basilica with full honours.[57] Twenty years later Charles died of a stroke, having never been recognised by the papacy as the rightful king. Henry did not publicly pursue the family claim to the throne after the death of his brother, although he commissioned a medal depicting him in his cardinal robes with the legend 'Henry IX King of Great Britain, France and Ireland, Defender of the Faith, Cardinal Bishop of Tusculum', and he was subsequently known privately by the nominal title of Henry IX.[58]

Despite his position in the Catholic Church, Henry still wanted his royal status to be recognised. Throughout his lifetime Henry commissioned some beautiful pieces from the workshop of Luigi Valadier, a goldsmith who also produced work for the Vatican.[59] Arguably the most significant piece commissioned by Henry was the York chalice [Fig. 8.8] (also known as the Stuart chalice}, which he bequeathed to the Vatican on his death. Decorated in a far more elaborate and ostentatious style than the Holyrood Communion chalice, the Stuart chalice was designed by Giuseppe Valadier in 1800.[60] The base is adorned with the heads of winged cherubs, and roundels depict various symbols including an image of a relic housed at St Peter's Basilica. Most notably, the chalice is set with the Sobieski jewels which Henry had inherited through his mother Clementina, making it a symbolic union of the Stuart dynasty and the Catholic Church. The Sobieski jewels represent the wealth and ambition of the exiled Stuarts and serve as a poignant reminder of the royal connections that had been cultivated to support their claim. Henry also had the Sobieski Sapphire symbolically mounted in his bishop's mitre.[61] The Stuarts, with the exception of Charles, were determined

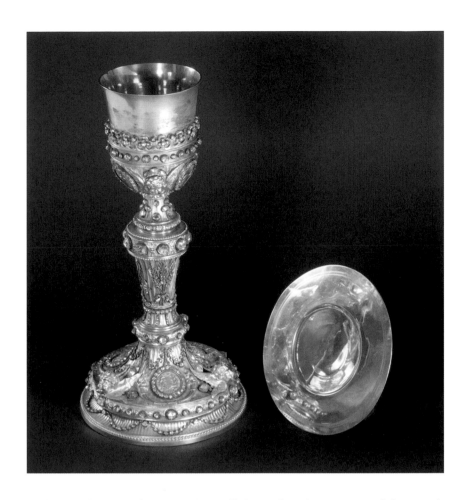

in their Catholicism, but were above all devoted to their pursuit of the British crown. This chalice is a symbol of the faith and religion that was interwoven with Stuart affairs throughout the 18th century and concludes their story with this final and irrevocable bond between Henry and the Catholic Church. After a century of Stuart attempts to be restored in their three kingdoms, Henry died as a cardinal of the Church rather than as a king.

The relationship between the exiled Stuarts and their religion was complex. Catholicism was fundamental to their initial loss of the throne and it ultimately undermined their attempts to regain it. The material culture shows the importance that James VII and II, and his son James VIII and III, placed in their faith and the sincerity with which they viewed it. The York chalice in particular shows the success of Henry in his pursuit of power and influence within the Catholic Church, at the expense of the Stuart claim to the throne. The conflict surrounding faith and kingship had an impact on relationships within the Stuart family, something which is evident in the lives of both Clementina and her son Charles

and their interactions with James VIII and III as husband and father. For James, walking the line between his faith, the demands of the Catholic Church and those of his followers, was a huge challenge. No matter how carefully he tried to navigate his way through these demands, the Stuart family found itself caught up in a web of politics and religion that extended throughout Europe.

For the Jacobite followers, adherence to both the Catholic and Episcopalian faiths had very real repercussions. Not all were motivated by faith but religion was a key factor in the Jacobite movement, which should not be underestimated. Association with the Jacobites was for Catholicism born out of religious affiliation and a firm belief in loyalty to a divinely appointed king. While the Episcopalians did not share religious affiliation with the exiled royal family, their support of the dynasty was rooted in their conviction of the Stuart's divine right to rule. Although the persecution succeeded in damaging both faiths by restricting their growth and in removing clergy, affiliation with Jacobitism was also reinforced by this marginalisation of both faiths. In the most significant Jacobite campaigns of 1715 and 1745, Catholic and Episcopalian clergy were notably present, preaching to the laity, offering Communion, and in some cases participating in the fighting. Whether or not the Jacobite soldiers chose to fight because of their faith, the Appin chalice, Morar vestments and the Gaelic bible show the very real presence of faith and religious ceremony throughout the campaigns. Religion was therefore crucial at every level of the Jacobite movement and the material culture is a tangible reminder of the role it played for both the key protagonists and their followers.

Notes

1. Bruce Lenman, *The Jacobite Risings in Britain 1689–1746* (1980), p. 55.

2. Dr Evelyn Lord, *The Stuart Secret Army: the Hidden History of the English Jacobites* (2004), p. 11.

3. Bruce Lenman, 'The Scottish Episcopal clergy and ideology of the Jacobitism', in Eveline Cruickshanks (ed.), *Ideology and Conspiracy: Aspects of Jacobitism, 1689–1759* (1982), pp. 36–48, p. 41.

4. John Watts, *Scalan: The Forbidden College 1716–1799* (1999), p. 13.

5. Daniel Szechi, 'Negotiating Catholic Kingship for a Protestant People: "Private" Letters, Royal Declarations and the Achievement of Religious Detente in the Jacobite Underground, 1702–1718', in Anne Dunan-Page and Clotilde Prunier (eds), *Debating the Faith: Religion and Letter Writing in Great Britain, 1550–1800* (2013), pp. 107–22.

6. The Earl of Mar initiated the rising of 1715 and declared James VIII and III as king; however, his motivation stemmed from the loss of his own position of influence. See Lenman, *The Jacobite Risings in Britain 1689–1746*, p. 134.

7. Pittock, M. G. H., *Scottish Nationality* (2001), p. 67.

8. Alistair Livingstone, *Muster Roll of Prince Charles Edward Stuart's Army* (1984), p. 33.

9. Pittock, *Scottish Nationality*, pp. 48–49.

10. Alistair J. Mann, *James VII: Duke and King of the Scots, 1633–1701* (2014), p. 65.

11. William Arthur Speck, *James II* (2002), p. 25.

12. McRoberts, David and Charles Oman, 'Plate made by King James II and VII for the Chapel Royal of Holyroodhouse in 1686', *Antiquaries Journal* 48: 2 (1968), pp. 285–95.

13. For further information on the use of Communion pieces, see Rt. Rev. Monsignor John Walsh, *The Mass and Vestments of the Catholic Church, liturgical, doctrinal, historical and archeological* (1916).

14. McRoberts and Oman, 'Plate made by King James II and VII for the Chapel Royal of Holyroodhouse in 1686', p. 294.

15. Edward Corp, *Court in Exile: The Stuarts in France, 1689–1718* (2003), p. 236; King James II, *The Pious Sentiments of the Late King James II of Blessed Memory Upon Divers Subjects of Piety* (1704).

16. Brian M. Halloran, *The Scots College Paris 1603–1792* (1997), p. 80.

17. James II, *Pious Sentiments*, p. 30.

18. Speck, *James II*, p. 27.

19. Daniel Szechi, 'Jamie the Soldier and the Jacobite Military Threat 1706–1727', in Allan I. Macinnes and Douglas Hamilton (eds), *Jacobitism, Enlightenment and Empire 1680–1820* (2014), p. 18.

20. G. Charles, *History of the Transactions in Scotland in the Years 1715–16 and 1745–46*, 2 vols (1816–17), vol 1, p. 346.

21. Szechi, 'Negotiating Catholic Kingship for a Protestant People: "Private" Letters, Royal Declarations and the Achievement of Religious Detente in the Jacobite Underground', p. 111.

22. Edward Corp, *The Stuarts in Italy: A Royal Court in Permanent Exile 1719–1766* (2011), p. 20.

23. Frank McLynn, *Bonnie Prince Charlie: Charles Edward Stuart* (2003), p. 20.

24. Corp, *The Stuarts in Italy*, pp. 28–32.

25. McLynn, *Bonnie Prince Charlie*, p. 399.

26. Ibid.

27. Helen B. Farquhar, 'Royal Charities Part IV – Conclusion of Touchpieces for the Kings Evil … Anne and the Stuart Princes', *British Numismatic Journal* 15 (1919–20), p. 170.

28. Farquhar, 'Royal Charities', p. 173.

29. Noel Woolf, *The Medallic Record of the Jacobite Movement*. (1988), p. 135.

30. Neil Guthrie, *The Material Culture of the Jacobites* (2013), pp. 115–16.

31. Paul Monod, *Jacobitism and the English people, 1688–1788* (1993), p. 129.

32. Noel Woolf, 'The Sovereign Remedy: Touch-pieces and the King's Evil', *British Numismatic Journal* 49 (1979), p. 3.

33. Peter Guilday, 'The Sacred Congregation De Propaganda Fide (1622–1922)', *The Catholic Historical Review* 6: 4 (1921), pp. 478–94.

34. Szechi, 'Negotiating Catholic Kingship for a Protestant People: "Private" Letters, Royal Declarations and the Achievement of Religious Detente in the Jacobite Underground', p. 399.

35. See the National Museums Scotland targe (H.LN 52) used by the Duke of Gordon as Marquis of Huntly, when he joined the Jacobite forces during the 1715 rising.

36. In the challenge of 1745 one of Henrietta's sons, Lewis Gordon, joined the Jacobite forces while brother Charles fought in the Hanoverian army. Alistair Taylor and Henrietta Taylor, *Jacobites of Aberdeenshire and Banffshire in the Forty-Five* (1928), p. 230.

37. Rev. Robert Forbes, *The Lyon in Mourning*, vol. 3, Publications of the Scottish History Society 20 (1895), pp. 50–52.

38. Thomas McInally, 'Missionaries or soldiers for the Jacobite cause? The conflict of loyalties for Scottish Catholic clergy', in Macinnes and Hamilton (eds), *Jacobitism, Enlightenment and Empire 1680–1820* (2014), p. 57.

39. Sarah Bailey, *Clerical Vestments: Ceremonial Dress of the Church* (2013), p. 33.

40. Pauline Johnstone, *High Fashion in the Church: The Place of*

Church Vestments in the History of Art, From the Ninth to the Nineteenth century (2002), pp. 88–90.

41 Watts, *Scalan: The Forbidden College 1716–1799*, pp. 63–64.

42 Forbes, *The Lyon in Mourning*, vol. 1, pp. 163 and 323.

43 Lenman, 'The Scottish Episcopal clergy and ideology of the Jacobitism', p. 37.

44 Halloran, *The Scots College Paris 1603–1792* (1997), p. 95.

45 Andrew L. Drummond and James Bulloch, *The Scottish Church 1688–1843: The Age of Moderates* (1973), p. 8.

46 Kieran German, 'Jacobite Politics in Aberdeen and the '15', in Paul Monad, Murray Pittock and Daniel Szechi, *Loyalty and Identity* (2010), p. 85.

47 See National Museums Scotland H.MEQ 1584, the travelling canteen of Prince Charles Edward Stuart made by Ebenezer Oliphant; and H.NT 241.21, a white cambric rose worn by Robert Strange.

48 Mary E. Ingram, *A Jacobite Stronghold of the Church* (1907), p. 47.

49 George Dalgleish and Henry Steuart Fothringham, *Silver: Made in Scotland* (2008), p. 142.

50 Margo Todd, *The Culture of Protestantism in Early Modern Scotland* (2002), pp. 86–87.

51 Dalgleish and Fothringham *Silver: Made in Scotland*, p. 145.

52 The National Archives (NA), State Papers of Scotland; Series II, SP 54/20/48E.

53 Lenman, 'The Scottish Episcopal clergy and ideology of the Jacobitism', p. 42.

54 Henry Paton, 'Preface' in Forbes, *The Lyon in Mourning*, vol. I, p. xv.

55 Forbes, *The Lyon in Mourning*, vol. I, pp. 3–21.

56 Corp, *The Stuarts in Italy*, p. 344.

57 Ibid., p. 349.

58 Woolf, 'The Sovereign Remedy', p. 132.

59 See the Cardinal York caddinet, Royal Collections, RCIN 45182.

60 *Valadier: Three Generations of Roman Goldsmiths. An exhibition of drawings and works of art: 15th May to 12th June 1991, Monday to Friday, 10am to 5pm at David Carritt Limited, 15 Duke Street, St James's, London, SW1Y 6DB*, pp. 122–23.

61 Corp, *The Stuarts in Italy*, p. 283.

Opposite: Objects associated with Cardinal York

A caddinet (above), was exclusively used by royalty in Britain for dining. In commissioning such a piece depicting his own coat of arms, Cardinal York was making a political statement. The arms of the Cardinal have also been embroidered onto the cover of his Book of Hours (below, left) and can be seen on this painted dish (right).

The Royal Collection / HM Queen Elizabeth II 2017, RCIN 45182. 1005087 and 43815

CATALOGUE NOS 269, 270 AND 272

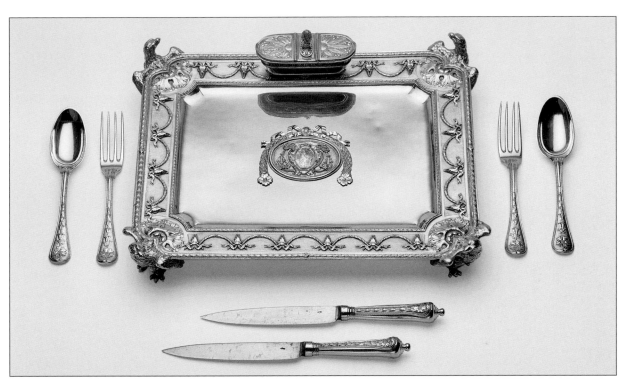

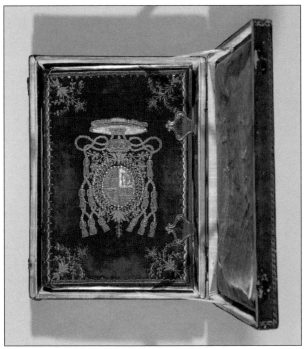

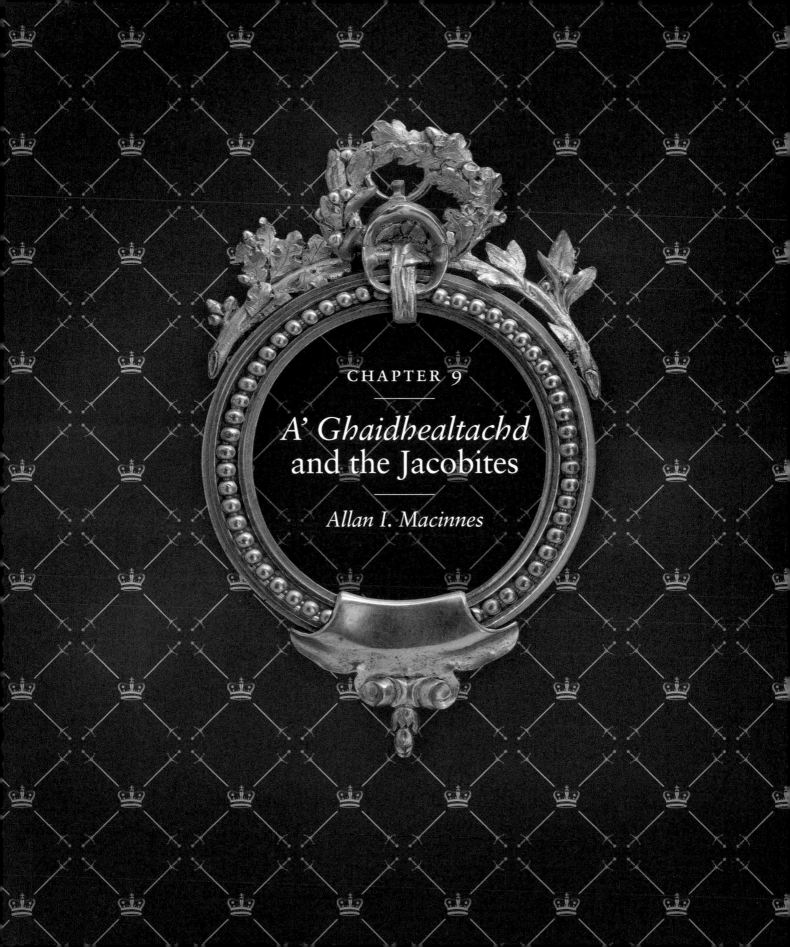

CHAPTER 9

A' Ghaidhealtachd
and the Jacobites

Allan I. Macinnes

THE HIGHLAND CLANS WERE THE MILITARY BEDROCK OF JACOBITISM IN Scotland; this was the case for the first major rising in 1689–91, for the second in 1715–16 (the Fifteen) and the final rising in 1745–46 (the Forty-Five) when they formed the front-line troops in all battles. The clans were on stand-by but not called into action in the minor rising of 1708, and were again prominent in that of 1719. All risings in which they were active tended to begin and end in the Highlands. Why should this be so? The persistence of hosting – that is, the mobilising of clansmen for hunts, funerals, marriages and demarcating territories – could readily be adapted for military purposes, especially on the passing round of the fiery cross to signify an immediate call to arms. The difficulties of communication, both geographic and linguistic in the *Gaidhealtachd*, circumscribed the capacity of British governments and their Whig sympathisers to mount any prompt counter-offensive.[1]

The military readiness of the clans can be overplayed, however. Before the Battle of Killiecrankie in July 1689, the victorious Jacobite commanders were concerned that clansmen were predominantly raw, undisciplined troops who had never seen blood. The clan élite were increasingly reluctant to meet the expense of providing guns which had replaced bows and arrows as weapons of choice. Want of arms and ammunition, no less than money, greatly hindered the recruitment of clansmen for the Jacobite cause in the Fifteen. Despite the disarming acts of 1716 and 1725 meeting with limited compliance from Jacobite clans, functioning weapons were again in short supply at the Forty-Five. Prior to the Battle of Prestonpans in September 1745, Donald Cameron of Lochiel was obliged to dismiss around 150 clansmen for want of arms and ammunition. When the clans lined up for battle, the best armed, usually the clan gentry, were in the vanguard, with the less well-armed clansmen ranked behind according to their possession of guns, swords and targes [Fig. 9.1]. The Highland Charge favoured by the clans in battle was a superb tactic for irregular infantry that made optimum use of hillsides, the

Fig. 9.4 and page 160: The Battle of Glenshiel, 1719

By Peter Tillemans (c.1684–1734) [detail], painted in 1715, oil on canvas, 118 x 164.5 cm, Scottish National Portrait Gallery, Edinburgh, PG 2635

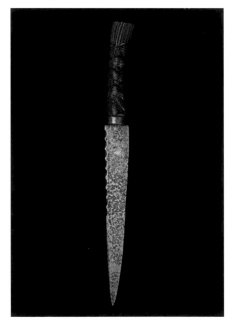

technology the clans could afford, and the effectiveness of the sword and targe at close quarters after firearms were discharged prior to their descent.

Warfare for the clans was secondary to their peaceable and productive settlement of land in a rocky and watery terrain usually more suitable for pastoral than arable farming, and periodically afflicted by inclement weather. The clans were an amalgam of feudal landholding, kinship and local association. The feudal dimension determined how lands were held; kinship and local association ensured continuity of possession. Clans were composed of dominant kindreds to whom other families in their localities were associated. The heads of these satellite families were part of the clan gentry along with the leading members of the dominant kindred who provided the chief. Succession in the clans by the late 17th century was governed by primogeniture not election. The chief was more than a landlord who collected and lived off rents; he was trustee for his people, providing hospitality and protection, and where necessary leadership, in the field. However, clans were no longer immersed in territorial feuds; the last clan battle over the lands of Glenroy and Glenspean was fought at Mulroy in the Braes of Lochaber in September 1688 when the MacDonalds of Keppoch defeated the Mackintoshes and their allies in Clan Chattan. By this juncture, clans were rarely involved in wholesale cattle-lifting, which had become a freelance activity mainly undertaken by bandits or cateran bands operating out of Lochaber and Rannoch who had thrown over the social constraints of clanship. Nonetheless, the MacDonalds of Keppoch, the MacDonalds of Glencoe and the Camerons of Lochiel remained prone to cattle-lifting. As all were stalwart Jacobites, the cause became tainted with banditry by their Whig opponents who continuously claimed that the clans were impoverished mercenaries who slavishly and ignorantly adhered to their chiefs and gentry.[2]

Such propaganda can be easily debunked. General George Wade arrived in the Highlands in 1725 to enforce military occupation on behalf of the British government. This was to be achieved by a road-building programme; by refurbishing garrisons at Fort William, Fort Augustus and Inverness along the Great Glen, together with Bernera in Glenelg and Ruthven in Badenoch; by the development of an intelligence network with the notorious Rob Roy MacGregor serving as his chief informer; and by the raising of Independent Companies from loyal clans to guard the passes to prevent cattle-stealing from the Lowlands [Fig. 9.2]. As part of this programme, Wade issued a list of bandit clans which corresponded to the Jacobite clans who fought in the Fifteen. Among the clans listed were the Campbells of Glenorchy, whose future chief, John, 3rd Earl of Breadalbane, was then a British ambassador serving in Denmark and Russia.[3] Although the Independent Companies were to be formed into the Black Watch, the first Highland regiment of the line in British service from 1739, command over these Companies was actually given to political opportunists like Simon Fraser, Lord

Fig 9.1, opposite: Highland dagger

Known as a *sgian achlais*, this knife was found at Culloden in 1875.

Early 18th century, National Museums Scotland, H.LC 67

CATALOGUE NO. 208

Fig. 9.2: Obligation to deliver cattle by Rob Roy (detail on reverse)

27 December 1711, National Museums Scotland, H.OA 40

CATALOGUE NO. 97

Lovat, and Ewen Macpherson of Cluny, both of whom reverted to Jacobitism at the Forty-Five. Another commander was Coll MacDonnell of Barrisdale, a Jacobite sympathiser who nevertheless used his Company to extort blackmail from the clans in Lochaber and Rannoch.

Even in the aftermath of the Forty-Five, government agents were claiming the droving trade was losing £37,000 annually through theft. But this figure should not be accepted uncritically. The yearly value of livestock lost was no more than £5000 from a trade that was generating well in excess of £100,000. Recovery expenses for lost cattle were computed at £2000, with blackmail and watch money at £5000. Under-stocking as a result of theft was generously estimated to be £15,000 and the remaining £10,000 was loosely apportioned to additional expenses arising from herding.[4] These losses were easily absorbed by a trade enjoying increased demand from the development of London as an imperial metropolis and the growth in urban markets through industrialisation from the mid-18th century. Droving was a major growth point in the Scottish economy in which Highland clans were to the fore from the 1680s. This profitable enterprise had given the clans a vested interest in acting within the law, albeit chiefs and leading gentry had used the profits from droving to underwrite their absenteeism, rent-raising and accumulation of debts from lavish consumer expenditure in Lowland towns and cities as later in London.

But the profits of droving were not all frittered away. Profits provided liquidity for the inventive banking policies of the Bank of Scotland (established 1695) and the Royal Bank of Scotland (established 1727), whose rivalry led to the pioneering of overdrafts, deposit accounts and promissory notes for commercial exchange which attracted considerable investment from England. At the same time, droving financed the influx of such colonial commodities as tea, sugar, coffee, tobacco, cocoa, peppers, nutmeg, cloves and other culinary spices from Glasgow and the

leading Scottish cities into retail outlets throughout the *Gaidhealtachd*. The growth of consumerism and lifestyle choices among the clans in the 18th century had been long preceded by the development of vernacular Gaelic poetry as a polemical vehicle for political and social criticism in the 17th century. Such criticism, which was widely circulated through informal social gatherings like the *ceilidh*, was directed against the errant politics and profligate lifestyles of chiefs and clan gentry who subordinated their duties as trustees to their rights as landlords. Vernacular poetry, more than material artefacts like medals, drinking glasses and lockets, affirmed the positive reasons for Jacobitism: adherence to dynastic legitimacy, confessional commitment and patriotism.

The dynastic appeal of Jacobitism was grounded in adherence to the hereditary principal of kinship. The royal house of Stuart was the rightful trustee of Scotland in the same way that clan chiefs were the customary protectors of their followers. Dynastic legitimacy was seen as the source of justice, the basis of government. But the lawful exercise of government and the maintenance of justice were imperilled by the sundering of genealogical continuity, first by the replacement of James VII and II by his son-in-law William of Orange in 1689, and then by the succession of the house of Hanover under George I in 1714. Roderick Morison, the Blind Harper from Lewis, condemned the Revolution that set aside King James as the work of men without honour:

Thug iad stràc cho mallaichte
's gur annamh e r' a luaidh –
gràdh thoirt do righ annasach
's an ceanna a chur uath'.[5]

[*They struck a blow so accursed that the like has seldom been told – to give their love to an alien king and to disown their true sovereignty.*]

In vernacular poetry, Jacobitism represented a divinely warranted tradition that acted as a corrective to political, social and commercial deviations from custom. Poets such as Aonghus MacAlasdair Ruaidh (Angus MacDonald) from Glencoe and Iain MacAilean (John Maclean) from Mull essentially upheld the rightful trusteeship of the Stuarts, not their divine right as monarchs to suspend or dispense laws. It was his exercise of these prerogative powers on behalf of his fellow Catholics that instigated the removal of James VII and II from the thrones of Scotland, England and Ireland by 1689. For the Glencoe bard, the Revolution was an act of unmitigated treachery:

Chan eil e ceadaicht' dhuinn claonadh
No'n righ saoghalta mhùcadh

's gur e'n t-oighre fìor dhligheach,
O'n a ghineadh o thùs e;
Chan fhaod deifer an crèidimh,
No neo-chreidimh ar taladh
'S gun ùghdaras laghail
Is gnìomh foilleil dhuinn aicheadh.[6]

[*It is not permissible for us to turn aside from, or suppress our temporal king. For, from the moment he was first conceived, he was the true rightful heir. No difference of faith, or even lack of faith, may draw us away; without lawful authority, it is a treacherous thing for us to renounce him.*]

The morality of the Whigs in deposing their king was questioned by the Mull bard:

Dham bharail fèin, ga beag mo lèirsinn,
Gheibh mi ceud ga chòmhdach,
Ge b'd ti dhe'n dèan Dia righ
Gur còir bhith strìocadh dhò-san;
'S gad thomhais e ceum d'a làn-toil fèin
'S gun e cur èiginn òirne,
Saoil sibh pèin an lagh no reusan
Dol a leum na sgròban?[7]

[*I am of the opinion, though limited my vision, I will get a hundred to confirm it, that whoever the man God makes king to submit to him is proper; and though he behaved just as he pleased but without putting us to trouble, do you think by law or reason of leaping up at his gullet?*]

Highland support for the exiled house of Stuart was based on practical experience no less than traditional allegiance. Prior to becoming king in 1685, James, then Duke of Rothesay and York, had been despatched to govern Scotland by his brother Charles II. During his stint in Scotland he instigated the Commission for Securing the Peace of the Highlands which, for the first time, involved a raft of chiefs and clan gentry to administer justice. Their circuits of the *Gaidhealtachd* between 1682 and 1684 disabused notions of clan lawlessness, endemic feuding and inveterate cattle-lifting. Moreover, James promoted colonial ventures to South Carolina and New Jersey which involved Highland entrepreneurs from such clans as the Campbells, the Camerons and the Mackintoshes. James also successfully fended off the rebellion of Archibald Campbell, 9th Earl of Argyll, after he became king. The suppression of this rebellion, which demonstrated

that the Crown was a check on the most powerful and acquisitive clan in the Highlands, was aided by the mobilisation of clans from Lochaber, Rannoch and Atholl, which served as a preparatory run for the first major Jacobite rising in 1689–91. Curtailing the powers of the Campbells was a recurring theme in Gaelic poetry and certainly was an issue in mobilising recruitment for the Jacobites in the western and southern Highlands. However, only the Campbells of Argyll were consistent Whigs; the other two main branches of the clan – of Glenorchy and of Cawdor – flirted with Jacobitism in the Fifteen.

While James VII and II was removed as monarch because of his personal commitment to Catholicism, the majority of the Jacobite clans did not share his religious faith. The number of fighting men among the clans can be computed at around 22,000, of whom Catholics made up less than 14 per cent of the total and little more than 20 per cent of the forces mobilised in support of Jacobitism in all the major risings. The majority of the Jacobite clans and about 75 per cent of those activists mobilised in 1689–91, 1715–16 and 1745–46 were Protestants but Episcopalian. Episcopalianism (government by bishops) had been ousted from its established position as the Kirk of Scotland in favour of Presbyterianism (governed by ecclesiastical courts) at the Revolution. A minority of Episcopalians in the Lowlands were prepared to seek an accommodation first with William of Orange, his successor Queen Anne and then the Hanoverians, in order to secure religious toleration as jurors. The refusal of the vast majority of Episcopalians to abjure the exiled house of Stuart, despite offers of toleration in 1693, 1695 and 1712, subjected them as non-jurors to the same penal laws applied to Catholics. Nevertheless, Episcopalianism, again like Catholicism, provided a religious complement to the hierarchical nature of clanship. Accordingly, the removal of James VII in favour of his daughter Mary and her husband William of Orange was castigated by Donnchadh nam Pios (Duncan MacRae), an Episcopalian minister from Kintail, as an abnegation of patriarchal honour:

Neo-nàdur a'bheart so
Do nach a ghabh baisteadh
Ann an ainm nan trì peasron th shuas.[8]

[*This is an unnatural act for one who received baptism in the name of the Trinity.*]

Other Jacobite clansmen reaffirmed their commitment to Jacobitism by their religious faith. Prior to the Forty-Five, the aged Aonghas MacAlastair Ruaidh from Glencoe confidently proclaimed:

Bidh miadh air Eaglaisean
Us sunnd air teagast ant',[9]

[The {Epicopal} Church will be honoured, its teaching respected, …]

Dr Archibald Cameron from Lochaber, a companion of Prince Charles Edward Stuart, was the last Jacobite executed after being found guilty of plotting to bring down the British government in 1753. In a personal testimony smuggled out of the Tower of London, he testified that he was to die

… a member though unworthy of that Church in whose communion I have always lived: The Episcopal Church of Scotland as by law established before the most unnatural Rebellion begun in 1688.[10]

Of the fifty principal clans, 18 were predominantly non-juring and another 18 had a significant commitment to Episcopalianism. However, the Presbyterian establishment, which was confirmed by the Treaty of Union in 1707, did have some success in winning adherents in the *Gaidhealtachd*. In this task they were assisted from 1709 by the Society for Propagating Christian Knowledge, and annually from 1724 by royal bounties to help finance their schools and ministers in Highland parishes. Although Presbyterianism was the Whig interest at prayer in Scotland, and although their pulpits in the Highlands thundered against Jacobitism, no more than eight of the principal clans actually adhered to the Whig cause, but only five consistently so in all major risings. Nevertheless Presbyterianism conspicuously weakened support for Jacobitism among clans, either by dividing their allegiances or persuading them to stay neutral. The spread of Presbyterianism in Wester Ross was reputedly instrumental in persuading the MacRaes to move from Jacobitism to neutrality in the Forty-Five. Conversely, the revival of Episcopalianism among the MacLachlans in Argyll persuaded them to switch from neutrality back to Jacobitism. Much of the credit for this revival can be given to John MacLachlan of Kilchoan, Episcopal minister in Appin, who in 1723 had been gifted a chalice and paten to hold respectively the wine and wafers used in communion services. The Appin chalice and paten [Cat. no. 211] were almost certainly utilised by him on 16–19 April 1731, when this non-juring clergyman preached in fields and administered communion to over a thousand people of both sexes drawn from the Camerons of Lochaber, the MacDonalds of Glencoe and the Stewarts of Appin. Indeed, this communion season in North Ballachulish was deemed by a government informant as the largest gathering of Jacobites since the Fifteen. Fourteen years later, the Rev. MacLachlan accompanied the Appin Regiment in the Forty-Five and used the chalice and paten to administer communion at Prestonpans, Derby, Falkirk and Culloden. On the latter occasion, wine and wafers were seemingly replaced by whisky and oatmeal for the living before and for the dying after the battle.[11]

Nonetheless, Jacobite commitment was not determined by religious unifor-

Fig. 9.3: Highland targe

The embossed pattern on the surface of this shield includes a lion rampant, a ship and a fish. It was possibly used by MacDonald of Keppoch at Culloden.

Early 18th century, National Museums Scotland, A.1905.1035

CATALOGUE NO. 206

mity. William MacKenzie, the 5th Earl of Seaforth, a Catholic, led out his predominantly Episcopalian clan in the Fifteen, when Angus MacDonald of Glengarry, an Episcopalian, led out his Catholic clansmen. Coll MacDonald of Keppoch [Fig. 9.3], who fell at Culloden, was also the Episcopalian chief of a Catholic clan. Some Presbyterian ministers, such as Reverend John Cameron in Lochaber, supported the Jacobite cause espoused by his non-juring and Catholic clansmen in the Forty-Five when Francis Farquharson of Monaltrie commanded a mixed clan of non-jurors and his fellow Presbyterians.[12]

Jacobitism acquired a new impetus from the making of the Treaty of Union between Scotland and England in 1706–7. Patriotism no less than dynasticism became its driving force. Patriotism was part of the continuous process of redefining Jacobitism in Scotland that was not always to the taste of the exiled house of Stuart. The identity of the Scottish people was expressed through the momentous attainments of scholars, soldiers and adventurers no less than monarchs. George Mackenzie was prominent among those who argued that territorial nationhood should take precedence over dynastic statehood.[13] Jacobitism could also draw on anti-Unionism, aggravated by the misgovernment of Scotland after 1707, to forcibly end Scottish political subjection. Silis na Ceapaich (Julia MacDonald of Keppoch) from Lochaber tapped into a vernacular Gaelic and Scots tradition that the Union had been accomplished by bribery when she exhorted prior to the Fifteen:

Ach Alba éribh comhla
Mun gear Sasunnaich ur sgòrnan
'Nuair thug iad air son óir naibh
Ur creideas is ur stòras,
'S nach eil e'n duigh 'n ur pòca.[14]

[*But arise, Scotland, as one, before the English cut your throats, since they have robbed you of your credit and your possessions in return for gold which is not in your pocket today.*]

'Prosperity to Scotland and No Union' became a common theme on Jacobite banners, in manifestos and on occasional swords [Fig. 9.8] after the commencement of the Fifteen in Braemar and the Forty-Five at Glenfinnan in Lochaber. However, this slogan had more force in the Fifteen, two years after an attempt to initiate the repeal of the Union was lost by only four votes in the House of Lords. After the Fifteen, leading chiefs and clan gentry had their estates forfeited to the

Crown. This had occurred during the Revolution, but forfeiture was relatively short-lived as the government of William of Orange sought to build up support in Scotland after stage-managing the massacre of the MacDonalds of Glencoe in February 1692. Forfeiture after the Fifteen also opened up the *Gaidhealtachd* to speculative interests, notably from the York Buildings Company of London which was intent on asset-stripping timber and mining resources. At the same time, forfeiture was met with widespread civil disobedience as clans sent their rents overseas to chiefs and gentry in exile. When government troops attempted to uplift rents on the Earl of Seaforth's estates in Wester Ross, the chamberlain, Donald Murchieson, mobilised the MacKenzies for an ambush at Ath-na-mullach in Kintail. The government troops were repelled with significant casualties in October 1721. After six years of civil disobedience the forfeited estates in the *Gaidhealtachd* were restored to the chiefs and leading gentry in return for sureties for their own and their clans' peaceable conduct. Yet in 1727 there was a further act of blatant discrimination when the Jacobite heartlands in the Highlands and in the north-east of Scotland were left out of the remit of the newly-constituted Board of Trustees charged to develop the fisheries and manufacture of woollens and linen.

Nevertheless, the manifest neglect of Scottish economic, social and administrative interests was less pronounced thereafter as opportunities in Empire were opened up to chiefs and clan gentry. The managerial dominance of Scottish politics exercised by Archibald Campbell, Earl of Islay (later 3rd Duke of Argyll), and his associates from 1725 ensured that the limited offices and other places of profit in the gift of the Scottish establishment continued to be monopolised by Presbyterians and other committed Whigs.

However, placement in Empire was different on account of the pervasive contacts of John Drummond of Quarrel. Having begun his career as an Edinburgh merchant, he moved to Amsterdam where he established himself as the leading continental financier for the British forces during the War of the Spanish Succession (1702–13). Following the conclusion of the war, Drummond shuttled between Amsterdam, Edinburgh, Paris and London. He helped shape the direction of the East India Company after he settled in London from 1724. A committed Unionist, he nonetheless had strong Episcopal and Jacobite connections, which made him the ideal imperial complement to Islay's domestic political management. Drummond enjoyed the backing of Prime Minister Robert Walpole who had factored in Jacobites, particularly clansmen from the west and central Highlands, as expendable manpower to maintain the British presence in the Caribbean and secure the frontiers of American colonies such as Georgia and North Carolina. Drummond used imperial patronage in the West and East Indies not just to reward Whigs but to rehabilitate Jacobites. Until his death in 1740, he was the chief mover in placing Scots, regardless of their political or religious

affiliations, in Empire. The Jacobite clans who benefited from his patronage included the Camerons in Jamaica, the Mackintoshes and the Clan Chattan in the Leeward Islands, the Campbells of Glenorchy in India, China and Brazil, the MacKenzies with lucrative army and navy commissions in the West Indies, and the Grants in India, Barbados and Jamaica from where they traded to Mexico. Other clans in the southern Highlands with strong non-juring affinities – notably the Buchanans, the MacFarlanes, the MacNeills, the Colquhouns, and even the MacColls from Appin – profited from the upsurge of the tobacco and sugar trades from Glasgow in the wake of Union.

Increased prosperity from droving, the growth of consumerism, the spread of denominationalism, the threat of renewed forfeiture and, above all, engagement with Empire, impacted significantly on the commitment of the clans to Jacobitism. In all three major risings, support among the fifty principal clans for the Jacobite cause was consistently higher than commitment to the Whigs who mobilised nine clans in 1689–91, eight in 1715–16 and seven in 1745–46. The respective figures for the Jacobites were 29 at the Revolution, a drop of three to 26 at the Fifteen, and a further drop of seven to 19 at the Forty-Five. Around one-fifth of the leading clans took no part in each of the three major risings. Only the Sinclairs of Caithness remained consistently neutral as pressure from surrounding Whig clans obliged them to contain their Jacobite inclinations. The more significant change in clans mobilised for civil war was the rise in the number of divided clans from two at the Revolution to five at the Fifteen to twelve at the Forty-Five. Divisions were not only within clans, but within the same family. William Mackintosh, chief of Clan Chattan, sought to expunge his clan's Jacobite past by raising an Independent Company for the British government at the Forty-Five. All but a handful deserted to join the regiment raised for the Jacobites by his wife, Lady Anne Mackintosh. Only two clans, the Atholl Men (the Stewarts, the Fergussons and the Murrays) and the Grants, had divided allegiance in all three major risings. Despite the endeavours of their clan élite to enforce neutrality, Atholl Men joined with Grants from Glenmoriston and Glenurquhart to fight for Jacobitism at the Revolution, in the Fifteen and the Forty-Five. Indeed, by the later rising, clansmen mobilised in defiance of their chiefs in at least five other clans. While there was undoubtedly evidence of clansmen being forced out and deserting in all risings, the Whigs found it far more difficult to enlist and retain their troops.

All Jacobite campaigns were affected by ill-fortune, incompetence and inconsistency. Led by John Graham, Viscount Dundee, the Jacobites defeated William of Orange's forces at Killiecrankie in Perthshire on 27 July 1689. Dundee was killed towards the close of battle. The Jacobites failed to break out of the Highlands, being held at Dunkeld in Perthshire on 21 August, and turned back at Cromdale in Aberdeenshire on 30 April 1690. In 1708 a French fleet arrived in the Firth of

Fig. 9.4: The Battle of Glenshiel, 1719

By Peter Tillemans (c.1684–1734), painted in 1715, oil on canvas, 118 x 164.5 cm, Scottish National Portrait Gallery, Edinburgh, PG 2635

Forth, but the appearance of superior forces of the Royal Navy prevented the establishment of a bridgehead. The ferocious and ill-defined English law of treason was then foisted on Scotland in direct breach of the Treaty of Union, a measure which made possible the show trials of Jacobites in English courts after the Fifteen and the Forty-Five. A further full-scale invasion launched by Spain in 1719 was wrecked by storms. The command of the expeditionary force sent to the Western Isles was disputed between William Murray, Marquess of Tullibardine, and George Keith, the Earl Marischal. Excessive delay in Stornoway meant that the government forces had already mobilised by the time Tullibardine attempted to rally the clans on the mainland. The British government won a decisive victory on 10 June at Glenshiel in Wester Ross [Fig. 9.4], and selective military reprisals were inflicted on Jacobite clans in the vicinity, again a harbinger of state-sponsored terrorism after the Forty-Five.

The most glaring strategic inconsistencies resulting from the differing objectives of British dynastic restoration and Scottish patriotism were manifest in both the Fifteen and the Forty-Five. John Erskine, Earl of Mar, who had steered the Union through the Scottish Parliament, was removed from office as the Secretary of State for Scotland at the Hanoverian Succession. He was able to play

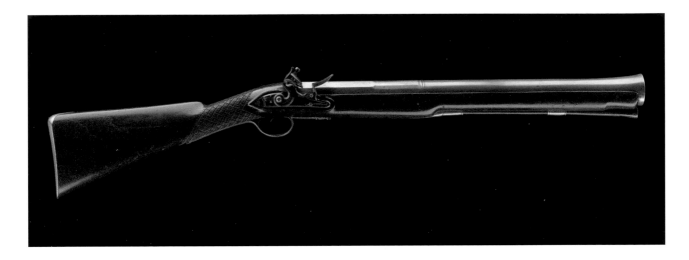

Fig. 9.5: The 'Preston Blunderbuss'

A brass and wood flintlock blunderbuss with the engraved inscription, 'This was taken from a Highlander at Preston 1715 loaded with 17 balls'.

Late 17th century (barrel), late 18th century (butt), National Museums Scotland, X.2015.143

CATALOGUE NO. 84

on the Scottish Jacobites' need for a prominent leader at the Fifteen. Mar's undoubted managerial abilities were not matched by any perceptible military expertise. He failed to channel widespread discontent with the Union into a successful patriotic rising. Rather than consolidate in the central Lowlands after capturing Perth, Mar sent a Highland detachment across the Firth of Forth under the command of William Mackintosh of Borlum to liaise with Scottish and English Borderers. Instead of concerting a pincer movement on Edinburgh, the Borderers at the insistence of Northumberland gentry marched into England; a course which ended in emphatic defeat at Preston in November 1715 [Fig. 9.5], the same day as Mar suffered a decisive reversal at Sheriffmuir near Dunblane. Although the Jacobites did have a military commander with a dash of brilliance in the Forty-Five, Lord George Murray was constantly undermined by a fatal personality clash with the charismatic, but strategically inept, Charles Edward Stuart, elder son of the exiled 'James VIII & III'. The failure of Prince Charles to consolidate in Scotland before invading England led to a collective loss of political will to sustain patriotic campaigning after defeat at Culloden near Inverness on 16 April 1746.

The initial success of Prince Charles in winning the Battle of Prestonpans near Edinburgh on 21 September 1745, then marching his troops south as far as Derby, flattered to deceive. The lack of foreign support undermined the confidence of English Jacobites, while the wholesale adoption of Highland garb led to their complete failure to identify with the Prince's Scottish army. By the time of retreat at the outset of December, Jacobite lines of communication had been over-extended and provisioning was extremely difficult. Despite their victory at Falkirk on 17 January 1746 there were no secure bridgeheads for assistance from France or Sweden. But the Highland Army's highly mobile incursion into the English Midlands, though it was orderly, civilised and restrained,[15] had persuaded

the commanders of the superior British forces by land and sea that Jacobitism should be annihilated.

In the wake of the Forty-Five, the British government pursued a final solution to the Jacobite problem, particularly in the *Gaidhealtachd*, by active terrorism directed against the clans by land and sea. Indiscriminate punitive action, initiated by the Hanoverian victor at Culloden, William Augustus, Duke of Cumberland [Fig. 9.6], verged on genocide. Writing on 20 March 1746 to James Campbell, Earl of Loudoun, commander of the Highland Regiment raised from the Whig clans, Cumberland had commended the destruction of Jacobite clans, particularly the Frasers and those around Inverness. Nine days after Culloden [Fig. 9.7], the duke moved to the wholesale destruction of the livelihood and lives not only of known Jacobites but those suspected of being their associates. On 25 April, he instructed Loudoun that on his troop manoeuvres in Glenelg and Ardnamurchan

> *… you will constantly have in mind to distress whatever Country of Rebels You may pass through, & to seise or destroy all Persons You can find, who have been in the Rebellion, or their Abettors.*[16]

Livestock was driven off and fishing boats holed to induce starvation. The genocidal intent of Cumberland was condoned not only by chiefs of Whig clans, but by chiefs whose clansmen had defied them to fight for Jacobitism. Apart from occasional retaliatory assassinations in Lochaber, banditry became a form of social protest for renegade clansmen into the 1750s.

The terrorism perpetrated in the immediate aftermath of Culloden, the crass brutality of selecting clanship for eradication and the repression prolonged beyond the escape of Prince Charles to France in September 1746, has become ingrained in the folk memory of the Gael.[17] The butchery of Cumberland cannot be exonerated on the grounds that several thousand clansmen had assembled at Ruthven in Badenoch within days of Culloden. Although they remained in armed readiness for a month, the faction-ridden Jacobite command had abandoned a cause which no longer constituted a threat to a triumphalist British state. Despite the personal cost of reprisals, an anonymous female poet prioritised the fate of Prince Charles:

> *Mharbh iad m'athair, mharbh iad mo bhràithrean*
> *Mhill iad mo chinneadh is chreach iad mo chàirdean*
> *Loisg iad mod dhùthaich is rùisg iad mo mhathair –*
>
> *'S cha chluinnte mo mhulad nam buinnigeadh Teàrlach.*[18]

Fig. 9.6: Portrait of General H.R.H. Prince William Augustus, Duke of Cumberland

By David Morier (1705–70), painted in 1746–70, oil on canvas, 144.5 x 120 cm (framed), National Museums Scotland, M.1990.141

CATALOGUE NO. 187

[*They've killed my father, they've killed my brothers, they've savaged my kindred and plundered my kinsfolk, they've burned my country and raped my mother – And if Charles won no one would hear me grieving.*]

The optimistic expectation of vernacular poets that the rightful cause of Jacobitism would ultimately triumph now gave way to an unredeemed fatalism. Alasdair MacMhaighstir Alasdair (Alexander MacDonald) from Ardnamurchan, the foremost vernacular poet of the 18th century, attested that the emphatic defeat of the '45 had undermined the social fabric of the *Gaidhealtachd*:

> *Chaill sinn ar stiùir 's ar buill-bheairte*
> *Dh'fhalbh uainn ar n-acair-bàis,*
> *Chaill sinn ar compass us ar cairean,*
> *Ar reul-iùil, 's ar beachd ga là.*[19]

[*We've lost our tiller and our rigging, our Sheet-anchor's torn away, we've lost our charts, our compass with them, our pole-star, our daily guide.*]

Notes

1. This chapter draws heavily on past work, notably Allan I. Macinnes, *Clanship, Commerce and the House of Stuart, 1603–1788* (1996), pp. 159–217; Allan I. Macinnes, 'Jacobitism in Scotland: Episodic Cause or National Movement?', *Scottish Historical Review* 86 (2007), pp. 225–52; and 'Union, Empire and Global Adventuring with a Jacobite Twist' in A. I. Macinnes and D. J. Hamilton, *Jacobitism, Enlightenment and Empire, 1680–1820* (2014), pp. 123–39.

2. Margaret Steele, 'Anti-Jacobite pamphleteering, 1701–1720', *Scottish Historical Review* 60 (1981), pp. 140–55; Andrew Ferguson, *A genuine Account of All of the Persons of note in Scotland, who are now engaged in the service of the Chevalier* (1745); Anon., *The History of the Rise, Progress and Extinction of the Rebellion in Scotland in the Years 1745 and 1746* ([1750]).

3. J. Allardyce (ed.), *Historical Papers relating to the Jacobite Period 1699–1750*, 2 vols (1895), vol. I, pp. 131–65.

4. Gartmore MS, printed as appendix in a revised edition of Edmund Burt, *Letters from a Gentleman in the North of Scotland*, R. Jamieson (ed.), 2 vols (1818), vol. II, p. 359.

5. William Matheson (ed.), *The Blind Harper: The Songs of Roderick Morison and his Music* (1970), pp. 26–27.

6. The value of this and other polemical sources in Scottish and Irish Gaelic is discussed in more depth in Allan I. Macinnes, 'Gaelic culture in the seventeenth century: polarization and assimilation', in Steven G. Ellis and Sarah Barber (eds), *Conquest & Union: Fashioning a British State, 1485–1725* (1995), pp. 162–94.

7. Colm Ó Baoill (ed.) and Meg Bateman (trans.), *Gair nan Clarsach: The Harps' Cry. An Anthology of 17th Century Gaelic Poetry* (1994), pp. 188–89.

8. M. Macfarlane (ed.), *Lamh Sgriobhainn Mhic Rath: The Fernaig Manuscript* (1923), p. 187.

9. John L. Campbell (ed.), *Highland Songs of the 'Forty-Five* (1984), pp. 16–17.

10. British Library, London. Miscellanea, Stowe MS 1083, f. 104.

11. National Archives, London. Secretaries of State: State Papers Scotland, series I, SP 54/20, fo. 48.

12. For the fifty principal clans, their territories and their religious and political affiliations, see Macinnes, *Clanship, Commerce and the House of Stuart, 1603–1788*, pp. 242–49.

13. George Mackenzie, *The Lives and Characters of the Most Eminent Writers of the Scottish Nation*, 3 vols (1908–22).

14. Colm Ó Baoill (ed.), *Bàrdachd Shìlis na Ceapaich: Poems and Songs by Julia MacDonald of Keppoch* (1972), pp. 18–19.

15. Ian G. Brown and Hugh Cheape (eds), *Witness to Rebellion: John Maclean's Journal of the 'Forty-Five and the Penicuik Drawings* (1996), pp. 21–40.

16. Huntington Library, San Marino, California. Loudoun Scottish Collection, box 47/LO 9504–05.

17. H. Paton (ed.), *The Lyon in Mourning*, 3 vols (1895–96).

18. Ronald Black (ed.), *An Lasair: Anthology of 18th Century Scottish Gaelic Verse* (2001), pp. 184–5.

19. John L. Campbell (ed.), *Highland Songs of the 'Forty-Five*, pp. 90–91.

Fig. 9.8, opposite: Broadsword

The blade of this broadsword has been engraved with pro-Jacobite slogans: 'Prosperity to Scotland and no Union' and 'For God my Country and King James the 8'. The figure of St Andrew is also present.

Hilt by Henry Bethune, *c.*1715; blade, early 18th century, 102 cm (length), National Museums Scotland, H.LA 124

CATALOGUE NO. 81

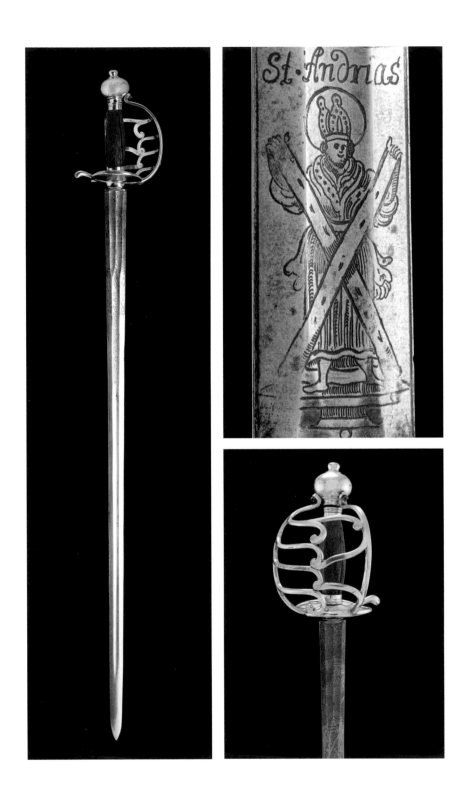

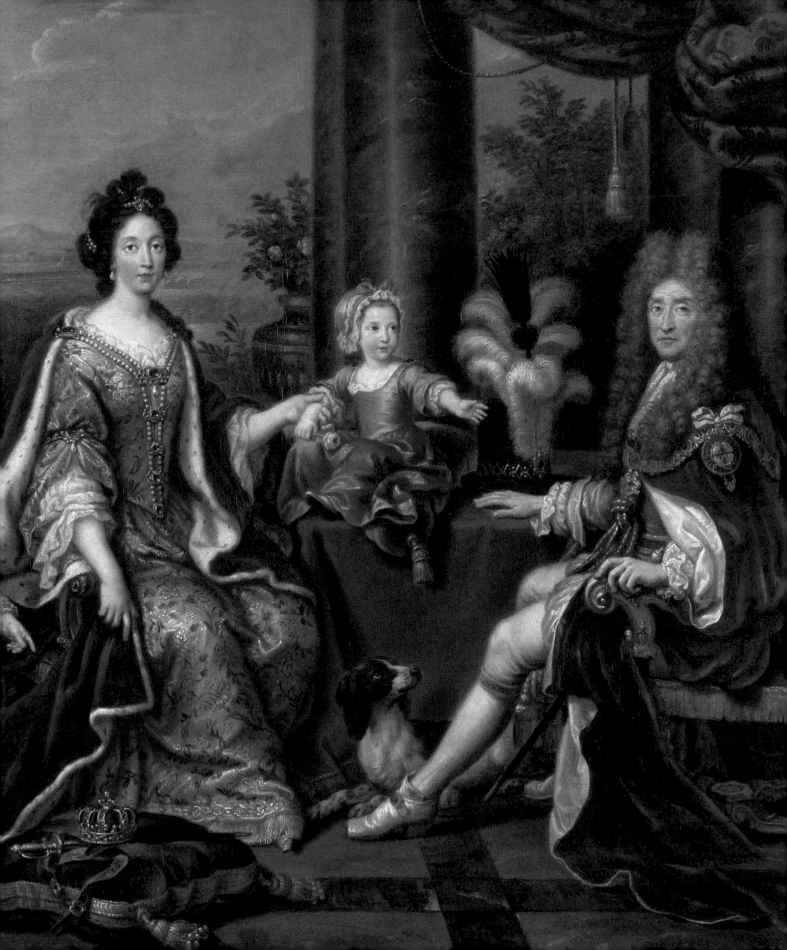

CHAPTER 10

Material
Matters

An Introduction to Jacobite
Material Culture[1]

Viccy Coltman

THIS ESSAY OPENS WITH A CAVEAT: NOT ALL MATERIAL CULTURE IS JACOBITE and not all Jacobite culture is material, although it is beyond the confines of this brief essay to deal with its literary or oral counterparts and the ways in which they intersect with the material and with each other. Broadly speaking, the term 'material culture' refers to artefacts or objects, to the things that populate our lives in all manner of manifestations, inhabiting the spaces we inhabit, adorning our bodies, and constituting our built environment both now and in the past. It is an unfortunate truism that objects are so ubiquitous that in the 21st century we often look through them or around them, rather than at them, too often taking them for granted in the ways in which they facilitate our activities or enhance our surroundings. While some definitions insist on material culture as referring to objects constructed or modified by humans, others are more elastic, embracing their naturally-occurring counterparts as shaped by human intervention. The majority of Jacobite objects conform to the first definition, although this excludes the corporeal relics – the afterlives of lives – of the Jacobite figureheads which have yet to be systematically discussed in the scholarly literature as a discrete group.[2] This essay opens with some reflections on material culture as an academic discipline, before proceeding to apply some of these ideas and methodologies to a series of objects drawn from across the exhibition.

The rubric material culture denotes both the stuff itself and its academic study. One of the earliest proponents of a theory of material culture, art historian Jules Prown, in an article first published in 1982, finds the term itself 'unsatisfactory, even self-contradictory' given the association of material with base things and culture with its antithesis – with lofty, intellectual, abstract things.[3] In the last thirty years a wide range of academic disciplines has pursued its exploration in and beyond art history, in archaeology, anthropology and across a broad spectrum of histories, including but not limited to histories of science, design, technology and culture. It is said to be a discipline, as opposed to a field, although the anthropologist Daniel Miller recently characterised it as 'a rather undisciplined substitute for a discipline' with its 'inclusive, embracing, original sometimes quirky researches and observations'.[4]

Fig. 10.2 and page 178: Painting entitled *James II and Family*

By Pierre Mignard (1612–95), painted in 1694, oil on canvas, Royal Collection Trust / © Her Majesty the Queen 2017, RCIN 400966

CATALOGUE NO. 38

A similarly disordered array of objects cluster under the term 'material culture' where they envelop and represent a dazzling variety of sizes, shapes, materials and social functions. Prown devised a series of six broad categories for object classification as follows: Art, Diversions, Adornment, Modifications of the Landscape, Applied Arts, and Devices, categories which he organised sequentially from the more decorative or aesthetic (Art) to the more utilitarian (Devices). An alternative taxonomy determined by their shared physical materials or their common method of fabrication proved unworkable. Those objects included in the exhibition represent from the first category, paintings, drawings, prints and sculpture; from the second, books and games; jewellery and clothing from the third; furnishings and receptacles from applied arts that are category five; and instruments and implements from what Prown calls Devices. The physical constraints of the exhibition gallery space exclude examples from category four that is modifications of the landscape (architecture, town planning, agriculture and mining). Many of the objects in the exhibition seem to lend themselves to more than one of Prown's categories. This highlights the essentially fluid nature of material culture study, even when the objects themselves have an unyielding materiality.

Having tentatively categorised our objects, how do we go about analysing them? Various precedents for object analysis exist in the secondary literature. In 1961, C. F. Montgomery published a series of 14 steps that he described as 'the prosaic homework of study' in order to determine the date and place of an object's manufacture and authorship.[5] A decade later in 1974, McClung Fleming proposed a model for artefact study which utilises two conceptual tools – a five-fold classification of the basic properties of an artefact (history; material; construction; design; function) and a set of four operations to be performed on these properties (identification; evaluation; cultural analysis; interpretation).[6] It is effectively a 'how to' model, the idea being that the student of material culture will apply it him/herself to examples of material culture. Both of these approaches are rooted in the study of early American folk and decorative arts; McClung Fleming, for instance, applies his model to a court cupboard from Salem, Massachusetts, of 1680, now in the Winterthur Museum, Delaware. Montgomery and McClung Fleming's models have informed what I have dubbed elsewhere 'material thinking' – or 'thinking with things' as the historian of science, Lorraine Daston, puts it.[7] Figure 10.1 is intended to aid this process of object analysis. Placing the object at the centre of our enquiry, it radiates out into four distinct blocks headed objecthood, production, consumption and afterlife/afterlives. Each block contains a series of questions which might be asked of the object under scrutiny. The block titled objecthood asks about the material and physical properties of the artefact; production, about its making or manufacture; consumption, about its possession and function; and afterlife, about its later histories, up to and including the present. Each block is in dialogue clockwise and anticlockwise with others. Even

OBJECTHOOD

What is it?
What does it represent?
What is it made of?
What size and/or weight is it?
What date is it?

PRODUCTION

– Who made it?
– Is it signed? If not, can it be attributed?
– Where was it made?
– What is noteworthy about its (i) construction; (ii) design; (iii) technique?
– Is it the only one?

CONSUMPTION

– Who owned it?
– How did they acquire it?
– If they purchased it, how much did it cost?
– What was its function?
– Where was it used and/or displayed?
– Was it a static or mobile object?

AFTERLIFE/AFTERLIVES

– Where is it now?
– How is it presented and/or displayed?
– What is it made of?
– What size and/or weight is it?
– What date is it?

Fig. 10.1:
Questioning a Material Artefact

though in many instances the questions can only be posed rather than definitively answered, asking them invariably aids a keener sense of their historical currency. Such close and careful questioning seeks to make objects 'talkative' – in Daston's account, 'mak[ing] things eloquent without resorting to ventriloquism or projection'.[8] This model has informed the narrative that follows, albeit in a rather meandering fashion.

If we accept the proposition that material culture 'is not just the product or reflection of culture [– it] is embedded in culture; it is symbolic, active and communicative', then what do objects tell us about Jacobitism which is often defined by similar criteria?[9] Some historians are sceptical about the agency of objects; as Paul Langford writes, 'a Pretender whose remembrance was preserved by emblematic drinking glasses, buckles, bracelets and garters, more than by musket and bayonet, was unlikely to prove much of a threat.'[10] Langford differentiates between the efficacy of genteel artefacts versus bellicose weaponry in a

polite/impolite distinction that has been pursued in a recent essay by Jennifer Novotny.[11] Are glassware, jewellery, dress and white roses simply 'knick-knacks', as Szechi would have it, in an objectscape that casts Jacobitism as artefactually acquisitive rather than political or militaristic?[12] Do these spheres have to be mutually exclusive? By focusing on six individual examples from across the exhibition of around 350 objects, this narrative turns to consider to what extent Jacobitism was 'symbolic, active and communicative' via its material culture during the period designated the Jacobite century, from 1688 to 1788. The first four objects are the courtly productions of the Jacobites in exile at Saint-Germain-en-Laye in France and later at the Palazzo Muti in Rome. The portraits and medals discussed offer pictorial representations of the protagonists that provided the figureheads for the cause across three successive generations: James VII and II, James VIII and III, and Prince Charles Edward Stuart. The narrative then shifts to consider how the cause was ideologically invested in objects made and owned in Britain; seeking to highlight the function and form as well as the message and meaning of particular types of objects that facilitated social interaction: namely glasswear and fans.

There is an oil on canvas portrait of 1694 by Pierre Mignard [Fig. 10.2], principal painter to Louis XIV, showing the family of James VII and II. It is prized for being the only portrait that shows the family in exile together on a single canvas, rather than on a series of individual or pendant canvases that when hung together would make discrete familial grouping.[13] It represents James VIII and III and Mary of Modena attired in precise sartorial splendour that is their coronation robes and seated in a suitably palatial location with a lush landscape in the distance. They are accompanied by their children, with Louise Marie perched on a cushion on a table between them, and the son and heir, James VIII and III, standing to the left of the composition where he points towards a crown and sword displayed on a cushion. The gestures and gazes of the figures, including the dog turning towards his master, claim our attention and invite the external viewer to mirror the direction of their internal gazes. The black servant holding the young prince's extended train contributes to the aesthetic presentation of power at this royal family court. The prince's striking physiognomic resemblance to the portrait of his mother may be contrived to refute the 'warming pan' myth which was concocted by the Whigs to suggest the Jacobite heir was an imposter – the son of a brick maker's wife, smuggled into the queen's bed during her labour by means of such a vessel (another object of material culture and part of the repertoire of pots and pans history).[14] We know that the image was displayed in James VII and II's antechamber at Saint-Germain where, measuring a colossal 247 x 293 cm, it occupied an entire wall. Any visitor granted access beyond the king's guard chamber, one of the most public spaces of the palace, would come face-to-face with the assembled royal family via their large-scale pictorial representa-

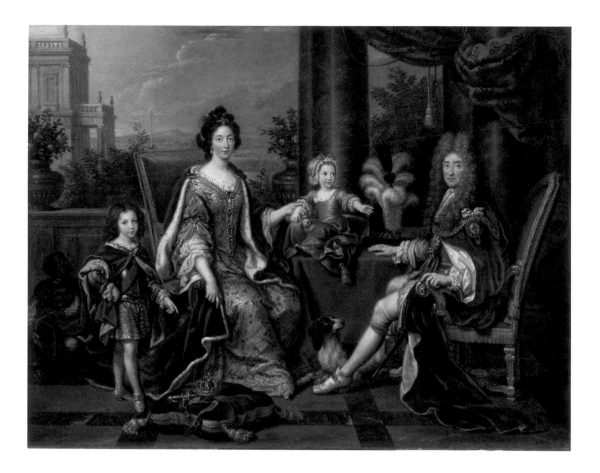

Fig. 10.2: Painting entitled *James II and Family*

Pierre Mignard (1612–95), painted in 1694, oil on canvas, 66.2 x 76.7 x 10.7 cm, Royal Collection Trust / © Her Majesty the Queen 2017, RCIN 400966

CATALOGUE NO. 38

tions, in an interaction that would render the viewer physically subordinate to the painted figures, even in their seated poses. The dimensions and content of the portrait reveal the power of the image as one of dynastic sovereign power which draws on a long line of Stuart portraits; of a king and queen temporarily removed from their throne, and a young prince, their legitimate heir, poised to reclaim it by peaceful means once he had come of age.

The enormous family portrait is now in a private collection; its much-reduced size *modello* in the exhibition is in the Royal Collection. It is one of the ironies of the afterlives of Jacobitism that prized items of its material culture were subsequently acquired by the ancestors of those Hanoverians from the opposite side of the political spectrum who had usurped their throne and that they sought to displace. These objects, once part of the ideological armoury of Jacobitism, became part of the mythology of royalty and privileged acquisitions for the British Royal Collection.[15] This speaks to the vicissitudes of objects in the fluctuating weft and warp of regimes of power.

Oil on canvas portraits like the Mignard populate art historical enquiry and

conform to Prown's first category for material culture that is Art. Yet material culture could not only be a reflective or refractive mirror for the exiled family and their court in the enclave that was Saint-Germain. The reproduction, circulation and distribution of their portraits were an integral part of their biography as objects of Jacobite intent as well as content. In 1695 Nicolas de Largillière, another leading court painter, painted the Prince of Wales and his sister in a large (192.8 x 145.7 cm) double portrait in which the gestures and gazes of the sitters unambiguously signal the hopes for a Stuart restoration [Fig. 10.3]. Brother and sister are represented before an urn containing a flowering orange tree, whose base is inscribed with their respective ages, of seven and three years. On this occasion Louise Marie points to her brother, resplendent in red that contrasts with the blue of the Order of the Garter sash. On his right a greyhound gazes up in adoration at the young prince. While the viewer is left in no doubt on whom their loyalty should be focused, the image may contain an additional subtext – a message concerning the projected fate of the interlopers of the British crown – to William of Orange. The potted plant is an orange tree and the princess holds a sprig of its blossom cut from the plant in her hand. Could this be a visual metaphor, a sign to the House of Orange that their cultivation in Britain was to

Fig. 10.3, left: *Prince James Francis Edward Stuart and Princess Louisa Maria Theresa Stuart*

Nicolas de Largillière (1656–1746), painted in 1695, oil on canvas, 192.8 x 145.7 cm, National Portrait Gallery, London, NPG 976

CATALOGUE NO. 52

Fig. 10.4, right: *Prince James Francis Edward Stuart and Princess Louisa Maria Theresa Stuart*

John Smith (1652–1743), after Nicolas de Largillière, 1699 (1695), mezzotint, 40 x 30.2 cm, National Portrait Gallery, London, NPG D34723

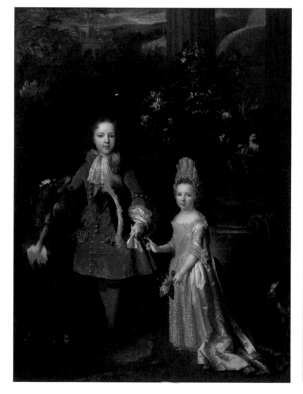 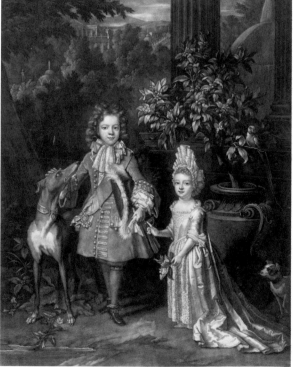

be similarly curtailed? While Mary II had died without issue in 1694, the portrait celebrates the progeny of Mary of Modena, in producing a new generation of Stuart heirs to ensure their restoration. A mezzotint engraving was produced by John Smith on a secret visit to Saint-Germain in 1698 [Fig. 10.4]. It was published in Paris, the then centre of the international print trade, so disseminating multiple, reduced-size monochrome copies of the double portrait across the water.[16] Reproductions in engravings enabled once singular and static objects like large-scale court portraits to become serial and mobile, sending messages of hope for an eventual restoration to Jacobite supporters and of hostility to their enemies.

The medallic record of Jacobitism provides a link between 'flat' objects in two dimensions and 'fat' in three. Like portraits and engravings, medals as a class of sculpture conform to Prown's first category of Art. Mobile and manifold, they had formed part of the material output of a European court since the Renaissance, albeit one in flight as the Jacobites were, with a veritable production line of diminutive objects that articulated through highly formulaic images and phrases, the hyperbole of the cause.[17] A minute silver medal [Fig. 10.5], 3.48 centimetres in diameter, designed by Norbert Roettier and dated 1708, depicts on the obverse the bust in profile, looking right, of James VIII and III. The Latin phrase 'CUIUS EST', written around the circular edges of the coin, asks 'whose [image] is it?' On the reverse side is a map of Britain and Ireland surrounded by ships, with Scotland and England identified separately and the imperative plural 'REDDITE', 'restore' – an instruction directed at the followers of the Stuarts. The medal projects that the restoration of James VIII and III, whose portrait on the obverse is crowned with victory laurels, would unite the territories shown on the reverse by a maritime invasion. The birth of his son and heir Prince Charles Edward Stuart in 1720 heralded the dawning of a new golden age – if we adopt a literal reading of the medallic propaganda produced in its wake. A silver medal by Ottone Hamerani, just over 4 centimetres diameter, commemorates the providential arrival of the Stuart heir and celebrates his propitious future [Fig. 10.6]. On the obverse is a conjoined bust portrait of his parents, James VIII and III and Queen Clementina, shown in profile to the right. The reverse is inscribed with the prince's name and date of birth in Latin at the foot of the coin. Its pictorial tondo depicts a female figure holding a baby and standing in front of a column. The figure is identified from the accompanying inscription as a personification of Providentia Obstetrix, the midwife at the birth of the prince, whose territorial domination is foretold by the globe which she points to on her right. The globe is marked with abbreviations for England, Scotland and Ireland. The symbiotic relationship between the obverse and reverse of these medals should be noted; as should the relationship between their Latin

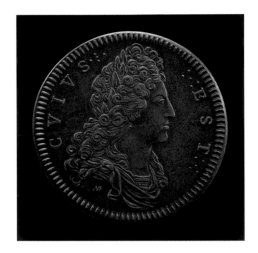

Fig. 10.5: Medal of James VIII and III

Silver medal of James VIII and III, on the Restoration of the Kingdom. Probably issued to promote James's cause during abortive peace negotiations between Britain and France.

Norbert Roettier (1665–1727), France, 1708, silver, 3.48 cm (diameter), British Museum, BM M.8076, obverse and reverse

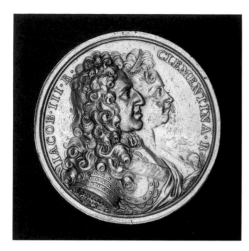

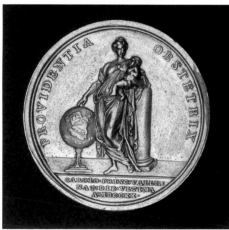

Fig. 10.6: Medal of James and Clementina

Ottone Hamerani (1694–1761), 1720, silver, 4.1 cm (diameter), National Museums Scotland, H.1950.731, obverse and reverse

mottoes and shorthand images. The inscriptions on a range of Jacobite artefacts, not only medals, are frequently in Latin, the language of the laity and the learned of cosmopolitan Europe, that was itself a form of encrypted code to the unlearned.

* * *

'Medals … were designed for display; though they could be handled, they were primarily to be looked at … fit[ting] into a masculine-coded culture of collecting and categorization.'[18] Thom's description of medals, in her account of what she calls anti-Jacobite visual strategy during the period 1745–46, brings us chronologically into the 1740s and artefactually into the realms of 'looked-at-ness', object handling and gendered preferences, although much more could be said about them as partisan objects. While James VII and II, and his son VIII and III, exploited the material conventions of court culture first at Saint-Germain and later in Rome, their son and grandson, Charles Edward Stuart, enjoyed what we might describe as multimedia coverage in material culture in Britain both before and after the Battle of Culloden. Existing analyses of this material can lean unhelpfully towards dichotomies including élite/popular, exclusive/inclusive, active/passive and real/ideal, which are far too simplistic.[19] The British-made articles may appear popular, inclusive and passive. In other words, less explicit in their Jacobite call to arms than the court portraits and medals, yet that message is often embedded in the architecture of the object in terms of its design and execution. An awareness of this can assist us in our understanding of them as treacherous objects, as Murray Pittock has called them.[20] Medals, glassware and fans are all objects that required handling within spatial zones that were variously social, personal and intimate – they could not be public for fear of prosecution. In this way, the anthropological study of proxemics (the study of people and their use of space as an elaboration of culture) can be applied to Jacobites and their use of things which operated within a clandestine spatial culture of display and concealment.[21]

As one of 35 surviving 'Amen' glasses, Fig. 10.7 belongs to the most famous class of all Jacobite glass. Its appellation derives from a design that, in this example, incorporates two verses of the Jacobite anthem engraved in diamond point on the exterior of the trumpet-shaped bowl. The anthem prays for a Jacobite restoration, asking God to save and 'bless' the unnamed king 'Soon to reign over us' and the 'true-born' Prince of Wales. The two verses are separated by an engraved crown, with the cipher 'JR' – shorthand for *Jacobus Rex* – below, and at the foot of the bowl on this vertical axis, 'Amen'. The bowl is engraved with two additional dates of significance to the Jacobite calendar, 1716 and 1745. It stands

at a petite 12.6 cm high and the bowl has previously been cracked and repaired, which reminds us of the fragility of the medium, unlike, say, the more materially robust medallic record. This particular example is known as the Haddington 'Amen' glass, after a town in East Lothian, Scotland, where it was said to have been brought from. It has been in the collections of National Museums Scotland since 1897, i.e., very shortly after the bi-centenary of the 'Glorious Revolution', when a major exhibition devoted to 'The Royal House of Stuart' was held in London. Its 1159 items, spanning three hundred years from the end of the 15th century, represented a landmark event in the historiography of Jacobite material culture. As a receptacle for liquids the Haddington 'Amen' glass confirms to Prown's fifth category of Applied Arts.

G. B. Seddon's *The Jacobites and their drinking glasses* (1995) places emphasis on the artistic production of these contraband objects, rather than their use as receptacles – as vessels in the promulgation of a heady concoction of homosociability and Jacobitism. To this end, Seddon considers all the 'Amen' glasses to have been produced in London, by one engraver, during the 1740s.[22] For the historian of material culture there is a significant disparity between the large body of surviving material examples (Seddon's monograph focuses on 487 examples) and the lack of information regarding their culture, which due to the risk of prosecution should more properly be understood as a culture of dissent. Typically associated with lost or secret drinking societies, Jacobite glass resists wider comprehensive analysis for the same reasons that made them successful in the first place: as a culture and a means of communication which were designed to avoid prosecution for the very thing that later historians seek to identify.[23] The material record is less covert and the profusion of glasses with their accompanying engravings seem to imply a dynamic ritual interaction between Jacobites and their artefactual culture, when supporters of the Stuart restoration would congregate and drink the King's health, passing their glasses over water to signify his exile, singing the anthem engraved in part or in whole on the exterior of the bowl and kissing the engraved star.

Although we should resist using historical evidence as a transparent window onto social practice in the past, a painting by Herman van der Mijn, *The Loyal Toast*, c.1740, seems to offer a tantalizing glimpse of one such Jacobite gathering in contemporary visual culture. In this work, three male figures are shown in an interior, seated at a table laid for dessert with a bowl of fruit. A figure on the far right balances a wine glass in his artificially-poised hand and, leaning forwards, seems to pass it over a blue and white ceramic bowl on the table in front of a bowl of fruit. Could this figure be toasting the king 'over the water', while his com-

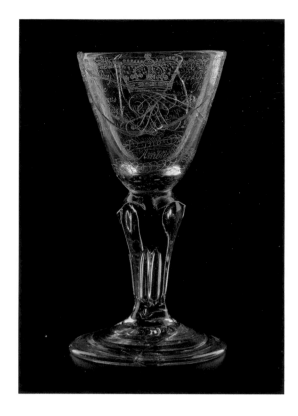

Fig. 10.7: Haddington 'Amen' glass

Haddington, East Lothian, 1716, glass, 12.6 cm (height), National Museums Scotland, H.MEN 3 (see also Catalogue Nos 91 and 247 for examples of 'Amen' glasses in the exhibition)

panions hold and fill their own glasses? Such a reading may appear contrived, but it is worth noting that each of the wine glasses displays a star or flower petal reflection that could be read as Jacobite symbols. What also are we to make of the elderly female servant installed in the left background, from where she seems to eavesdrop on the conversation and take notes in a journal? The small (21 x 25 cm) painting may well be saturated with Jacobite meanings, which now elude us, though which are implied through the surviving material record. Like the innocuous-looking ceramic bowl on the table, which is reminiscent of a punch bowl now in the British Museum, whose interior (26 cm diameter) contains a blue-painted portrait of Charles Edward Stuart [Fig. 10.8]. The prince wears full Highland dress with a targe and crossed pistols at his feet; he gestures across his upraised sword to a suspended crown. 'AUDENTIOR IBO; ALL OR NONE' is inscribed on garlands above him, the former a quotation from Book 6 of Virgil's *Aeneid* which, with the Bible, was one of one of the lexicons of Jacobite mottoes.

Our final object derives from Prown's sixth category for the classification of material culture, that is Devices. Figure 10.9 is a fan, an 'instrument for agitating the air' according to the title of an article published in the 1960s, made of paper mounted on ivory (29.5 x 45 centimetres, open) and painted on both sides.[24] The centre of the leaf on one side is hand-painted with a half-length portrait of Prince Charles Edward Stuart encircled in a gold frame inscribed with a biblical phrase in capital letters: 'RENDER TO CAESAR THE THINGS THAT ARE CAESARS.' The directive comes from the Gospels of Mark and Matthew where Christ orders the tribute money to be paid to Caesar ('CUIUS EST'), having identified him from his portrait on a coin. Prince Charles is represented in profile to the right wearing armour, the Order of the Garter, and a cloak of velvet, ermine and tartan. His representation on the fan reminds us of the palm-sized miniatures of him which proliferated, and which were secreted on the Jacobite body in pockets or appended to chains as jewellery; and off the body, housed in discreet cases or in hidden lids of snuff boxes. On the fan leaf, Prince Charles's image is held aloft in the clouds by two putti floating above maps of England, Scotland and Ireland. The geographical territories separated by a channel representing the Irish sea are demarcated by female personifications with their defining attributes, from left to right, a harp for Ireland, a St George's red cross on a white background for England, and a crown and a thistle for a tartan-clad and bonnet-wearing Scotland. The image of the prince as the figure destined to unite the nations of Britain and Ireland harks back to the medals produced under his father, James VIII and III, with their 'REDDITE' inscriptions [Figure 10.5]. Like the medals, this fan has a connective relationship between the obverse and reverse. On the centre of the

Fig. 10.8: Punch bowl

Made in Liverpool or London, 1749, earthenware, 26 cm (diameter), © The Trustees of the British Museum, 1890,210.1

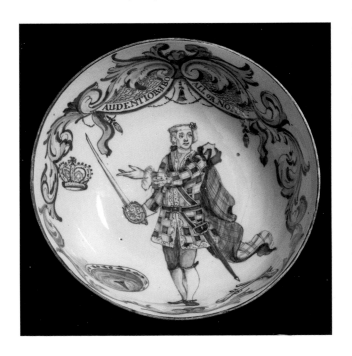

otherwise undecorated reverse is a red brick gatehouse with a dove flying overhead carrying an unfurling banner on which is inscribed the text 'My House shall be Called the House of Prayer'. The image projects to a time when St James's Palace would once again be occupied by the Stuarts. This would also see the resulting union of England, Scotland and Ireland as ideologically represented on the obverse. Hugh Cheape has pointed out that the sequential phrase to 'My House shall be Called the House of Prayer' in the Gospels of Matthew, Mark and Luke, is 'But you have made it a den of thieves'.[25] This is a piece of invective directed at the Hanoverian interlopers.

Figure 10.9 has been associated with events that took place at the re-established court at the Palace of Holyroodhouse. Fans were gendered objects – used by women as a prosthetic extension of their arms and a portable instrument in social discourse. Armed with a fan like Figure 10.9, a woman could choose to unfurl a visual declaration of political allegiance to the Jacobites, making women active participants in the machinations of the extra-parliamentary nation through the fashionable prosthetic devices available to them.[26] Fans are also what we might term metamorphic objects, since at their holders' instigating they changed their shape. Some fans have a Jacobite message on one side, with a more prosaic one on the other, ensuring that their partisan message could be concealed or revealed with a judicious flick of the wrist. Like the engraved glassware, the painted fans invited close inspection in a culture of seditious sociability that is echoed in our later scrutiny of it.

Since material culture is, relatively speaking, a still burgeoning area of investigation, it seems premature to offer any definitive conclusions at this point. This essay should be understood as an exploratory invitation whereby all or any of the objects in this exhibition might be categorised and analysed as a means of making them speak of their import to and for the Jacobites. Prown calls this 'piercing the mute carapace of objecthood to let the work speak'.[27] But we should always proceed with caution when dealing with the crowded objectscape that is the material culture of Jacobitism because, as Pittock reminds us, the language these objects speak is an 18th-century one of subterfuge, 'a protective code or quotation, not a manifestation of transparency'.[28] In the historical contexts in which they were produced and consumed, these were treasonous objects, obdurate artefacts, the very stuff of sedition.

Fig. 10.9 opposite and above: Jacobite fan and details

Fan with hand-painted leaf showing Prince Charles Edward Stuart, with detail from reverse of fan (above).

Mid-18th century, National Museums Scotland, H.1994.1052

CATALOGUE NO. 184

Notes

1. Thanks to Hal Crichton, Freya Gowrley, Hannah Lund and Catriona Murray.
2. As a starting point, see Jan Graffius, 'The Stuart relics in the Stonyhurst collections', *Recusant History* 31: 2 (2012), pp. 147–69.
3. Jules David Prown, 'Mind in Matter: An Introduction to Material Culture Theory and Method', *Winterthur Portfolio* 17: 1 (1982), p. 2.
4. Daniel Miller, *Stuff* (2010), p. 1.
5. Charles F. Montgomery, 'Some Remarks on the Practice and Science of Connoisseurship', *American Walpole Society Notebook* (1961); republished in 1982 as 'The Connoisseurship of Artifacts', Thomas J. Schlereth (ed.), *Material Culture Studies in America* (1982), pp. 143–52.
6. E. McClung Fleming, 'Artifact Study: A Proposed Model', *Winterthur Portfolio* 9 (1974), pp. 153–73.
7. Viccy Coltman, 'Material Culture and the History of Art(efacts)', in Anne Gerritsen and Georgio Riello (eds), *Writing Material Culture History* (2015), pp. 17–31; Lorraine Daston, *Things that Talk: Object Lessons from Art and Science* (2004), p. 20.
8. Daston, *Things that Talk*, pp. 21, 9.
9. Ann Smart Martin and J. Ritchie Garrison (eds), *American Material Culture: The Shape of the Field* (1997), p. 15.
10. Paul Langford, *A Polite and Commercial People: England, 1727–1783* (1989), p. 201.
11. Jennifer L. Novotny, 'Polite War: Material Culture of the Jacobite Era', in A. I. Macinnes, K. German and L. Graham (eds), *Living with Jacobitism: The Three Kingdoms and Beyond, 1690–1788* (2014), pp. 153–72.
12. Daniel Szechi, *The Jacobites: Britain and Europe, 1688–1788* (1994), p. 25.
13. Edward Corp, *The King over the Water: Portraits of the Stuarts in Exile after 1689* (2001), p. 35.
14. Sara Pennell, '"Pots and pans history": The Material Culture of the Kitchen in Early Modern England', *Journal of Design History* 11: 3 (1998), pp. 201–16.
15. Kathryn Barron, '"For Stuart blood is in my veins" (Queen Victoria): the British monarchy's collection of imagery and objects associated with the exiled Stuarts from the reign of George III to the present day', in Edward Corp (ed.), *The Stuart Court in Rome, The Legacy of Exile* (2003), pp. 149–64.
16. On Jacobite prints, see Richard Sharp, *The Engraved Record of the Jacobite Movement* (1996).
17. On Jacobite medals, see Noel Woolf, *The Medallic Record of the Jacobite Movement* (1988).
18. Danielle Thom, '"William, the Princely Youth": The Duke of Cumberland and Anti-Jacobite Visual Strategy, 1745–46', *Visual Culture in Britain* 16: 3 (2015), p. 254.
19. Neil Guthrie, *The Material Culture of the Jacobites* (2013), p. 42, makes this point in relation to the élite/court and the popular.
20. Murray Pittock, *Material Culture and Sedition, 1688–1760: Treacherous Objects, Secret Places* (2013).
21. Beverley Gordon, 'Intimacy and Objects: A Proxemics Analysis of Gender-based Response to the Material World', in Katherine Martinez and Kenneth L. Ames (eds), *The Material Culture of Gender, the Gender of Material Culture* (1997), pp. 237–52.
22. Geoffrey B. Seddon, *The Jacobites and their Drinking Glasses* (1995), p. 174.
23. Pittock, *Material Culture and Sedition, 1688–1760*, p. 94.
24. E. A. Standen, 'Instruments for Agitating the Air', *Metropolitan Museum of Art Bulletin* 23: 1 (1965), pp. 243–58.
25. Hugh Cheape, 'The Culture and Material Culture of Jacobitism', in Michael Lynch (ed.), *Jacobitism and the '45* (1995), p. 41.
26. Angela Rosenthal, 'Unfolding Gender: Women and the "Secret" Sign Language of Fans in Hogarth's Work', in *The Other Hogarth: Aesthetics of Difference*, Bernadette Fort and Angela Rosenthal (eds) (2001), p. 123. See also Elaine Chalus, 'Fanning the Flames: Women, Fashion and Politics', in Tiffany Potter (ed.), *Women, Popular Culture and the Eighteenth Century* (2012), pp. 92–112.
27. Jules David Prown, *Art as Evidence: Writings on Art and Material Culture* (2001), p. 1.
28. Pittock, *Material Culture and Sedition, 1688–1760*, p. 15.

CAT. NO. 69

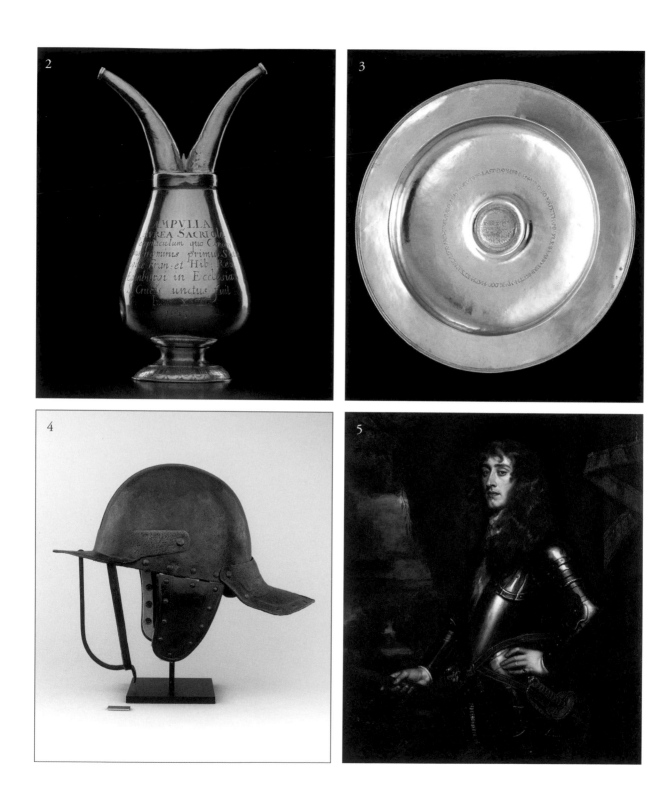

Introduction

1. PAINTING ENTITLED *BONNIE PRINCE CHARLIE ENTERING THE BALLROOM AT HOLYROODHOUSE*

By John Pettie (1839–93), prior to 1892
Oil on canvas, 158.8 x 114.3 cm
The Royal Collection / HM Queen Elizabeth II, RCIN 401247

The Stuart Dynasty

2. AMPULLA

Possibly by James Denniestoun, Scottish, *c*.1633
Gold, 12.5 cm (height)
National Museums Scotland, H.KJ 164

This unique phial has a Latin inscription stating that it held the sacred anointing oil used during the coronation of Charles I at Holyroodhouse on 18 June 1633. This came from the belief in the mystical power of the holy oil with which the king was anointed at his coronation. The Stuarts exercised their power through absolute monarchy, which they justified through their faith in the divine right of kings. They were not accountable to any earthly power and their authority and right to rule came directly from God.

3. COMMUNION BREAD PLATE

By Thomas Kirkwood, Scottish, *c*.1632–33
Silver, 50.7 cm (diameter)
National Museums Scotland, K.2001.466.5

Thomas Sydserf, the minister of Trinity College Church in Edinburgh, was a staunch follower of Charles I and his anglicising church policies. This plate was probably commissioned to coincide with Charles's Scottish coronation in June 1633. It depicts a scene of a figure kneeling to receive Communion. In 1618 James VI attempted to bring the Scottish Church into line with the practices of the English Church, including the requirement of kneeling to take Communion. This was unpopular with many Scots who were increasingly drawn to Presbyterianism.

4. HARQUEBUSIER'S HELMET

By Richard Holden, English, *c*.1660–88
Composite steel
The Royal Collection / HM Queen Elizabeth II, RCIN 28137.a

Harquebusiers were armoured cavalrymen. This helmet is struck with the royal cipher 'IR' for James VII and II. The arbitrary use of power and the creation of a standing and permanent army was one of the main complaints of those who opposed the absolutist tendencies of the Stuart dynasty.

Dynasty Restored

5. PAINTING ENTITLED *JAMES VII & II (1633–1701) WHEN DUKE OF YORK*

By Sir Peter Lely (1618–80), *c*.1665
Oil on canvas, 126.1 x 102.1 cm
The Royal Collection / HM Queen Elizabeth II, RCIN 403224

Charles II's younger brother, James, Duke of York, served in the French and Spanish armies during his exile. After the Restoration in 1660 he became Lord High Admiral of England.

6. COAT OF ARMS OF JAMES VII AND II AS DUKE OF YORK

English, limewood, *c*.1665–73, 105.5 x 74 cm
National Maritime Museum, Greenwich, London, ZBA3082

These arms are surmounted by a royal crown and placed on an admiralty anchor, which signifies James's position as Lord High Admiral of England.

7. MIRROR

French, 1660–61
Gilded silver, mahogany, kingwood, 55.8 x 55 cm
Paris, musée du Louvre, département des Objets d'art, OA 10906

Toilet mirror with cyphers of Anne Hyde, Duchess of York and wife of James VII and II. Anne, a Catholic convert and commoner, became the mother of two future queens, Mary and Anne.

8. MASS BOOK

From the workshop of Germain Hardouyn, 1530
19.8 x 13 cm x 4.6 (closed)
The President and Fellows of St John's College, Oxford, HB4/6.A.3.14

This mass book, '*Enchiridion preclare ecclesiae Sarum*', has become associated with Mary of Modena, wife of James VII and II, an unpopular choice of consort because of her Catholicism.

9. TOUCHPIECE OF JAMES VII AND II

*c.*1685, silver, 1.9 cm (diameter)
National Museums Scotland, H.1950.720

This touchpiece was used to 'touch' (cure) scrofula, a form of tuberculosis. This came from belief in the mystical power of the holy oil which was applied to the monarch during their coronation.

10. PROCLAMATION OF ACT FOR THANKSGIVING FOR THE BIRTH OF A PRINCE, 14 JUNE 1688

Scottish, 14 June 1688, paper, 39 x 26 cm
National Records of Scotland, NAS: RH14/239

This proclamation of James VII ordered thanksgiving to be enjoyed throughout Scotland to celebrate his wife, Mary of Modena, giving birth to an heir, James Francis Edward Stuart. With the birth of James the prospect of a Catholic succession was more secure.

11. ORDER OF THE THISTLE ROBES

*c.*1687–88
Silk velvet, silk and gold metallic threads, 172 cm (neck to hem)
Grimsthorpe and Drummond Castle Trust, IL.2016.19.1 and 2

In 1687 James VII and II created The Most Ancient and Most Noble Order of the Thistle, Scotland's premier order of chivalry. The order rewarded those that supported James in securing toleration for Catholicism. These robes belonged to Sir James Drummond, 4th Earl of Perth, one of the first Knights of the Thistle alongside his brother, John, 1st Earl of Melfort.

12. HOLYROOD ALTAR PLATE

In 1687 James VII and II converted the Chapel Royal for Catholic worship in the Palace of Holyroodhouse. The Earl of Perth was responsible for furnishing it and a full suite of silver altar plate was made. Once in Edinburgh, a locally made Sanctus bell and incense spoon were added.

CHALICE AND PATEN
English, *c.*1686, silver, 28.5 cm (height)
Lent by the Scottish Roman Catholic Hierarchy, IL.2009.16.1 and 2

Chalice engraved with the royal cypher of James VII.

CIBORIUM AND COVER
By 'W F', probably English, *c.*1686, silver, 25.5 cm (height)
Lent by the Scottish Roman Catholic Hierarchy, IL.2009.16.3.1 and 2

Ciborium engraved with royal cipher of James VII on the base.

SANCTUS BELL
By Zacharius Mellinus, Scottish, 1686–87, silver, 12 cm (height)
Lent by the Scottish Roman Catholic Hierarchy, IL.2009.16.4

Sanctus bell to announce the commencement of Mass.

INCENSE SPOON
By Walter Scott, Scottish, *c.*1686–87, silver, 10.2 cm (length)
Lent by the Congregation of the Ursulines of Jesus, IL.2009.17.4

Incense spoon engraved with an earl's coronet, presumably for James Drummond, Earl of Perth, who commissioned the Holyrood altar plate at the request of James VII.

13. CUP AND COVER

Unmarked, English, *c.*1685, silver gilt, 13 cm (height with cover)
Victoria and Albert Museum. Purchased with the assistance of the
 Art Fund, the National Heritage Memorial Fund, the Hugh Phillips
 Bequest to the V&A, the Friends of the V&A, the Worshipful
 Company of Goldsmiths and an anonymous donor, M.34:1,2-2008

This cup commemorates the coronation of James II on 23 April 1685. It is made from silver melted down from one of the pole mounts or stave mounts, and one of the bells which supported and adorned the coronation canopies. The cup has also been coated in a thin layer of gold.

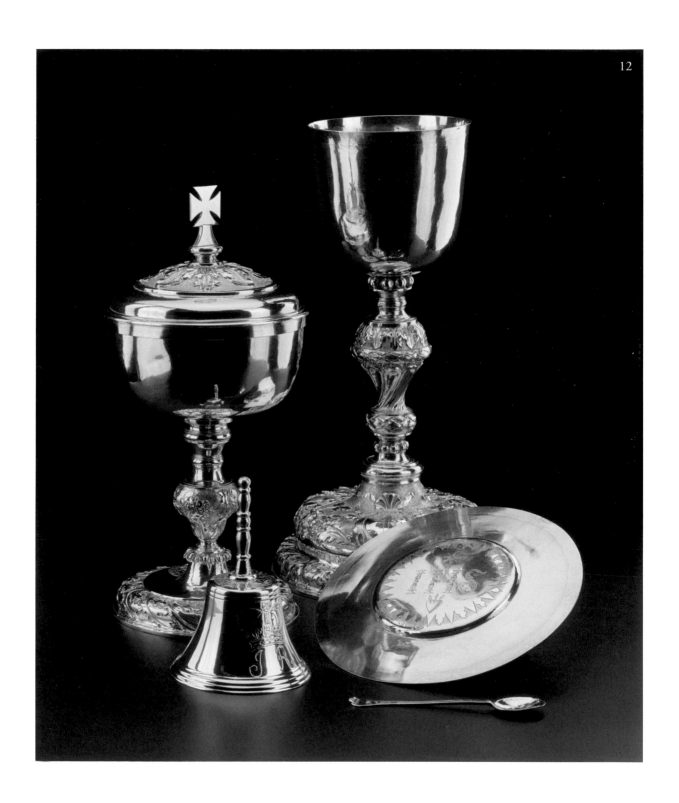

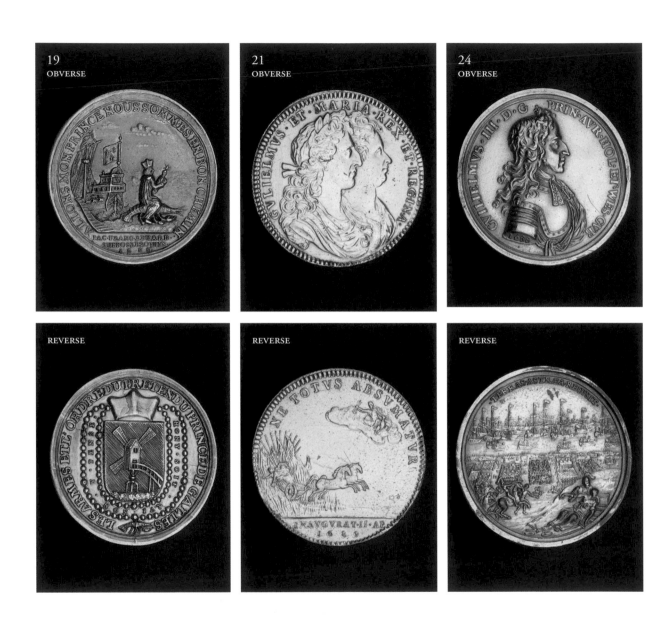

19
OBVERSE

21
OBVERSE

24
OBVERSE

REVERSE

REVERSE

REVERSE

14. BREAST STAR OF THE MOST NOBLE ORDER OF THE GARTER

English, 1600s
Silver thread, strip, wire and silk, 28.8 cm (height and width)
Victoria and Albert Museum, T.7-1922

The Most Noble Order of the Garter, founded in 1348, is the premier Order of England. James VII as king was naturally head of this organisation which is the world's oldest Order in continuous existence.

15. PORTRAIT OF JAMES VII AND II

Artist unknown, c.1690
Oil on canvas, 124.6 x 101.7 cm (unframed)
National Portrait Gallery, London, NPG 366

Painted after the king's forced exile to France. Such portraits were used to reinforce the loyalty of supporters in Britain

James and William

16. ARMOUR OF JAMES VII AND II

By Richard Holden, English, 1686
Ferrous alloy, copper alloy and leather
On loan from the Royal Armouries, II.123

This harquebusier armour was made for James VII and II and was the last suit of armour to be made for a British monarch. On the face-guard are the initials 'IR', together with the royal coat of arms. During the Commonwealth (1649–60), James had a successful career in the French and Spanish armies.

17. PISTOLS

By John Shaw, English, late 17th century
Walnut and steel, 42.1 cm (pair)
National Museums Scotland, X.2015.105.1.1 and 2

Flintlock pistols associated with James VII and II. The pistol butt is decorated with a cartouche and the initials 'J2R', together with the head of a goddess of war.

18. MEDAL

By Jean Mauger, French, 1688, bronze
On loan from the Drambuie Collection by kind permission of William Grant and Sons, PGL 1750

Medal commemorating the arrival of James VII and II in France. The reverse shows the recently exiled royal family being welcomed by Gallia, the personification of France.

19. MEDAL

By Christian Wermuth, German, c.1688
Silver, 3.2 cm (diameter)
National Museums Scotland, H.1952.774

This medal depicts the flight of Prince James Francis Edward in 1688. He is being carried in the arms of a Jesuit priest, mounted on a lobster, the symbol of the Jesuits. The design has a satirical intent and also suggests that he was a changeling.

20. FINGER RING

c.1688, gold, enamel and crystal, 2 cm (diameter)
National Museums Scotland, H.NJ 100

Ring with crowned 'JR' under crystal, given by James VII and II, on the night he fled from London in 1688, to Sir Peter Halkett. Halkett was a member of a royalist family at the time of the Restoration.

William and Mary

21. MEDAL

By James or Norbert Rottier, French, c.1689
Possibly silver, 3.4 cm (diameter)
National Museums Scotland, H.R 72

Medal of William III and II, and Mary II. Many medals were struck to celebrate the coronation of William and Mary in London on 11 April 1689.

22. DISH

Dutch, late 17th century
Tin-glazed earthenware, 35.5 cm (diameter)
National Museums Scotland, A.1924.692

Delftware dish with a portrait bust of King William III in the centre. Commemorative ware was produced in support of different sides, in this case the Williamite cause.

23. MEDAL

By Jan Smelzing, Dutch, 1689, silver, 4.9 cm (diameter)
National Museums Scotland, H.1992.1872

Medal with anti-Jacobite and anti-Catholic sentiments. James is shown as a bear overturning three hives which represent the three kingdoms.

24. MEDAL

By George Bower, c.1688, silver, 5.1 cm (diameter)
National Museums Scotland, H.R 71

Medal struck to commemorate the landing of William III of Orange at Torbay, on 5 November 1688. William of Orange was invited to land an invasion force in England with the aim of deposing James.

25. BADGE

c.1690, gold, enamel, silver and rock crystal, 10.4 x 6.9 cm
The Royal Collection / HM Queen Elizabeth II, RCIN 52282

This William III badge was possibly used as a diplomatic gift. The reverse has a portrait miniature of the new king.

Dundee and Boyne

26. MINIATURE OF JOHN GRAHAM OF CLAVERHOUSE

By David Paton, c.1670, ink on paper, 10.5 x 8.3 cm
Scottish National Portrait Gallery, Edinburgh. Presented by A. Sholto Douglas 1900, PG 588

John Graham, 1st Viscount Dundee, led the Jacobite army to victory at the Battle of Killiecrankie on 27 July 1689. Although the Jacobites won, 'Bonnie Dundee' was killed.

27. LETTER

30 November 1689, paper, 40.5 x 24 cm
National Museums Scotland, H.OA 36

Letter from James VII and II to McDonell of Keppoch, alluding to the death of 'the brave Viscount Dundee'. Claverhouse was a loyal supporter of the Stuart dynasty and commanded the Jacobite army during the first challenge of 1689.

28. GLOVES

Late 17th century, leather and silver wire, 27 x 32 cm
National Museums Scotland, K.2011.64.2

Pair of gloves said to have been worn by John Graham of Claverhouse, Viscount Dundee.

Boyne

29. MITRE CAP

c.1690, velvet and gold thread, 29.8 cm (height)
National Museums Scotland, M.1985.128

Officer's mitre cap of a Scottish grenadier unit in the army of William III. The Scottish identity is shown by thistles at either side of the royal crown and cypher of King William and Mary.

30. SHIP'S BELL AND CANNONBALLS FROM HMS *DARTMOUTH*

Cannonballs, c.1690, iron, c.5 cm (diameter)
Bell, English, mid- to late 17th century, bronze, 43.5 cm (height)
National Museums Scotland, H.HXD 77.3, 6, 8 and H.HXD 174

HMS *Dartmouth* was used to police the West Highland seaboard in the aftermath of the first Jacobite challenge. On 9 October 1690, while lying at anchor off the Jacobite stronghold Duart Castle in the Sound of Mull, the ship was caught in a violent storm and subsequently sank.

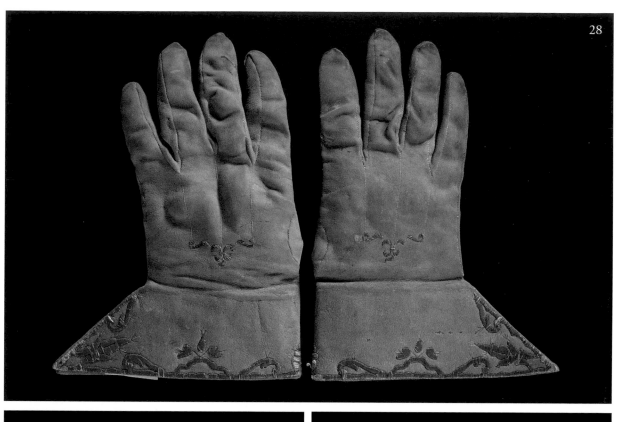

31. WINE GLASS

English, c.1740–50, glass, 16.9 cm (height)
National Museums Scotland, A.1950.9

Commemorating William's role as commander of his troops at the Battle of the Boyne, 1 July 1690, an engagement of the Jacobite war in Ireland between William and James VII and II.

Glencoe

32. PISTOLS

By Alexander Logan or Adam Lawson, Scottish, c.1660
Steel, 66 cm (length)
National Museums Scotland, H.LH 433 and 434

Pair of scroll butt pistols with snaphaunce locks, owned by the earls of Stair. Sir John Dalrymple, 1st Earl of Stair, was Secretary of State for Scotland at the time of the massacre of the MacDonalds of Glencoe. His decision to make an example of the MacDonalds led to the massacre carried out by government troops billeted with the clan in 13 February 1692.

33. AMBER BEADS

Late Bronze Age, Scottish, National Museums Scotland, H.NO 4, 6

A charm against blindness used by the MacDonalds of Glencoe.

34. ORDER

1692, paper, 29 x19 cm
The National Library of Scotland, Adv.23.6.24

Handwritten order for the massacre of the MacDonalds at Glencoe. After the Jacobite challenge of 1689 the government tried a number of ways to bring the Highlanders into line. By the summer of 1691 negotiations were sought with the various clan chiefs. Delays led to the Secretary of State for Scotland, Sir John Dalrymple, Earl of Stair, insisting that an oath of allegiance to the crown be signed by 7th January 1692. Those that failed to meet this deadline would face military action. Although not the only offenders, their punishment was vicious: 'put all to the sword under seventy ….' The order was signed by Major Robert Duncanson.

35. WARRANT

1695, paper, 36.8 x 29.6 cm,
National Museums Scotland, H.OA 37

Warrant for a commission of inquiry into the slaughter of the MacDonalds of Glencoe, with the autograph of William III. The heavy-handed actions of the government caused revulsion and strengthened the cause of Jacobitism in the Highlands.

A Court in Exile

36. SCONCE

By Robert Smythier, c.1670
Silver gilt, 35.4 x 54.0 cm
The Royal Collection / HM Queen Elizabeth II, RCIN 49162.1

A sconce from the Palace of Whitehall which displays the cypher of William and Mary, replacing that of James VII and II.

37. PORTRAIT OF JAMES FRANCIS EDWARD STUART

By Benedetto Gennari (1633–1715), 1689
On loan from Stonyhurst College, Clitheroe, IL.2016.54.2

The young prince had been exiled along with his parents, James VII and II, and Mary, to France. In 1689 it became necessary to create a propaganda image of the Stuart family to coincide with James's invasion of Ireland. This image of a handsome healthy baby was meant to reinforce the family image of the Stuarts, in contrast to his childless half-sister Mary and her husband, William.

38. PAINTING ENTITLED *JAMES II AND FAMILY*

By Pierre Mignard (1612–95), 1694
Oil on canvas, 66.2 x 76.7 x 10.7 cm
The Royal Collection / HM Queen Elizabeth II, RCIN 400966

This painting shows six-year-old Prince James Francis Edward pointing to the crown and the sword at his mother's feet, an allusion to the Prince of Wales being prepared to make his claim on the crowns of the three kingdoms.

39. MANUSCRIPT

By Berthault, 1692, leather, paper, metal clasps, 15 x 17 cm
The Royal Collection / HM Queen Elizabeth II, RCIN 1006013

An explanation of the Lord's Prayer (*Explication de l'oraison dominicale présentée à monseigneur le prince de Galles*) presented to the young Prince of Wales, James Francis Edward.

40. SERVICE BOOK

Published by Antoine Dezallier, 1691, 20 x 5 cm
The Royal Collection / HM Queen Elizabeth II, RCIN 1006016

This book of daily office (*Office de la semaine sainte a l'usage de Rome*) bears the arms of James VII and II and Mary of Modena. It belonged to the lady of the bedchamber, Mary, Duchess of Perth, wife of James Drummond, a leading Jacobite supporter.

41. DEVOTIONAL BOOK

By permission of The Board of Trinity College Dublin, MS 3529

A volume of individual private devotions of James VII and II, mostly dated 1698–1700.

42. PRAYER BOOK

Late 17th century, paper and leather
On loan from Stonyhurst College, Clitheroe, IL.2016.54.3

Easter week prayer book of James VII and II. James's Catholic faith was a constant comfort to him throughout his life. Like the Book of Hours of his great-grandmother Mary, Queen of Scots, the exterior of the book is richly bound, while the interior is relatively plain. It is covered in scarlet leather, tooled and gilded with the royal arms of James II as King of England on the front and back.

43. MISSAL

Printed by Dionysius Thierry, French, 1684, paper, leather and brass
On loan from Stonyhurst College, Clitheroe, IL.2016.54.4

The missal of Princess Louise Marie, sister of James VII and II, who was born at the exiled court and died at only 19 years old.

44. SPECTACLES AND CASE

Probably French, *c.*1685–88, painted and gilded mother of pearl
Victoria and Albert Museum, W.5A.1970 and W.5 to B-1970

These spectacles and case may have belonged to James VII and II.

45. JEWEL OR BADGE

Late 17th or early 18th century, gilt brass, 5.2 x 3.7 cm
National Museums Scotland, K.2001.716

Possible jewel of the Order of the Thistle featuring a thistle on one side and figure of St Andrew on the other. James continued to use the Order while in exile to encourage loyalty, and to exercise his kingly duties.

46. MEDAL

By Norbert Roettier, French, 1697
Silver, 4.5 cm (diameter)
National Museums Scotland, H.1949.1089

This medal, which recognises James Francis Edward as the true heir to the three kingdoms, may have been struck in 1697 either to influence the negotiations leading up to, or protesting against, the Treaty of Ryswick, which recognised William of Orange as the British king.

47. MEDAL

By Norbert Roettier, French, 1712
Silver, 3 cm (diameter)
National Museums Scotland, H.1950.729

Silver medal of Princess Louise Marie and her brother, James VIII and III, issued to mark her death in April 1712.

48. WEDDING RING OF MARY OF MODENA

Italian, 1674, gold, ruby
By permission of His Grace The Duke of Norfolk, Arundel Castle, ID1272

49. SIGNET RING

English, late 17th century, topaz, gold and enamel
© Trustees of the British Museum, AF.846

Signet ring with the letters 'JR' in a monogram enamelled on the back of the bezel, probably for James VII and II.

50. SEAL

English, early 18th century, silver
© Trustees of the British Museum, 19,740,901.10

Seal matrix with three oval faces on a swivel depicting James VII and II, Mary of Modena, and their son James, the future James VIII and III.

51. CAMEO MEDAL

British, early 18th century, onyx, diamonds, emeralds and silver gilt
© Trustees of the British Museum, AF.2652

Depicting the Prince of Wales feathers and motto '*ICH DIEN*', 'I serve'.

52. PAINTING OF *PRINCE JAMES AND PRINCESS LOUISE MARIE THERESA*

By Nicolas de Largillière (1656–1746), 1695
Oil on canvas, 192.8 x 145.7 cm (unframed)
National Portrait Gallery, London. Bequeathed by Horatio William
 Walpole, IV, Earl of Orford, 1895, NPG 976

This portrait of James and his sister was painted while in exile. Louise Marie points to the prince and the greyhound stands loyally beside him looking in his direction. Both are acknowledging James as the rightful heir to the throne.

53. ENGRAVING

By Gérard Edelinck, after Nicolas de Largillière, 1692
Paper, 68.7 x 58.5 cm
Lent by Miss Flure Grossart, IL.2017.8.2

Engraving of young Prince James Francis Edward with head-dress, possibly a reference to the Prince of Wales feathers.

54. ENGRAVING

By Petrus Drevet after Nicolas de Largillière, late 17th century
Paper, 71.5 x 56 cm
Lent by Miss Flure Grossart, IL.2017.8.4

Engraving of Prince James Francis Edward, Prince of Wales.

55. PRINTED SILK

French, 1701, silk, 46.8 x 40.6 cm
National Records of Scotland, CH12/12/1546

The last expressions and dying words of King James VII and II: 'I Am now going to make my Exit out of this miserable World ….'

The Jacobite Challenges of James VIII and III

56. *PRINCE JAMES FRANCIS EDWARD STUART (1688–1766)*

Attributed to Alexis-Simon Belle (1674–1734), *c.*1705, French
Oil on canvas, 95.5 x 82.5 cm
The Royal Collection / HM Queen Elizabeth II, RCIN 401250

One of a number of Jacobite French portraits painted to support the young prince's claims to his father's thrones.

57. *JAMES VI AND I, 1566–1625*

By John de Critz (*c.*1550–1642), Flemish/English, 1604
Oil on canvas, 140 x 95 cm
Scottish National Portrait Gallery, Edinburgh. Bequeathed by Sir
 James Naesmyth 1897, PG 561

This painting was commissioned to commemorate James's coronation a year after the Union of the Crowns in 1603. James acceded to the throne of England and Ireland after the death of Elizabeth I, uniting the three kingdoms under the one monarch for the first time.

47
OBVERSE

REVERSE

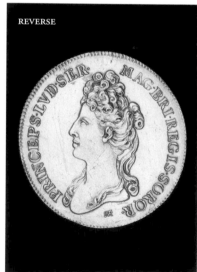

56

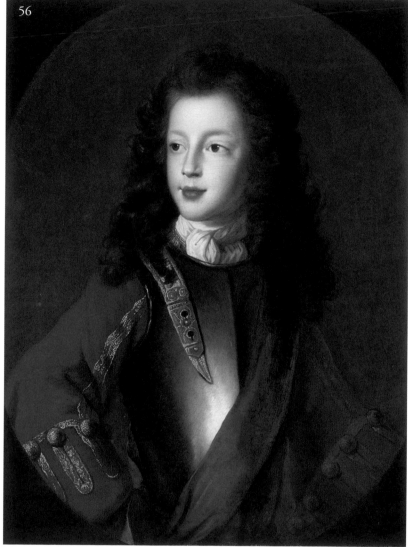

Death of William

58. PENDANT

*c.*1702, gold and thread, 1.8 x 2 cm
National Museums Scotland, H.NK 102

Pendant containing a verse lamenting the death of William III, who died as a result of a riding accident. William was succeeded by his sister-in-law, Anne.

59. BASIN AND EWER

Attributed to Hans Jacobsz Wesson, Dutch, *c.*1640, silver gilt
The Royal Collection / HM Queen Elizabeth II, RCIN 51081 (basin) and 51452 (ewer)

This basin and ewer belonged to Elizabeth Stuart, daughter of James VI and I, and mother of Sophia Electress of Hanover. Sophia was named as Anne's successor in the English Act of Succession of 1701. However, she predeceased Anne by less than two months and the throne went to Sophia's son George.

60. MEDAL

*c.*1710, silver gilt, 4.6 cm (diameter)
National Museums Scotland, H.NT 259

Medal portraying Queen Anne and Prince James. This medal is a possible reminder that James and Anne were half-brother and half-sister, although on opposing sides.

61. TOUCHPIECE OF ANNE

1702, gold, 2 cm (diameter)
National Museums Scotland, K.1998.53

Unlike William and Mary, Anne continued the custom of touching for the 'king's evil'. Touchpieces were used to cure scrofula, a form of tuberculosis.

62. COLLAR AND ST ANDREW

Collar by John Campbell of Lundie, British, *c.*1707–8
Gold and enamel, 180 cm (approx. length)

St Andrew by John James Edington, English, 1825–26
Gold and enamel, 6.8 x 4.0 cm
National Museums Scotland, M.1992.1 and 2

The Order of the Thistle was re-instituted by Queen Anne early in her reign. This was another example of monarchical continuity with her father James VII and II, the original founder of the Order.

63. TABARD

Scottish, *c.*1702–7, satin, 104.1 cm (length)
National Museums Scotland, A.1888.303

Herald's tabard which displays the Stuart arms from the reign of Anne prior to the Act of Union of 1707 when these arms were changed.

James

64. MINIATURE

Probably based on a portrait by Alexis-Simon Belle (1674–1734), French, prior to 1734, oil on copper, 11.5 x 9.3 cm (framed)
National Museums Scotland, H.NT 241.15

Miniatures such as this were produced for circulation at home and abroad among Jacobite supporters.

65. MEDAL

Norbert Roettier, French, 1704, silver, 2.8 cm (diameter)
National Museums Scotland, H.1962.921

This medal is the first to bear the regal titles of James VIII and III. It commemorates his protection under Louis XIV and the French king's recognition of James's claims to the three kingdoms.

66. TOUCHPIECE OF JAMES VIII AND III

1708, gold, 2.0 cm (diameter)
National Museums Scotland, H.1958.2051

James VIII and III continued with the regal tradition of touching or healing those ill with scrofula, the 'king's evil'.

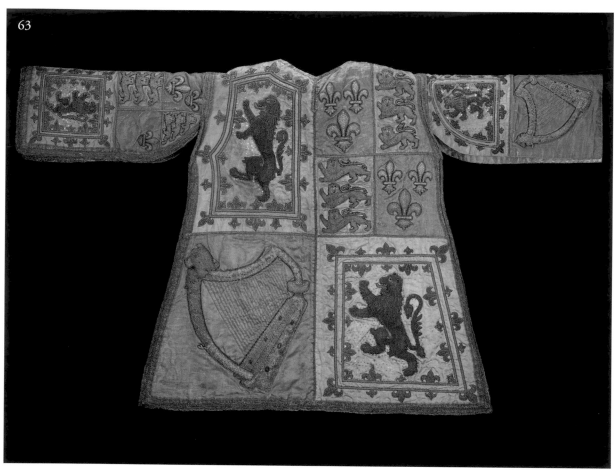

63

58

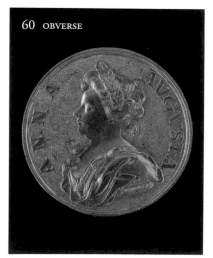

60 OBVERSE

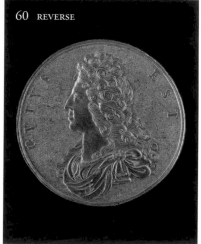

60 REVERSE

67. BROADSHEET

Printed by Charles Bill, English, 1707
Paper and ink, 40.5 x 33.5 cm
On loan from the Drambuie Collection by kind permission of William
Grant and Sons, PGL 1705

In 1708 there was an attempted Jacobite invasion of Scotland
supported by France. James hoped to take advantage of the
unpopularity of the government over its polices, especially the
Act of Union of 1707.

68. OFFICIAL DOCUMENT

1707, parchment and cord, 47 x 57 cm
National Museums Scotland, H.OA 80

This document confirms that the Honours of Scotland would
be kept in safekeeping in Scotland after the passing of the Act
of Union in 1707, a stipulation of one of the articles of the
Treaty of Union.

69. FAN

1707, paper and ivory, 26 x 46 cm
National Museums Scotland, H.UI 1

Women were able to express their political opinions and
allegiances through objects such as this fan, which is decorated
with devices commemorating the Union of Scotland and
England in 1707.

Death of Anne: Succession of the Hanoverians

70. ROYAL WATERMAN'S BADGE

By Francis Leake, English, 1684–85
Silver, parcel-gilt, 17.2 x 16.1 cm
The Rosalinde and Arthur Gilbert Collection on loan to the Victoria
and Albert Museum, London, Gilbert.596:1-2008

This Royal Waterman's badge [and 71] are of note because
crown and armorial were created for two royal dynasties mark-
ing the change from the Stuart to the Hanoverian dynasty. The
marks on the crown date from the reign of Charles II or James
VII and II, both monarchs of the House of Stuart.

71. ROYAL WATERMAN'S BADGE

By Francis Garthorne, English, c.1720
Silver, parcel-gilt, 17.2 x 16.1 cm
The Rosalinde and Arthur Gilbert Collection on loan to the Victoria
and Albert Museum, London, Gilbert.595-2008

This royal armorial is that of the Hanoverian dynasty. George
I was the first Hanoverian on the British throne, succeeding
Anne, the last reigning Stuart in Britain, in 1714.

72. MEDAL

1707, silver, 3.5 cm (diameter)
National Museums Scotland, H.R 99

Medal from the reign of Anne, commemorating the Union
of the Parliaments of Scotland and England, on 1 May 1707.
One of the main constitutional clauses of the Treaty of Union
guaranteed the succession of the Protestant Hanoverians.

73. MEDAL

By Georg Hautsch, German, 1708, silver, 4 cm (diameter)
National Museums Scotland, H.M 246

This medal shows the French fleet being chased from the Firth
of Forth by ships of the Royal Navy under the command of
Admiral Byng.

74. MEDAL

By J. Crocker and S. Bull, English, 1708, bronze
National Museums Scotland, M.1950.766

Medal marking the flight of the French fleet from the Firth of
Forth. The French ship *Salisbury* has been caught by a Royal
Navy ship, while the figure of Scotia (Scotland) is shown ask-
ing Britannia for help.

75. MEDAL

By Martin Smeltzing, Dutch, 1708, silver, 4.8 cm (diameter)
National Museums Scotland, H.1949.1096

This medal marks the failure of the 1708 invasion. An entwined thistle and rose signifies the Union of Scotland and England, while Jacobite prisoners are depicted on their way to the Tower of London.

76. MEDAL

By Norbert Roettier, French, 1710
Bronze, 5.1 cm (diameter)
National Museums Scotland, H.1950.727

This pro-Jacobite medal on the 'Restoration of the Kingdom' may have been re-issued in 1712 for circulation among James's supporters during peace negotiations between Britain and France.

77. MEDAL

By Norbert Roettier, French, 1710, bronze, 7 cm (diameter)
National Museums Scotland, H.R 103

Portrait medal of James VIII and III with the inscription 'CUIUS EST' which asks 'Whose is it?' This is a pro-Stuart statement that questions who should be the rightful monarch of Britain.

78. TWO-HANDED SWORD

Swedish, 1657
Leather, wood and steel, 142 cm (length)
On loan from the Royal Armouries, IX.36

Two-handed sword, also known as the Scottish sword of Mercy. This sword [and 79, known as the Scottish sword of Justice] are believed to have been carried 'before the old Pretender on his being proclaimed King of Scotland' during his time in Scotland at the rising of 1715. After landing at Peterhead, Aberdeenshire, James made his way to Scone Palace where he set up a court in January 1716.

79. TWO-HANDED CLAYMORE

Scottish, 1600–30, steel and wood, 131 cm (length)
On loan from the Royal Armouries, IX.11

1715–16

80. SWORD

English, late 17th century
Steel and oak, 105.6 cm (length)
National Museums Scotland, A.1905.643

This sword was recovered from the site of the Battle of Sheriffmuir, the major if inconclusive engagement of the 1715 rising.

81. SWORD

Hilt by Henry Bethune, Scottish, c.1715
Blade, German, early 18th century
Silver, steel and wood, 102 cm (length)
National Museums Scotland, H.LA 124

The blade of this broadsword, with a silver half-basket, has been engraved with pro-Jacobite slogans: 'Prosperity to Scotland and no Union' and 'For God my Country and King James the 8'. It is also engraved with the figure of St Andrew, patron saint of Scotland.

82. TARGE

Scottish, 1715, leather, wood and brass, 54 cm (diameter)
National Museums Scotland, H.LN 52

This traditional highland shield or targe was believed to have been carried by the Marquis of Huntly at the Battle of Sheriffmuir in November 1715. Huntly was a leading aristocrat in the north-east of Scotland, traditionally a stronghold of Jacobite support, where he raised forces to take part in the 1715 rising.

83. PISTOLS

By N. Atkinson, English, early 18th century, silver, 36 cm (length)
National Museums Scotland, H.1992.4 and 5

This pair of 'Queen Anne holster' pistols have been engraved with 'AMD Clanranald 1712' and 'To AMD Dalelea 1715'. Allan Macdonald, the then Chief of Clanranald, was killed at the Battle of Sheriffmuir on 13 November 1715.

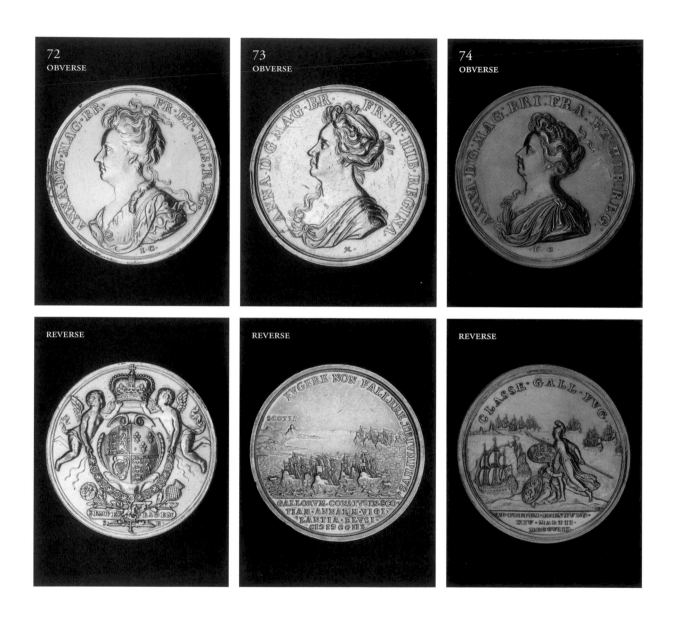

72
OBVERSE

73
OBVERSE

74
OBVERSE

REVERSE

REVERSE

REVERSE

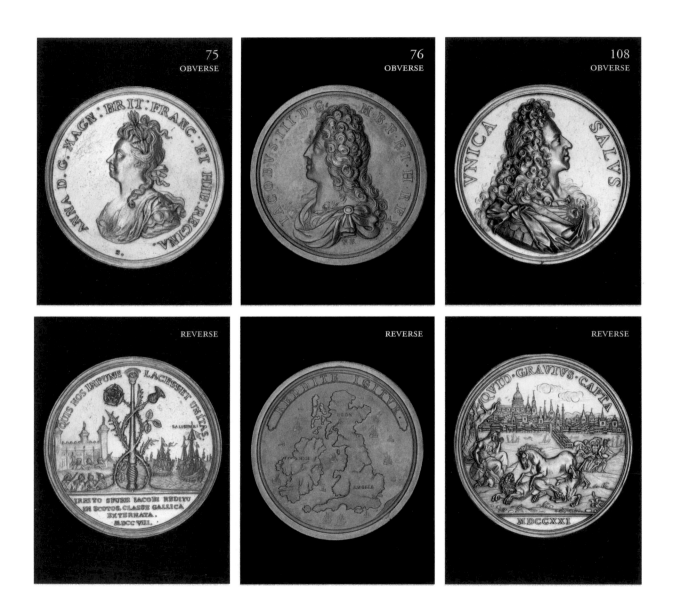

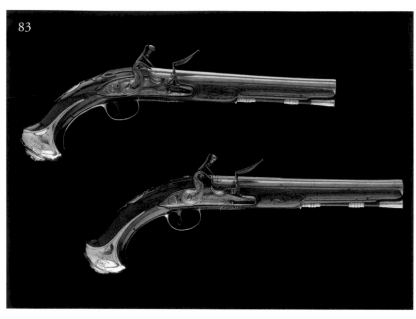

83

83
DETAIL

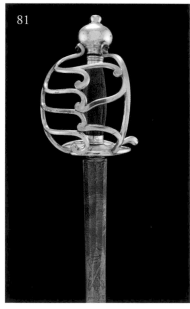

81

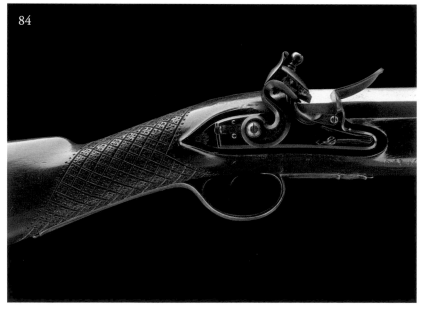

84

84. BLUNDERBUSS

Late 17th century (barrel), late 18th century (butt)
Brass and wood, 96.5 cm (length)
National Museums Scotland, X.2015.143

The 'Preston Blunderbuss' is inscribed, 'This was taken from a Highlander at Preston 1715 loaded with 17 balls'. Between 9 and 14 November 1715, the Jacobite army fought government forces at Preston, Lancashire. This blunderbuss is likely to have been removed from the battlefield as a trophy of war by one of the victorious government officers.

85. MARISCHAL STAFF BATON

Scottish, c.1400–1600
Metal, gold, copper alloy, brass, iron and steel
On loan from the University of Aberdeen Museums, Scotland,
 ABDUA:17612

This baton belonged to George Keith, 10th Earl Marischal, a prominent Jacobite supporter who played a key role in the rising of 1715. Keith went into exile, but returned with the Spanish-supported attempt of 1719, sustaining wounds at the Battle of Glenshiel. Later he joined the Prussian diplomatic service; however, as his title had ceased, he sent this baton back from Prussia to Marischal College, Aberdeen, in 1760.

86. SNUFF MULL

Scottish, 1715, ivory and silver, 6.5 x 9.5 x 7.3 cm
National Museums Scotland, M.1953.282

Donald Murchison fought at the Battle of Sheriffmuir. This snuff mull was probably given to Murchison by a fellow Jacobite, one of the MacGregors of Glengyle whose crest and motto are engraved alongside the cipher 'IR' for *Jacobus Rex*.

87. POWDER FLASK

Scottish, c.1715, ram's horn and silver, 14.5 cm (length)
National Museums Scotland, X.2013.24

This powder flask is engraved with pro-Hanoverian inscriptions celebrating the Hanoverian defeat of the 1715 rising. It alludes to the Battles of Sheriffmuir, and Preston. Key Hanoverian figures are mentioned, such as the Duke of Argyll and the Earl of Sutherland.

88. SNUFF BOX

Unmarked, silver, National Museums Scotland, X.2015.142

This snuff box is associated with Alexander McGrouder, who supported the Duke of Perth in the rising of 1715. After his capture at Preston in November 1715, McGrouder was imprisoned in London. The twin covers are engraved with 'Fear God and Honour thee King', and 'Be Not Given to Changes'. The base is engraved 'Newgate 17 July 1717', McGrouder's place of imprisonment.

89. SNUFF MULL

Scottish, c.1715, horn and silver, 13.5 cm (length), 5.4 cm (diameter)
National Museums Scotland, H.MEQ 1554

The taking of snuff was a sociable activity, where political allegiances could be shared. This pro-Jacobite snuff mull is engraved with a crown and 'I VIII R', and 'A gift from a friend to James Buchanan of Kirenach', c.1715.

90. SNUFF MULL

Probably French, c.1715
Ivory, 9 cm (height)
National Museums Scotland, H.NQ 217

This snuff mull is a very accurate representation of a Highlander fully armed with broadsword, pistol, dirk and targe, and wearing a belted plaid and a bonnet. A possible French provenance might refer to the fact that many Jacobites went into exile there after the 1715 rising.

91. 'AMEN' WINE GLASS

British, c.1743
Glass, 16.1 (height), 7.7 (bowl diameter), 8.3 cm (base diameter)
National Museums Scotland, H.MEN 93

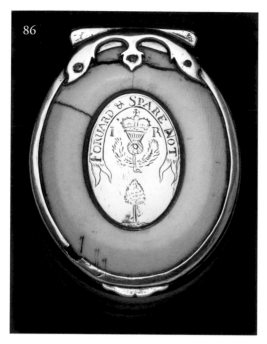

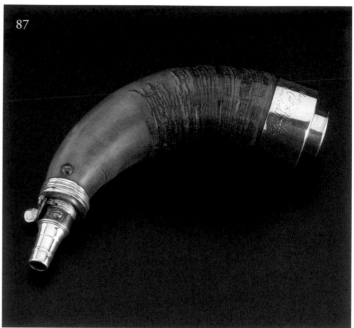

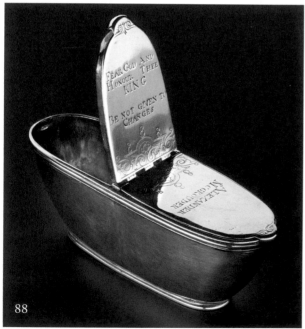

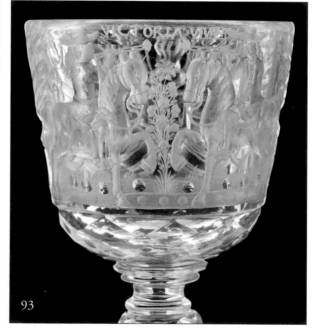

The base of this Jacobite 'Amen' wine glass is inscribed 'Prosperity to the Bank of Scotland and A Bumper to the memory of David Drummond', the bank treasurer, 1700–43. In 1715 he was custodian of a fund set up to assist individuals imprisoned at Carlisle as a result of their involvement in the rising.

92. PRINTED CLOTH

Spanish, 1715, silk, 56 x 83.5 cm
National Museums Scotland, A.1942.43

Pale red silk cloth printed in black, in Latin, showing the Confession of Faith of William MacNair. It is probably dedicated to King Phillip V of Spain and the inhabitants of Seville.

93. GOBLET

Bohemian, c.1720
Glass, 19.7 (height) x 12.1 cm (diameter)
National Museums Scotland, A.1979.404

A goblet decorated with horsemen and war trophies, probably made to commemorate the Quadruple Alliance of 1718. The alliance of Britain, France, the Dutch republic and Austria was a response to Spanish aggression in Italy, although it did not stop Spain under Philip V from seizing control of Sardinia and Sicily, much to the anger of the allied countries.

94. PURSE

Scottish, 18th century, deerskin, 9.5 x 9.2 cm
National Museums Scotland, H.NE 37

Small deerskin purse with a rectangular brass clasp incised with dot-and-circle ornament, said to have been owned by Rob Roy MacGregor, who joined with the small Jacobite force which landed in 1719.

95. TODDY LADLE

Scottish, 18th century, wood, 41.3 (length)
National Museums Scotland, H.SJB 23

Toddy ladle, said to have been used by Rob Roy MacGregor.

96. POWDER HORN

Scottish, 18th century
Horn and brass, 17.6 cm x 7.2 x 3.8 cm
National Museums Scotland, H.1992.208

Powder horn with globular-shaped body and brass mounts, said to have belonged to Rob Roy MacGregor, with maker's mark of a crowned 'CR'. Powder horns were used for carrying and dispensing gun powder.

97. OBLIGATION

27 December 1711 (Glasgow)
Paper, 33.8 x 21.9 cm
National Museums Scotland, H.OA 40

Obligation by Rob Roy MacGregor to deliver to James, Duke of Montrose, sixty Kintail Highland cows at 'fourteen pounds Scotts per piece with ane bull to the bargane'.

98. COMMISSION

French, 2 January 1717, paper, 32 x 20.7 cm
National Museums Scotland, H.OA 44

Commission from James 'VIII', and subscribed by the Earl of Mar, to the Marquis of Tullibardine, appointing him lieutenant general of forces, signed at the Jacobite court in Avignon on 2 January 1717.

99. NEWSPAPER

2 January 1716, paper, 55.9 x 40.6 cm
National Library of Scotland. On long term loan to the Scottish National Portrait Gallery, Edinburgh, Blaikie

'Prince James Landing at Peterhead', 2 January 1716.

100. MAP

By Herman Moll, English, 1714
Paper, 63 x 104 cm
National Museums Scotland, H.OJ 55

This map of 'The North Part of Great Britain Called Scotland' is by Herman Moll and dates from 1714. It is dedicated to John Erskine, 11th Earl of Mar (1675–1732). At either side of the map are sketches of towns and landmarks in Scotland. The back of the map is labelled 'G.H. Paton & Co, 42 Pitt Street, Edinburgh'. The 1715 Jacobite rising was led by Mar who switched support from George I to the Jacobites. Mar was known as 'Bobbing John' because he switched sides and was indecisive as a general.

101. SNUFF BOX

French, 18th century, tortoisehell and gold, 8 cm (width)
On loan from a private Jacobite collection

All Roads lead to Rome

102. PAINTING ENTITLED *PRINCE JAMES FRANCIS EDWARD STUART (1688–1766)*

By Francesco Trevisani (1656–1746), *c*.1719–20
Oil on canvas, 113 x 107.5 cm
The Royal Collection / HM Queen Elizabeth II, RCIN 401232

This portrait, painted in Rome, shows James in the robes of a Knight of the Garter with the crown of England beside him. It was commissioned as a gift for Maria Clementina Sobieska, whom he married in 1719. Trevisani also painted the portraits of other prominent Jacobites at the exiled Stuart court in Rome.

103. PRINT OF *THE SOLEMNISATION OF THE MARRIAGE OF PRINCE JAMES STUART, THE OLD PRETENDER, AND PRINCESS MARIA CLEMENTINA SOBIESKA*

By Antonio Friz after Agostino Masucci (1691–1758), *c*.1735
Line engraving on paper, 63.5 x 50.8 cm
Scottish National Portrait Gallery, Edinburgh, SPL 62.4

James and Maria Clementina were initially married by proxy on 9 May 1719 in Bologna, as James was absent on diplomatic mission to Spain to seek support for another challenge. The couple's marriage was finally formalised in a ceremony almost four months later in the cathedral of Santa Margherita in Montefiascone, Italy, on 3 September 1719.

104. ENGRAVING ENTITLED *'THALPOLECTRUM PARTURIENS' OR 'THE WONDERFUL PRODUCT OF THE COURT-WARMING PAN'*

1719–66, engraving on paper, 37.7 x 24.4 cm (unframed)
The Royal Collection / HM Queen Elizabeth II, RCIN 603552

Even as a man in his thirties at the time of marriage, James was unable to escape the anti-Stuart propaganda of the 'warming pan' myth, which cast doubts on his legitimacy and made the claim that he was a changeling. This engraving depicts his new wife Maria Clementina holding a warming pan with James's portrait.

Marriage, and the Birth of Charles

105. VALANCES

Scottish, 1719, wool, linen and silk
National Museums Scotland, A.1988.263, C and E

The valances are a Scottish domestic expression of Jacobite support through a tribute to the marriage of James VII and III and Maria Clementina. The central sunflower symbolises constancy to a monarch. It surrounds the crowned initials of the newlyweds, 'IRCR', and the date of the marriage. The initials 'AV' possibly refer to Anne Urquhart of Newhall, Ross and Cromarty.

106. MEDAL

By Ottone (Otto) Hamerani, Italian, 1719, silver, 4.9 cm (diameter)
National Museums Scotland, H.R 116

Maria Clementina's safe escape from imprisonment by the Austrian Emperor, Charles VI, and her safe arrival in Bologna, allowed a proxy marriage to proceed. As James and Clementina are not conjoined in this medal, it is possible that it was struck to celebrate the proxy marriage on 9 May 1719.

107. MEDAL

By Norbert Roettier, French, 1720, silver, 4.5 cm (diameter)
National Museums Scotland, H.1950.734

102

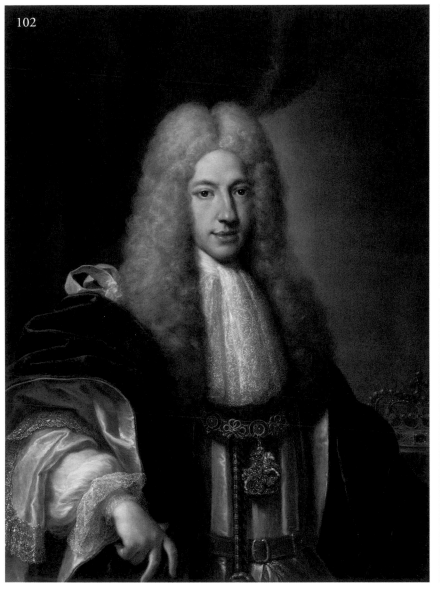

106
OBVERSE

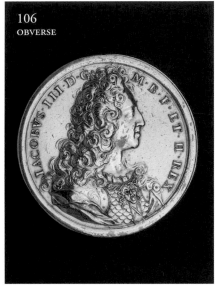

REVERSE

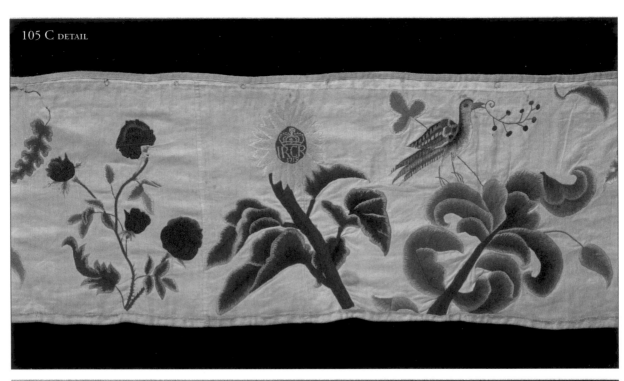

105 C DETAIL

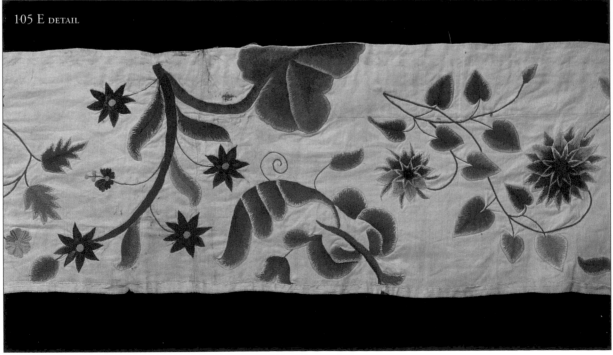

105 E DETAIL

Just over a year after their marriage, Maria Clementina gave birth to her first child, a son, Prince Charles Edward. James now had an heir to continue the Stuart cause. This medal shows the figure of Providence holding a child; the inscription on each side translates as 'The hope of Britain'.

108. MEDAL

Possibly Ottone (Otto) Hamerani, Italian, 1721, silver
National Museums Scotland, H.1950.733

This is the last medal to be struck bearing James's portrait. The reverse here shows a Hanoverian horse trampling on Britain, as represented by a Lion and Unicorn. In the background the citizens of London are shown in poverty, Jacobite propaganda blaming the Hanoverians for Britain's economic woes. The inscription on the front of the medal *'Unica Salus'*, translates as 'the only safeguard', inferring that the Stuarts were Britain's only hope.

109. MARRIAGE CERTIFICATE OF JAMES VIII AND III AND MARIA CLEMENTINA

1 September 1719, paper
By permission of The Board of Trinity College Dublin, MS 7574

This elaborate certificate is an official record of the marriage of James VIII and III to Maria Clementina. It has been signed by James and his new wife. It is likely to have been brought back to Ireland from Rome, either by a Jacobite sympathiser or a collector of Jacobite 'relics'.

110. BAPTISMAL CERTIFICATE OF PRINCE CHARLES EDWARD STUART

Paper, Italian, 1720
Scottish National Portrait Gallery, Edinburgh

The infant prince was baptised on the evening of the day of his birth, 31 December 1720, in the chapel of the Palazzo Mutti.

111. BOOK COVER

The National Library of Scotland, IL.2016.42.1

A book cover with armorial binding made for Princess Maria Clementina Sobieska to house an illuminated vellum manuscript of a patent admitting the princess into the Roman Archconfraternity of the Most Holy Name of Mary.

112. PORTRAIT OF JAMES FRANCIS EDWARD STUART, KING JAMES VIII AND III

By Antonio David (1680–1737), Italian, 1730
Oil on canvas, 74 x 62 cm (unframed)
The Pininski Foundation

These two portraits [with 113], a pair, were based on lost originals by Martin van Mytens. They were first painted in 1725 to celebrate the birth of Prince Henry Benedict.

113. PORTRAIT OF CLEMENTINA SOBIESKA, WIFE OF JAMES FRANCIS EDWARD STUART

By Antonio David (1680–1737), Italian, 1730
Oil on canvas, 74 x 62 cm (unframed)
The Pininski Foundation

114. PORTRAIT OF CHARLES EDWARD STUART

By Antonio David (1680–1737), Italian, 1726
On loan from Stonyhurst College, Clitheroe

Antonio David continued to be one of the favoured painters at the Stuart court in Rome. This full-length portrait is of the prince when he was five years old. He is shown pointing to the Prince of Wales feathers. This portrait was engraved to allow for wider circulation among supporters.

The Family

115. MINIATURE OF MARIA CLEMENTINA SOBIESKA

Antonio David (1680–1737)
Rome, 1702–35, oil on copper, 17.8 x 14 cm
On loan from a private collection

Maria Clementina Sobieska is wearing a white dress and blue wrap, three-quarter length.

116

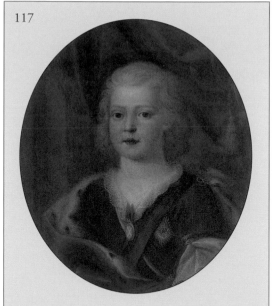

117

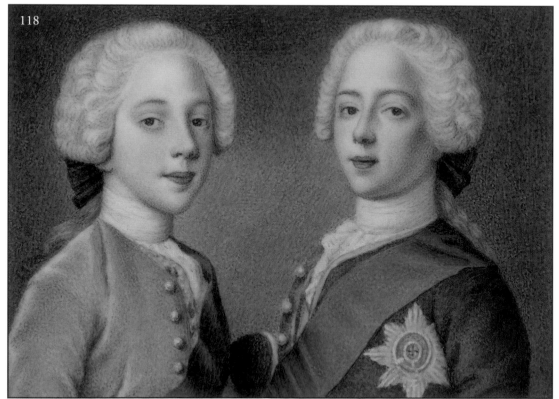

118

116. MINIATURE OF CHARLES EDWARD STUART AT *c.* THREE YEARS OLD

Artist unknown, oil on copper, 7.3 x 5.4 cm
National Museums Scotland, H.NT 244

This miniature [and 117] is part of a large collection of Jacobite relics that belonged to the leading English Jacobite, Sir John Hynde Cotton and members of his family. Portrait miniatures of the exiled Stuart family, painted in oil on copper plates, were popular with Jacobite supporters and were versions of portraits by leading court painters.

117. MINIATURE OF CHARLES EDWARD STUART AT *c.* FIVE YEARS OLD

Artist unknown, oil on copper, 16.4 x 13.1 cm
National Museums Scotland, H.NT 245 A

118. MINIATURE OF CHARLES EDWARD AND HENRY BENEDICT STUART

Artist unknown, watercolour on bone, 5.9 x 8.2 x 3.7 cm
National Museums Scotland, H.NT 246

This double miniature is a later copy after the court painter Jean-Étienne Liotard. This closely resembles Liotard's own miniature versions of the two princes made when they were around fifteen and ten years of age.

119. NECK SLIDE

Probably after 1715
Gold, crystal covering hair and gold wire, 2 x 1.5 cm
National Museums Scotland, H.NA 630

Jacobite supporters, men and women, would express their loyalties through jewellery or other personal adornments. Although this neck slide would have been worn in a prominent position, it would require close examination to discern the wearer's loyalty to the Stuart cause. James's crowned initials are in the centre and are surrounded by the motto 'God Save the King' in gold wire.

120. PORTRAIT RING

First half of the 18th century
Gold, glass and hair, 2 cm (diameter)
National Museums Scotland, X.2015.105.3

Portrait rings were used as a means of discreetly wearing one's loyalty. The inclusion on the reverse of the ring of a glazed locket, containing a woven panel of hair and the initials 'CR' surmounted by a crown, suggests a reference to 'Clementina Regina' or Queen Clementina. Clearly a previous owner has attempted to imbue this ring with Jacobite credentials. It is unlikely that the sitter in this miniature is Maria Clementina Sobieska, wife of James VIII and III, as she is always depicted with powdered hair.

121. RING

Gold, diamond and hair, 2.2 cm (diameter)
National Museums Scotland, X.2015.105.5.1

The portrait cameo on this ring bears a likeness to the profile of James VII and III. The reverse has been set with a glazed locket containing a lock of hair, with the initials 'IR', 'VIII' and surmounted by a crown. Whether or not the portrait is that of James, the significance of this object is the attempt to present it as a Jacobite relic.

122. RING

Gold, gemstones and hair, 2.2 cm (diameter)
National Museums Scotland, X.2015.105.4

This ring is from the collection of a leading Jacobite-supporting family. The reverse contains a woven panel of hair, possibly a hidden Jacobite relic.

123. LETTER

4 May 1728, 25.8 x 17.4 cm
The Royal Collection / HM Queen Elizabeth II, RA SP/MAIN/115 162

This letter was written by the young Prince Charles Edward to his father on 4 May 1728. It was intended as an apology for jumping out and startling his mother, Maria Clementina.

124. MEDAL

By Ottone (Otto) Hamerani, 1731, bronze, 4 cm (diameter)
National Museums Scotland, H.1950.735

This medal was struck to mark Prince Charles Edward's eleventh birthday. To the right of the prince is the star, reported to have been seen in the sky on the night of his birth. The Latin inscription translates as, 'He shines in the midst of all'.

125. MEDAL

By Augustino Franchi, Italian, 1737, bronze, 4.7 cm (diameter)
National Museums Scotland, H.1992.1877

Charles made a tour of Italy's northern cities, including Venice, in the summer of 1737, where he was received as a rightful royal prince. The inscription around his portrait declares him as Charles 'Prince of Wales', the official title of the heir to the British throne.

126. MEDAL

Probably by Ermenegildo Hamerani, c.1737
Bronze, 4.5 cm (diameter)
National Museums Scotland, H.R 126

The medal of the two royal brothers presents them to be second and third in line to three kingdoms of Scotland, England and Ireland. Now in his seventeenth year, Prince Charles Edward had had his previously long hair cut and was fitted for wig, a sign that he was now considered to be approaching adulthood. He was also shaved for the first time that same year. Such rites of passage were considered significant enough for commemoration.

127. SNUFF BOX

Horn, porcelain and ormolu, 4 x 8 cm
On loan from a private collection

A snuff box representing all three Stuarts: James, Charles and Henry. The traditional Jacobite iconography to represent James VII and II and his sons was a white rose in bloom for James, with two buds, one half-opened and the other closed, to represent Charles Edward and Henry Benedict respectively. James's birthday, 10 June 1688, was known as white rose day.

128. TOUCHPIECE

Silver, with white ribbon
National Museums Scotland, H.NT 242.10

James VIII and III continued the practice of touching (healing) for the 'king's evil' using such touchpieces. The king's evil was a skin disease associated with tuberculosis. The ability to provide the 'royal touch' was a sign that the monarch's right to rule was granted directly from God. This belief had been held by monarchs since the medieval period.

129. SEAL

Gold, wax, 2.4 x 1.3 x 1.2 cm, National Museums Scotland, H.NT 248

Oval fob seal with the head of James Francis Edward Stuart, and an impression in red wax. Objects produced to signify support for the exiled Stuarts, such as this fob seal with a portrait bust of James VIII and III, were often small. As such they were easily concealed and only shared among trusted companions with a mutual allegiance to the cause of Jacobitism.

130. MEDAL BOX

Italy, c.1725, leather and velvet, 27.5 x 20.8 cm
The Hunterian, University of Glasgow, GLAHM:36656

It was not only Jacobite supporters who collected medals. James was also known to have kept a box on his desk for his most prized medals during his exile in Rome. This box appears to have been designed to house 13 medals. From the shape of the remaining depressions, five must have been touchpieces.

131. QUAICH OF JAMES VIII AND III

c.1730, wood and silver, 17.2 cm (width across lugs)
On loan from the Drambuie Collection by kind permission of William Grant and Sons, PGL 1786

The 'James VIII Quaich' with silver lugs bears the cypher of the king. This domestic object has been modified to emphasise the owner's loyalty to the Stuart cause. The engraved lettering on the silver lugs (handles) dates to the early-18th century and reflects other examples of cyphers of James VII and III. The crown which surmounts the cypher is later.

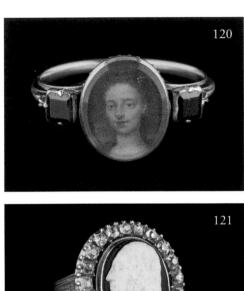

120

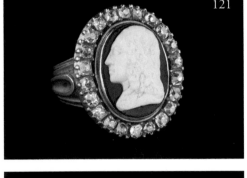

121

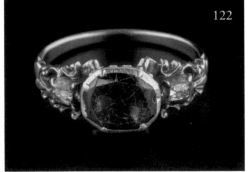

122

129

132. INKSTAND

Early 18th century
Wood, silver, with glass inlay, 1.5 x 24.3 x 16.3 cm
National Museums Scotland, X.2015.105.7.1 to 5

This inkstand has clearly been commissioned by a supporter of James VII and III, although its use would be restricted to a private space, probably the owner's study. James's crowned cypher 'JR' has been engraved on the covers of the inkwell, the pounce pot (named for the fine powder used to dry the ink and to smooth the paper), the wafer pot (which contained the paste to seal letters), and the quill pen holder.

133. TARGE

Scottish, 1739–41
Wood, pigskin, silver mounts, jaguar skin, 47 cm (diameter)
National Museums Scotland, H.LN 49

Although this Highland targe is constructed in the traditional way with wooden boards covered with pigskin, it has been elaborately decorated with silver mounts. The central boss is a Medusa head, a mythological monster. This and backsword 135 are thought to be part of the accoutrements from the complete set of Highland clothes sent out to Prince Charles Edward to the court at Rome by James Drummond, 3rd Duke of Perth. Drummond also sent out a set to Prince Henry Benedict.

It has been suggested that this outfit may have been a gift from Drummond, in response to his installation as a Knight of the Thistle the previous year. The decoration on the targe includes Scots bonnets, the cap badges of which, though now faint, are engraved with the crest, motto and St Andrew Badge of the 3rd Duke of Perth.

134. SWORD

By Charles Frederick Kandler, London, 1740–41
Silver (basket), 96 cm (length)
National Museums Scotland, H.MCR 2

This basket-hilted backsword is the other surviving accoutrement presented to the two princes by Drummond. The silver hilt was made in London, 1740–41, by a silversmith called Charles Frederick Kandler. Although elaborate, the sword and targe are typical of the weapons used by clansmen in his army.

There is an account that on 8 February 1741 Prince Charles Edward 'went after ye opera to a publick Ball, masked in a fine complete Highland Dress which became him very well and he did not return until daylight'.

The targe was rescued from Culloden battlefield in 1746 by Jacobite clan chief, Ewan MacPherson of Cluny, and remained in his family until the 20th century. The backsword was in the Royal Collection in the early 19th century. It was presented to the chief and captain of Clanranald by King George IV.

135. BASKET-HILTED BACKSWORD

Backsword, London, 1739–41
Silver (basket), 98 cm (total length)
On loan from the National Trust for Scotland

The 'Brodie sword' is an elaborately decorated basket-hilted backsword with a Medusa head on the hilt. It is very similar in design to the targe presented by James, 3rd Duke of Perth, as one of the accoutrements that would have been part of the full Highland outfit sent out to each of the princes. However, as it is unmarked, it is difficult to be precise about its provenance. This sword was said to have been recovered from the abandoned baggage train in the immediate aftermath of Culloden.

136. CANTEEN

By Ebenezer Oliphant, Scottish, 1740–41
Silver, 16.5 cm (height of canteen), 10.5 (maximum width)
National Museums Scotland, H.MEQ 1584.1 to 16

This travelling canteen may have been commissioned as a 21st-birthday present for Prince Charles Edward from a Scottish supporter. From the makers' marks we know that the exquisite outer case and the wine beakers were made by Ebenezer Oliphant. As a member of a leading pro-Jacobite family, the Oliphants of Gask, he was a clear choice for this commission.

The decoration of the linked thistles from the collar and the badge of St Andrew reflect these elements of the regalia of the Order of the Thistle. Prince Charles Edward was made a Knight of this Order as an infant. The presence of the feathers of the Prince of Wales on the front of the canteen further links this object to the prince.

The canteen was abandoned with the prince's other baggage as he fled from the Battle of Culloden. It came into the possession of the Duke of Cumberland. The duke then presented it to his aide-de-camp and close friend, George Kepple, later Earl of Albemarle, who was charged with taking the news of the defeat back to King George II.

137. PAINTING ENTITLED *PRINCE CHARLES EDWARD STUART (1720–88)*

By Louis Gabriel Blanchet (1705–72), *c.*1739
Oil on canvas, 119.8 x 95 cm (unframed)
The Royal Collection / HM Queen Elizabeth II, RCIN 401208

William Hay, a leading courtier, who had been Prince Charles Edward's groom of the bedchamber from 1727–39, commissioned this pair of portraits of the royal brothers [with 138]. Charles Edward had turned 21 the previous year and had therefore reached the age of majority. He was now the object of Jacobite attention and in this portrait is shown purposefully as a 'warrior prince' wearing a half-armour. Charles prominently wears the Orders of the Garter and the Thistle, and indeed the Garter star is welded to his breast-plate.

138. PAINTING ENTITLED *PRINCE HENRY BENEDICT STUART (1725–1807), LATER CARDINAL YORK*

By Louis Gabriel Blanchet (1705–72), *c.*1739
Oil on canvas, 119.8 x 95 cm (unframed)
The Royal Collection / HM Queen Elizabeth II, RCIN 401209

Henry Benedict is shown opening his red coat to reveal both orders beneath it. As a Scot, William Hay, who commissioned the two paintings, had insisted that the Thistle badge should be displayed as prominently as possible in each portrait, resting on top of the blue sash of the Garter.

139. PAINTING OF JOHN HAY OF CROMLIX, EARL OF INVERNESS

By Francesco Trevisani (1656–1746), *c.*1725
Oil on canvas, 121.7 x 101.4 cm
Lent by the Earl of Kinnoull

Having participated in the 1715 rising William Hay joined James in exile, becoming a member of the royal household. This painting was made around 1725, at the time he was Secretary of State at the Jacobite court in Rome. He did not enjoy a good relationship with Maria Clementina and resigned after only two years in office.

140. PORTRAIT OF MRS JOHN HAY, COUNTESS OF INVERNESS

By Francesco Trevisani (1656–1746), *c.*1725
Oil on canvas, 115.5 x 89.30 cm
From the collection of the Earls of Mansfield, Scone Palace

Marjorie Hay, her husband John Hay of Cromlix, and her brother James Murray, were a close group of courtiers whom Maria Clementina disliked intensely. The devoutly Catholic Clementina was distrustful of the Murrays because of their Protestantism and the final straw came when James appointed James Murray as governor to Charles Edward in 1725, followed by Henry Benedict in 1729. Adding to this rancorous situation, Maria Clementina accused Marjorie of being her husband's mistress.

141. TARTAN SUIT

Scotland, 1744
National Museums Scotland, K.2005.16.1 to 3

Sir John Hynde Cotton of Madingley, Cambridgeshire, was described as 'one of the most zealous Jacobites in England'. During a visit to Scotland in 1744, Cotton either commissioned this tartan suit of a jacket and trews from an Edinburgh tailor, or it was presented to him as a gift. As a man of some physical stature it had to be enlarged to fit him properly. From the 1730s onwards there was a growing perception of tartan 'as the cloth and attire of Jacobitism'. Perhaps Cotton acquired this suit with the specific intention of identifying himself with the cause.

142. TARGE

Scotland, leather and brass, 48.7 cm (diameter)
National Museums Scotland, K.2005.16.4

This leather targe is reputed to have been acquired by Sir John Hynde Cotton, as an accoutrement for his tartan suit, during his visit to Scotland in 1744.

143. DECLARATION

On loan from the Drambuie Collection by kind permission of William Grant and Sons, PGL 1735

A contemporary transcription of a declaration by James VIII and III outlining the continuing claims to the British thrones. James and the court became increasingly confident about the prospect for another challenge against the Hanoverian monarchy in Britain.

144. PAINTING ENTITLED *ACTION BETWEEN HMS 'LION' AND 'L'ELIZABETH' AND THE 'DU TEILLAY', 9 JULY 1745*

By Dominic Serres the Elder (1722–93), 1780
Oil on canvas, 51 x 70 cm (framed)
National Maritime Museum, Greenwich, London, Macpherson Collection, BHC0364

After only two days at sea after embarking at St Nazaire en route to Scotland, the prince was soon in the midst of the first engagement of the 'Forty-Five' in July 1745. The *Du Teillay* and its escort ship *l'Elizabeth* were intercepted by HMS *Lion* and an intense gun battle ensued that lasted around four hours. Both French ships managed to escape as HMS *Lion* was badly damaged during the engagement.

145. BUST OF KING GEORGE II

Made by the Richard Chaffers factory, English, 1757–60
White glazed porcelain, 47 cm (height), 32 cm (width)
National Museums Scotland, A.1882.19

George II was the Hanoverian king who faced the final Jacobite challenge of Prince Charles Edward Stuart. In this bust of him he is shown in a cuirass (breast-plate) and the Star of the Order of the Garter. It was made towards the end of his reign in October 1760.

146. LETTER

2 September 1745 (1827 watermark)
Paper and textile, 45 x 38 cm
National Museums Scotland, H.OA 167

Letter signed 'Charles PR' (Prince Regent) to Sir James Kinloch requesting him to join the Standard, 2 September 1745. This was later mounted with a piece of the prince's plaid. This letter, however, has a watermark for 1827 and is possibly a facsimile copy made at a time when there was a growing romantic interest in Jacobite relics.

147. PROCLAMATION

1 August 1745, 40 x 31.3 cm
National Records of Scotland, RH14/653

A proclamation of reward offered for the capture of Charles Edward Stuart, dated 1 Aug 1745. The government knew that the prince was on his way to Scotland. This proclamation was issued not long after his arrival on 23 July 1745.

148. COUNTER PROCLAMATION

22 August 1745, 33.6 x 21 cm
National Museums Scotland, K.2001.332

Prince Charles Edward's supporters persuaded him to issue a counter proclamation against a similar proclamation issued by the Hanoverian government, offering 30,000 pounds sterling for the capture of the prince. The counter proclamation offered a like sum for anyone 'who shall seize or secure_ the Person of the Elector of Hanover', dated at '_ our camp in Kinlockeill, Aug.st 22d 1745', signed 'Charles P.R. by his Highness's Command, Jo, Murray'.

149. CUTLASS

French, 18th century, 82 (length)
Clan Cameron Museum, Achnacarry

This French-style cutlass found in Coire nan Cnamha ('the corrie of the bones'), Moidart, on the coast of the Western Highlands, was presumably lost by a crew member of the French privateer *Du Teillay*.

150. COMMISSION

7 September 1745 (Perth)
Paper, 32 x 21 cm
National Museums Scotland, H.OA 60

A blank commission signed by Prince Charles Edward Stewart in Perth on 7 September 1745, authorising Ewan Macpherson of Cluny to appoint officers in his regiment.

151. BEAKERS

By James Ker, Scottish, 1737–38
Silver, 9.5 x 9 cm (both)
National Museums Scotland, K.2004.207.1 and 2

This pair of silver canteen beakers, one with an everted rim to fit inside the other, is engraved with the coat of arms for John Hay, 4th Marquess of Tweeddale. Hay was Secretary of State for Scotland during the rising of 1745 and a key Hanoverian supporter. He famously reported that he flattered himself that 'they [the Jacobite army] have been able to make no great progress', while Prince Charles Edward was already occupying the Palace of Holyroodhouse.

These beakers may originally have also held travelling cutlery like the prince's canteen. This pair was made by a Hanoverian goldsmith, James Ker.

152. BATTLE MAP OR PLAN

National Museums Scotland, LIB.2016.75

Plan of the Battle at Prestonpans drawn up by an army officer. The battle took place on 21 September and was part of the larger 1745 rising. The government troops were ill-prepared, and with the skilful tactics employed by Lord George Murray and others, a Jacobite victory ensued.

Battle of Prestonpans

153. PISTOLS ASSOCIATED WITH CLAN CAMERON

On loan from Donald Cameron of Lochiel

154. MOVEMENT OF A POCKET WATCH

By 'I.' [John] Moncrief, English
Late 17th or early 18th century, 4 cm (diameter)
National Museums Scotland, H.NL 9

This part of a pocket watch was recovered from a field near the site of the Battle of Prestonpans. Made in London by John Moncrief, it was one of the earliest acquisitions by the Society of Antiquaries.

155. TRANSCRIPT OF A LETTER WRITTEN BY PRINCE CHARLES EDWARD STUART TO HIS FATHER

21 September 1745
On loan from the Drambuie Collection by kind permission of William Grant and Sons, N120822OT.14

A contemporary transcript of a letter written by Prince Charles to his father, with news of his victory at the Battle of Prestonpans on 21 September 1745. The prince was magnanimous in victory declaring there should be no 'public rejoicing'.

156. COMMEMORATIVE SNUFF BOX

c.1745, thorntree wood, 2.5 x 7.2 cm
National Museums Scotland, H.NQ 31

A snuff box made from part of a thorn tree close to the spot where Colonel James Gardiner was killed at the Battle of Prestonpans. Gardiner was a commander of a troop of government dragoons and after his death he became a hero of the Hanoverian side.

157. WOODEN TRUNK ASSOCIATED WITH JOHN COPE

Wood and hide, 61 x 26 x 28 cm
National Museums Scotland, H.NT 199

This trunk is associated with Sir John Cope, the defeated commander of the government army at the Battle of Prestonpans. It is said to have been abandoned as Cope fled the battlefield.

Charles Prince of Wales &c Regent of Scotland England France and Ireland and the Dominions thereunto belonging To our Trusty and Welbeloved

Greeting Wee reposing especial trust and Confidence in your Courage Loyalty and good Conduct Doe hereby Constitute and Appoint you to be a Lieutenant of his Majesties forces in the Regiment commanded by Evan McpherSon of Clunie and to take your Rank in the Army as Such From the date hereof You are therefor carefully and dilligently to discharge the duty and trust of Lieutenant aforesaid by doing and performing every thing which belongs thereto And Wee hereby require all and every the Officers & Soldiers to observe and obey, You as a Lieutenant and yourSelf to observe and follow all Such orders Directions and Commands as you shal from time to time receive from us our Commander in Chieff for the time being or any other your Superior Officer according to the Rule and Discipline of War in pursuance of the trust hereby reposed in you Given at Perth this Seventh September 1745

Charles P R

OA 60

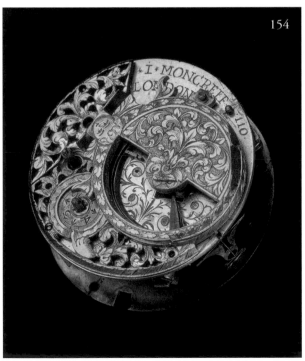

158. SILVER SLEEVE LINKS

1745, agate and silver
On loan from Robert Maitland

These sleeve links were taken from James Sandilands, Master of Torphichen. Sandilands was severely wounded at the Battle of Prestonpans, where he fought on the government side.

159. BIBLE FROM THE KIRK OF PRESTONPANS

Dutch, 1683, leather binding
National Museums Scotland, K.1999.415

This bible contains a 19th-century note with an assertion that Jacobite soldiers tried to burn it. As the bible repeatedly fell from the fire, the soldiers supposedly used their broadswords to return it to the flames. Reputedly rescued by a girl, the bible and this story remained in her family. This is probably a later piece of anti-Jacobite propaganda.

160. PORTRAIT OF PRINCE CHARLES EDWARD STUART PAINTED BY ALLAN RAMSAY

By Allan Ramsay (1713–84), 1745, oil on canvas, 26.8 x 21.8 cm
Scottish National Portrait Gallery, Edinburgh. Accepted in lieu of
 Inheritance Tax by H M Government from the Trustees of the
 Wemyss Heirlooms Trust and allocated to the Scottish National
 Portrait Gallery, 2016, PG 3762

This portrait of the prince was painted at the Palace of Holyroodhouse at the time a Stuart court was re-established there in autumn 1745. The prince is depicted wearing conventional court dress with the Star of the Order of the Garter. This painting was aimed at an English audience at the time Charles was contemplating a march on London.

161. ENGRAVING OF PRINCE CHARLES EDWARD STUART

By Robert Strange (1721–92), 1745, line engraving on paper
Scottish National Portrait Gallery, Edinburgh, SP IV 123.20

The 'Everso Missus' engraving by Robert Strange, based on Allan Ramsay's portrait of Charles Edward [160], was painted while the prince held court at the Palace of Holyroodhouse in 1745.

Power Dressing

162. DICE BOX

c.1745, 6.8 x 2.5 cm
On loan from Inverness Museum & Art Gallery, 1945.009

This dice box is loaded with covert Jacobite symbolism. It has a double lid to conceal a miniature of Prince Charles Edward. Two of the dice depict cockades, a symbol of Jacobitism, while a third has 'JR', standing for *Jacobus Rex,* and the symbol of a crown.

163. SNUFF BOX

Hardwood, pinchbeck and enamel, 3.2 (height), 6.5 cm (diameter)
National Museums Scotland, H.NQ 470

Snuff boxes were useful objects to conceal images of the prince. This example has an inner lid which, when opened, reveals a secret enamelled portrait of Charles Edward. The portrait is based on the work of Allan Ramsay and Robert Strange.

164. MINIATURE PORTRAIT OF PRINCE CHARLES EDWARD STUART

By James Ferguson, Scottish, c.1745, 6 x 4.8 cm
On loan from the Drambuie Collection by kind permission of William
 Grant and Sons, PGL 1601

This is a very rare half-length miniature drawn by a Scottish artist. Unusually the prince is without any of the orders of chivalry normally depicted in such portraits. With his tartan coat, and stripped of any royal symbols, the prince is presented as a Scottish gentleman.

165. SNUFF BOX

Mid- to late 18th century, ormulu
On loan from the Drambuie Collection by kind permission of William
 Grant and Sons, PGL 1782

The miniature portrait on this snuff box would have originally been concealed underneath another lid. Depending with whom the user was sharing a pinch of snuff, double-lidded snuff boxes allowed a Jacobite supporter to conceal or reveal a continuing allegiance to the Stuart cause.

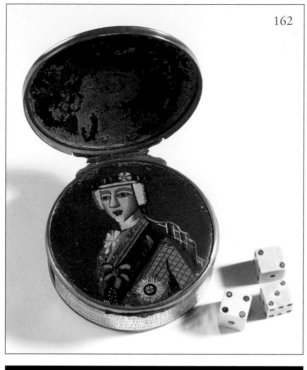

162

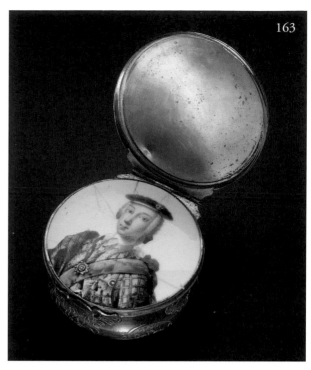

163

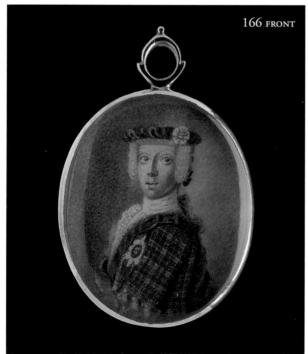

166 FRONT

166 BACK

166. LOCKET

Gold and hair, 4.1 x 2.6 cm
National Museums Scotland, H.NA 631

A locket with a miniature portrait of Prince Charles Edward Stuart. Locks of hair were commonly found on such 'relics' purporting to be from the prince. Four pieces of his hair are attached to the reverse of the locket.

167. PENDANT

Copper, glass, 5.5 x 3.8 cm, National Museums Scotland, H.NF 40

This pendant has a miniature portrait of Prince Charles Edward Stuart in Highland dress. Intended for a Scottish audience, the prince is wearing tartan, while the badge of his Scottish Order of St Andrew, with its green ribbon, is prominently pinned onto the blue sash of his English Order of the Garter.

Court Martial

168. COPY OF A LETTER FROM PRINCE CHARLES EDWARD STUART TO THE INHABITANTS OF EDINBURGH

1745, paper, 37.5 x 29.1 cm
National Records of Scotland, GD 12/6/29

The prince writes of his pleasure at the thought of visiting the capital of his 'ancient and beloved kingdom of Scotland'. He shares his concern that as Edinburgh Castle remains in the hands of the 'usurper', its guns may be fired on the citizens of Edinburgh.

169. PRINTED PROCLAMATION FROM PRINCE CHARLES EDWARD STUART

Signed 'J. Murray', 25 September 1745
National Museums Scotland, M.1938.144

Issued by the prince from his residence at the Palace of Holyroodhouse on 25 September 1745, after his victory at the Battle of Prestonpans, the proclamation forbids public rejoicing of the event out of respect for those subjects who had suffered in the fighting.

170. COMMISSION ISSUED BY PRINCE CHARLES EDWARD STUART

1745, 27.6 x 17.5 cm
National Museums Scotland, M.1961.221

A commission appointing James Colquhoun Grant as an officer in the Jacobite army. This was issued by Prince Charles under his title 'Prince of Wales, Prince Regent of Scotland'. Colquhoun Grant was a 'printer and newswriter' who became involved in the Jacobite cause. He joined a regiment raised in Edinburgh by Colonel John Roy Stewart, a professional soldier who had served in the British and French armies.

171. NOTICE

26 September 1745, 10.2 x 17.4 cm
The Royal Collection / HM Queen Elizabeth II, RCIN 1015897

This notice calling for volunteers to enter Prince Charles Edward's service was issued from the Palace of Holyroodhouse on 26 September 1745. The prince's time in Edinburgh was spent planning and preparing his campaign to depose King George II.

172. BALLGOWN

On loan from the Earl of Airlie

This ballgown is thought to have been worn by Lady Ogilvy when presented at court at the Palace of Holyroodhouse.

173. SILK GOWN WORN AT THE GREAT BALL AT HOLYROOD PALACE

British, c.1745, silk, 207 cm (length)
National Museums Scotland, A.1964.553 and A

This gown was reputedly worn by Margaret Oliphant of Gask when she was presented at court at the Palace of Holyroodhouse in 1745. Oliphant was a leading Jacobite woman of her time. Born into a Jacobite family, she married Lawrence from another key Jacobite family.

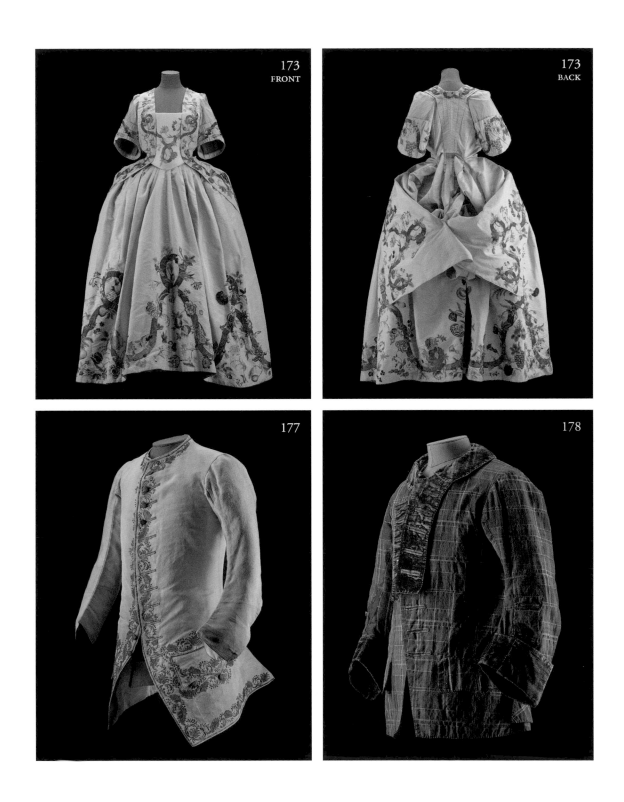

173
FRONT

173
BACK

177

178

174

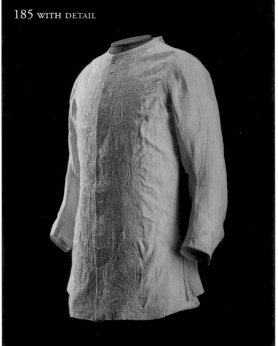

185 WITH DETAIL

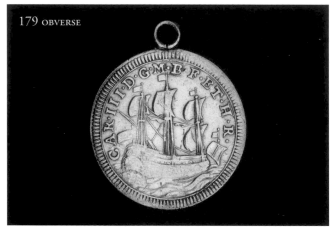

179 OBVERSE

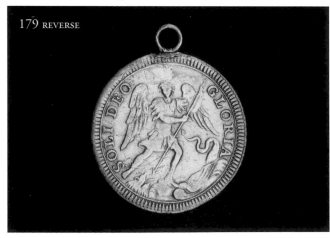

179 REVERSE

174. BUTTONS ENGRAVED WITH A JACOBITE ROSE

c.1746, silver
2 cm (diameter) (5 buttons), 1.3 cm (diameter) (6 buttons)
On loan from the University of Aberdeen Museums, Scotland,
 ABDUA:17618

Personal dress and jewellery were used to convey symbols or messages of support for the Jacobite cause. These buttons have been discreetly engraved with a Jacobite rose; it would require very close examination by an observer to discern the hidden meaning on the buttons.

175. DAMASK NAPKIN FROM A SET OF SIX

Linen
National Museums Scotland, Q.L.1979.18.2 A

This napkin was possibly used by Prince Charles. It is decorated with a crowned thistle in the centre surmounted with the motto of the Order of the Thistle: *'Nemo Me Impune Lacessit'*, 'nobody hurts me with impunity'.

176. ORDER OF THE THISTLE BREAST BADGE

Mid-18th century
Silk, silver thread
On loan from a private Jacobite collection, IL.2016.28.2

Prince Charles Edward Stuart's breast badge or star of the Order of the Thistle is comprised of silk, a silver fringed border and cross, with a central circular badge displaying a thistle and the Order's motto, *'Nemo Me Impune Lacessit'*. This badge is believed to have been bestowed upon the prince by his father. It was later gifted to James Drummond, 3rd Duke of Perth, by Charles after the Battle of Culloden.

177. SLEEVED WAISTCOAT

1727–60, silk, 86.4 cm (length)
National Museums Scotland, A.1906.337

This waistcoat was reputedly worn by the prince during his time in Scotland in 1745–46. The Ramsay portrait shows his dress was not confined to tartan, and he wore conventional European court dress of the quality of this waistcoat.

178. TARTAN FROCK COAT

Mid-18th century, wool, velvet and linen, 67.5 cm (length)
National Museums Scotland, K.2002.1031

This tartan frock coat with velvet collar and cuffs was in the possession of a Jacobite-supporting family for many years. The family had direct links with Prince Charles at the time of the 1745 rising and family provenance says it was understood to have been worn by him during his time in Scotland. Its style is from the period.

179. TOUCHPIECE OF PRINCE CHARLES EDWARD STUART

1765, silver, 2 cm, National Museums Scotland, H.1950.722

There are accounts that Prince Charles Edward touched for the 'king's evil' (to heal scrofula) on his father's behalf during his time at Holyroodhouse. It is unlikely that a touchpiece was used in Edinburgh, as the prince had not expected to take part in such a ceremony. This touchpiece dates from just before James's death, when the prince took on the title Charles III. He is recorded as continuing to touch on several occasions.

180. RIBBON, GARTER AND STAR INSIGNIA OF THE MOST NOBLE ORDER OF THE GARTER

© Ashmolean Museum, University of Oxford, AN1923.8

This is the insignia of the Noblest Order of the Garter. The Order of the Garter, 1348, is the world's oldest, continuous, order of chivalry. The honour of becoming Garter Knights was bestowed on Charles and Henry while in exile, although not officially recognised as such in Britain. As England's premier order, the prince was often depicted wearing a Garter badge.

181. SASH OR RIBBON

Ribbon, 157.8 cm (length), 9.8 cm (width)
National Museums Scotland, H.NC 57

This blue sash is said to have been worn by the prince as part of the insignia of the Order of the Garter. It was donated to the Museum in 1798 with this assertion.

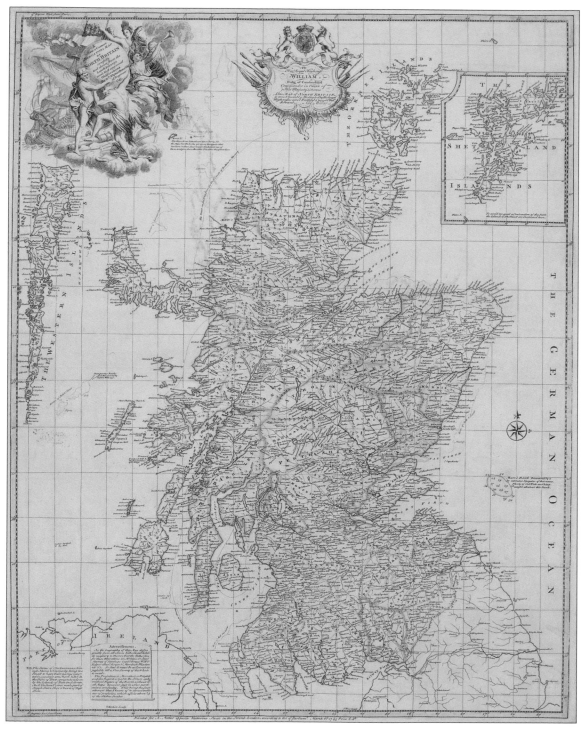

188

182. MINIATURE OF ANDREW LUMISDEN

By James Tassie (1735–99), 1784, paste, 6.7 cm (height)
National Museums Scotland, H.NT 241.13

Andrew Lumisden was Prince Charles's private secretary in Scotland and joined the prince in exile in 1746, although he left to become secretary to James VIII and III. He then rejoined the prince for two years until he left after further quarrels over the prince's drinking.

183. MEDICINE CHEST

Wood and glass, 30 x 60 x 30 cm
The Royal College of Physicians of Edinburgh

This medicine chest was owned by Sir Stuart Threipland. Threipland became a fellow of the Royal College of Physicians in 1744. In 1745 he and his brother joined the Jacobite forces in support of Prince Charles. Threipland was appointed physician-in-chief to the prince, who presented this medicine chest to him. Threipland carried the chest throughout the campaign.

184. FAN

Mid-18th century, 29.5 x 45 cm (open)
National Museums Scotland, H.1994.1052

The medallion in the centre of this fan depicts Prince Charles Edward with three female figures representing the three kingdoms of England, Scotland and Ireland, offering the crown to the prince. Biblical references emphasise the Stuarts' divine right to the throne. Fans allowed women to display their political allegiances within the social confines of the time.

185. WAISTCOAT

c.1740–50, linen, 70 cm (length)
National Museums Scotland, A.1987.242

Robert Strange was an engraver who was based in Edinburgh in 1745 when Prince Charles arrived in Scotland. He married Isabella Lumisden, the sister of the prince's private secretary. Robert Strange engraved several portraits of the prince, including the 'Everso Missus' print which was based on Allan Ramsay's portrait [160 and 161].

186. WHITE COCKADE

1745, cambric, 9.2 cm (diameter)
National Museums Scotland, H.NT 241.21 A to C

The white rose was a symbol of allegiance to the Stuart royal family. The birthday of James VIII and III (10 June), was known as white rose day. White cockades, usually worn on a bonnet, were a symbol of Jacobite support for their cause.

187. PORTRAIT OF GENERAL H.R.H. PRINCE WILLIAM AUGUSTUS, DUKE OF CUMBERLAND

By David Morier (1705–70), 1746–70
Oil on canvas, 144.5 x 120 cm (framed)
National Museums Scotland, M.1990.141

The Duke of Cumberland is depicted as a triumphant leader of the Hanoverian army, with the battlefield of Culloden in the background.

188. MAP OF NORTH BRITAIN DEDICATED TO THE DUKE OF CUMBERLAND

By John Elphinstone (cartographer), Thomas Kitchen (engraver), Andrew Millar (publisher), 1745, engraving, coloured paper
National Museums Scotland, T.2003.309.156

This map, made in colour, was the most current map of Scotland available at the time of the 1745 campaign. It was created by John Elphinstone, a military engineer who served with the Duke of Cumberland's army. Although a great improvement on earlier maps, it attracted criticism for its lack of detail, especially on the mountainous terrain of the Highlands.

March South Retreat North

189. PORCELAIN BUST OF WILLIAM AUGUSTUS, DUKE OF CUMBERLAND

English, c.1750, soft-paste porcelain, 11.8 x 9.2 cm
National Museums Scotland, A.1981.155

The Duke of Cumberland was the second son of George II. Known as the 'Butcher' in the Highlands due to the brutal aftermath of Culloden, he was fêted as hero in Hanoverian Scotland and across most of England.

190. GRENADIER CAP

English, 1745, velvet and embroidery, 33.2 x 25.4 x 13.1 cm
Council of the National Army Museum, London, NAM.1999-07-31-1

The design on this grenadier cap depicts the arms of Sir John Hobart, Earl of Buckinghamshire, Lord Lieutenant of the County of Norfolk. He raised the Norwich Artillery Company in January 1746 for the defence of the city against the threat of a Jacobite incursion during the rising of 1745–46.

191. GRENADIER CAP

Probably French, 1745, velvet and silk, 34.5 x 27 x 12 cm
National Museums Scotland, M.1996.59

A mitre cap belonging to a grenadier officer of the Royal Écossais. This was a regiment of the French army with Scottish associations, which also recruited in the Highlands. They were sent to Scotland in 1745 as part of French support for the campaign. The officer who owned this cap was probably on board the French ship *l'Esperance* when captured by the Royal Navy in November 1745. His regiment had landed safely near Montrose. It displays a mixture of Scottish and French national symbols such as the thistle and *fleur-de-lys*.

192. MEDAL OF THE CUMBERLAND SOCIETY

1746, gold, 5.6 x 3.6 cm
National Museums Scotland, H.1967.435

This society was founded in Inverness on 17 April 1746, the day after the Battle of Culloden. The medal was given to officers who had commanded regiments at the battle. This example was owned by Sir William Middleton of Northumberland, one of the original 24 members of the society.

193. ENGRAVING ENTITLED *A REPRESENTATION OF THE MARCH OF THE GUARDS TOWARDS SCOTLAND IN THE 1745*

From a painting by J. Hogarth, 18th century
Paper, etching, engraving
National Museums Scotland, M.1954.508

An engraving of a Hogarth satirical painting, it depicts soldiers gathering at Tottenham Court Turnpike north of London before encamping at Finchley Common for the defence of the city.

194. LETTER FROM JAMES VIII AND III

1 November 1745, paper, 18.3 x 23 cm
On loan from the Drambuie Collection by kind permission of William Grant and Sons, PGL 1747

Written to the Marquis D'Argenson on 1 November 1745, James urged the marquis to press the French king Louis XV to provide support to Charles in Scotland: 'Continue, I implore you, to press our interests to His Majesty with your most effectual offices, for the least delay could be fatal.'

195. LETTER FROM PRINCE HENRY BENEDICT

1 February 1746, paper, 23 x 18.5 cm
On loan from the Drambuie Collection by kind permission of William Grant and Sons, PGL 1748

Written to Louis XV, king of France, on 1 February 1746, Henry asked the king for assistance for his brother Charles in order to end Hanoverian rule: 'What misfortune if such generous efforts, for lack of being supported by France, were to be after all forced to succumb to the power of a usurper.'

196. PAPER CUT-OUT OF A THISTLE SURMOUNTED BY A CROWN

1743, paper, 32.6 x 20.5 cm
National Records of Scotland, CH12/16/43

Contained in a copy of James VIII and III's declaration in which he expressed his sorrow at the corrupt state of Britain under Hanoverian rule. James also promised to send his son, the Prince of Wales, to lead a campaign.

197. HIGHLAND TARGES

18th century, wood and leather
National Museums Scotland, H.LNA 53 (a), 54 (b) and 56 (c) and A.1905.1036 (d)

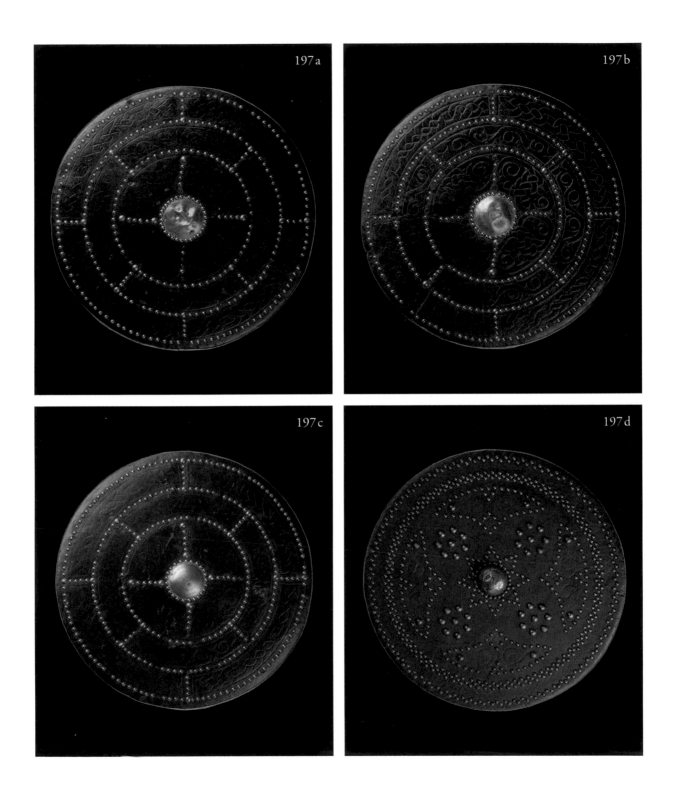

Targes were circular shields carried by Highlanders in battle. Made from wood and covered with leather and studs, targes were used in conjunction with broadswords which were used for slashing. This tactic was known as the Highland charge and Culloden was the last time it was used in a major battle.

198. ENGRAVED MAP SHOWING THE BATTLE OF CULLODEN

Attributed to John Finlayson, 1746
Paper, 50.9 x 68.1 cm (unframed)
National Museums Scotland, T.1983.102

John Finlayson was a mathematical instrument maker who also served in the Jacobite artillery at Culloden. Although the map includes genuine details of the battle, it is also highly partisan. The inset text makes observations on the reasons for the defeat. Highly symbolically, the Unicorn, the mythical national animal, is shown with a broken horn.

199. PAINTING ENTITLED *AN INCIDENT IN THE REBELLION OF 1745*

Attributed to David Morier (*c.*1705–70), mid-18th century
Oil on canvas, 74.6 x 114.6 cm
The Royal Collection / HM Queen Elizabeth II, RCIN 401243

This painting depicts hand-to-hand combat between a party of Highland soldiers and a grenadier company of the 4th King's Own (Barrel's) Regiment.

200. SKETCH OF THE FIELD OF THE BATTLE OF CULLODEN

By Thomas Sandby (1721–98), 1746
Pen, ink and watercolour on paper, 29.2 x 53.1 cm
The Royal Collection / HM Queen Elizabeth II, RCIN 914722

This sketch shows the view from the north between the lines of the troops at the Battle of Culloden, with the charge of the Jacobite forces from the right towards the government army on the left. Though the battle scene is accurate, Sandby has used some artistic licence to reverse the background to show a more dramatic terrain and the presence of the Royal Navy in the Moray Firth.

The Battle of Culloden

201. ENGRAVING

Published 27 October 1746, hand-coloured engraving and etching
National Museums Scotland, M.1953.1008

A coloured engraving showing a view of the Battle of Culloden, first published on 27 October 1746. The Duke of Cumberland is shown in a central position in command of the government army at the front of this engraving.

202. ARMOURER'S TOOLBOX

Scottish, 18th century, wood, 7 x 18.5 x 12 cm
National Museums Scotland, H.1994.1126.1

Cameron of Lochiel presented this toolbox to Edward McNab of Innishoan who led the McNab detachment at Culloden.

203. BRITISH INFANTRY MUSKET

1742–46, steel, wood and leather, 155.5 cm (length)
National Museums Scotland, K.2002.980

Known as a 'Brown Bess', this 1742 Long Land pattern musket is said to have been used by a Hanoverian soldier at Culloden. It is the right date and pattern for the period.

204. OATH OF FEALTY OF KING JAMES VIII

1745, paper, 59.3 x 45.7 cm
National Museums Scotland, M.1996.84

Signed by the members of the Duke of Perth's regiment who served in the Jacobite army in 1745, this document also includes an Abjuration (renunciation) of Allegiance to George, Elector of Hanover. By signing this, the signatories swore their loyalty to James VIII and III, recognising him as the true king.

205. BASKET-HILTED BACKSWORD

Scottish, 18th century
Steel, wood and leather, 95.6 cm (length)
National Museums Scotland, A.1905.727

This backsword is inscribed with *'Jacobus tertius Magnae Brittaniae Rex'*, 'Long live King James III of Great Britain'. Each side has an effigy of James with a crown.

206. HIGHLAND TARGE

Scottish, 18th century, wood, leather and brass, 49.5 cm (diameter)
National Museums Scotland, A.1905.1035

This targe, with the heraldic emblems of a galley, fish and lion, is a more decorative example of the traditional Highland shield. It may have belonged to MacDonald of Keppoch, a clan chief who supported the Jacobite cause and was possibly at Culloden.

207. BASKET-HILTED BACKSWORD

1746, steel, wood, leather, shagreen, 94 cm (length)
National Museums Scotland, H.LA 129

This sword was taken as a trophy of war from a Jacobite soldier after the battle at Culloden in 1746.

208. HIGHLAND DAGGER

Scottish, early 18th century
Steel and wood, 42 cm (length)
National Museums Scotland, H.LC 67

Known as a *sgian achlais* (armpit dagger), this knife was found at Culloden in 1875. The *sgian achlais* was a weapon intended to be concealed on the person of its bearer.

209. FLINTLOCK PISTOL

By Alexander Campbell of Doune, Scottish
18th century, steel, 35 cm (length)
National Museums Scotland, H.LH 248

Made by the noted pistol maker Alexander Campbell of Doune, this pistol was taken from Culloden in 1746. The scroll-shaped butt and button trigger are distinctive features found on Scottish-made examples of this type of pistol.

210. FLINTLOCK MUSKET

Scottish, 1675–1725
Wood, steel and silver, 153 cm (length)
On loan from Museum of the Isles, Armadale Castle, Isle of Skye, OBJ/CD/268

A flintlock musket, known as the *Gunna Breac*. A small silver plaque on the right-hand side of this musket's butt lists every battle, both clan and Jacobite, in which the *Gunna Breac* had served the MacDonalds.

Culloden Faith

211. APPIN CHALICE AND PATEN

By James Tait, Scottish, 1723, silver
On temporary loan from the Warden and Vestry of St John's Episcopal Church, Ballachulish

This chalice and paten were made in Edinburgh in 1723 by the goldsmith James Tait for the Episcopal church in Appin. Rev. John McLauchlan from the parish in Appin joined the Jacobite forces in 1745. He held a commission as chaplain-general in the prince's army throughout the campaign. The chalice and paten are said to have been rescued from the field of Culloden after the Jacobites' defeat.

212. ROMAN CATHOLIC VESTMENTS

c.1730, silk
Roman Catholic Parish of Our Lady of Perpetual Succour and St Cumin, Morar

These vestments are associated with Allan Macdonald who was the Catholic chaplain to Prince Charles Edward during the 1745 campaign. This chasuble and stole would have been worn by the priest during Communion and are probably made from the silk of a lady's dress donated to the church.

213. GAELIC BIBLE

18th century, paper, card and leather, 16 x 7.6 x 6 cm
National Museums Scotland, M.L1930.173

The government soldier Alexander Anderson, who carried this Gaelic bible at Culloden, served with the Argyll Militia, a regiment raised by Clan Campbell. This version of scripture is known as 'Kirk's' bible after the Episcopal clergyman Robert Kirk who adapted an Irish Gaelic bible for use in Scotland and distributed it throughout the Highlands.

Culloden Stories

214. BLUE BONNET

1746, wool, 28 x 22.9 cm
On loan from a private collection

This traditional blue bonnet was worn by many in the Jacobite army. This bonnet has become associated with the visit of Prince Charles Edward to Moy Hall, seat of Clan Mackintosh, in February 1746. At this time Lady Anne Mackintosh tricked a unit of the government army into thinking that a mere handful of her servants constituted a large force of Jacobites.

215. BUCKLE

Silver, Continental, 13.1 x 10.4 cm
On loan from Inverness Museum & Art Gallery, 0.136

Inscribed *'Tearlach Stuart, Righ n'an Gael'*, which translates as 'Charles Stuart, King of the Gaels'.

216. *THE LYON IN MOURNING*

Compiled by Robert Forbes, 1746–75
The National Library of Scotland, Adv.32.6.19 vol 4

Compiled by Robert Forbes, a bishop in the Scottish Episcopal Church and staunch Jacobite, *The Lyon in Mourning* is an extensive collection of letters, accounts and relics relating to Prince Charles's time in Scotland and the aftermath of Culloden.

217. CAPTAIN O'NEIL'S JOURNAL

The National Library of Scotland

An account written on playing cards by Captain O'Neil, an officer who accompanied Charles in his escape after Culloden.

218. FRENCH WRITING SET

National Trust for Scotland, IL.2016.46.1

219. CAMERON OF LOCHIEL'S SWORD

On loan from Donald Cameron of Lochiel

Known as 'Lochiel's sword', this traditional backsword is associated with Donald Cameron of Lochiel, 'Gentle Lochiel', 19th chief of his clan, who led his clan 'out' in the 1745 rising. He was key ally of the prince and fought at Culloden where he was injured. The defeat of the Jacobites forced him into exile in France where he died in 1748.

To the Victor the Spoils

220. FAN CELEBRATING THE VICTORY AT CULLODEN

*c.*1746, paper and wood, 28.5 cm (length)
Victoria and Albert Museum. Given by HM Queen Mary, T.205-1959

A fan celebrating the victory at Culloden. The hand-coloured scene depicts the surrender of the Jacobite leaders to the Duke of Cumberland after the Battle of Culloden.

221. PUNCH BOWL WITH ANTI-JACOBITE IMAGE

Chinese, *c.*1785, porcelain, 12 cm (height), 28.5 cm (max. diameter)
National Museums Scotland, A.1992.166

A porcelain punch bowl painted with a copy of the anti-Jacobite engraving 'Sauney's Mistake' showing a Highlander in an unfortunate predicament when faced with a latrine. This punch bowl was exported from China.

222. PUNCH BOWL DEPICTING THE DUKE OF CUMBERLAND

Chinese, *c.*1747, porcelain, 11 cm (height), 26.3 (diameter)
National Museums Scotland, A.1983.1069

This punch bowl is painted with a portrait of the Duke of Cumberland and depicts the Battle of Culloden.

223. BASKET-HILTED BACKSWORD

Scottish, 1738/39, steel
The Royal Collection / HM Queen Elizabeth II, RCIN 61385

Made in Edinburgh in 1738/39, the blade of this sword is marked 'Andrea Ferrara', a maker associated with Scottish backswords. It is also engraved with a thistle and a 'JR' standing for *Jacobus Rex*. It possibly came from the Duke of Cumberland's collection.

224. TODDY LADLE

Scottish, 1740–50
Wood and silver, 34.9 cm (length)
On loan from the University of Aberdeen Museums, Scotland, ABDUA:19291

The base of this toddy ladle is formed by a George II three-penny piece. It would have belonged to a Hanoverian supporter, to be used when drinking with like-minded friends who shared the owner's political views.

225. PASS ISSUED BY THE DUKE OF CUMBERLAND

21 June 1746, paper
National Museums Scotland, H.OA 62

Issued from Fort Augustus and dated 21 June 1746, this pass permitted the lady-in-waiting to Lady Houston to pass, with some baggage, from Greenock to Bordeaux.

226. DUKE OF CUMBERLAND MEDAL

1746, silver, 4.3 cm (diameter)
National Museums Scotland, H.R 184

This Duke of Cumberland medal was made to celebrate the defeat of the Jacobite rising.

227. BURGESS TICKET

January 1747, paper, 34.2 x 31.7 cm
National Museums Scotland, M.1931.613

This burgess ticket conveys the Freedom of the City of Edinburgh to the Duke of Cumberland. Despite the actions of the duke and the government army in the aftermath of the Battle of Culloden, many Scots continued to support the House of Hanover. For these Hanoverian Scots, the duke was fêted as a hero.

Trials, Pardons and Retributions

228. MOURNING RING FOR LORD LOVAT

*c.*1747, gold, 2.4 cm (diameter)
National Museums Scotland, H.NJ 88

Lord Lovat was executed for his part in the Jacobite campaign in 1747. This ring commemorates his death and bears the Latin inscription, *'Dulce et Decorum est Pro Patria Mori'*, which translates as, 'It is a sweet and fitting thing to die for one's country'.

229. PIN CUSHION

1746, satin, 7.5 x 5.7 cm
National Museums Scotland, A.1987.258

There are 67 names of Jacobites printed on this pin cushion, along with the words 'MART: FOR:K:&COU:1746', meaning 'Martyred for King and Country 1746'.

230. 'FOUR PEERS' RING

Possibly Ebenezer Oliphant, 1747, gold and enamel
National Museums Scotland, H.NJ 154

This ring commemorates the execution of the four Jacobite lords, Kilmarnock, Derwentwater, Balerino and Lovat. The shoulders of the ring are in the shape of a thistle and a rose. Family tradition says that this ring was made by Ebenezer Oliphant, the Jacobite-supporting goldsmith who made the prince's travelling canteen. A Hanoverian supporter would never have accepted such a commission.

231. PARDON

3 September 1731, parchment, ink and cord
National Museums Scotland, H.OA 68

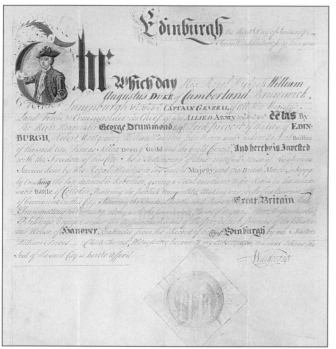

227

FRONT AND BACK

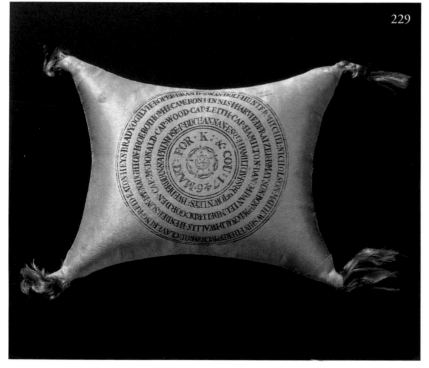

229

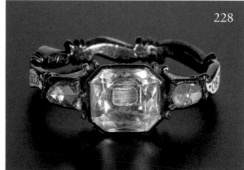

228

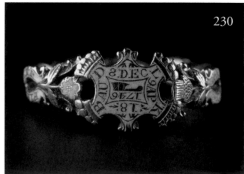

230

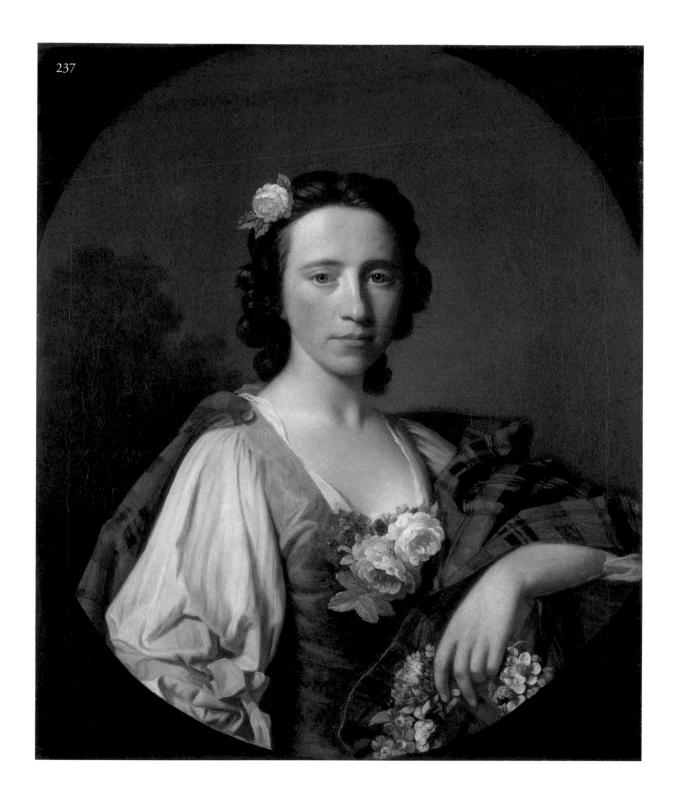

Alexander Robertson of Strowan (or Struan) in Perthshire was a leading Jacobite, who participated in the Jacobite challenges of 1689, 1715 and 1745. Though his whole clan did not 'come out' in the 'Forty-Five', the government considered him to have rebelled as a body of his men joined the Jacobite army.

232. EXECUTION BLOCK

English, 1746, oak, 63 x 55.4 x 32.8 cm
On loan from the Royal Armouries, XV.3

Used in the execution of Simon Fraser, Lord Lovat, in 1747 at the Tower of London.

233. AN ACT FOR THE RESTRAINING OF THE USE OF HIGHLAND DRESS IN SCOTLAND

English (London), 1747, paper
On loan from the Drambuie Collection by kind permission of William Grant and Sons, PGL 1692

A seven-page pamphlet in the name of King George II printed in London in 1747. The Act forbade the wearing of tartan, plaid, philabeg or anything else associated with Highland dress.

234. MEDICINE CHEST

Early to mid-18th century, mahogany, brass and glass, 25 x 25.2 x 25.5 cm
National Museums Scotland, X.2015.105.9

A chest that contains medicine, with drawers labelled, for example, 'Roman Vitriol', 'Flower of Brimstone', 'Sal Prunel', 'Bol Armenia', 'Senna Leaves' and 'Tully Prepared'.

235. PORTRAIT OF LADY ANNE MACKINTOSH

Attributed to Allan Ramsay (1713–84), c.1745
Oil on canvas, 147.3 x 121.9 cm (framed)
On loan from a private collection

Lady Anne and her husband, a government officer, were on the opposing sides of the Jacobite/Hanoverian split. On two separate occasions, each was given over to the other's custody after their arrest by each other's 'enemy'.

236. GLASS BOTTLE

1746, glass and silver, 26.8 x 10.5 x 10 cm
National Museums Scotland, M.1934.536.2

The silver label on the bottle claims that Prince Charles used it at Kingsburgh on 2 June 1746. Kingsburgh was the house where Charles was taken when he arrived in Skye with Flora MacDonald.

237. PORTRAIT OF FLORA MACDONALD

By Allan Ramsay (1713–84), 1749
Oil on canvas, 95 x 82.5 cm (framed)
The Ashmolean Museum, Oxford. Bequeathed by the Revd Dr Richard Rawlinson, 1755, WA1960.76

Flora was not a willing Jacobite supporter. She initially refused to help in fear that the clan chief would be punished if her attempts to help the prince were discovered. It was Flora who insisted that the prince disguise himself as a woman.

238. SNUFF BOX

Scottish, later than mid-18th century, silver, 6.9 x 7.4 x 2.8 cm
Blairs Museum, Aberdeen, T 0081 BLRBM

The inscription on the box was supposedly composed by Sir Walter Scott and reads, 'Presented by Prince Charles Edward Stewart to Angus Macdonald of Borrodale, whose roof afforded him shelter on two memorable occasions the first and the last nights which he spent in Scotland in 1746'. This is a prime example of an object with an imputed personal association with the prince which cannot be true. It is of a style much later than the mid-18th century.

239. BASKET-HILTED BROADSWORD

By John Allan Snr, Scottish, 1716
Steel and velvet, 94.3 cm (length)
National Museums Scotland, H.MCR 1

Made by John Allan of Stirling in 1716, this sword was part of the large Clanranald collection of Jacobite relics. This collection included the backsword given to the prince as part of a set of Highland dress by the Duke of Perth.

240. SNUFF BOX

18th century, silver, tortoiseshell, 1.5 x 8 x 6.5 cm
National Museums Scotland, H.MCR 5

This snuffbox, with a portrait of James VIII and III, bears the inscription, 'A gift from Prince Charles Stewart to Miss Flora Macdonald 1746'. Mementoes or relics which linked the prince to Flora MacDonald were highly sought after. As the bitterness around the 1745 rising subsided, there was a rise in the romantic interest in the Jacobites and the prince, especially his short time with Flora MacDonald.

241. SNUFF BOX

Scottish, 18th century, silver and tortoiseshell, 6.2 x 3.5 x 1.6 cm
National Museums Scotland, H.MCR 8

This tortoiseshell snuffbox was bequeathed to the Museum by the chief and captain of Clanranald. It was a treasured clan heirloom and is engraved with Flora MacDonald's initials 'FMD' on its lid.

242. TEA CADDY

18th century, pewter, 9.5 x 10.7 x 7.8 cm
National Museums Scotland, H.MCR 9

A tea caddy said to have been at Kingsburgh House during the time that Prince Charles Edward stayed there. Kingsburgh House was the family home of Flora MacDonald's husband, Allan MacDonald.

243. CUTLERY SET

French, 1730s, silver
Lengths, 22.3 cm (knife), 19.5 cm (fork), 19.8 cm (spoon)
National Museums Scotland, H.MEQ 1596 A to D

Initially gifted to the prince by Clanranald during his flight from Culloden, Prince Charles Edward gave this cutlery set to Dr Murdoch McLeod of Raasay as a token for aiding the his escape from Raasay back over to Skye as he attempted to elude government forces. Each piece is engraved with *'Ex Dono / C.P.R. / July 3d. / 1746'*.

244. RING

18th century, gold and precious stones, 2.2 cm (diameter)
National Museums Scotland, H.NJ 50

A gift said to have been presented to Francis Buchanan of Arnprior by Prince Charles Edward Stuart for his assistance in the prince's escape. Buchanan was executed for his involvement in the Jacobite campaign in 1746.

245. RING

Gold, hair and pearls, 1770–90s, 2.4 cm (diameter)
National Museums Scotland, H.NJ 84

Containing a lock of Prince Charles's hair, this ring was thought to have been gifted by the prince to Alexander Stuart of Invernayle. The ring also once also contained seed pearls forming the initials 'C.R'.

King, Claimant, Cardinal

246. BUST OF PRINCE CHARLES EDWARD STUART

Modelled by Jean Baptiste Lemoyne (1704–78), Rome, *c.*1747
Bronze, 48.3 cm (height)
Scottish National Portrait Gallery, Edinburgh, PG 1024

After a plaster original, modelled by Jean Baptiste Lemoyne in Rome.

247. SPOTTISWOODE 'AMEN' GLASS

1775, glass
On loan from the Drambuie Collection by kind permission of William Grant and Sons, PGL 1501

A rare example of a drinking glass engraved with the cipher of James VIII and III, with verses from a Jacobite hymn.

248. RING WITH A MEDALLION OF PRINCE CHARLES EDWARD STUART

Probably by Adam Tait, French, *c.*1750, gold and enamel, 2 cm (diameter), National Museums Scotland, H.NJ 91

244

245

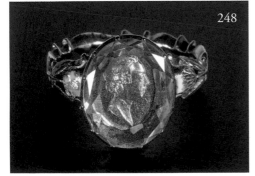

248

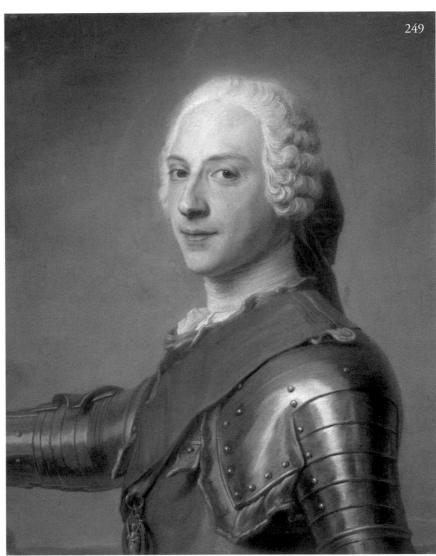

249

Inscribed 'DUM SPIRAT SPERO', which translates as 'While he lives, I hope', this ring was probably made by exiled Edinburgh goldsmith Adam Tait in Paris, *c.*1750.

249. PORTRAIT OF PRINCE HENRY BENEDICT CLEMENT STUART

By Maurice-Quentin de la Tour (1704–88), 1746–47
Oil on canvas, 82.55 x 71.12 cm (framed)
Scottish National Portrait Gallery, Edinburgh. Purchased with aid of the Art Fund 1994, PG 2954

Painted by the artist Maurice-Quentin de la Tour, this portrait depicts Prince Henry in armour and wearing the Order of the Garter. Henry and Charles both sat for la Tour between 1746–47 just before Henry was made a cardinal in the Catholic Church.

Claimant

250. MINIATURE PASTEL OF PRINCE CHARLES EDWARD STUART

From original portrait by Maurice-Quentin de la Tour (1704–88), 1739, pastel, 7.5 x 5.7 cm (framed)
Scottish National Portrait Gallery, MOS.SNPG.L.191

The original portrait which inspired this miniature was painted by Maurice-Quentin de la Tour. La Tour was commissioned to complete the portrait for the cost of 1200 French *livres*.

251. OVAL SNUFF BOX

Mid-18th century, French, silver gilt
On loan from The Executors of the Estate of the late A. Grahame B. Young

252. WATCH WITH PORTRAIT OF CHARLOTTE, DUCHESS OF ALBANY

By Jean Antoine L'Pine (1720–1814), French, *c.*1740
Gold, enamel and glass, 3.5 cm (diameter)
Blairs Museum, Aberdeen, T 0082 BLRBM

This watch was made for Prince Charles Edward Stuart with a portrait of his only child, Charlotte.

253. TOBACCO PIPE AND PRICKER

Ivory or bone (pipe), silver (pricker), 8.2 cm (length)
National Museums Scotland, H.NQ 416

Silver mounted meerschaum pipe decorated with rings of ivory or bone. This pipe is said to have belonged to Prince Charles Edward Stuart.

254. WATCH CHAIN

*c.*1747, gold
The Royal Collection / HM Queen Elizabeth II, RCIN 29020

Prince Charles Edward Stuart gifted this watch chain to James Gordon of Cobairdie in Paris, 1747. It was acquired by Queen Mary for the Stuart Collection in 1923.

King and Cardinal

255. PORTRAIT OF HENRY BENEDICT STUART AS CARDINAL OF YORK

Artist unknown, 18th century, oil on canvas, 97 x 84 cm
Blairs Museum, Aberdeen, T 9110 BLRBM

256. ENGRAVING OF ST PETER'S BASILICA IN ROME

1774, paper, 115 x 88 cm
Blairs Museum, Aberdeen, T 2091 BLRBM

An engraving dedicated to Prince Henry Benedict, Cardinal York, in 1774. As Arch-Priest of the Vatican Basilica, the cardinal was responsible for the fabric of the Basilica and he initiated a series of improvements to the buildings.

257. MINIATURE PORTRAIT OF JAMES VIII AND III

18th century, watercolour on ivory, 15.3 x 8.2 cm
National Museums Scotland, X.2015.105.6

258. SNUFF BOX

18th century, tortoiseshell and gold
National Museums Scotland, X.2015.105.2

A note inside this snuff box states that the box was owned by James VIII and III and was given to Andrew Lumisden by Cardinal York in 1769 as a token of gratitude for Lumisden's services to the royal family.

259. BOOK-BINDING EMBOSSED WITH THE ARMS OF CARDINAL YORK

18th century, leather, 25 x 18.3 cm
National Museums Scotland, H.NT 263

Henry Benedict's arms are surmounted by a Cardinal's hat representing his position in the Church. In the centre is a crescent shape showing his place as the second son.

260. BASIN AND EWER OWNED BY CARDINAL YORK

Silver gilt, 52 x 42 cm (basin), 31 cm (height)
On loan from a private collection

261. ENGRAVING OF THE FUNERAL PROCESSION OF JAMES VIII AND III, 1766

Engraving, 81.3 x 55.9 cm
Scottish National Portrait Gallery, Edinburgh, SP EXL 59.1

262. PORTRAIT OF PRINCE CHARLES EDWARD STUART

By Ozias Humphry (1742–1810)
Black chalk on paper, 34.2 x 23.5 cm
Scottish National Portrait Gallery, Edinburgh, PG 2991

Painted by Ozias Humphry, this portrait depicts Prince Charles as an older man.

Kings over the Water

263. LETTER FROM ROBERT BURNS

1787, paper, 30 x 38.3 cm
National Museums Scotland, H.OP 7

This letter was written by the poet Robert Burns in 1787, accepting an invitation to dine with the Steuart Club on the anniversary of Prince Charles Edward Stuart's birthday.

264. WINE GLASS WITH A PORTRAIT OF PRINCE CHARLES EDWARD STUART

c.1775, glass and enamel, 14.8 cm (height)
National Museums Scotland, H.MEN 94

One of a set of six glasses commissioned in 1775 by Thomas Erskine, who would later become the 9th Earl of Kellie. Erskine was one of a group of aristocratic Jacobites who continued to celebrate Prince Charles's birthday until his death in 1788.

265. PORCELAIN SCENT BOTTLE

Italian, c.1752–60, porcelain, 10.6 x 4.7 x 2.5 cm
The Syndics of the Fitzwilliam Museum, University of Cambridge. Purchased with the Seamus V. Finn Fund, and grants from The Art Fund, and the MLA/V&A Purchase Grant Fund, C.28 & A-2007

Made from Italian porcelain, this scent bottle was owned by Lady Mary Hervey, whose personal arms appear on one side. The scent bottle is also decorated with a portrait of Prince Charles Edward Stuart.

Prince of the Church

266. PORTRAIT OF PRINCE CHARLES EDWARD STUART IN OLDER AGE

Artist unknown, 30 x 33.8 cm
On loan by kind permission of His Grace, The Duke of Hamilton and Brandon, 0277/748

267. PORTRAIT OF PRINCE HENRY BENEDICT STUART IN OLDER AGE

Artist unknown, 30.5 x 34 cm
On loan by kind permission of His Grace, The Duke of Hamilton and
 Brandon, 0277/747

Rehabilitation

268. RING WITH MINIATURE OF PRINCE CHARLES EDWARD STUART

c.1745, watercolour on ivory, gold
The Royal Collection / HM Queen Elizabeth II, RCIN 422281

269. CADDINET WITH ARMS OF CARDINAL YORK

By Luigi Baladier, Italian, late 18th century, silver gilt
The Royal Collection / HM Queen Elizabeth II, RCIN 45182

A caddinet was traditionally and exclusively used for dining by
royalty in Britain. In commissioning such a piece depicting his
own coat of arms, Cardinal York was making a political state-
ment.

270. CARDINAL YORK'S BOOK OF HOURS

By Jean Pichore, French, c.1500, vellum, 28.5 x 6.5 cm
The Royal Collection / HM Queen Elizabeth II, RCIN 1005087

This Book of Hours was produced in the 16th century and was
passed down to Prince Henry Benedict through his mother's
family, the Sobieskis. The arms of Cardinal York have been
embroidered onto the cover of the Book of Hours.

271. BROTH BOWL AND STAND

Vincennes Porcelain Factory, French, c.1750, porcelain
The Royal Collection / HM Queen Elizabeth II, RCIN 19605

Probably owned by Prince Charles Edward, this broth
bowl and stand depict the Stuart coat of arms. Made from
Vincennes porcelain, it is thought that the set may have been
commissioned by the prince when he lodged briefly in the
château de Vincennes in the winter of 1748.

272. PAINTED DISH WITH ARMS OF CARDINAL YORK

Italian, c.1750–75, maiolica
The Royal Collection / HM Queen Elizabeth II, RCIN 43815

Cardinal York bequeathed this dish to King George III on the
former's death in 1807.

273. KNIFE AND FORK BELONGING TO PRINCE CHARLES EDWARD STUART

18th century, steel and agate
The Royal Collection / HM Queen Elizabeth II, RCIN 37009

This knife and fork set was given to George IV by Colonel
Belford on 24 June 1820. They had been taken by the Colonel's
father General Belford's Royal Horse Artillery at the Battle of
Culloden in 1746.

274. YORK (OR STUART) CHALICE AND PATEN

Valadier goldsmiths workshop, Italian, 1800
Gold and diamonds, 32 x 16 cm (chalice), 15 cm (diameter of cup)
Per gentile concessione del Capitolo di San Pietro in Vaticano,
 CSPV 0053

A commission by Cardinal York from the Valadier goldsmiths
workshop in Rome, this elaborately decorated communion
chalice is inset with jewels said to be Sobieski diamonds
inherited by Henry through his mother, Maria Clementina.

275. GRAVE MARKER FOR JAMES VIII AND III, c.1766

The Pontifical Scots College, Rome

276. GRAVE MARKER FOR PRINCE CHARLES EDWARD STUART, c.1788

The Pontifical Scots College, Rome

277. GRAVE MARKER FOR PRINCE HENRY BENEDICT STUART, c.1807

The Pontifical Scots College, Rome

278. HEART-SHAPED BROOCH

18th century, gold, silver, diamond, glass and hair, 3.5 x 2.3 x 1 cm
National Museums Scotland, H.NGB 65

This brooch is said to contain the hair of Prince Charles Edward Stuart and was given to him by Lady Mary Clark. The hair forms the shape of a saltire, with wire lettering 'C.E.P.R'.

279. GOLD PIN

c.1746, gold (pin), wool (piece of tartan)
On loan from the University of Aberdeen Museums, Scotland,
 ABDUA:63392 and 63394

The pin was used by Prince Charles Edward Stuart to fasten his philabeg, a type of plaid and kilt. It was presented by the prince to Lady Mackintosh who hosted him at her home in Moy Hall in 1746.

280. ROSETTE OF CORDED RIBBON

18th century, silk, 14.5 cm (diameter)
National Museums Scotland, A.1987.184 D

Woven with a crown motif, this rosette was probably a wedding favour for King George III and Queen Charlotte, modified to read 'CPR'.

281. GOBLET ENGRAVED WITH PORTRAIT OF PRINCE CHARLES EDWARD STUART

18th century, glass
On loan from the Drambuie Collection by kind permission of William
 Grant and Sons, PGL 1503

On this large glass Prince Charles is depicted wearing a tartan jacket. The glass is also engraved with the phrase 'Fiat' meaning 'Let it come to pass'.

282. CHASTLETON HOUSE DECANTER

18th century, glass
On loan from the Drambuie Collection by kind permission of William
 Grant and Sons, PGL 1555

This decanter is associated with an English Jacobite club known as the Cavalier Club. It is engraved with Jacobite symbols of the rose bud and oak leaves. Founded in 1657, the Cavalier Club continued well into the 19th century and was based at Chastleton House where the decanter was discovered.

283. WINE GLASS WITH PORTRAIT OF PRINCE CHARLES EDWARD STUART

English, 18th century, glass, 14.8 cm
National Museums Scotland, A.1966.227

This engraving depicts Prince Charles in a tartan jacket and wearing a bonnet and cockade. The phrase *'Audentior Ibo'* translates as 'I shall go more boldly' and is probably taken from a verse in Virgil's epic poem, *The Aeneid*.

284. 'SIR WATKIN WILLIAMS WYNNE' WINE GLASS

c.1750, glass, 16 cm (height)
On loan from the Drambuie Collection by kind permission of William
 Grant and Sons, PGL 1593

This glass is engraved around the rim with 'SUCCESS TO THE FRIENDS OF SR. WATKINS WILLIAMS WYNNE'. Sir Watkins William Wynne, a Welsh member of parliament, established the Cycle Club, one of the most well-known Jacobite societies.

285. FIRING GLASS

c.1750, glass, 8.8 cm (height)
On loan from the Drambuie Collection by kind permission of William
 Grant and Sons, PGL 1594

Firing glasses were used for toasting. This example is engraved with a tribute to the Friendly Hunt, a Jacobite society.

286. SPIRIT TUMBLER

c.1750, glass
On loan from the Drambuie Collection by kind permission of William
 Grant and Sons, PGL 1559

This rare example of a Jacobite spirit tumbler is engraved with a portrait of Prince Charles Edward Stuart. The reverse is engraved with a crown which rests on Prince Charles's head when viewed from a certain angle.

287. WINE GLASS WITH INSCRIPTION 'TREW BLUE'

On loan from the Drambuie Collection by kind permission of William Grant and Sons, PGL 1586

This wine glass has an ogee bowl and a blue twisted stem.

288. RING

18th century, gold and enamel
National Museums Scotland, H.NT 253

This ring is associated with the Order del Toboso, an exclusively Jacobite fraternal association, the membership of which numbered some of the leading lights of the Jacobite movement both at home and abroad, including the two Stuart princes. The inscription on the ring, 'A FAIR MEETING ON THE GREEN', is the motto of the Order, based on a passage in Miguel de Cervantes' novel *Don Quixote*.

289. MINIATURE PORTRAIT OF PRINCE CHARLES EDWARD STUART

By Jean Daniel Kamm (1722–c.90), 1748, on vellum, after a lost oil painting by Louis Tocqué, engraved by Johann Georg Wille (1704–88), 1748
From the collection of John Nicholls MBE
Image © John Nicholls MBE

Kamm's miniature (the only known painted copy) uniquely shows the colours of the original painting. It is only one item in a case of several Jacobite and Stuart relics given to Ralph Standish of Standish, Lancashire, by Prince Charles when he visited Standish Hall in the 1740s.

290. MINIATURE PORTRAIT OF PRINCE CHARLES EDWARD STUART

By Jean Daniel Kamm (1722–c.90), 1748–50, on vellum, after original pastel by Maurice-Quentin de La Tour (1704–88)
From the collection of John Nicholls MBE
Image © 2017 Christies Images Limited

The original pastel by Maurice-Quentin de la Tour was Prince Charles's favourite painting of himself. It was made and exhibited in Paris in 1748, but last heard of in Florence in 1785 (now lost). Kamm painted his original miniature some time between summer 1748 and autumn 1750. Only three other versions of the present miniature are known. The prince wears the blue sash of the Order of the Garter and the green sash of the Order of the Thistle; his red cloak is embroidered with the Garter star.

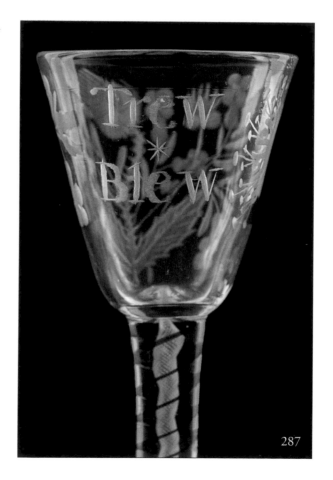

287

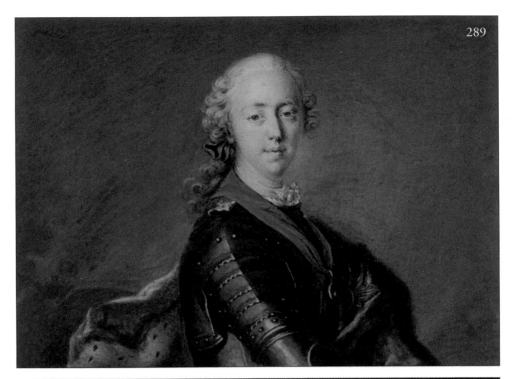

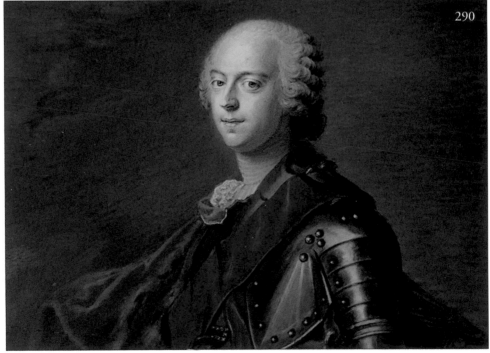

Bibliography

NOTE: All listings below are associated with the chapter texts only. Collection and accession details for objects in the exhibition are listed in the Exhibition Catalogue section.

Collections

Arundel Castle, England: Collection of the Duke of Norfolk
Biblioteca Apostolica Vaticana, Rome, Italy
British Library (BL), London, England
British Museum, London, England
Brodie Castle, nr Forres, Scotland
Castel Sant'Angelo, Rome, Italy
Château de Breteuil, Yvelines, France
Chiddingstone Castle, Chiddingstone, England
Collège des Ecossais, Paris, France
Diocese di Frascati, Italy
Downside Abbey, Stratton-on-the-Fosse, England
Drambuie Collection, William Grant and Sons, Scotland
Drummond Castle, nr Crieff, Scotland
Galleria Sabauda, Turin, Italy
Gosford House, nr Longniddry, Scotland
Harrow School, London, England
Huntington Library, San Marino, CA, USA
Montefiascone Cathedral, Viterbo, Italy
Musée Municipal de Saint-Germain-en-Laye, Paris, France
National Archives (NA), London, England
National Galleries Scotland, Edinburgh, Scotland
National Gallery, Prague, Czech Republic
National Library of Scotland, Edinburgh, Scotland
National Museums Scotland, Edinburgh, Scotland
National Portrait Gallery, London, England
National Register of Archives for Scotland (NRAS), Edinburgh, Scotland
Neues Palais, Potsdam, Germany
Palacio de Liria, Madrid, Spain
Pinacoteca Nazionale, Bologna, Italy
Private collections
Records of the Parliament of Scotland [www.rps.ac.uk]
Royal Archives (RA), Windsor Castle: Cumberland Papers (CP); Stuart Papers (SP)
Royal Collection Trust (RCIN), London, England
Royal Library, London, England

Royal Museums Greenwich, London, England
Sizergh Castle, Cumbria, England: Strickland Collection
Stonyhurst College, Lancashire, England
Trinity College, Dublin, Ireland
Ushaw College, Durham, England
Vatican, Rome, Italy
Victoria and Albert Museum, London
Walker Art Gallery, Liverpool, England
Warwick Castle, England
Weiss Gallery, London, England
Windsor Castle, Berkshire, England

Periodicals, Magazines, Papers

Archivio Storico Vicariato di Roma, Santi Apostoli, vol. 12 (Battesimi).
Art Journal: New Series, The 1892. p. 220.
Bergeron, David M. 1992. 'Charles I's Edinburgh pageant (1633)', *Renaissance Studies* 6: 2 (June), pp. 173–84.
Breingan, Adrienne 2015.'"Keep your powder dry": Mementoes of 1715', *Review of Scottish Culture* 27, pp. 1–8.
Burnett, Charles J. 1987. 'The Collar of the Most Ancient and Most Noble order of the Thistle', *The Journal of the Orders and Medals Research Society* 26, pp. 150, 154.
Caledonian Mercury, 20 August 1745, p. 2.
Cameron, Peter 1996. 'Henry Jernegan, the Kandlers and the client who changed his mind', *The Silver Society Journal* (Autumn 1996), pp. 487–501.
Corp, Edward 1995. 'James FitzJames, 1st Duke of Berwick: A New Identification for a Portrait by Hyacinthe Rigaud', *Apollo* CXLI: 400 (June), pp. 53–60.
Corp, Edward 1998. 'An Inventory of the Archives of the Stuart Court at Saint-Germain-en-Laye, 1689–1718', *Archives* XXIII: 99 (October), pp. 118–46.
Corp, Edward 2001. 'The Remains of James II', *History Today* 51 (September), p. 25.

Corp, Edward 2004. 'Scottish People at the Exiled Jacobite Courts', *The Stewarts* 22: 1, pp. 40–46.

Corp, Edward 2008: 'Scottish People at the Exiled Stuart Court: Part II', *The Stewarts* 23: 1, pp. 12–21.

Corp, Edward 2010–11. 'The Facciata of Cardinal York: An Unattributed Picture in the Scottish National Portrait Gallery', in the *Journal of the Scottish Society for Art History* 15, pp. 33–38.

Corp, Edward 2014. 'James II and David Nairne: The Exiled King and his First Biographer', *English Historical Review* 129: 541, pp. 1403–4.

Farquhar, Helen B. 1919–20. 'Royal Charities Part IV – Conclusion of Touchpieces for the Kings Evil … Anne and the Stuart Princes', *British Numismatic Journal* 15, p. 170.

Fleming, E. McClung 1974. 'Artifact Study: A Proposed Model', *Winterthur Portfolio* 9, pp. 153–73.

Graffius, Jan 2012. 'The Stuart Relics in the Stonyhurst Collections', *British Catholic History (Recusant History)* 31: 2 (October), pp. 147–69.

Grosvenor, Bendor 2008. 'The restoration of King Henry IX: Identifying Henry Stuart, Cardinal York', *The British Art Journal* 9: 1, pp. 28–32.

Grosvenor, Bendor 2016. 'Bonnie Prince Charlie Returns to Edinburgh', *Country Life* CCX: 19 (11 May), pp. 122–25.

Guilday, Peter 1921. 'The Sacred Congregation De Propaganda Fide (1622–1922)', *The Catholic Historical Review* 6: 4 [www.jstor.org/stable/25011717], pp. 478–94.

Hamilton, Marion F. (ed.) 1941. 'The Locharkaig Treasure', *Miscellany of the Scottish History Society* 35, pp. 158–59.

Historical Manuscripts Commission 1902, *Calendar of the Stuart Papers belonging to His Majesty the King preserved at Windsor Castle*, vols I–II (London: Printed for HMSO by Mackie & Co. Ltd) [https://archive.org/details/calendarofstuart01greauoft]

Journal of the Edinburgh Bibliographical Society, The (2006) 1, p. 9.

Lang, Andrew 1892. 'At the Sign of the Ship', *Longman's Magazine* 20: 117 (1 July), pp. 325–31, p. 330.

Lax, Lucinda, forthcoming 2017. 'The Bonnie Prince in Print: Robert Strange's Everso missus Portrait and the Politics of the '45', *Journal of the Scottish Society for Art History* 22 (2017/18).

Macinness, Alan I. 2007. 'Jacobitism in Scotland: Episodic Cause or National Movement?', *Scottish Historical Review* 86, pp. 225–52.

McRoberts, David and Charles Oman 1968. 'Plate made by King James II and VII for the Chapel Royal of Holyroodhouse in 1686', *Antiquaries Journal* 48: 2, pp. 285–295.

Malloch, R. J. 1977. 'The Order of the Thistle', *Journal of the Heraldry Society of Scotland* 1, pp. 40–41.

Marshall, Rosalind K. 2014. 'The Palace of Holyroodhouse', *The Court Historian* 1: 3, pp. 2–6, 3. (Published online, 22 October)

[http://dx.doi.org/10.1179/cou.1996.1.3.001]

Marville, Charles 1992. *Revue de la Bibliothèque Nationale* 46 (winter), special edition devoted to 'Les Jacobites'.

Nicholson, Robin 1998. 'The Tartan Portraits of Prince Charles Edward Stuart: Identity and Iconography', *British Journal for Eighteenth-Century Studies* 21: 2, pp. 145–60, 148–49.

'N. L. L' 1792. 'Letter to editor, 6 August 1792', *The Gentleman's Magazine* 62: 2 (August), pp. 703–4.

Norman, A. V. B. 1976–77. 'Prince Charles Edward's Silver-hilted Sword', *The Proceedings of the Society of Antiquaries of Scotland* 108, pp. 324–26.

Norman, Vesey 1988. 'George IV and Highland Dress', *Review of Scottish Culture* 10 (1988), p. 5.

Pennell, Sara 1998. '"Pots and pans history": The Material Culture of the Kitchen in Early Modern England', *Journal of Design History* 11: 3, pp. 201–16.

Prown, Jules David 1982. 'Mind in Matter: An Introduction to Material Culture Theory and Method', *Winterthur Portfolio* 17: 1, p. 2.

Riding, Jacqueline 2011. 'Charlie will come again', *History Today* 61: 4 (April), pp. 42–48.

Standen, E. A. 1965. 'Instruments for Agitating the Air', *Metropolitan Museum of Art Bulletin* 23: 1, pp. 243–58.

Steele, Margaret Steele 1981. 'Anti-Jacobite pamphleteering, 1701–1720', *Scottish Historical Review* 60, pp. 140–55.

Steuart, A. Francis 1928. 'The Plenishing of Holyrood House in 1714', *Proceedings of the Society of Antiquaries* 62 (1927–28), pp. 181–96, 188.

Szechi, Daniel 1996. 'Defending the True Faith: Kirk, State, and Catholic missioners in Scotland, 1653–1755', *The Catholic Historical Review* 82.

Thom, Danielle 2015. '"William, the Princely Youth": The Duke of Cumberland and Anti-Jacobite Visual Strategy, 1745–46', *Visual Culture in Britain* 16: 3, p. 254.

Woolf, Noel 1979. 'The Sovereign Remedy: Touch-pieces and the King's Evil', *British Numismatic Journal* 49, p. 3.

Books

Allan, David 2002. *Scotland in the Eighteenth Century* (London: Longman).

Allardyce, James (ed.) 1895. *Historical Papers relating to the Jacobite Period 1699–1750*, 2 vols (Aberdeen: Printed for the New Spalding Club).

Anon. [1750]. *The History of the Rise, Progress and Extinction of the Rebellion in Scotland in the Years 1745 and 1746* (London: R. Thomson).

Anon. 1747. *Genuine Memoirs of John Murray, Esq, late secretary to*

the young Pretender. Together with remarks on the same, in a letter to a friend (Dublin: Printed by J. Esdall).

Attwood, Philip and Felicity Powell 2009. *Medals of Dishonour* (London: British Museum Press).

Bailey, Sarah 2013. *Clerical Vestments: Ceremonial Dress of the Church* (London: Shire Publications).

Barron, Kathryn 2003. '"For Stuart blood is in my veins" (Queen Victoria): the British monarchy's collection of imagery and objects associated with the exiled Stuarts from the reign of George III to the present day', in Corp (ed.) 2003.

Birch, Thomas (author) 1743–51 [George Vertue and Jacobus Houbraken (engravers)], *The Heads of Illustrious Persons of Great Britain* (London: J. & P. Knapton).

Black, Ronald (ed.) 2001. *An Lasair: Anthology of 18th Century Scottish Gaelic Verse* (Edinburgh: Birlinn).

Blaikie, Walter Biggar 1897. *Itinerary of Prince Charles Edward Stuart from his Landing in Scotland July 1745 to his Departure in September 1746 Compiled from the Lyon in Mourning supplemented and corrected form other contemporary sources by Walter Biggar Blaikie* (Edinburgh: Printed at the University Press for T. & A. Constable for the Scottish History Society).

Bongie, L. L. 1986. *The Love of a Prince* (Vancouver: University of British Columbia Press).

Boyse, Samuel 1747. *An historical review of the tranfactions of Europe: from the commencement of the War with Spain in 1739, to the infurrection in Scotland in 1745. With Proceedings in Parliament and the most remarkable Domestick Occurrences during that Period. To which is added; an Impartial History of the late Rebellion …*, 2 vols (Reading: Printed for and by D. Henry).

Brewer, John 1989. *The Sinews of Power: War, Money and the English State 1688–1783* (London: Unwin Hyman).

Brogan, Stephen 2015. *The Royal Touch in Early Modern England* (London: Royal Historical Society).

Brown, Ian G. and Hugh Cheape (eds) 1996. *Witness to Rebellion: John Maclean's Journal of the 'Forty-Five and the Penicuik Drawings* (East Linton: Tuckwell Press and National Library of Scotland).

Buoncore, Marco and Giovanna Cappelli (eds) 2007. *La biblioteca del Cardinale* (Rome: Gangemi).

Burnett, Charles J. and Helen Bennett 1987. *The Green Mantle* (Edinburgh: National Museums Scotland).

Burt, Edmund 1818. *Letters from a Gentleman in the North of Scotland*, R. Jamieson (ed.), 2 vols (London: Printed for R. Fenner).

Campbell, John L. (ed.) 1984. *Highland Songs of the 'Forty-Five* (Edinburgh: Scottish Gaelic Text Society).

Campbell, Mungo (ed.) 2013. *Allan Ramsay: Portraits of the Enlightenment*, (Munich, London and New York: Prestel), exhibition catalogue.

Chalus, Elaine 2012. 'Fanning the Flames: Women, Fashion and Politics', in Potter (ed.) 2012.

Chambers, Robert 1835. *Biographical Dictionary of Eminent Scotsmen*, 8 vols (Glasgow: Blackie and Sons).

Chambers, Robert 1869. *History of the Rebellion of 1745–6*, 7th edn (Edinburgh: W. & R. Chambers).

Charles. G. 1816–17: *History of the Transactions in Scotland in the Years 1715–16 and 1745–46*, 2 vols (Stirling: J. Fisher & Co.).

Cheape, Hugh 1991. *Tartan: The Highland Habit* (Edinburgh: National Museums Scotland).

Cheape, Hugh 1995. 'The Culture and Material Culture of Jacobitism', in Lynch (ed.) 1995.

Clark, J. C. D. and Howard Erskine-Hill (eds) 2012. *The Politics of Samuel Johnson* (London: Palgrave Macmillan).

Clarke, Deborah 2010. *The Palace of Holyroodhouse: Official Souvenir Guide* (London: Scala Arts & Heritage Publishers).

Clarke, Deborah and Vanessa Remington 2015. *Scottish Artists 1750–1900: From Caledonia to the Continent* (London: Royal Collections Trust).

Clayton, Timothy 2017. 'Strange, Sir Robert (1721–1792)', *Oxford Dictionary of National Biography* (Oxford: Oxford University Press, 2004).
Online edition, September 2015, accessed 5 February 2017: [www.oxforddnb.com/view/article/26638],

Coltman, Viccy 2015. 'Material Culture and the History of Art(efacts)', in Gerritsen and Riello (eds) 2015.

Corp, Edward 2001. *The King over the Water: Portraits of the Stuarts in Exile after 1689* (Edinburgh: Scottish National Portrait Gallery), exhibition catalogue.

Corp, Edward (ed.) 2003. *The Stuart Court in Rome: The Legacy of Exile* (Aldershot: Ashgate).

Corp, Edward 2004/2009/2011. *A Court in Exile: The Stuarts in France, 1689–1718* (Cambridge: Cambridge University Press).

Corp, Edward 2009. *The Jacobites at Urbino: An Exiled Court in Transition* (Basingstoke: Palgrave Macmillan).

Corp, Edward 2009. 'The Jacobite Court at Saint-Germain-en-Laye', in Cruickshanks 2009.

Corp, Edward 2011/2013. *The Stuarts in Italy: A Royal Court in Permanent Exile 1719–1766* (Cambridge: Cambridge University Press).

Corp, Edward and Jacqueline Sanson 1992. *La Cour des Stuarts à Saint-Germain-en-Laye au temps de Louis XIV* (Paris: Réunion des Musées Nationaux).

Cruickshanks, Eveline (ed.) 1982. *Ideology and Conspiracy: Aspects of Jacobitism, 1689–1759* (Edinburgh: John Donald Publishers Ltd).

Cruickshanks, Eveline 1995. 'Attempts to Restore the Stuarts, 1689–96', in Cruikshank and Corp (eds) 1995.

Cruikshanks, Eveline and Edward Corp (eds) 1995. *The Stuart*

Court in Exile and the Jacobites (London: Hambledon Continuum).

Cruickshanks, Eveline (ed.) 2009. *The Stuart Courts* (Stroud: The History Press).

Dalgleish, George 1988. 'The Silver Travelling Canteen of Prince Charles Edward Stuart', in Fenton and Myrdal (eds) 1988.

Dalgleish, George and Dallas Mechan 1985. *'I am Come Home': Treasures of Prince Charles Edward Stuart* (Edinburgh: National Museum of Antiquities of Scotland), exhibition catalogue.

Dalgleish, George and Henry Steuart Fothringham 2008. *Silver: Made in Scotland* (Edinburgh: National Museums Scotland).

Daston, Lorraine (ed.) 2004. *Things that Talk: Object Lessons from Art and Science* (Brooklyn, NY: Zone Books).

de Brosses, Charles 1799. *Lettres Historiques et Critiques sur L'Italie*, 3 vols (Paris), vol. 2, letter XVIII. Translation from Charles Louis Klose 1846. *Memoirs of Prince Charles Stuart, (count of Albany) commonly called the Young Pretender; with notices of the rebellion in 1745*, 2nd edn, 2 vols (London: Henry Colburn).

Defoe, Daniel 1742. *A Tour Thro' the Whole Island of Great Britain …*, 3rd edn, 4 vols (London: Samuel Richardson).

Doddridge, Philip 1812. *The Life of the Honourable Col. James Gardiner: Who was slain at the battle of Prestonpans, September, 21st, 1745* (Greenock: William Scott).

Drummond, Andrew L. and James Bulloch 1973. *The Scottish Church 1688–1843: The Age of Moderates* (Edinburgh: The Saint Andrew Press).

Drummond R.S.A., James 1881. *Ancient Scottish Weapons. A Series of Drawings by the Late James Drummond R.S.A., with Introduction and Descriptive Notes by Joseph Anderson* (Edinburgh and London: George Waterson & Sons).

Dunan-Page, Anne and Clotilde Prunier (eds) 2013. *Debating the Faith: Religion and Letter Writing in Great Britain, 1550–1800*, (Netherlands: Springer).

Dunbar, John Telfer 1981. *The Costume of Scotland* (London: Batsford; original from Cornell University).

Ellis, Steven G. and Sarah Barber (eds) 1995. *Conquest & Union: Fashioning a British State, 1485–1725* (London: Routledge).

Evans, Godfrey 2003. 'The Acquisition of Stuart Silver and Other Relics by the Dukes of Hamilton', in Edward Corp (ed.) 2003.

Exhibition of the Royal House of Stuart, 1889 (London: Richard Clay and Sons), exhibition catalogue.

Fenton, Alexander and Janken Myrdal (eds) 1988. *Food and Drink and Travelling Accessories; Essays in Honour of Gosta Berg* (Edinburgh: John Donald).

Ferguson, Andrew 1745. *A genuine Account of All of the Persons of note in Scotland, who are now engaged in the service of the Chevalier* (Edinburgh: John Donald).

Finance Accounts, &c. of the United Kingdom in Eight Classes for the year 1831 (1832), vol. 26, 'Royal Palaces and Buildings' (London: Ordered, by the House of Commons to be Printed).

Forbes, Rev. Robert [and William Biggar Blaikie] (ed. Henry Paton) 1895. *The Lyon in Mourning*, 3 vols, Publications of the Scottish History Society, 20 (Edinburgh: Printed at the University Press for T & A Constable for the Scottish History Society).

Fort, Bernadette and Angela Rosenthal (eds) 2001. *The Other Hogarth: Aesthetics of Difference* (Princeton: Princeton University Press and Oxford).

Gaehtgens, Thomas W. and Louis Marchesano 2011. *Display and Art History: The Düsseldorf Gallery and Its Catalogue* (Los Angeles: Getty Research Institute).

Gartmore MS, printed as appendix in revised edition of Burt 1818.

German, Kieran 'Jacobite Politics in Aberdeen and the '15' in Monod, Pittock and Szechi 2010.

Gerritsen, Anne and Giorgio Riello (eds) 2015. *Writing Material Culture History* (London: Bloomsbury).

Gibson, John Sibbald. 'Drummond, James, styled sixth earl of Perth and Jacobite third duke of Perth (1713-1746)', *Oxford Dictionary of National Biography* (Oxford: Oxford University Press, 2004) Online edition (May 2006), accessed 5 Feb. 2017 [www.oxforddnb.com/view/article/8072]

Gordon, Beverly 1997. 'Intimacy and Objects: A Proxemics Analysis of Gender-based Response to the Material World', in Martinez and Ames (eds) 1997.

Gray, John M. (ed.) 1892. *Memoirs of the Life of Sir John Clerk of Penicuik* (Edinburgh: Scottish History Society).

Greig, James (ed.) 1926. *The Diaries of a Duchess* (London: Hodder & Stoughton).

Guthrie, Neil 2012. 'Johnson's Touch-piece and the 'Charge of Fame': Personal and Public Aspects of the Medal in Eighteenth-century Britain', in Clark and Erskine-Hill (eds) 2012.

Guthrie, Neil 2013 and 2016. *The Material Culture of the Jacobites* (Cambridge: Cambridge University Press).

Haile, Martin 1905. *Queen Mary of Modena: Her Life and Letters* (London, Dent).

Halloran, Brian M. 1997. *The Scots College Paris 1603–1792* (Edinburgh: John Donald).

Hamilton, Antoine 1731. *Oeuvres mêlées en prose et en vers* (Paris).

Hardie, Martin 1908. *John Pettie R.A., H.R.S.A.* (London: A. & C. Black).

Hardie, Martin 1910. *John Pettie R.A., H.R.S.A.* (London: A. & C. Black).

Harris, Tim and Stephen Taylor (eds) 2013. *The Final Crisis of the Stuart Monarchy: The Revolutions of 1688–91 in their British, Atlantic and European Contexts* (Woodbridge: Boydell Press).

Hawkins, Edward, Augustus W. Franks and Herbert A. Grueber (eds) 1885. *Medallic illustrations of the History of Great Britain*

and Ireland to the Death of George II, vol. II, (London: British Museum).

Henderson, Andrew 1748. *The History of the Rebellion, 1745 and 1746,* 2nd edn (London: printed for R. Griffiths).

Henderson, Andrew 1753. *The History of the Rebellion, 1745 and 1746,* 5th edn (London: printed for A. Millar, W. Owen, W. Reeve, and J. Swan).

Home, John 1869. 'History of the Rebellion', quoted in Chambers 1869.

Home, John 1802. *The History of the Rebellion in the Year 1745* (London: printed for T. Cadell Jun. and W. Davis).

Important Medieval and Renaissance Works of Art and Celebrated Stuart Relics 1928 (London: Sotheby's), exhibition catalogue.

Ingram, Mary E. 1907. *A Jacobite Stronghold of the Church* (Edinburgh: R. Grant & Son).

Jacobite, Stuart & Scottish Applied Arts, Lyon and Turnbull, Edinburgh, Wednesday, 13 May 2015, auction catalogue.

James II, King 1704. *The Pious Sentiments of the late King James II of Bleſſed Memory upon Divers Subjects of Piety: Written with His own Hand and found in His Cabinet after His Death* (London).

Johnstone, Pauline 2002. *High Fashion in the Church: The Place of Church Vestments in the History of Art, From the Ninth to the Nineteenth century* (Leeds: Maney Publishing).

Jones, Rica 2013. 'Painting a Face All Red at the First Sitting: Ramsay's Technique for Portraits, 1725–60', in Campbell (ed.) 2013.

Kinsey, James (ed.) 1973. *Alexander Carlyle. Anecdotes and Characters of the Times* (Oxford: Oxford University Press).

Lang, Andrew 1900/1903. *Prince Charles Edward Stuart: The Young Chevalier* (London: first published by Messrs. Goupil & Co. 1900; new edition by Longmans, Green and Co. 1903).

Langford, Paul 1989. *A Polite and Commercial People: England 1727–1783* (Oxford: Oxford University Press).

Lenman, Bruce 1980. *The Jacobite Risings in Britain 1689–1746* (London: Eyre Methuen Ltd).

Lenman, Bruce 'The Scottish Episcopal clergy and ideology of the Jacobitism' in Cruickshanks (ed.) 1982.

Lewis, W. S. (ed.) 1937–83. *Correspondence of Horace Walpole*, 48 vols (New Haven and London: Yale University Press).

Livingstone, Alistair 1984. *Muster Roll of Prince Charles Edward Stuart's Army* (Aberdeen: Aberdeen University Press).

Lockhart, George 1817. *The Lockhart Papers: Containing Memoirs And Commentaries upon the Affairs of Scotland from 1702 to 1715 by George Lochart … published from original manuscripts in possession of Anthony Aufrere Esq.*, 2 vols (London: Printed by Richard and Arthur Taylor for William Anderson).

London Park Lane Arms Fair 2016. [Spring], exhibition catalogue.

Lord, Dr Evelyn 2004. *The Stuart Secret Army: the Hidden History of the English Jacobites* (London: Longman).

Lynch, Michael (ed.) 1995. *Jacobitism and the '45* (London: Historical Association).

MacDonald, Alexander 1817. 'Journall and Memoirs of P. C. Expedition into Scotland … By a Highland Officer in his Army', in Lockhart 1817.

Macfarlane, Malcolm (ed.) 1923. *Lamh Sgriobhainn Mhic Rath: The Fernaig Manuscript* (Dundee: C. S. MacLeoid).

McInally, Thomas, 2014. 'Missionaries or soldiers for the Jacobite cause? The conflict of loyalties for Scottish Catholic clergy', in Macinnes and Hamilton (eds) 2014.

Macinnes Allan I. 1996. *Clanship, Commerce and the House of Stuart, 1603–1788* (East Linton: Tuckwell Press).

Macinnes, A. I., K. German and L. Graham (eds) 2014. *Living with Jacobitism: The Three Kingdoms and Beyond, 1690–1788* (London: Pickering and Chatto).

Macinnes, Allan I. 1995. 'Gaelic Culture in the Seventeenth Century: Polarization and Assimilation', in Ellis and Barber (eds) 1995.

Macinnes, Allan I. 2014. 'Union, Empire and Global Adventuring with a Jacobite Twist', in Macinnes and Hamilton 2014.

Macinnes, Allan I. and Douglas J. Hamilton (eds) 2014. *Jacobitism, Enlightenment and Empire, 1680–1820* (London: Pickering and Chatto).

Mackenzie, George 1908–22. *The Lives and Characters of the Most Eminent Writers of the Scottish Nation*, 3 vols (Edinburgh).

Mackie, Charles 1819. *Historical Description of the Monastery or Chapel Royal of Holyroodhouse: with a Short Account of the Palace and Environs* (Edinburgh: Printed for Mrs J. Petrie).

McLynn, Frank 1988. *Charles Edward Stuart: A Tragedy in Many Acts* (Oxford: Oxford University Press). Republished in 2003 as *Bonnie Prince Charlie: Charles Edward Stuart* (London: Random House).

McLynn, Frank 2003. *Bonnie Prince Charlie: Charles Edward Stuart* (London: Pimlico).

Mann, Alistair J. 2014. *James VII: Duke and King of the Scots, 1633–1701* (Edinburgh: John Donald).

Marquis of Ruvigny and Raineval, The 1904. *The Jacobite Peerage: Baronetage, Knightage and Grants of Honour [extracted by permission, from the Stuart Papers now in possession of His Majesty the King at Windsor Castle, and supplemented by Biographical and Genealogical Notes by the Marquis of Ruvigny and Raineval]* (Edinburgh and London: T. C. & E. C. Jack).

Marshall, John 2013. 'Whig Thought and the Revolution of 1688–91, in Harris and Taylor (eds) 2013.

Martin, Ann Smart and J. Ritchie Garrison (eds) 1997. *American Material Culture: The Shape of the Field* (Winterthur: Winterthur Museum).

Martinez, Katherine A. and Kenneth L. Ames (eds) 1997. *The Material Culture of Gender, the Gender of Material Culture* (Winterthur: Winterthur Museum).

Matheson, William (ed.) 1970. *The Blind Harper: The Songs of Roderick Morison and his Music* (Edinburgh: Scottish Gaelic Texts Society).

Maxwell, James of Kirkconnell 1861. *Narrative of Charles Prince of Wales' Expedition to Scotland in the Year 1745* (Edinburgh: T. Constable).

Ménéstrier, Claude-François 1682. *La Philosophie des Images* (Paris: Robert J. B. De La Caille).

Miller, Daniel 2010. *Stuff* (Cambridge: Polity Press).

Monod, Paul 1989/1993. *Jacobitism and the English people, 1688–1788* (Cambridge: Cambridge University Press).

Monod, Paul, Murray Pittock and Daniel Szechi 2010. *Loyalty and Identity; Jacobites at Home and Abroad* (Palgrave Macmillan, Basingstoke).

Montgomery, Charles F. 1961. 'Some Remarks on the Practice and Science of Connoisseurship', *American Walpole Society Notebook*. Republished in 1982 as 'The Connoisseurship of Artifacts', Thomas J. Schlereth (ed.), *Material Culture Studies in America* (AASLH Press: Nashville).

Murdoch, Steve 2010. 'Tilting at Windmills: The Order del Toboso as a Jacobite Social Network', in Monod, Pittock and Szechi 2010.

National Trust 2001. *Sizergh Castle Guidebook* (London: National Trust).

Nicholas, Donald 1973. *The Portraits of Bonnie Prince Charlie* (Maidstone: published by the author).

Nicholson, Robin 2002. *Bonnie Prince Charlie and the Making of a Myth: A Study in Portraiture, 1720–1892* (Lewisburg, PA: Bucknell University Press, and London: Associated University Presses).

Novotny, Jennifer L. 2013. 'Sedition at the supper table: the material culture of the Jacobite wars, 1688–1760' (University of Glasgow PhD thesis).

Novotny, Jennifer L. 2014. 'Polite War: Material Culture of the Jacobite era', in Macinnes, German and Graham (eds) 2014.

Ó Baoill, C. 1972. *Poems and Songs by Julia MacDonald of Keppoch* (Edinburgh: Scottish Gaelic Text Society).

Ó Baoill, Colm (ed.) and Meg Bateman (trans.) 1994. *Gair nan Clarsach: The Harps' Cry. An Anthology of 17th Century Gaelic Poetry* (Edinburgh: Birlinn).

Order of the Thistle 1978. *Statutes of the Most Ancient and Most Noble Order of the Thistle: Revived By His Majesty King James II of England and VII of Scotland and Again Revived By Her Majesty Queen Anne* (Edinburgh: Order of the Thistle).

Paton, Henry (ed.), *The Lyon in Mourning*, 3 vols (1896), vol. 2. See Forbes [and Blaikie] (ed. Henry Paton) 1895.

Piacenti, Kirsten A. and John Boardman 2008. *Ancient and Modern Gems and Jewels in the Collection of her Majesty the Queen* (London: Royal Collection Trust).

Pittock, Murray 1991. *The Invention of Scotland: The Stuart Myth and Scottish identity, 1638 to the present* (London: Routledge).

Pittock, Murray 1995. *The Myth of the Jacobite Clans: The Jacobite Army in 1745* (Edinburgh: Edinburgh University Press).

Pittock, Murray 1998. *Jacobitism* (Basingstoke: Macmillan).

Pittock, M. G. H. [Murray] 2001. *Scottish Nationality* (Basingstoke: Palgrave Macmillan).

Pittock, Murray 2009. *The Myth of the Jacobite Clans: The Jacobite Army in 1745*, 2nd edn (Edinburgh: Edinburgh University Press).

Pittock, Murray 2013. *Material Culture and Sedition, 1688–1760: Treacherous Objects, Secret Places* (Basingstoke: Palgrave Macmillan).

Pittock, Murray 2014. *The Invention of Scotland: The Stuart Myth and Scottish identity, 1638 to the present*, Revivals Series (London: Routledge).

Pittock, Murray 2016. *Culloden (Cùil Lodair)* (Oxford: Oxford University Press).

Potter, Tiffany (ed.) 2012. *Women, Popular Culture and the Eighteenth Century* (Toronto: University of Toronto and London).

Prown, Jules David 2001. *Art as Evidence: Writings on Art and Material Culture* (New Haven: Yale University Press and London).

Riding, Jacqueline 2016. *Jacobites: A New History of the '45 Rebellion* (London: Bloomsbury Publishing).

Rimer, Graeme 2016. 'A fine Silver-Hilted Jacobite Sword from the Stuart Court in Exile, perhaps a Sword of Bonnie Prince Charlie', in *London Park Lane Arms Fair* 2016 [Spring].

Rosenthal, Angela 2001. 'Unfolding Gender: Women and the "Secret" Sign Language of Fans in Hogarth's work', in Fort and Rosenthal (eds) 2001.

Russell, John 1748. *Letters from a young painter abroad to his friends in England* (London: printed for W. Russell).

Scharf, George 1861. *Catalogue Raisonné, or a List of the Pictures in Blenheim Palace; with Occasional Remarks and Illustrative Notes* (London: Dorrell and Son).

Scharf, George 1888. *A Historical and Descriptive Catalogue of the Pictures, Busts, &c. in the National Portrait Gallery* (London: Eyre and Spottiswood).

Scots Confession 1560: chapter XVI: 'The Kirk', various editions.

Scott, Sir Walter 1814. *Waverley; or 'Tis Sixty Years Since*, 3 vols (Edinburgh: Archibald Constable).

Scott, Sir Walter 1842. *Tales of a Grandfather*, 3 vols (Edinburgh: Cadell & Co.).

Scottish National Appeal for Boys' Clubs 1946. *Second Centenary Loan Exhibition of Jacobite Relics and Rare Scottish Antiquities, August 31st–September 30th, 1946, under the Auspices of the Scottish National Appeal for Boys' Clubs* (Edinburgh: Scottish National Appeal for Boys' Clubs).

Seddon, Geoffrey B. 1995. *The Jacobites and Their Drinking Glasses* (Woodbridge: Antique Collectors Club).

Sharp, Richard 1996. *The Engraved Record of the Jacobite Movement* (Aldershot: Scolar Press)

Speck, William Arthur 2002. *James II* (London: Pearson Education Limited).

Stanhope, Philip (Lord Mahon) 1851. *'The Forty-Five'* (London: John Murray).

Szechi, Daniel 1994. *The Jacobites: Britain and Europe, 1688–1788* (Manchester: Manchester University Press).

Szechi, Daniel 2006, *1715: The Great Jacobite Rebellion* (New Haven and London: Yale University Press).

Szechi, Daniel 2013. 'Negotiating Catholic Kingship for a Protestant People: 'Private' Letters, Royal Declarations and the Achievement of Religious Detente in the Jacobite Underground, 1702–1718', in Dunan-Page and Prunier (eds) 2013.

Daniel Szechi 2014. 'Jamie the Soldier and the Jacobite Military Threat 1706–1727' in Macinnes and Hamilton (eds), *Jacobitism*, 2014.

Tayler, Alistair and Henrietta Tayler 1928. *Jacobites of Aberdeenshire and Banffshire in the Forty-Five* (Aberdeen: Milne & Hutchison)

Tayler, Alistair and Henrietta Tayler (eds) 1938. *1745 and After* (Edinburgh: Thomas Nelson and Sons).

Tayler, Henrietta (ed.) 1948. *A Jacobite Miscellany: Eight original papers on the Rising of 1745–6* (Oxford, Printed for the Roxburghe Club by C. Batey at the University Press).

The Swords and the Sorrows 1996 (National Trust for Scotland), exhibition catalogue.

Thomson, Mrs [Katherine] 1845. *Memoirs of the Jacobites of 1715 and 1745* (London: Richard Bentley).

Todd, Margo 2002. *The Culture of Protestantism in Early Modern Scotland* (New Haven: Yale University Press).

Valadier: Three Generations of Roman Goldsmiths. An exhibition of drawings and works of art: 15th May to 12th June 1991, Monday to Friday, 10am to 5pm at David Carritt Limited, 15 Duke Street, St James's, London, SW1Y 6DB 1991 (London: David Carritt Ltd), exhibition catalogue.

Virgil, *Georgics* 1: 498; translation based on H. Rushton Fairclough (trans.) 1916. *Virgil. Eclogues, Georgics, Aeneid*, Loeb Classical Library, vol. 63 (Cambridge, MA: Harvard University Press).

Walsh, Rt. Rev. Monsignor John 1916. *The Mass and Vestments of the Catholic Church, liturgical, doctrinal, historical and archeological* (New York, Cincinnati, Chicago: Benziger Brothers).

Watts, John 1999. *Scalan: The Forbidden College 1716–1799* (East Linton: Tuckwell Press).

Weston, William [printer] 1700. *The Psalmes of David, translated from the Vulgat*, trans. John Caryll and David Nairne (attrib. Caryll) (2nd edition, 1704, titled *The Psalms* [sic] *of David;* with twelve further editions up to 1986).

Weymss, David (Lord Elcho) with memoir and annotations by The Hon. Evan Charteris 1907. *A Short Account of the Affairs of Scotland in the Years 1744, 1745, 1746* (Edinburgh: David Douglas).

Whatley, Christopher A. 2006. *The Scots and the Union* (Edinburgh: Edinburgh University Press).

Whatley, Christopher A. 2014. '"Zealous in the Defence of the Protestant Religion and Liberty": The Making of Whig Scotland, *c.*1688–*c.*1746', in Macinnes, German and Graham 2014.

Woodhouselee MS, The 1907. *A narrative of events in Edinburgh and district during the Jacobite occupation, September to November 1745: Printed from original papers in the possession of C. E. S. Chambers, Edinburgh* (London and Edinburgh: W. & R. Chambers).

Woolf, Noel 1988. *The Medallic Record of the Jacobite Movement* (London: Spink & Son Ltd).

Acknowledgements

National Museums Scotland would like to thank all those who have contributed to the exhibition, *Bonnie Prince Charlie and the Jacobites*, and to this publication.

Author Information

Viccy Coltman is a Professor in History of Art at the University of Edinburgh, where she specialises in visual and material culture of the 18th and early 19th centuries. To date she has published two books, edited one volume and co-edited another on Henry Raeburn. Her current project is a cultural history of Scotland from the rising of 1745 to the death of Sir Walter Scott in 1832, which includes a chapter on Jacobite material culture.

Edward Corp lives in France, and is now retired. He was Professor of British History at the University of Toulouse, and has written extensively on the exiled Stuarts. Publications include *The King over the Water: Portraits of the Stuarts in Exile after 1689* (National Galleries of Scotland 2001) and a three-volume history of the Jacobite court, *A Court in Exile: The Stuarts in France, 1689–1718* (2004), *The Jacobites at Urbino* (2009) and *The Stuarts in Italy, 1719–1766* (2011). His next book, a biography of the Jacobite Sir David Nairne (1655–1740), is due to be published later this year.

George R. Dalgleish MA, FSAScot FSA was born in Galashiels and educated at the University of Edinburgh, where he studied Scottish Historical Studies. He joined the staff of the then National Museum of Antiquities of Scotland in 1980, eventually being appointed Keeper of the Scottish History and Archaeology Department of National Museums Scotland in 2012. He was involved in the creation of the 18th- and 19th-century displays of the Museum of Scotland, and more recently curated the exhibitions *Silver: Made in Scotland* and *Mary, Queen of Scots*. Special interests include Scottish ceramics,

clocks, Jacobite relics, pewter and silver on which he has published extensively. He was a Vice President of the Society of Antiquaries of Scotland from 2008–11 and is currently a member of the Incorporation of Goldsmiths of Edinburgh, a Trustee of the Abbotsford Trust and of the Advocates Abbotsford Collections Trust. He retired from the Museum in 2016.

David Forsyth is a Principal Curator in the Department of Scottish History and Archaeology at National Museums Scotland, where he oversees the medieval to early-modern collections and curators. He was Lead Curator on the *Bonnie Prince Charlie and the Jacobites* exhibition, reprising a role which he performed in 2013 for the National Museums Scotland special exhibition *Mary, Queen of Scots*. In both he has been responsible for the catalogues which accompanied the exhibitions.

Adrienne Hynes is Assistant Curator in the Late Modern section of the Department of Scottish History and Archaeology at National Museums Scotland. She has an MA (Hons) in Medieval History and MLitt in Museum and Gallery Studies from the University of St Andrews. Her current area of research is Jacobite material culture, specifically the 1715 rising, as well as exploring the relationship between faith and the Jacobite cause. She also works with Scottish decorative art collections dating from 1750 onwards and is particularly interested in the history of museum-collecting in this area.

Dr Lucinda Lax is Senior Curator of Eighteenth-Century Collections at the Scottish National Portrait Gallery in Edinburgh, where her work focuses on the relationships between art, politics and culture in 18th- and early 19th-century Scotland. She recently curated the exhibition 'Scots in Italy: Artists and Adventurers', exploring Scotland's fascination with the Mediterranean world, and will shortly publish the results of her recent research into the

production of Robert Strange's *Everso missus* print of Charles Edward Stuart (forthcoming in the *Journal of the Scottish Society for Art History*).

Lyndsay McGill is a graduate of the universities of Glasgow and St Andrews and is currently Curator for the medieval-early modern collections in the Department of Scottish History and Archaeology at National Museums Scotland. Her background is in archaeology and Scottish history and her research interests, although wide and varied within Scottish material culture, primarily focus on silver – particularly 18th-century design and form – and more recently, the Order of the Thistle in relation to the Stuarts.

Allan I. Macinnes is Emeritus Professor of History at the University of Strathclyde. He has written extensively on British state formation, Scottish Jacobitism, and Highland clans and clearances. He is currently researching the extent to which engagement with Empire helped secure Scottish acceptance of the Treaty of Union in the 18th century. He is also editing and contributing to works on Enlightenment and Empire, the Hanoverian Succession and the Scottish liturgical tradition and the Jacobite Church.

Murray Pittock D.Litt. FRSE is Bradley Professor and Pro-Vice Principal of the University of Glasgow, and a prize lecturer of both the Royal Society of Edinburgh and the British Academy. He is Scottish History advisor to the National Trust for Scotland and an advisor to the National Galleries of Scotland. He has held numerous international visiting appointments. Recent work include *Culloden*, one of *History Today*'s top ten titles of 2016; *The Road to Independence? Scotland in the Balance* (2014) and *Material Culture and Sedition* (2013), shortlisted for Saltire research book of the year. He is currently working on 'Smart City: Infrastructure, Innovation and Edinburgh's Enlightenment 1660-1760' and on 'Occupation? The British Army in Scotland, 1746-60'. He is general editor of the Edinburgh Edition of the Works of Allan Ramsay and a co-editor of the Oxford Burns.

Dr Jacqueline Riding specialises in Georgian History and Art. She read History and Art History at the universities of Leicester, London and York and has over 25 years of experience working as a curator and consultant for a variety of museums, galleries and historic buildings including The Guard's Museum, Tate Britain and Historic Royal Palaces. From 1993–99 she was Assistant Curator at the Palace of Westminster and from 1999–2004 founding Director of the

Handel House Museum, London. She was the consultant historian on Mike Leigh's 'Mr. Turner' (2014) and is working on his forthcoming feature film, 'Peterloo'. Her publications include 'Hogarth, Britain and the 1745 Jacobite Rebellion' in *Canaletto – Celebrating Britain* (2015) and *Jacobites: A New History of the '45 Rebellion* (2016).

Helen Wyld joined National Museums Scotland as Senior Curator of Historic Textiles in March 2017, and prior to this was Curator at the National Trust for Scotland, where she had responsibility for the Culloden Battlefield Museum and other sites. Alongside her enthusiasm for Jacobite material culture, Helen specialises in the history of tapestry in Britain and Europe and has published and lectured widely in this area.

Thanks are also due to all the staff of National Museums Scotland who have contributed in numerous ways to the exhibition and to this publication.

Image Credits

All images © National Museums Scotland, unless otherwise credited. Acknowledgements for use of additional images within chapters and catalogue section are as follows:

Archives départmentales des Yvelines / 7Q1 19
 For Fig 2.2

Archivio di Stato di Roma. Courtesy of the Italian Ministry of Cultural Property and Archives
 For Figs 4.1, 4.2

Image © Ashmolean Museum, University of Oxford

Barrett-Lennard Collection, Essex Record Office, by kind permission of the Corporate Custodian of Art, Essex County Council (ECC457)
 For Fig. 2.4 and page 24; and Catalogue no. 237

© Bibliothèque nationale de France
 For Figs 2.1, 2.2 and page 41

From the collection at Blair Castle, Perthshire
 For Fig. 3.8

© The Trustees of the British Museum. All rights reserved.
 For Figs 6.8, 6.9, 6.10, 6.11, 6.13, 6.14, 7.6, 10.5, 10.8

© 2017 Christie's Images Limited
 For page 57 and Fig. 5.3; and Catalogue no. 290

On Loan from the Drambuie Collection by kind permission of
William Grant and Sons
For Fig. 3.10 and page 57; and Catalogue no. 287

Fundación Casa de Alba. Palacio de Liria.
For pages 57, 58 and Fig. 4.6

Highland Photographic Archive, Inverness Museum & Art Gallery,
High Life Highland
For Catalogue no. 162

© John Nicholls MBE
For Catalogue no. 289

Louvre, Paris, France / Bridgeman Images
For Fig. 6.6

Marischal Museum, University of Aberdeen
For Catalogue no. 174

National Galleries of Scotland / Scottish National Portrait Gallery
For Figs 1.13, 3.3, 3.7, page 57, 4.3, 5.1, 5.2, 5.6, 6.2, 6.12, page
126, 7.2, 7.3, 7.4, 7.5, page 160, 9.4; and Catalogue no. 249

Reproduced by Permission of the National Library of Scotland
For Fig. 8.7

National Library, Vienna / ÖNB/Wein
For Fig. 3.2

© National Portrait Gallery, London
For Figs 4.5, 6.5, 6.7, 10.3, 10.4

National Trust for Scotland. Image © John Paul Photography.
For Figs 5.7 a–c

The Pininski Foundation, Warsaw, Poland
For Fig. 4.4

Prussian Palaces and Gardens Foundation Berlin – Brandenberg /
Photographer Wolfgang Pfauder
For Fig. 2.3

Royal Collection Trust / © Her Majesty Queen Elizabeth II 2017
For Figs 1.7, 3.11, 3.12, page 94, 6.3, 6.4, 6.15, 8.2, page 159, 9.7,
page 178, 10.2; and Catalogue nos. 4, 5, 36, 39, 40, 56, 102, 200

Courtesy of St Peter in the Vatican Capitola (Per gentile conces-
sione del Capitolo di San Pietro in Vaticano)
For Fig. 8.8

Scottish Roman Catholic Hierarchy. Image © National Museums
Scotland.
For page 138, Figs 8.3; and Catalogue no. 12

© UK Government Art Collection
For Fig. 2.5

Victoria and Albert Museum, London
For Catalogue no. 44

Additional Credits

Fig. 1.3 and Catalogue nos 2, 81, 105:
Acquired with the aid of the Art Fund. Image © National
Museums Scotland.

Catalogue nos 4, 5, 36, 39, 40, 56, 102, 200, 269, 270, 271:
Royal Collection Trust / © Her Majesty Queen Elizabeth II

Catalogue no. 62:
Acquired with the aid of the National Heritage Memorial
Fund. Image © National Museums Scotland.

Catalogue no. 136:
Purchased with the assistance of The Glenmorangie Company,
the National Heritage Memorial Fund, the Hugh Fraser
Foundation, and contributions from over 600 businesses and
members of the public.

Catalogue no. 158:
On loan from Mr Robert R. Maitland.

Catalogue no. 249:
Scottish National Portrait Gallery, Edinburgh. Purchased with the
aid of the Art Fund 1994.

With thanks to:
The Royal College of Physicians of Edinburgh
The Scottish Roman Catholic Hierarchy

For cover design, title spreads and design advice:
Mark Blackadder

For endpapers and title spreads graphic:
Design by Studioarc, Edinburgh

Fig. 1.4 and Catalogue no. 3:
Acquired with the aid of the Heritage Lottery Fund and the
Art Fund. Image © National Museums Scotland.

Art Fund_

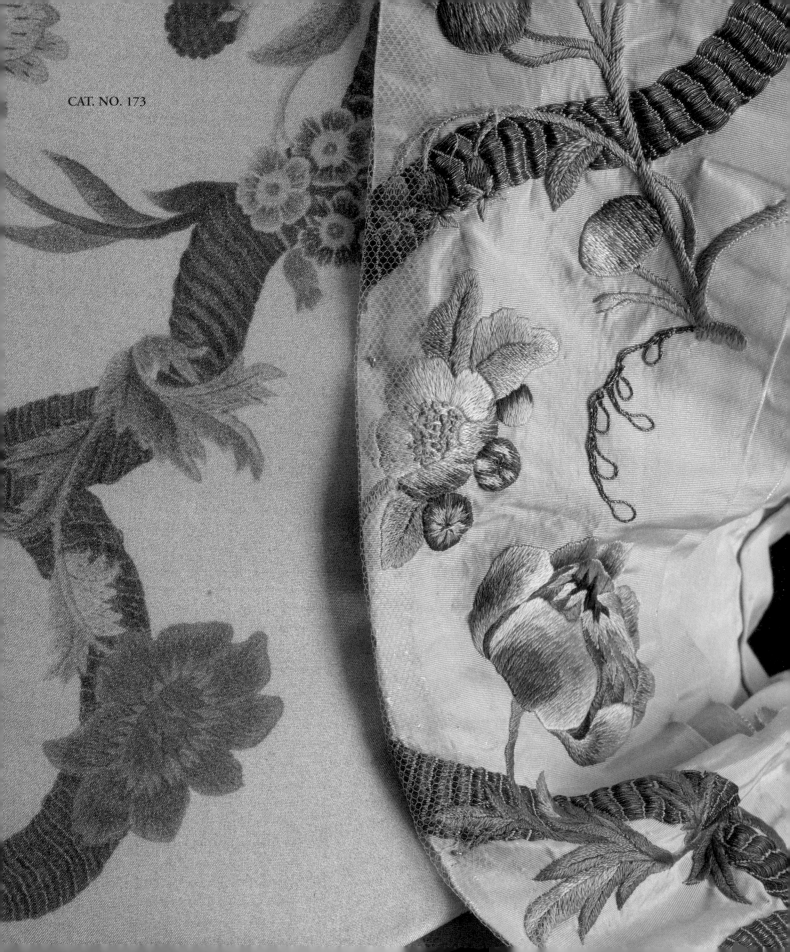

CAT. NO. 173